Urgent Moments

Urgent Moments

**Art and Social Change:
The Letting Space Projects
2010–2020**

Edited by
Mark Amery
Amber Clausner
Sophie Jerram

MASSEY UNIVERSITY PRESS

Contents

7 Open Call
Chris Kraus

17 The Time Travellers
Pip Adam

20 Before

///

2010

24 Realty Pitch

34 Popular Archaeology: Cassette, c.1967–94
Dugal McKinnon

42 Free Store
Kim Paton

52 Beneficiary's Office
Tao Wells

68 Taking Stock
Eve Armstrong

2011

- 80 Shopfront
 Suburban Floral Association
- 88 The Market Testament
 Colin Hodson
- 96 Pioneer City
 Bronwyn Holloway-Smith

2012

- 110 Free of Charge
 Julian Priest
- 116 Productive Bodies
 Mark Harvey
- 128 The Public Fountain & D.A.N.C.E. FM 106.7
 Tim Barlow & D.A.N.C.E. Art Club
- 144 Open Plan: An Art Party
- 148 Urban Dream Brokerage 2012–18

2013

- 154 Studio Channel Art Fair
- 158 Transitional Economic Zone of Aotearoa 2013

2014

- 194 Please Give Generously
 Judy Darragh
- 202 Te Ika-a-Akoranga
 Bronwyn Holloway-Smith

2015

- 214 Moodbank Wynyard
 Vanessa Crowe
- 220 Projected Fields
 Siv B. Fjærestad
- 232 Transitional Economic Zone of Aotearoa 2015

2016

2017

- 272 Groundwater: Common Ground Arts Festival
- 298 Unsettled
 Rana Haddad & Pascal Hachem
- 304 Our Future Masterton — Ahutahi ki mua

After

///

- 317 Human First, Artist Second
 Mark Amery & Sophie Jerram
- 327 Shifting the Urgency
 Zara Stanhope

///

- 334 Project Notes
- 344 Acknowledgements
- 345 Note on the Text
- 346 Image Credits
- 347 About the Contributors
- 349 About the Commissioned Artists

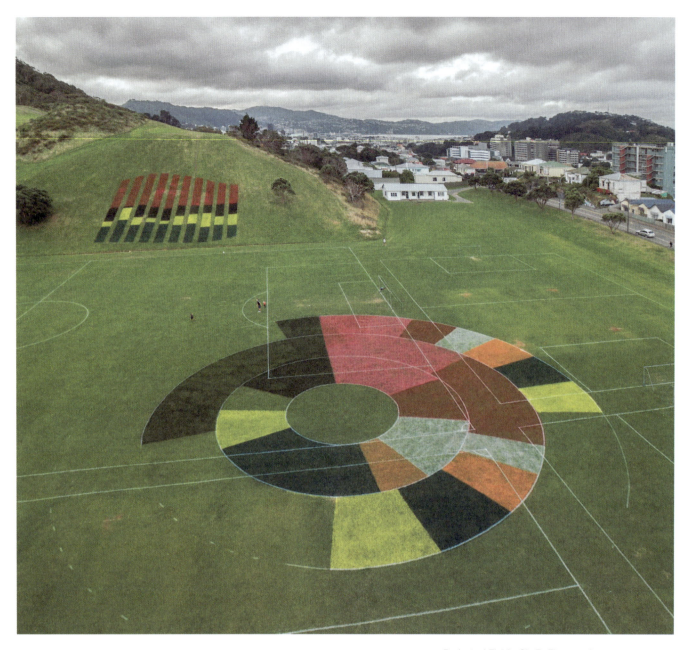

Projected Fields, Siv B. Fjærestad, Wellington, April 2015.

Open Call // Chris Kraus

During the seven years chronicled in this book, Letting Space ranged wildly and admirably between disciplines and genres. The project is almost impossible to define. Letting Space producers Mark Amery and Sophie Jerram's mission was broad and ambitious: 'to transform the relationship between artists, the public and their environments to enable social change'. It's only now, by examining the extraordinary documents contained in this book, that it's possible to appreciate the unusual agenda that Amery and Jerram devised: to create an organisationally stable but conceptually fluid enterprise capable of responding to changes in the social landscape as it evolved.

Seven years is a very old age for an artist-run enterprise. The project's longevity can be attributed to its ability to shape-shift between high-art conceptualism, institutional critique and para-artistic social repair . . . a shift that was determined by the artists and other practitioners who responded to Amery and Jerram's many open calls.

As Amery sets out in his account of the project's beginnings (page 20), Letting Space began in 2010 in the wake of the global financial crisis (GFC) of 2007–08. In the ensuing years, Wellington's central business district became a ghost town of vacant commercial spaces that developers were reluctant to lease long-term at temporarily low market rents. All over the world, from Tijuana's Avenida Revolución and West Amsterdam to downtown Los Angeles, artists and artisans saw this catastrophe as an opportunity to occupy space, escape from the prevailing institutional structures and launch new careers with a very low overhead.

Amery and Jerram had, in a sense, been here before. They'd witnessed the explosion of alternative enterprises that arose in Tāmaki Makaurau Auckland after the 1987 stock market crash, from the artist-run gallery Teststrip on Vulcan Lane to the more institutionally organised Artspace, which moved into a large, rent-free space on Quay Street courtesy of the building's developers after they had been unable to lease it at a viable commercial rate. This phenomenon wasn't unique to Aotearoa New Zealand. Among many notable international examples from this time, Marianne Weems' multi-media theatre company The Builders Association was born of a deal that Weems struck with Tribeca developers in New York intent upon warehousing their vacant space. These late twentieth-century enterprises were proactively parasitic. The artists involved were able to recognise adverse economic conditions and then capitalise on them, turning empty space into creative opportunity zones.

In 2010, the year of the Arab Spring and the year before the worldwide Occupy movement, Jerram and Amery realised that, this time, the situation was urgent and things had to be different. The GFC was just the latest in a long series of international influences and domestic policy shifts — from the destruction of the social safety net enacted by Rogernomics and Ruthanasia in the 1980s and 1990s to the Disneyfication of New Zealand that followed the success of *The Lord of the Rings* and its global perception as a billionaire's bolthole — that violently separated winners from losers and transformed the national mood to one of quiet, impending doom.

As the American writer Eugene Lim writes in his post-Occupy book *Dear Cyborgs*:

> Everywhere there is no there there. Except for those and that that's fucked. There there's hell. Detroit, Dharavi, Guryong Village, Cova da Muta, Oakland . . . The smoothing of all difference into capitalist civility is remarkably unremarked on. Oh, the omnipotent juices of the market's gut — it eats it all! And maybe the non-remarking is but one other aspect of the digestive process. (How quietly it eats!) . . . Like the city itself the complex is unknowable, one's neighbors are so close yet so far away . . .[1]

Everywhere included Aotearoa, where a sense of the elegiac hovered over it all.

In a post on *The Standard* from 2020 titled 'The Real Cause of New Zealand's Failing Housing System', regular blogger Micky Savage recalls his experience growing up in the 1960s and 1970s: 'My dad was a boilermaker and my mum had to cope with five of us, but we had a modest but reasonable home to live in, plenty to eat . . . I grew up in a real working class area . . . where the cost of putting a roof over everyone's head was not a major draw on incomes that increased every year.'[2]

Similarly, in her 2017 essay about Groundwater, a festival curated by Letting Space (page 291 of this volume), Moira Wairama recalls the Hutt River that she and her sisters and cousins and friends knew during her childhood: 'The river was our playground and everyone swam there . . . Later, my own children swam at water holes at the entrance to Stokes Valley and under the Silverstream bridge. Now my mokopuna and our whānau whānui drive up to Akatarawa, Te Mārua or Kaitoke where the river water is still clean . . .'

Planning their venture in 2010, Amery and Jerram realised that Letting Space would need to be more like a predator and less like a happy parasite, using the donated spaces to interrogate what people want and where things went wrong. They asked: How best to activate these feelings of loss and regret into a liveable present and future? Their answer: supporting projects that exposed all the contradictions between the artistic participants and their developer hosts — projects that explicitly raised economic and environmental concerns.

This was a tricky position for Letting Space to navigate. How would it remain critical while accepting a development company's generous offer of free space? How to evolve from the parasitical position of grateful oblivion without actively biting the hand that feeds it?

///

The earliest Letting Space projects addressed the proliferation of plastics (Eve Armstrong's *Taking Stock*, 2010); the grocery supply chain and retail experience (Kim Paton's *Free Store*, 2010); alternative paths towards development — on Mars! (Bronwyn Holloway-Smith's *Pioneer City*, 2011); and, most controversially of all, Tao Wells' *Beneficiary's Office*, in 2010.

Wells famously set up an office on Manners Street for three weeks in 2010, courtesy of The Wellington Company, a prominent local developer, for his new

1. Eugene Lim, *Dear Cyborgs: A novel* (New York: Farrar, Straus and Giroux, 2017).
2. Micky Savage, 'The Real Cause of New Zealand's Failing Housing System,' *The Standard*, 23 February 2020, https://thestandard.org.nz.

public relations firm The Wells Group. The firm's first agenda was to advocate for unemployment as an environmentally sustainable lifestyle. As the firm pointed out, 'The average carbon footprint of the unemployed person is about half that of those earning over $100,000 . . . we need to work less so we consume less.'[3]

A beneficiary himself, with this project Wells provoked a torrent of rage from the media and general public. If this felt like déjà vu, it's because it was: in 2004, Parliament debated withdrawing funding from the artist chosen to represent New Zealand at the 2005 Venice Biennale exhibition because she refused to use her own name. Wells' action further exposed New Zealand's abhorrence of conceptual art that receives any amount of public funding and his benefit from Work and Income New Zealand was temporarily suspended. 'So that's where our money goes', the *Dominion Post* wrote.[4]

An editorial in the *New Zealand Listener* cavilled that Wells 'disparages working people, and exhorts them to ditch their jobs, live off the state and become minimalist consumers'.[5] 'If only he'd put the same effort and energy into his CV he probably wouldn't have a problem', acting Minister of Social Development Judith Collins remarked to *Prime News*.[6] Of all the Letting Space projects, *Beneficiary's Office* was the most successful at stirring up a hornet's nest of unresolved contradictions. Still, New Zealand being the small place that it is, Wells' contemporaneous video documentation *The Happy Bene* finds him in the office with The Wellington Company's CEO Ian Cassels, amiably chatting and bantering.[7]

Capitalising on the same small-country level of direct communication and accessibility, in two pitch events in 2010 and 2011, called Urban Dream Brokerage, Jerram and Amery enlisted members of Wellington City Council to listen to artists, landlords and property managers pitch their ideas for creative uses of vacant space. The open call was an improbable spin on reality television. Artist Kim Paton proposed setting new benchmarks for real estate pricing that included social and cultural benefit; artist and filmmaker Colin Hodson suggested transforming the upper floors of high-rise buildings into wild urban spaces; while artist and prankster James R. Ford proposed inviting the public to help him destroy his 'cursed Nissan Primera'. Of these three, only the car demolition project was funded. Nevertheless, in 2012 Urban Dream Brokerage became a permanent institution, matching artists and property owners.

Although less inflammatory than *Beneficiary's Office*, Kim Paton's 2010 project *Free Store* similarly exposed deep and revolving questions, this time regarding the psychosocial dynamics of generosity, food wastage and the boundaries of contemporary art projects within the genre of 'social practice'. An experienced grocer herself — she ran a grocery for three years in Raglan — Paton took over an empty shop owned by Foodstuffs on Ghuznee Street in central Pōneke Wellington to collect and 'market' donated food that would otherwise be discarded. Designed to look more like a shop rather than a food bank, *Free Store* aimed to remove (or at least examine) the stigma attached to receiving goods outside the normal means of exchange. Paton went on to develop a second temporary iteration of the store in West Auckland (to more media attention) and others picked up the Wellington store, which became a permanent institution beyond the artwork's demonstrational realm.

[3] 'Beneficiary's Office', page 52 of this volume.
[4] 'So That's Where Our Money Goes', *Dominion Post*, 16 October 2010.
[5] 'A Blow to the Art', *New Zealand Listener*, vol. 226, no. 3677, 30 October–5 November 2010.
[6] The Wells Group, 'Wells Group — The Beneficiary's Office on Prime News', 18 October 2010, https://vimeo.com.
[7] Dick Whyte and Tao Wells, *The Happy Bene — THE MOVIE —*, https://vimeo.com.

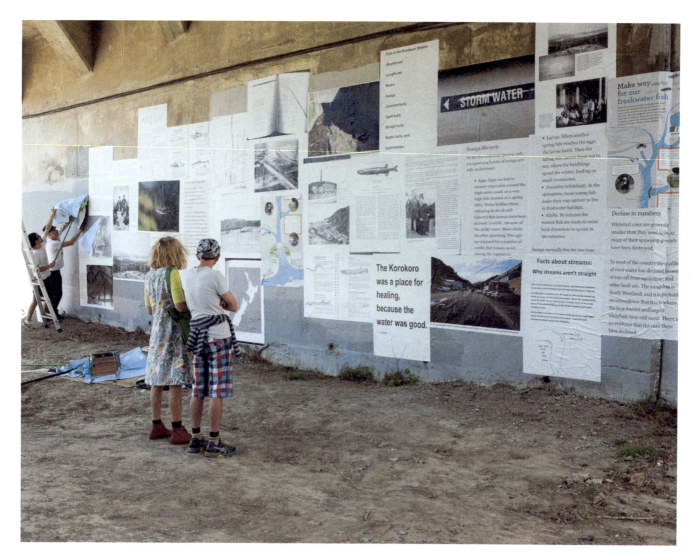

Inanga Love Park, Kedron Parker and collaborators, Groundwater: Common Ground Arts Festival, Hutt Valley, February–March 2017.

As Heather Galbraith writes in her essay 'Visible and Actual' (page 45 of this volume), art world observers became 'uncomfortable with the growing distance between the initial propositional "small (art) gesture" and the more concrete, large-scale social service initiative. If *Free Store* is taken up, formalised and made part of an official service delivery, does the subsuming or the lowering of visibility of the critical creative impulse and ethical/philosophical investigations of the project lessen its cultural value?'

For two weeks in 2011, Colin Hodson took over Asteron House on The Terrace, a seven-storey commercial building that was temporarily dormant while its owners made plans to renovate it. Leaving the remains of the building's vacated offices in place, Hodson programmed the building's fluorescent lights to turn on and off in tandem with share-trading volumes on the New Zealand stock exchange. This kinetic sculpture, *The Market Testament*, brilliantly rendered visible the invisible flows of the market that govern our lives. Like the sound of church bells ringing every quarter hour to remind people in the Middle Ages of the passage of time and their own mortality, Asteron House was transformed from a vacant building into an elusive monument, one that revealed the relentless laws of financial exchange that pulse under the skin of the present.

Translating the ungraspable abstraction of high economic exchange into a giant abstracted pattern of light, *The Market Testament* was less overtly challenging than Wells' and Paton's more social projects. Nevertheless, as Martin Patrick reports in this volume, readers of the *Dominion Post* didn't fail to observe that in 'wasting power', the project 'didn't seem very artistic at all'.[8]

///

A year later, in 2012, Amery and Jerram put out a call for new public artworks based on the theme of 'community service'. This was one year after the city of Ōtautahi Christchurch had been razed by the biggest of the Canterbury earthquakes. John Key was in the fourth year of what was to be an eight-year tenure as prime minister, fulfilling the National government's promise of privatisation by gutting the public service bureaucracy (or 'draining the swamp', as Donald Trump later put it). The Letting Space call for 'community service' projects was a pivot, a shifting of emphasis. If most of the projects produced up to that date had hovered somewhere in between conceptual art and social practice, this new series provided clarity and committed Letting Space to the exploration of a new means of public engagement.

Like all boundaries, the new definition would at once limit the scope of the enterprise and open new paths of discovery. One of the first projects, Mark Harvey's *Productive Bodies* in 2012, recruited a small cadre of unemployed people and stay-at-home parents to mill around office foyers pushing lift buttons for government workers and applaud Te Papa museum goers as they entered and left the building. These actions might at first glance seem self-conscious and silly, but they raised vital questions about the value accorded to work and the shifting of responsibility for social care from the state to the individual. As participant Gradon Diprose would later reflect, 'There was a certain pointlessness to some of our work, like collecting leaves off the grass . . . that made me think about the

8. Comments on Tom Pullar-Strecker and Tom Hunt, '$6500 grant to light up a building', Stuff, 12 April 2011, www.stuff.co.nz.

pointlessness of so much of my "employed labour", such as the endless work emails and report writing that will be forgotten next week.'[9]

But even more vitally, the new series opened the door to projects that took place outside city centres. D.A.N.C.E. FM 106.7 brought artists from Tāmaki Makaurau to Taupō and Tūrangi, where they set up a mobile temporary radio station, while Tim Barlow, in collaboration with engineers, constructed a temporary water fountain. Travelling around the region, the project involved many local storytellers, scientists, school and kura students and residents of a retirement village.

Building upon the ideas and exchanges that arose from these projects, in 2013 Letting Space set up the Transitional Economic Zone of Aotearoa (TEZA) in the suburb of New Brighton in Christchurch. Diminished by post-quake school mergers, a rise in sea levels and the abandonment of a once-thriving shopping district, New Brighton was paradigmatic of those (many) places left behind in the flush of neoliberal globalisation. It was an exurban 'hinterland', as defined by American geographer Phil A. Neel in his groundbreaking book of that title,[10] existing in limbo outside the cores of the supposedly post-industrial economy.

For a week in late 2013, Letting Space veterans such as Mark Harvey, Kim Paton and Tim Barlow joined forces with local organisations and a host of other artists, including the renowned musician/composer Phil Dadson, to host a series of events that would encourage New Brighton residents to imagine alternative futures. Letting Space producers and artists were aware of the failures of international projects that alight in troubled areas with evangelical condescension and zeal. To avoid this, Letting Space deliberately worked with existing local organisations. No conclusions were reached, but as respondent Andrew Paul Wood later noted, 'TEZA was doing a better job of outreach than many of the politicians'.[11]

///

Two years later, Letting Space set up another TEZA in Cobham Court, an underused cluster of vacant shops in Porirua. TEZA ran in tandem with a satellite Urban Dream Brokerage programme that Letting Space had established with the Porirua Chamber of Commerce. This spawned a series of projects, such as Toi Wāhine, a Māori women artists' space, which would continue for years. Historically working class, by 2015 Porirua was being rapidly gentrified as middle-class people priced out of Wellington moved into the suburb. Letting Space initially set up in a vacant McDonald's that had once been the scene of fondly remembered kids' birthday parties and hosted more than 40 events.

As Reuben Friend, the then director of Porirua's Pātaka Art + Museum, later noted, the presence of TEZA drew explicit attention to real but repressed racial and class divisions. 'In the midst of this maelstrom,' he writes in this volume, 'some sophisticated strangers strolled into town [and] managed to stir up difficult conversations that many stakeholders are either too polite or too politic to discuss on the public record.'[12] There were concerns, he writes, from local store owners that the pop-up projects simply added to 'the unrefined, construction-like feel of the area'. Local retailers were seeking large anchor businesses that could provide

9. Gradon Diprose, 'Productive Bodies: Reflections', page 182 of this volume.
10. Phil A. Neel, *Hinterland: America's new landscape of class and conflict* (London: Reaktion Books, 2018).
11. Andrew Paul Wood, 'TEZA Tour of Duty: A response', page 180 of this volume.
12. Reuben Friend, 'Art, or Community Service', page 235 of this volume.

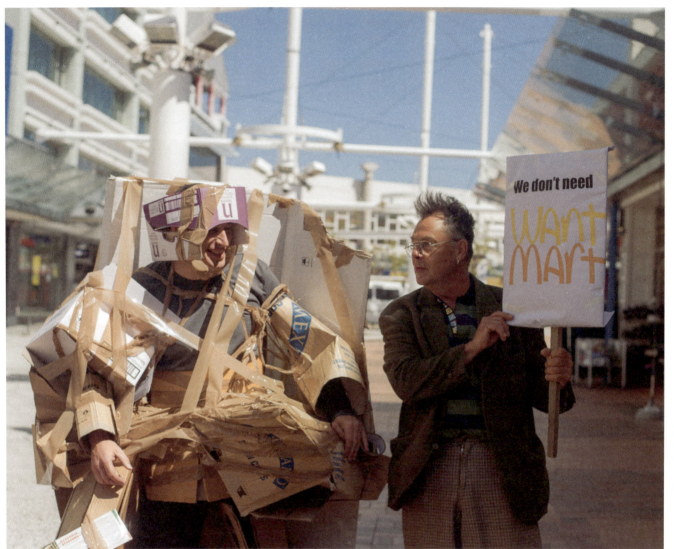

Mark Harvey with *Productive Promises* and Barry Thomas with *Want Mart*, Transitional Economic Zone of Aotearoa, Porirua, November 2015.

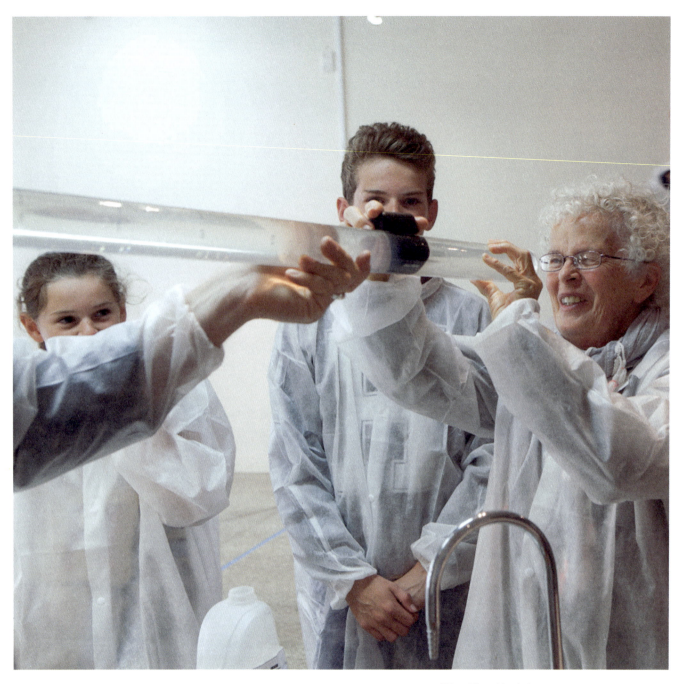

Citizen Water Map Lab,
Julian Priest, Groundwater:
Common Ground Arts Festival,
Hutt Valley, February–March 2017.

a permanent revitalisation. And yet, as respondent Murdoch Stephens notes, 'Retail spaces are being gutted and this is not going to stop . . . The losers will be those who don't understand the new sensitivities of the economic zones of our urban centres. As the boat is sinking,' he goes on, 'we cling on to whatever seems the most stable.'[13]

In Porirua, Letting Space used social practices to arrive at the same acute point of criticality achieved by their early conceptual projects. As Friend argues, 'They have activated our community in a way that no one else could or would have.' TEZA Porirua was 'a stealthy sleeper-project, distilled in plain view of the community', he concludes, and as such had 'a subversively powerful force'.[14]

The fine grain and social impact of these local projects offered a counterweight to other prevailing forces in the contemporary art world. The famously nomadic, inventive New Zealand artist Kate Newby now lives in the small town of Floresville, Texas. After completing her Master of Fine Arts at Elam in 2007, she — like most of her cohort — soon departed for the United States and Europe. Now, Newby says, the trend is for ambitious younger contemporary New Zealand artists to leave even earlier, after completing their BFA, to do postgraduate study in international centres. She mentions a handful of names, most of them names that I've heard of.

The genius of Sophie Jerram and Mark Amery's Letting Space was to provide a platform for interrogation for those artists who chose to remain in New Zealand. When you are almost inevitably going to be regarded as provincial, why not embrace that provinciality by producing works that critically, consciously engage with local conditions? For seven years, Letting Space ingeniously used Aotearoa New Zealand's singular circumstances — its physical distance from the international art world's main centres; the relative ease of communication that exists in a small, comparatively closed society — to enact something important, exemplary.

13. Murdoch Stephens, 'Doing Critique', page 252 of this volume.
14. Friend, 'Art or Community Service', 235.

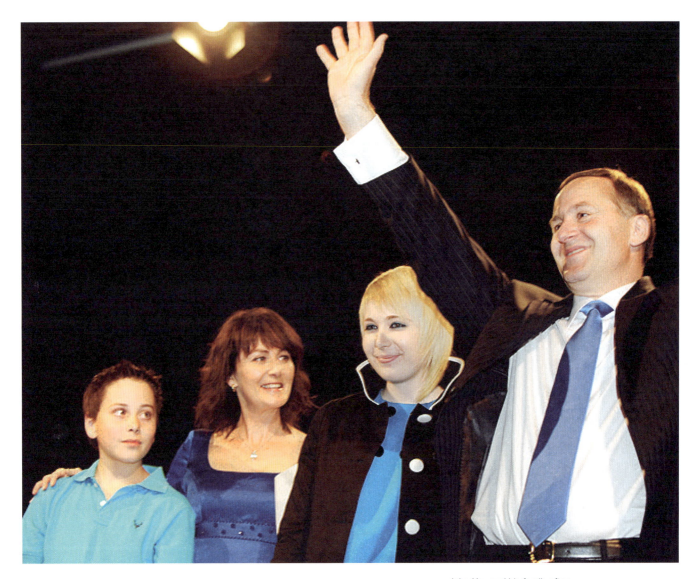

John Key and his family after the announcement of the 2008 general election results, Auckland, November 2008.

The Time Travellers // Pip Adam

In 2037 — bored with Mars, bored with boring, running from dead and injured workers, the fires coming closer, clean water nowhere to be found — the billionaires turn their money to time travel.

'Things,' they say (in private), 'are getting us down.'

'It's hard to stay positive.'

'And everywhere in history is better for a white, rich man.'

They move slowly though. Act calmly. There are no urgent moments when you have money and resources. They move slowly and smile and although the planet is burning the stocks stay stable.

And so — because of the money, because of the time, because of the connections — the people with the most power come to time travel first. And when they come to it, they imagine it white, empty. The logo is like that. The videos for investors are like that — beautiful, slim people walking in a white infinite space. They imagine a white room. No corners, no walls. Empty but for invited guests. This is the way a focus group imagines time. This is what they want to see. This is the vision of time that agrees with them. The branding people and the communications people and the marketing people who took these jobs to support their writing and their art and their dance and their families spend days, nights not writing, not painting, not dancing, away from their families, giving them exactly what they want. A white space. Empty except for the possibilities alive in them. And so the feedback is complete.

And they are shown what they suspect. Reassured by the animations and the artwork that their journey will be without politics. They expect travel through time will be completely neutral. That their presence will be welcomed. That their needs will be met. That they will observe but will always get what they want.

For them it is as if John Key is forever prime minister.

But of course they, like all colonists, are wrong. Time is already owned. Populated by the people who live there. Time cannot be commoned because it is already common.

They travel to Deepwater Horizon, to Fukushima, to Tongariro, to the *Costa Concordia*. They call it disaster tourism but it's not really. Not for them. Because they can leave. They do leave. As soon as it gets a bit too like a disaster they go somewhere else. To Sky City on 9 November 2008 — so happy to be here. Drinks flowing. People cheering. Max in a blue T-shirt. The last time we see Stephie. The only ones shouting, *Eight more years*. Thinking it's a joke and not fully understanding the consequences of their joke. Sheltered always from the consequences of their joke.

They travel to Tunisia in 2010 and want a Big Mac and want to be welcomed, and want a power point for their brand new iPad. They come and then they cough, and in 2012 Middle East respiratory syndrome coronavirus breaks out. And the consequences of their travel are not always unintended. The United States Department of Justice shuts down the file-hosting site Megaupload. They buy a pastel version of Edvard Munch's *The Scream*. They sell a pastel version of Edvard Munch's *The Scream*. Lorde's song 'Royals' makes it to number one in the US charts. Microsoft ends extended support for Windows X. At the start they are

conservative — starting small and in whispers but, gradually, they become brave and have the ear of everyone. And when it goes badly they leave. Time becomes their plaything. Just like everything else.

And so, Occupy Wall Street protests begin.

They become careless and leave a door open. They are careless because they have no cares. They have time travel, nothing can touch them. Like the safari from behind lion-proof glass, like a shark cage — nothing hurts.

A secretary is the first to notice the way in. A personal assistant who is also a sculptor, who didn't get funding and didn't get funding and didn't get funding and got this job because she said she had experience with budgets and project plans. 'I understand how to work in order to achieve predetermined outcomes,' she said in her interview. It wasn't entirely true, but she could imagine more than a white room.

It isn't a metaphorical door. When she explains it to the others — the cleaner, the comms person, the bookkeeper — she makes it clear she's not talking about a 'door' in any figurative way. There is literally a door on the fourth floor, by the toilets and it is open. 'I walked in,' she says. 'You can walk in and you can go where you want.'

'Is there food?' someone asks and the others nod like they would also like to know. Because there is no food in 2037, they are starving, and their children are starving.

'I didn't go anywhere,' she said. 'I just looked. But surely there is food.'

And they follow her and they look and they talk and of course, they say, they will also be colonisers. Their poorness and their desperation doesn't make them any less culpable. And they look out the window at the red, red sky and the acid rain. And in desperation they decide to go. Just for a moment. Just to eat.

And after they are fed. After they bring back food. After they ensure the way in. They start to make it possible for others to travel. There are rules like 'do no harm' but they know these are impossible rules to keep. So they make rules like 'stay and fix what you harm' and 'listen to the people you have harmed'. None of the rules make it right but some of them, sometimes, make the time travel less wrong. They will all travel just once, to one time, and then stay and do what they can.

Some don't travel. But for most of the workers in 2037, time becomes their arc. Those who want to travel make a case for the time they want to go back to. They research, they read books, they read this book. They weigh up the good and the bad and some walk among us now. Some came back through the gap that the financial crash left, some slipped in through the rain of a storm the size of Australia.

And once here, some of them find themselves in a room in a poorly funded archive. A soft din, a sonic tincture colouring the air. Some visit a free store. Some help carry things to the *Free Store*. Some are helped across a street. Some help others across the street. Their art dreams are fulfilled but in complicated ways. But they stay there, for the hard times and for the times during which they are hated, and for the times when what they thought was the right thing turns out to be the wrong thing. And they stay and they get old and they die — some in their sleep, some too early, all in a single urgent moment.

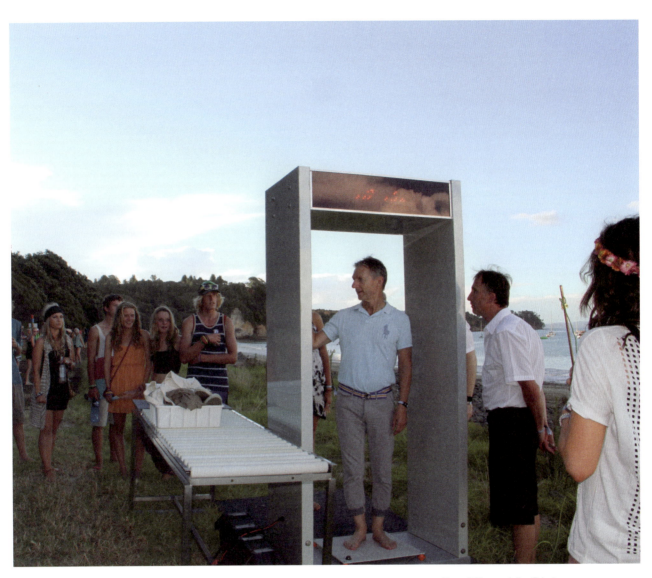

Free of Charge, Julian Priest,
Tāpapakanga Regional Park,
Auckland, February 2012.

The Time Travellers // Pip Adam

Before

///

After an intense period of state intervention in the economy and rising inflation during the early 1980s, the Fourth Labour Government began a programme of massive deregulation and privatisation of state assets. It contributed to stock market expansion and fast corporate growth.

This became physically evident in major New Zealand cities, including the Auckland central business district, where many historic buildings made way for tall towers or parking lots, while finance was arranged for new builds.

After a dramatic crash in the stock market in 1987, the flow of finance slowed drastically, a sustained recession set in and commercial vacancy in the CBD rose to high levels. The seeds of Letting Space were planted. Artists of all disciplines found space to live and practise in older inner-city buildings and developed fledgling gallery and theatre spaces. As a consequence, the 1990s were an important time for independent arts practice in major New Zealand cities. A range of festivals, venues and production organisations were established to support this practice, slowly adapting to the new neoliberal order as 'creative industries'. By the end of the decade property values were back on the rise, Auckland was home to a bustling professionalised arts scene and Wellington was officially dubbing itself the 'creative capital'.

Not-for-profit art gallery Artspace was established in Auckland in 1986. By 1988 it was operating in a large, old, open-plan first-floor space on the waterfront on Quay Street — a space offered for free by the property development company that owned the building and were unable to rent the space. With an ambitious exhibition and experimental performance programme, Artspace played a vital role in the development of contemporary arts practice in the city. It would be joined in 1992 by Teststrip on Vulcan Lane, often described as Auckland's first contemporary artist-run space.

In 1992 the future founders of Letting Space, Sophie Jerram and Mark Amery, joined Artspace's board. With fellow board member Judy Millar, they put together a programme of projects in vacant commercial sites under the title 'Letting Space' that aimed to provide 'the opportunity for artists to exhibit outside the dealer system, taking work out into the public domain, examining the relationship between society and art . . .'[1]

A 1994 Yuk King Tan installation on an upper floor of a distinctive red pagoda-shaped new office tower commented on the tower's representation of Asian business interests. Other projects were organised by Tessa Laird, Judy Darragh, the late Ant Sumich, Kathy Waghorn, Joyce Campbell, Jon Bywater and Donald Fraser.

Amery and Jerram separately moved to Wellington, and in 1994 Jerram initiated *The Concrete Deal*, a series of installations in the large spiral of the James Smith Carpark on Wakefield Street.

Between 2007 and 2009 the global financial crisis led to global economic recession, manifesting locally in another bout of commercial vacancy. In Wellington, Amery and Jerram decided to join forces again and use the newly

1. Artspace, 'Access All Areas' newsletter, 1994; Letting Space Archives

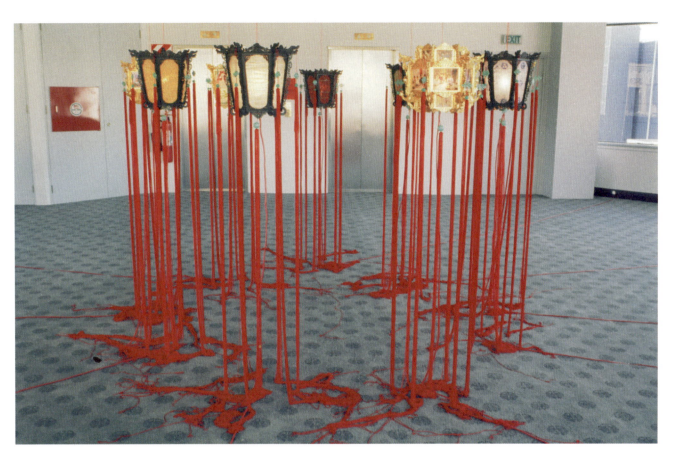

Yuk King Tan installation, Auckland, 1994.

available vacant space. Letting Space was established in 2009 under the auspices of the Wellington Independent Arts Trust. The proposed programme was different to that of 1993–94 — the new Letting Space was committed specifically to work that had economic and environmental concerns. During its first year of projects, in 2010, Jerram was also working with artist Dugal McKinnon to present a programme of public discussions called Dialogues with Tomorrow. These brought together artists, scientists and leaders in other fields to explore art's interface with issues of sustainability and ecology — concerns that would be key to many of Letting Space's projects to come.

John Key is prime minister of New Zealand // The first iPad is released // The Deepwater Horizon oil drilling platform explodes in the Gulf of Mexico and the resulting spill spreads for several months // Julian Assange leaks footage of a 2007 airstrike in Iraq titled 'Collateral Murder' on the website WikiLeaks // The 2010 flash crash, a trillion-dollar stock market crash, occurs over 36 minutes // A 7.1 magnitude Canterbury earthquake causes widespread damage // A 'storm the size of Australia' passes to the south of New Zealand causing widespread damage // GST is raised to 15 per cent // Breakfast broadcaster Paul Henry is suspended by TVNZ after questioning whether Governor-General Anand Satyanand is a proper New Zealander // Unions threaten to boycott the $670 million project to film *The Hobbit* // A gas explosion in Pike River kills 29 workers // Taika Waititi's *Boy* is released // A 7.0 magnitude earthquake in Haiti kills over 100,000 // The attempted suicide of Mohamed Bouazizi, a street vendor in Tunisia, triggers a revolution in the country and the wider Arab Spring // The European Union and International Monetary Fund bail out Greece // Major cyber attacks are made in response to the banning of file-sharing websites such as LimeWire and The Pirate Bay // A litre of regular petrol is $1.77 // A litre of milk is $3.25

2010

Realty Pitch

6 May 2010 and
29 July 2011
Wellington

Property panel at the 2011
Urban Dream Brokerage realty
pitch forum, Wellington.

From Letting Space's inception in 2009, it operated independently, outside of established arts institutions. Letting Space looked to inhabit new kinds of public space by building partnerships with the private property sector. It also sought grants from Creative New Zealand (CNZ) — itself two-thirds funded by lottery money derived from private individuals.

In its first application to CNZ, Letting Space pitched a dozen short project ideas from artists across the country that it admired. If successful, Letting Space advised CNZ, it would develop five of them as a programme.

In this way, Letting Space looked to develop support for a wider community of artists and encourage a different kind of public practice, where new ideas might grow. Final projects were very often different in form from their initial seed ideas. There was no PR company or beneficiary's office, for example, in Tao Wells' first project description. While the financial support they received was modest, artists were given space to allow more radical approaches to develop.

With the backing of Wellington City Council (WCC), Letting Space ran two live pitching sessions: at City Gallery Wellington in 2010 and the Wellington Town Hall in 2011. Designed as ice-breakers to generate creative ideas for the use of empty commercial space and encourage future thinking in the city, the events were called Urban Dream Brokerage.

In a twist on the reality TV show *Dragons' Den*, artists presented their creative ideas for vacant spaces — 'realty pitches' — to a panel of property owners and managers, then property owners and managers made their own pitches to an artist panel. The audience decided on their favourite ideas at the end. Letting Space had already conducted an open call for realty pitches from which four projects were selected to be presented at the event and a number of others were published online.

There was a full house for the first event, with property pitches made by The Wellington Company's Ian Cassels, property developer Richard Burrell and former city councillor turned commercial realtor Rosemary Bradford.

(Sophie Jerram had been able to meet property owners in Wellington through her previous role with the Sustainable Business Network.) On the artist side, pitches were made by Kim Paton, Bronwyn Holloway-Smith, Erica van Zon and theatre group The PlayGround Collective.

Following the 2010 event, WCC found funding for two projects from a pool of 20 realty pitch applications, to be produced independently. In *Smash n Tag*, James R. Ford invited the public to help him destroy his own 'cursed' car 'as a public, cathartic action for those badly treated or misled by dodgy retailers and online traders', and an abandoned Kent Terrace house became an immersive installation site, transformed by an entanglement of fabrics, in Siân Torrington's *Inhabitance*.

Ford also appeared as a live realty pitcher at Urban Dream Brokerage in 2011. Dressed as a Teenage Mutant Ninja Turtle, he proposed inviting tortoises to live on a bed of grass in a vacant retail space for a week, their shells decorated to correspond to 10 subatomic particles, including the Higgs boson or 'God particle'. Other pitchers were Tim Barlow, proposing a 'fearless speech lane'; Shona Jaunas, with Natalia Mann on violin and harp, who explained French squatter laws and proposed a composer and filmmakers' studio and presentation space; and Bruce Mahalski and Bev Hong, who revisited colonial exchanges of goods for land.

Letting Space went on to develop projects with Tim Barlow, Bronwyn Holloway-Smith and Colin Hodson inspired partly by their original realty pitches, and a number of other projects were realised independently.

In 2012, after further conversations with WCC, a permanent brokerage service between artists and property owners was formed. Naturally, it was named Urban Dream Brokerage.

Realty Pitch

Market Forces, Boom & Bust and the Death of the Small Business Dream // Kim Paton, April 2010

Premise: Dynamism is achieved in a commercial inner-city area that services multiple audiences in an ongoing and sustained way. **Vibrancy** is achieved through the historical legacy of an area, which builds, shifts and changes organically and independently over a sustained period of time. **Liveliness** is achieved through attracting tenants who are independent, diverse and wide-ranging in the products and services they offer.

Each tenant is different. All of them share only one common goal, which is to be successful enough in their endeavour to cover their costs and pay the rent. Some tenants are driven to make a great deal of money, some however are not. Some tenants are driven by the products and services they passionately believe in, some in the dream of self-employment and some in the people they encounter on a daily basis. It is this diversity that enriches the inner city.

If the property developer/manager is driven (as they should be) for rich, vibrant, bustling streets it is their fundamental obligation to understand, encourage and incubate these tenants.

Action: An overhaul of the current rent pricing structure for the inner city and the abolishment of the standard market square-metre rate.

Introduction of a new rent pricing system requiring three benchmarks are met:

1. The site will **benefit** from the tenant in a commercial, cultural and social context.
2. The tenant can realistically sustain the demands of the price for the **long term**.
3. The property developer/manager will not suffer **undue** financial burden by the fixed rate, but may choose to offset profit from one site against loss from another in pursuit of diverse tenants.

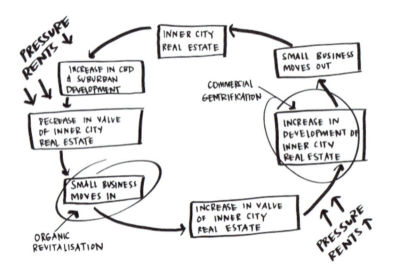

New Uses for High-Rise Developments During Times of Negative Growth // Colin Hodson, July 2011

The vertical levels of the inner city can accommodate the ebb and flow of a city's most dire economic fortunes. In times of slow apartment sales and decreasing tenancies, high-rise urban projects enter periods of low occupancy. This is the time to turn the upper floors of high rises into wild space.

The concept maximises urban high-rise use when floors (particularly upper floors) are under-tenanted during 'finance-energy' contractions. This vertically oriented concept is analogous with urban movement's lateral ebb and flow, wherein fringes of the city become a contested and shifting ground of wild spaces and newly emerging wastelands. Thus, during energy price ramp periods, disabling lift services and withdrawing services from upper floors will make economic sense. In these periods, we can look to the upper floors of under-tenanted buildings to stand in for our city fringes.

Open up the windows to allow New Zealand's flying wildlife access. Encourage them into this new habitat with lower-dwelling tenants contributing compostable waste upstairs rather than shipping to distant landfills. (The savings in energy transport costs to city fringes and associated health benefits from physically carrying this waste upwards are a big plus here.)

Feeding on this waste, urban birds — pigeons, seagulls and sparrows — can come to inhabit these floors. Their guano can help fertilise the growth of the burgeoning upper-level gardens. Native birds, feeding off the new plant life growing on these wild floors, will now have reason to set up here. Then, depending on the saturation of birds, predators like cats, dogs, stoats and rats can be released on to the upper floors when moderation is needed.

People with less affluence looking for accommodation would also find upper floors appealing, as ground-floor occupancy is highly sought after in times of high transport costs. Much like outer suburbs becoming ghettos when the ability to get to a mall becomes prohibitive, foot or bicycle access to necessities becomes a key driver of prime real estate, and these upper floors become the cheaper place to live. Thus, views and light become synonymous with financial and social isolation during these contraction periods.

So! When the next wave of cheap energy floods the market, these upper floors will become viable for tenancy again. Speedy lift services can now shoot rising artisans up to clearer views and fresher air, first displacing the human ghetto dwellers. These new occupiers start to clear these wildlands, taking out the compostable rubbish and junk, now squeezing out the animal settlers. By this time, the waste from outer landfills — the biodegradable part of it having been given time to decompose — can be put into service again.

And soon the upper floors become palatable again for an affluent market, and views, a feature that came to be associated with poverty, isolation and danger, are reclaimed as a sign of privilege. A new gentrification has taken place, and distance from the centre is back in vogue, the lower city abandoned and the upper limits celebrated.

In times of financial contraction, send urban waste upwards. In positive readjustments, resume horizontal displacement.

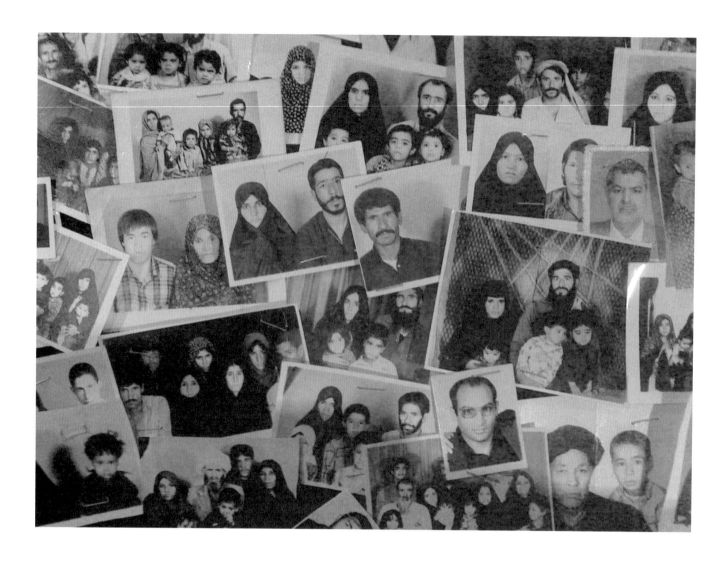

Security Matters // Murdoch Stephens, April 2010

In the desert of Central Iran is an abandoned caravanserai (silk-road trader hotel) which was used as a prisoner of war camp in the Iran–Iraq war (1980–88) and then as a detention centre (1989–2005) for Afghans who had fled the Soviets, warlords, Taliban and NATO. In one room of the caravanserai were thousands of abandoned files, each showing an image of a detained illegal immigrant.

I have 1100 of these photos.

I want to use either a series of empty apartments or a large commercial space to exhibit photographic reproductions of the most poignant of these images. They have not been shown or published before.

The commentary on these images is limitless, from sociological discussions on hospitality, war and family, to artistic/aesthetic discussions on the limits of found art and the ethics of documenting. The images will be voiceless sentries greeting citizens who are at war in Afghanistan, but who do not experience the war in any significant manner. Instead of using the apt sixties slogan of 'Bringing the War Home', I will simply quote the chilling new no-speak of the war on terror: 'You know that we don't comment on security matters.'

Postscript, 2022

I spent two years trying to work out what it meant for me to have these photos and where they belonged. In this first email to Letting Space I see how my focus was on the New Zealand context of using these images to speak to our government's role in the war on terror. While the secrecy of 'security matters' continues, my ideas about the images became less oblique as I thought more about what it would take to honour the people in the images. The first step was realising that I was in possession of an archive — the Anjīrak Afghan Archive.

I eventually showed the photos at Pātaka Art + Museum in 2013 and kept the idea of the sentry by having a curved wall where the viewer would feel themselves surrounded by the images and seen by those in the pictures. That same year I founded the Double the Quota campaign, which led to the first increase in New Zealand's refugee quota since 1987 and, eventually, a doubling of our refugee intake to 1500 places.

The photos in the exhibition were digitised and the originals given to the permanent collection of the Afghanistan Center at Kabul University.

After the return of the Taliban in 2021, an Afghan photojournalist friend told me that they had lit a small fire in the building housing this collection. There is no longer anyone there who might be able to report on the condition of the images. The safety of the images now means a lot less to me than the conditions being faced by my friends and their families who remain in Afghanistan.

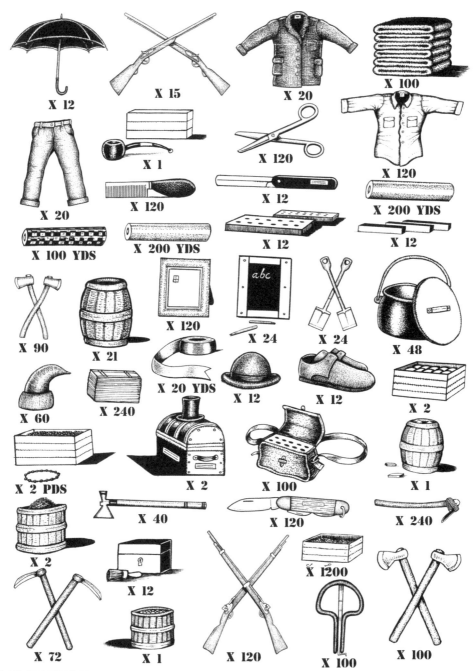

Price of Wellington // Bruce Mahalski, April 2010

The Ancient and Royal New Zealand Land Trading Company (since 1839) is proud to announce the opening of their new retail premises.

Do you have some land that you'd be happy to trade in?

We will give you top value in quality modern goods for your piece of unwanted real estate!

Goods swapped for land include:

- *ALCOHOL*
- *CARS*
- *CIGARETTES*
- *FOOD*
- *CLOTHES*
- *WEAPONS*

Come in and see what we will give you for your piece of land!

Spot prizes for lucky winners!!!

///

The proposed exhibition references the 1839–40 land transactions of the New Zealand Company, who believed that they had swapped goods worth £5000 — including tobacco/umbrellas/guns/fishhooks — for about one-third of the land in the country.

 The practice of swapping goods for land in perpetuity evolved in North America in the 1620s when English Puritans bypassed the English Crown and started swapping goods for land with the local inhabitants.

 Not much has really changed since, except we now use tokens — i.e. money — in exchange for goods where land deals are concerned.

 I have always found it interesting that it is possible to swap a piece of land — which is permanent — with something as insubstantial and impermanent as a keg of tobacco (or a carton of cigarettes).

 The proposed exhibition will not attempt to critique the 'wrongs of the past' but will rather ask the questions: 'What is land ownership?' and 'Should land really be sold — or swapped — at all?'.

 The exhibition space will be decorated with large posters advertising past and future goods for land deals and promoting the fact that 'It's time to think short term — not long term!'

 It will also be decorated like a stockroom, full of large cardboard boxes labelled 'FOOD' — 'ALCOHOL' — 'CLOTHES' etc., which will of course be full of nothing at all . . .

Realty Pitch

The Temporal Temple // Tiffany Singh, July 2011

Tiffany Singh's concept is to take one or several empty commercial sites around the city and transform them into shrines, or temporal temples, in order to produce art as an offering and a space for interaction, contemplation and cultural development.

By bringing together different traditional elements of ceremony and ritual the hope is to create an inclusive, accessible and respected space of contemplation within a commercial/urban environment. While re-examining the division between ritual space and productive space, this work attempts to invert a commercial sensibility to create an intervention of sanctity and rest and which hopes to initiate enquiry into ways in which cities understand their boundaries in relation in commercial and sacred space.

Fearless Speech Lane // Tim Barlow, July 2011

Fearless Speech Lane is a public assembly platform based on the classic Western model of the speakers' corner. Historically, the speakers' corner created a public commons site, often in the heart of the city, that was a space of free speech — anyone was able to stand on a soapbox and speak or perform whatever was on their mind.

The speakers' corner is based on a platform going back to the famous Stoa of Zeus, the covered walkway in the agora of ancient Athens, where Socrates is said to have met with other philosophers for debate; some say it was the site of the beginnings of Western democracy.

Strong arguments in favour of *Fearless Speech Lane* are: the encouragement of the arts of conversation, performance, instantaneous rapport, argument, heckling and choice of who to listen to, all happening in real space-time.

The Opera House Lane is the ideal central location for *Fearless Speech Lane* — it is weather protected, retail space is vacant and it is a busy commuter walkway.

This contemporary speakers' corner will add social media technology to the mix. With at least two monitors/projectors enabled for video conferencing links, national and international citizens will be connected to the local passersby, therefore all spatially included in an inter-communicative debate. Speakers would be invited to participate in the e-corner platform, possibly with a suggested topic or question, e.g., what does self-government mean to you?

The dramatic urban vistas in Opera House Lane also give a potent backdrop to anyone wanting to make a point.

Fearless Speech Lane will also include a 'political foods' market, offering the attractions of refreshments, enticing, delicious smells, warmth and atmosphere.

Popular Archaeology: Cassette, c. 1967–94

Dugal McKinnon
18 April–9 May 2010
Wellington

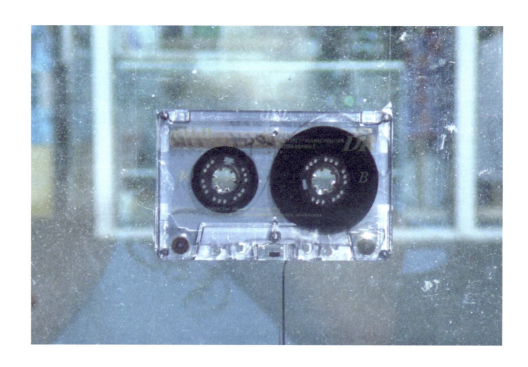

By 2010, the most likely place to see an audio cassette tape was in a player in the dashboard of an older-model car. Once abundant, considered to be vinyl's poor cousin in the seventies and eighties, usurped by the CD in the nineties and the iPod in the aughts, most people's once-beloved collections had long gone into storage.

Resembling a room in a poorly funded archive, Dugal McKinnon's *Popular Archaeology* exhibited vintage cassette players. Each played a short, looped fragment of a New Zealand chart hit in chronological order from 1967 to 1994 — the approximate period in which the cassette was a major mode of music distribution. The tape players were arranged on a grid of Lundia office shelves at the back of a dusty, bare, dimly lit concrete vacant space, spanning the width of the room as a wall of sound. You heard this long before you picked out any specific songs or saw any visual details. Sonic architecture, it was — a 'room that echoes', to quote the title of an 1985 New Zealand hit by Peking Man.

Each song was reduced to a disembodied, deteriorating voice; together, they were akin to a dying Gregorian chorus. McKinnon wrote: 'A soft din, a sonic tincture colouring the air. Shards of pop history puncture the noise of time. A choir of scavenged hooks, licks and choruses. An invitation to remember through the dismembered, the almost discarded, the chanced upon somewhere, the kept just because.'

In the new era of portable digital music libraries, and against the backdrop of the spectacular rise and fall of illegal file-sharing platform LimeWire (2004–10), *Popular Archaeology* emphasised the frailty of memory and analogue materiality. Loops needed constant repair; magnetic tape eroded through repeated use. 'The installation plays upon the myth of totality that has emerged in the online era,' wrote McKinnon, 'an era in which the entire world is available in digitised form, effectively replacing the real . . .'

The artist also invited the public to unearth their own tape collections and put them into a temporary public archive near the space's front doors. The exhibition of people's home-recorded tapes was a chance to air personal stories attached to mixtapes and cassette compilations of radio singles, LPs and CDs. It recalled that home taping on to blank cassette tapes (C60s and C90s) was once widespread and stereo systems with built-in tape-to-tape dubbers encouraged by the retail market.

Popular Archaeology opened on Record Store Day, a worldwide annual event celebrating independent record stores at a time when many had been closing, struggling to compete with chain stores and online downloads. A few doors up, the Samurai record store sizzled sausages while a DJ spun records. Across the road, stereo retailer Sound Expression had sleekly designed, multi-CD-player stereo systems exhibited in its window.

With offices in the building above being gradually renovated by The Wellington Company, 141 Willis Street was a temporary watercooler space as well as a community archive, and a place where Letting Space first became a community — a group of artists playing at keeping office for three weeks.

Popular Archaeology: Cassette, c.1967–94 // Dugal McKinnon

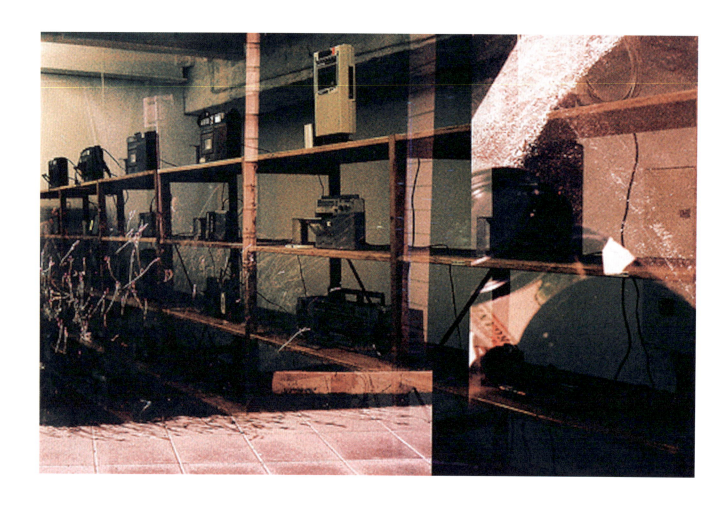

List of Archaeological Artefacts at 141 Willis Street

1967 Mr Lee Grant, 'Thanks to You'
1968 The Simple Image, 'Spinning Spinning Spinning'
1969 The Rebels, 'My Son John'
1970 John Rowles, 'Cheryl Moana Marie'
1971 David Curtis, 'Take Your Leave'
1972 Creation, 'Carolina'
1973 Creation, 'Tell Laura I Love Her'
1974 John Hanlon, 'Lovely Lady'
1975 Mark Williams, 'Yesterday Was Just the Beginning of My Life'
1976 Max Merritt, 'You're Slipping Away'
1977 Split Enz, 'My Mistake'
1978 Dragon, 'Are You Old Enough?'
1979 Tina Cross, 'Make Love to Me'
1980 Jon Stevens, 'Montego Bay'
1981 Split Enz, 'History Never Repeats'
1982 Howard Morrison, 'How Great Thou Art'
1983 Coconut Rough, 'Sierra Leone'
1984 The Dance Exponents, 'I'll Say Goodbye'
1985 The Mockers, 'Forever Tuesday Morning'
1986 Dave Dobbyn, 'Slice of Heaven'
1987 Herbs, 'Sensitive to a Smile'
1988 Holidaymakers, 'Sweet Lovers'
1989 Margaret Urlich, 'Escaping'
1990 The Chills, 'Heavenly Pop Hit'
1991 The Exponents, 'Who Loves Who the Most'
1992 Greg Johnson Set, 'Isabelle'
1993 Tim Finn, 'Persuasion'
1994 Southside of Bombay, 'What's the Time, Mr Wolf?'

Popular Archaeology: Cassette, c.1967–94 // Dugal McKinnon

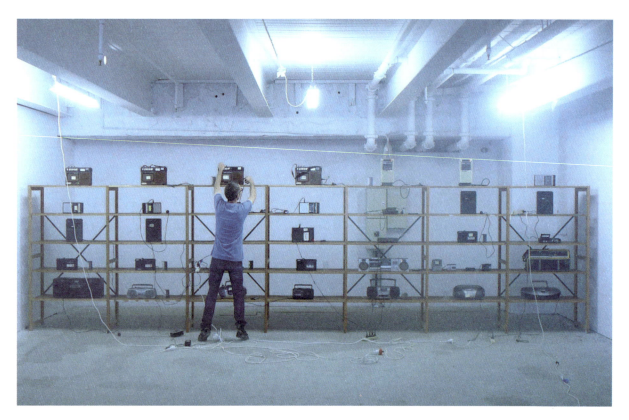
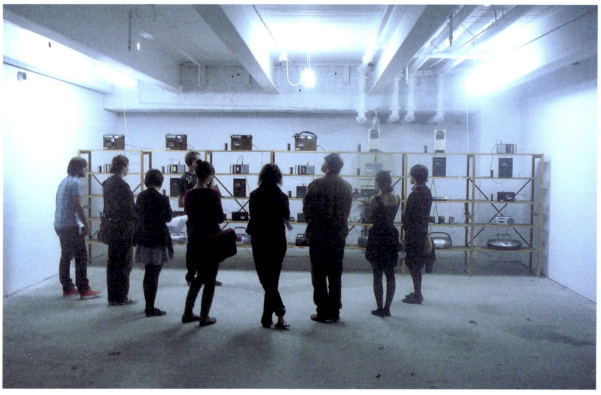

Magnetic North: Wow and flutter // Andrew Clifford*

The shop at 141 Willis Street is empty. The concrete floors are bare. Exposed pipes and ducting line the roof. But against the distant back wall are rows of old cassette players on shelves, echoing sound through the space in unison, like a ghostly mechanical choir, tape loops crinkly and stretched from wear. Sounds are indistinct, like the chattering of ethereal voices on the wind. If retail is the intention then these are bargain-basement tapes, commercial refugees left over from the final sale.

Key to the architectural nature of McKinnon's installation is the physical placement of vintage cassette players in chronological order, each playing a chronologically corresponding cassette. They are arranged in gridded rows across standard issue office Lundia shelves that span the width of a disused retail space. Each tape contains repeating fragments of a long-forgotten New Zealand chart hit from the years 1967 to 1994. No longer in the spotlight and left on repeat as if trying to perpetually recreate its lost moment of glory, one more voice added to the dustbin of history. Top left, in a brown education issue player, is Mr Lee Grant's 'Thanks to You'; bottom right, in a silver streamlined boombox, is Southside of Bombay's 'What's the Time, Mr Wolf?'

Up close, a listener can single out traces of an individual song, but move ever so slightly in any direction and you are immediately lost in the rubble of unmediated information, merged into a 'sonic dust' that slowly crumbles and fades as it awaits the attention of a pop archaeologist. By moving away from the wall, individual players become indistinguishable until, standing closest to the entrance, all that can be heard is a sonic stew that characterises the room's reverberant qualities.

Because music and sound are activities we can experience while attending to other things, they have a powerful mnemonic ability to revive associated memories.

I'm reminded of Michel Gondry's 2008 film *Be Kind Rewind*, a tribute to half-remembered cinema favourites. Gondry's story gets under way when a video rental store's entire VHS stock, outmoded and yet to be upgraded to DVD, is accidentally erased by disaster-prone character Jerry (Jack Black), who has become magnetised after a mishap in an electrical substation. *Be Kind Rewind* pays homage not only to a community-driven model of homemade entertainment, but also to the reclamation and adaptation of memory and heritage. In an analysis of Gondry's film, critic John Finlay Kerr describes the shared history of cinema as a collective memory, however incomplete or imperfect, and as a social process that maps public culture onto a space.[1]

In addressing popular culture through the disposable medium of hit songs on user-friendly ComPact cassettes, McKinnon's project addresses similar ideas of social memory and the reclamation of culture. He architecturally maps hand-looped fragments of pop history across a gridded space, layered one above another, both physically and sonically, like accretions of experience that combine and disguise each other, offering snatches of familiarity, whether genuine or imagined.

Popular Archaeology also recalls the 1969 Alvin Lucier performance *I Am Sitting in a Room*, in which the composer recorded his own recitation of a text

[1]. John Finlay Kerr, '"Rereading" *Be Kind Rewind* (USA 2008): How film history can be remapped through the social memories of popular culture', *Screening the Past*, issue 24 (2009), www.screeningthepast.com.

then repeatedly recorded the new recording being played back in the space. With each subsequent generation, the text was increasingly destroyed while the resonant frequencies of the room and the characteristics of the media became more pronounced.

As McKinnon's exhibition continued, the cassettes deteriorated, becoming muffled and distorted as the tape stretched and the recorded layer wore down, an effect not possible with digital media. This bears comparison to William Basinski's *The Disintegration Loops* (2002–03) a series of albums developed from the process of transferring tape loops, made in the 1980s, to digital format. During the transfer it became apparent that the resuscitation of these tapes was destroying them, and the subsequent recordings capture their gradual deterioration. The albums bring to life forgotten music from a previous era and simultaneously replace it with the sound of its own entropic demise. As one reviewer notes, 'as the tape winds on over the capstans, fragments are lost or dulled, and the music becomes a ghost of itself, tiny gasps of full-bodied chords groaning to life amid pits of near-silence'.[2]

The tape loop both revives and destroys an artefact, repeatedly bringing it to the listener's attention and, in the same gesture, obscuring it like an insect embedded in thick layers of resin, just as the fleeting nature of disposable pop culture is brought to light but then is always doomed to fade. Reliant on a constant process of renewal and redundancy, the commercial music industry's chief ally is time, building a precarious lineage with accumulated successions of fleeting achievements that become legend for those who remember.[3]

///

In the 1960s the move from expensive acetate record production — strictly the domain of record company technicians — to reel-to-reel magnetic tape allowed greater artist involvement and therefore experimentation in the recording process, starting a shift in the balance of power (and the means of production) from companies to musicians. With home-recording on ComPact cassettes, this power would eventually be handed to the consumer.[4] Whereas baby boomers had to receive the fixed statements of factory-pressed long-playing records, Generation X got to deconstruct their entertainment. The shift is signified by the motif of a DJ 'hacking' a vinyl record by scratching it back and forth, but more commonly evidenced by the home-taping revolution of audio cassettes and VHS.

The rise of the cassette set the scene for the post-punk era, which was founded on a DIY ethos that allowed indie culture to take control of the dissemination of its own content. Small labels could manufacture music to order, promoted through cheap advertisements in the backs of magazines and packaged with photocopied artwork, perhaps with an added dash of hand-colouring or some tinted paper to enhance the effect. Niche labels, such as Bruce Russell's Dunedin-based Xpressway Records, found an international audience through the establishment of mail-order networks — it certainly didn't hurt that a cassette could fit in a standard envelope and was unlikely to buckle or break.

Cassettes were also cheaper, almost disposable. Even major record companies knew this. From them, a purchased cassette seemed a lesser version of owning the same music on LP. Despite protesting that home taping would kill

2. Joe Tangari, 'William Basinski: The Disintegration Loops I–IV', *Pitchfork*, 8 April 2004, www.pitchfork.com.
3. Laura Preston and Mark Williams, 'Introducing Object Lessons: A musical fiction', in *Object Lessons: A musical fiction* (Wellington: Adam Art Gallery, 2010), 5.
4. Andre Millard, 'Tape Recording and Music Making', in Hans-Joachim Braun (ed.), *Music and Technology in the Twentieth Century* (Baltimore: Johns Hopkins University Press, 2002), 158–66.

the industry, they found they could get around giving free music to reviewers by supplying dubbed tapes. Radio station giveaways increasingly became cassettes, too. For me, many of the tapes shelved in *Popular Archaeology*'s racks bring back vivid recollections of the disappointment of picking up a cassette prize or receiving a dubbed review tape in the mail.

Also evoked by the cassettes that turn inside McKinnon's players is the physical memory of a multitude of rituals: the straightening of a twisted tape, unspooling tangled tape from a cassette-munching player, breaking out the record-tabs (or plugging them up to reuse the tape), taping from the radio while avoiding the announcer, deciding how to use the supplied stickers (and trying to put them on straight), hand-marking the labels with pen or using a more elaborate ransom-note-style system of collage and sticky tape to title each tape. Bypassing the capitalist control of music, mixtapes are usually traded or gifted. As handcrafted objects, they are more worthy to be an affectionate gift than equivalent commercial items.

Despite the promise of digital immortality, the portability of MP3s and the ubiquity of online formats, vinyl retains a niche market and cassettes are making a comeback. Somehow, in the crude techniques of glued-down covers and home taping, there is a sense of a back-to-basics sustainability that doesn't rely on design software, download speeds and compression rates. This tangibility is also manifest in the networks by which music is exchanged, notable in the rise of record fairs that double as community-driven social occasions.

As McKinnon has said, '[*Popular Archaeology*] plays upon the myth of totality that has emerged in the online era, an era in which the entire world is available in digitised form, effectively replacing the real in an enactment of Baudrillard's theory of simulacra. This totality is a myth, the digital archive is imperfect, and what is left behind will be forgotten or misremembered . . .'[5] McKinnon's nondescript selection of players and yesteryear hits presents no particular narrative of development or deviation. Instead, these tapes are the overlooked casualties of history, left out of the glamorous story of inventions and heroics. All speaking at once without the aid of a narrator, they cancel each other out.

** First published on the Letting Space website, March 2011.*

5. 'Popular Archaeology: Cassette, c.1967–1994', Letting Space, www.lettingspace.org.nz.

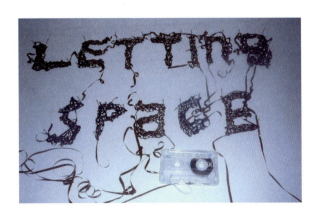

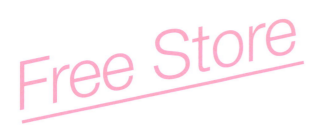

Free Store

Kim Paton
22 May–6 June 2010
Wellington

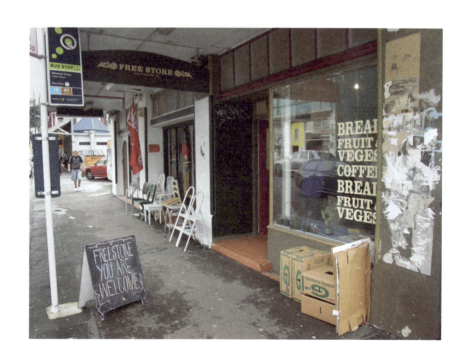

Resembling a small, well-loved independent grocery, *Free Store* stocked and provided food without a price attached. Everything, supplied by major retailers and individuals alike, was free. Founder Kim Paton proposed *Free Store* as a way of making visible the point in the supply chain that is usually unseen — the perfectly good groceries in our economic model that, when unsold, are treated as waste. A key concept for Letting Space was generosity. What does each of us have in excess that we can afford to give?

New Zealand's grocery retail sector remains in 2023 the most concentrated in the world, with just two supermarket companies, Foodstuffs and Woolworths New Zealand (formerly Progressive Enterprises), controlling around 85 per cent of the retail grocery market. This duopoly has been increasingly blamed for high food prices, and back in 2010 the battle between the two companies was fierce enough to be labelled 'trench warfare'.[1] An additional consequence has been the significant amount of urban land banking by these companies.

The property on the corner of Ghuznee and Leeds Streets that was to house *Free Store* had been bought by Foodstuffs a year earlier with the intention of eventually putting a supermarket on the site. Jerram got hold of a Foodstuffs marketing manager to argue for a better interim use of the building, and they agreed. Then in 2012 the building, built in 1909, was demolished. Like many other properties owned by the two food conglomerates, the site still hasn't been built on and today collects carparking income.

Foodstuffs provided the building, but it was Progressive whose supermarkets supplied most of the *Free Store* stock. Hundreds of individuals and many local retailers — Arobake and Brooklyn Bakery, Coffee Supreme and Peoples Coffee — also contributed. Caffe Italiano provided a pallet of Italian chocolate and panettone for the final days. A carpark right outside still had an old coin-operated parking meter, but it was broken — ironically, offering Letting Space a free parking space.

Free Store didn't look or operate like a food bank. It welcomed participation from a diverse range of locals who provided and received *Free Store* produce. The food rescue service Kaibosh was yet to launch, and *Free Store* was novel for its time, later described as the 'world's first retail food waste redistributor'.[2] The project received widespread national media attention and daily queues of the needy and curious.

Paton went on to run the second temporary iteration of *Free Store* in West Auckland in 2011 that led to the development of the food rescue charity Fair Food, which still operates today. In Wellington, a version of the store was permanently established and operates to this day from Willis Street premises; its stylish supermarket trolleys, picking up food waste around the city, are a common local sight. After volunteering at the permanent *Free Store*, backpacker Sinéad Browne was inspired in 2017 to set up a similar store currently operating in London, Compliments of The House.

In August 2022, as we were writing this book, the government finally announced plans to force Woolworths New Zealand and Foodstuffs to open up their wholesale arms to competitors, and to institute a mandatory code of conduct for the industry, with a watchdog attached.

1. Karyn Scherer, 'Big Two Supermarket Chains Locked in Fierce Food Fight', *New Zealand Herald*, 12 April 2010, www.nzherald.co.nz.
2. 'Our Story', Compliments of The House, www.complimentsofthehouse.org.

Visible and Actual // Heather Galbraith*

The *Free Store* concept was in some respects a found structure. It had a lineage that extended back to San Francisco in the late 1960s, with multiple subsequent international iterations. In this model, surplus food is redistributed to those in need, often employing some kind of barter system.

Paton's *Free Store* had a slightly different approach — I would argue its primary mission was political. The store sought to highlight the ludicrous degree of waste that occurs within contemporary food retailing and to propose a different solution. Paton stated that the 'point of *Free Store* was to create a brief respite from the usual rules of trade'.[1]

The interplay of supply and demand within a free-market, high-capital society is premised on a few basic principles: turnover must result in profit, and pricing structures incorporate a percentage of waste, which results in surplus stock ceasing to have value when it can no longer be sold at a profit. It's pretty peculiar that a product has value only up to a preconceived expiry date and then becomes something to be disposed of. When Paton was in business in Raglan, where she ran a grocery store for three years, she had increasingly baulked at a range of standard business assumptions, particularly with people in the community struggling to feed themselves and their families.

Making visible a point in the supply chain normally unseen is a provocative act. Some food producers and retailers who were approached to take part in *Free Store* were initially guarded. A number of companies donated but didn't want to be named or profiled, or else declined the invitation outright, feeling it would be detrimental to their brand to acknowledge their degree of stock waste. Independent local producers such as Arobake, Brooklyn Bakery, Coffee Supreme and Peoples Coffee came on board first. Then supermarket giant Progressive Enterprises signed up as the largest supplier — there's a certain irony in the fact that the vacant premises used by *Free Store* were owned by Foodstuffs, Progressive's key competitor.

Further, *Free Store* removed all forms of cash and any suggestion of barter from the retail environment, which made customers both pleased and unnerved. The store, Paton was clear, was not trying to compete with or undermine the role food banks and soup kitchens play in feeding those in need. *Free Store* required no proof of need or hardship from its users. The decision as to whether an individual visitor was 'entitled to' the produce or not was made by that individual. Of this, Paton said: 'We need to trust that you are standing in this queue because you sincerely feel you need to be here. This is the only contract we have with you. When we feel like we are trusted and given responsibility to make our own choices, it is empowering, it is uplifting; this is the real heart of what the *Free Store* is.'[2]

While Paton was keen to focus on commercial suppliers, the store also stocked gifts from home fruit trees, second-hand books, home baking and preserves — the stuff of charity fairs and cake stalls the world over. And with this mix of the unusual and the familiar, *Free Store* touched a nerve. Rarely has an art project in New Zealand provoked such engagement outside of art circles and an almost completely positive response. The press coverage was enormous, across all media platforms.

1. Kim Paton, 'Let's Be Human Beings', in *Now Future: Dialogues with tomorrow: 2010 series* (Wellington: Now Future, 2011).
2. RNZ podcast, 11 May 2011, http://podcast.radionz.co.nz/aft/akstory-20110511-1535-Auckland_Story_for_11_May_2011_-_Free_Store-048.mp3

///

Through the two iterations of *Free Store,* Paton became increasingly aware of the issues large-scale producers and distributors face when dealing with waste stock. A percentage of wastage is factored into pricing, and it is considerably cheaper to dispose of stock than to pay for the logistics support to transport surplus stock to outlets where it can be redistributed. If a readymade solution to the transport problem is presented, then producers are more inclined to sign up.

Paton's project consciously and successfully makes visible an invisible aspect of commodity culture, but it doesn't stop there. Initially, *Free Store* may seem in keeping with modes of relational art such as the work of contemporary artist Rirkrit Tiravanija. Since the early 1990s Tiravanija has transformed public or dealer gallery spaces into temporary social spaces for cooking and sharing food. Paton's work departs from the trend in art to highlight systems of societal production or consumption and then move on, however, in her investment in developing *Free Store* as a viable model of commercial and philanthropic partnership. The fact that the store doesn't just perform hospitality or gifting but demonstrates and articulates a reproducible distribution system (albeit one still reliant on a degree of civic/state underpinning, as seen in the funding provided to the project by Creative New Zealand and Wellington City Council) is crucial to its success.

I have had multiple conversations with art world colleagues about *Free Store*'s 'art' status, and whether Paton's visibility as an artist leading the project was significant or desirable. Opinions vary. For some, that the project was born through an art commissioning series, a forum where propositions could be tested and trialled, is enough. The potency of the project as an agent for actual change in real life is seen as its strength. *Free Store* has teeth and clear penetration of the everyday.

Other colleagues have felt uncomfortable with the gap between the initial propositional 'small (art) gesture' and the more concrete, large-scale social initiative. If *Free Store* is taken up, formalised and made part of an official service delivery, does the subsuming or the lowering of visibility of the critical creative impulse and ethical/philosophical investigations of the project lessen its cultural value?

How do we 'value' the effect of socially engaged artworks if not through their resonance, the way they make visible aspects of inequity and propose possible actions/solutions? Through a project's survival, the artist's role as change agent, activist and new-model-economy entrepreneur can be more resonant. While we may harbour desire and hope for art to be the space where new futures can be tested, Paton seems to be exploring a space where the prototype finishes and the road-tested model comes into its own. Whether *Free Store* is perceived as art or something else doesn't seem the point of primary import. It is more salient to ask: How can the work be most effective? How can it initiate sustained benefits for those in need? And how might it shift the way we as consumers and food producers/distributors think about waste?

** First published on the Letting Space website, October 2011.*

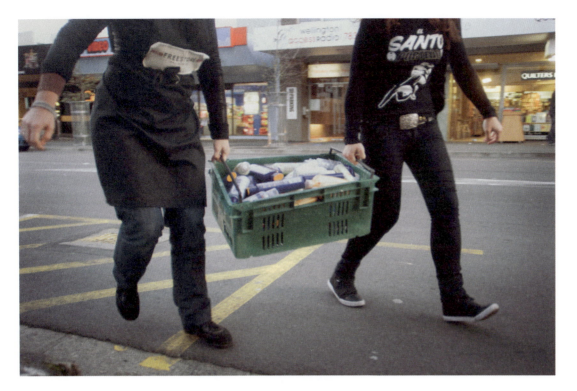

Free Store // Kim Paton

Please Take One: Darryl Walker reports on a performance in the Free Store // Friday, 28 May 2010

Please Take One was a performative intervention by me, Darryl Walker, into Kim Paton's art project *Free Store*.

Ten new $5 notes were signed and dated and put in an open box labelled 'Please take one'. They were placed on the counter during my shift as a volunteer shopkeeper. As with all other items in the shop, the money was positioned so that customers were free to take it.

I anticipated that customers would see the money and possibly ask about it. However, although the occasional person's eye flicked over the money, no one mentioned it. I decided to speed up the potential interactions and point it out in a similar way to the produce that was not going to last another day in the shop. So, when customers had gathered their items and were saying their thank yous and goodbyes, I pointed to the box containing the $5 notes and said, 'You can take one of these too if you like.'

The majority were bemused but declined, saying 'I can't do that' or 'I can take food, but I can't take money'. All but one who eventually accepted the money only did so after some persuasion. One young woman came back about an hour later with some handmade paper she had decorated with a 'Free Store' logo, saying she felt she could not accept the money without having given something in return.

Being given money openly and outright without having 'earned' it was a challenging concept for most. Almost all of those who took the $5 note walked out of the shop holding it along with the other items they had collected (only one person put it in their wallet), as if it had a different value or meaning to how they would usually perceive and treat small change.

While this work was not discussed with Kim Paton prior to the event, I considered it to meet the criteria of a donation to the project, and it was recorded in the daily logbook as '10 x $5 notes given as donation'. The idea emerged from a surprise find one Sunday morning when I discovered $50 outside my door on Cuba Street. The work sits comfortably within my practice, which is usually performative and typically based around some form of exchange, exploring notions of desire and constraint, the aesthetics of generosity, and concepts of reciprocity and obligation.

Free Store // Kim Paton

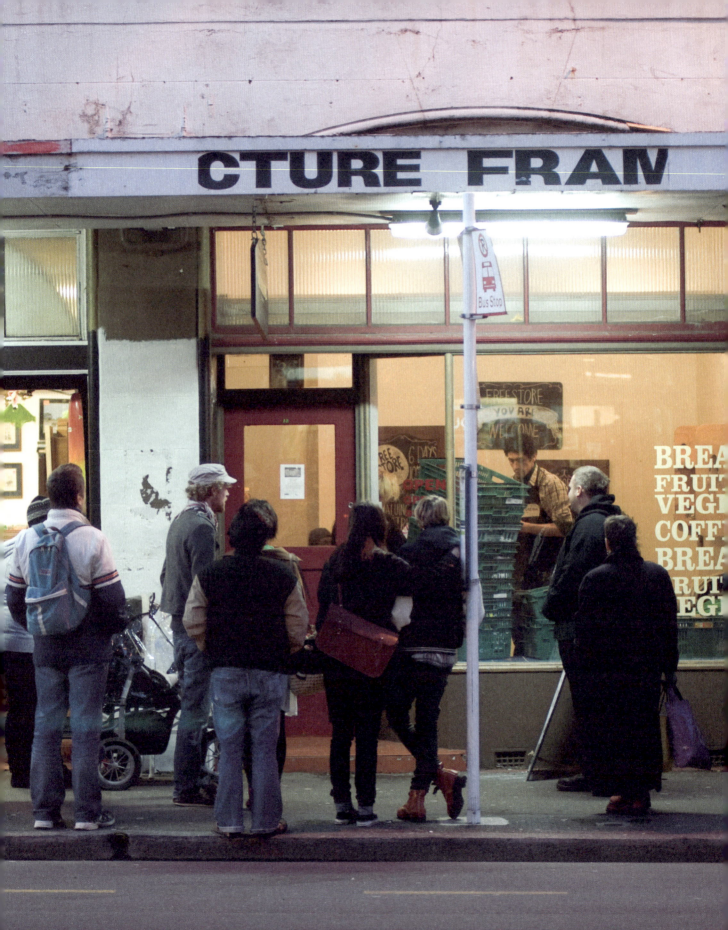

As I stood on the other side of the street last week and watched the *Campbell Live* current affairs reporter repeatedly fail to do her live to camera walk-and-talk spiel, because she simply could not navigate the mass of people milling at the store's entrance, it was clear that this artwork had achieved that rare phenomenon of popular lift-off.

David Cross, *EyeContact*, 7 June 2010

Free Store // **Kim Paton**

Beneficiary's Office

Tao Wells
15 October–
1 November 2010
Wellington

1. Federico Cingano, 'Trends in Income Inequality and its Impact on Economic Growth', OECD Social, Employment and Migration Working Papers, No. 163, www.oecd-ilibrary.org.
2. Chris Kraus, *Social Practices* (Los Angeles: Semiotext(e), 2018), 160.
3. Wikipedia contributors, 'Tao Wells,' *Wikipedia, The Free Encyclopedia*, https://en.wikipedia.org.
4. The Wells Group, 'Wells Group — The Beneficiary's Office on Prime News', 18 October 2010, https://vimeo.com.
5. The Wells Group, 'Wells Group — The Beneficiary's Office on Prime News', 18 October 2010, https://vimeo.com.
6. Robyn Gallagher, 'Review: Inuit Time', 19 October 2011, The Wellingtonista, https://wellingtonista.com.

New Zealand once ranked among the best in the world in terms of income equality. However, since the mid-1980s, according to the OECD, New Zealand has had one of the fastest-growing rates of income inequality among the world's richest countries.[1]

In *Beneficiary's Office*, established artist Tao Wells argued that before 1984 it was considered a basic human right that everyone in New Zealand had a job. Since then, he noted, a percentage of the population had been kept unemployed to create a fake climate of job competition and to keep wages down and control inflation. Many found these statements provocative.

In the face of the recession triggered by the global financial crisis, the unemployment rate almost doubled between 2007 and 2010. This, Wells believed, created a positive social opportunity. By making the welfare system visible, Wells sought to address the structural problems that affected not just artists like himself, but also New Zealand's growing underclass population. In taking this opportunity, The Wells Group, commented Chris Kraus, 'stirred up more scandal than the New Zealand art world has ever witnessed'.[2]

The Wells Group was a public relations company run by a small collective of volunteers and founded for this project by Wells, an artist and 'community conceptualist'[3] known for artwork critiquing established systems of power and value.

When he was interviewed on *Prime News*, Wells said of the project's approach: 'I believe the true artists of our times are the politicians, PR companies and lobby groups who are creating frames for how we interpret reality.'[4]

Beneficiary's Office was based on the third floor of a busy central-city office tower, thanks to Ian Cassels and The Wellington Company. Cassels was familiar with Jerram from her Sustainable Business Network days and Dugal McKinnon's earlier Letting Space project *Popular Archaeology*. Cassels contributed more than free space — he became actively involved in debate on the nature of work with Wells. The Wells Group used the tools of the media to argue that the average unemployed person causes less harm to others and the planet than many employed people. By highlighting the economic inefficiencies and environmental damage of providing unfulfilling employment, the group proposed that a shift in perceptions of labour and unemployment therefore provides an opportunity to realise a more efficient and balanced society.

'The average carbon footprint of the unemployed person is about half of that of those earning over $100,000,' stated Wells. 'Surely, an advanced society would see us work less, and enjoy the benefits of unemployed time. We need to work less, so we consume less.'[5]

With its office open to the public over the project's duration, The Wells Group entered into creative debates with politicians, policy-makers and variously employed citizens, some of whom, like Cassels, are captured in Wells and Dick Whyte's fly-on-the-wall feature film *The Happy Bene* (available on CIRCUIT's website).

Causing a storm of media attention and much agitation from right-wing politicians and commentators, the project could be said to have succeeded in its PR mission, while at the same time, as Wells felt, it was publicly blocked by an establishment who failed to engage.

On Labour Day The Wells Group led a small march through the empty streets of Wellington, chanting 'Stop buying crap to make yourself feel better, job satisfaction makes us all feel better', while carrying a banner made out of towels and splayed curtains. The march came three days after more than a thousand film technicians, artists and actors marched through Wellington to voice concern over the future of Peter Jackson's *Hobbit* films after the New Zealand Actors' Equity threatened to stage a boycott of the films unless there was collective bargaining.

As part of the project, Wells also produced a well-received experimental theatre show *Inuit Time: Artists, Employed vs Unemployed* at Fred's music venue.[6]

The Work of Art // Giovanni Tiso*

> Late capitalist society is engaged in a long-term historical process of destroying job security, while the virtues of work are ironically and even more insistently being glorified.
> — Stanley Aronowitz and Jonathan Cutler[1]

> And therefore, in short, I'm saying, all work that's done has to have the quality of art.
> — Joseph Beuys[2]

A vacant commercial space is a site of anxiety, more so than a vacant dwelling. If it happens to include a shop front, its emptiness becomes a concrete representation of crisis. An empty shop on the corner can bring down the whole neighbourhood. We use phrases like that: to bring down, to depress, as if to reify the mood. The Letting Space projects are partly a response to the anxiety, a way of replacing those conspicuous absences with another sort of activity, another kind of trade. But what of the empty office on the third floor of an otherwise bustling building? What of the emptiness of the spaces that we cannot see?

That Tao Wells' *Beneficiary's Office* occupied such a space is one of the least commented on aspects of this intensely debated project, yet it fitted in perfectly with the subject matter. Being unemployed means being less visible, having less of a voice, keeping or being made to keep a lower profile. And so Wells and the curators chose an empty office on the third floor of a downtown Wellington building, upstairs from a branch of the Bank of New Zealand. Below, the engine room of commerce; above, an interrogation of the nature and the value of work. Choosing for the first time in the series not to occupy a shop also meant a shift in the terms of implicit comparison, for *business* has a far broader set of meanings than *retail*, and these would quickly come into play.

But first one would have to deal with a piece of misdirection: for if you took the elevator to level 3, 50 Manners Street, you would look in vain for the *Beneficiary's Office* and find yourself instead at the headquarters of a PR firm set up by Wells and his collaborators called The Wells Group. This was almost invariably described in media accounts as a 'bogus public relations company',[3] which rather begs the question of what it was that made it fictitious in the eyes of journalists.

The Wells Group was in fact open during customary business hours, employed several people and engaged in public relations. The subject of these activities was the remit of the project itself, namely to advocate 'the opportunities and benefits of official unemployment' — nothing bogus about that either. Early reports were equally as reliable in referring to Tao Wells as an 'out-of-work artist'[4] even as he was being photographed, filmed or interviewed in the act of working.

The reaction to this set-up — an artist on a Work and Income benefit speaking publicly about the virtues of unemployment and receiving public money to do it — was swift and in some quarters inordinately savage. An early report in the *Dominion Post* printing the wrong claim that Wells had received $40,000 from Creative New Zealand for his project helped stoke the fire, but that the amount was a far more modest $3500, including expenses, seemed to matter less than

1. Stanley Aronowitz and Jonathan Cutler, *Post Work: The wages of cybernation* (New York: Routledge, 1998), 40.
2. Joseph Beuys, 'I am Searching for Field Character' (1973), in *Joseph Beuys in America: Energy plan for the Western man*, compiled by Karin Kuoni (New York: Basic Books, 1993), 5.
3. Sean Plunket, 'Films, like Art, Could Be an Unemployment Outrage in the Making', *Dominion Post*, 23 October 2010.
4. Lane Nichols, 'Artist Paints Noble Picture of Dole', *Dominion Post*, 16 October 2010. The *3 News* evening news bulletin of 18 October 2010 opted for 'unemployed artist'.

the principle of what an unemployed person should or should not be allowed to say. The alarming levels of rage that gripped some of the commenters on the Stuff website were perhaps less surprising or uncharacteristic than the initial reaction of prominent blogger David Farrar, who appeared quite unable to contain himself. His outburst deserves to be recorded in part:

> It's unfair that I have to work 60 hour weeks to fund your fucking life style, you bludging wanker . . .
>
> Not just a greedy selfish bludger, but a stupid one also . . .
>
> He refuses to work, but is happy to apply for grants so he can preach about why people should bludge like him . . .
>
> Listen Mr Fuckwit, you are not forced to take a job. So long as you don't want those of us who do work to pay you a benefit, you do not need to ever work again . . .
>
> Having a layabout wanker who is illegally claiming the dole, promote dole bludging as a lifestyle choice is not innovative. Would Creative NZ give money for a tax felon to set up an office and advise people not to pay their taxes? . . .
>
> This makes my blood boil . . .[5]

As the righteous indignation spread, Work and Income responded by suspending Wells' benefit. Except, contrary to Farrar's assertion, this had not been 'illegally claimed' at all, and the artist managed to have it reinstated in short order. In a second, less expletive-filled post,[6] Farrar shifted his focus and intimated he would put his influence to good use and lobby for the funding of Creative New Zealand to be cut, a view echoed in prime-time by former finance minister Roger Douglas. And after acting social development minister Judith Collins was given an equally prominent opportunity to observe that, seeing that Wells was such a creative chap, had he applied the same skills and effort to his CV then he 'probably wouldn't have a problem',[7] the time came for a new issue of the *New Zealand Listener* to hit the stands.

Presented with an opportunity to engage in thoughtful fashion with an art project that had caused such controversy, the *Listener*, the country's self-professed magazine of ideas, opted to publish an editorial that repeated — under a veneer of politeness and with better use of the subjunctive — all of the savage lines of attack that had been pursued by the most conservative commentators, parliamentarians and punters. Under the shrill headline 'A Blow to the Art', the editorial enquired rhetorically: 'When an artist bites the hand that feeds it, does he deserve that public funding?' and went on to offer the following analysis:

> To . . . bedevil our sense of the balance between free speech and public decency, Wells has accepted public money to create an art installation in which he disparages working people, and exhorts them to ditch their jobs, live off the state and become minimalist consumers. Officials deemed it art for the 37-year-old long-term beneficiary to glorify the notion of slacking and bludging off one's fellow citizens.

[5]. David Farrar, 'Paid to Promote Virtues of Unemployment', Kiwiblog, 16 October 2010, www.kiwiblog.co.nz.
[6]. David Farrar, 'Creative NZ PR', Kiwiblog, 18 October 2010, www.kiwiblog.co.nz.
[7]. 'Wells Group — The Beneficiary's Office on TV3 News', 18 October 2010, https://vimeo.com.

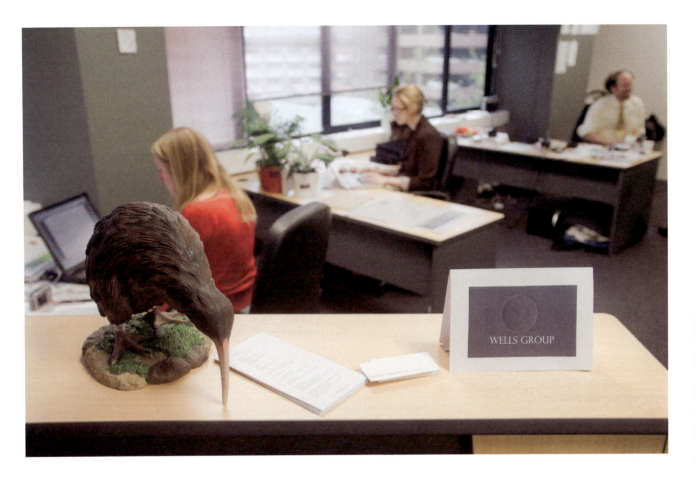

Beneficiary's Office // Tao Wells

The conclusion, in equal parts veiled threat and stern warning, is only a smidgen more oblique than Farrar's avowal to deal with the blaspheming funding agency directly: 'The risk for [Creative New Zealand] if it continues to make similar funding choices is that soon taxpayers may not be asking the question of the artworks, but of CNZ itself.'[8]

///

To the extent that conceptual or difficult art often seeks or indeed needs to provoke a strong reaction in order to engage its public, one could be tempted to reach the conclusion that these responses are sufficient to label the project a success. I myself indulged in that point in an earlier version of this essay, calling the *Listener* editorial excerpted above Wells' true masterstroke — and I am still convinced that it is: you will not find a better, more precise formulation of the politico-ideological consensus in this country, and how it needs to be guarded in the name of 'decency', than in those 700-odd unsigned words. David Farrar's tirade, too, is an emblematic performance piece on the simmering anger of the over-entitled and over-employed.

These and most other reactions collectively demonstrate the lengths that we will go to as a society to deny beneficiaries the right to speak, and constitute therefore a valuable social document. But provocation as a dimension, crucial as it is, cannot be allowed to exhaust the meaning and value of *Beneficiary's Office*. The project is better than that, and demands that we seek to account for the questions it left unanswered and for the silences that surrounded it.

For one thing, the extent to which the project generated actual debate must be qualified. A one-sided backlash is not the same thing as a two-way conversation, and one struggles to name many individuals or institutions who stood up in support of Wells when he was at his most exposed and vulnerable. So where was the left in all this? How did the Alternative Welfare Working Group pass on the opportunity to stroll into the limelight and defend an alternative view of welfare? Where were our public intellectuals and Wells' fellow artists when he had his livelihood abruptly cut off in what must be one of the most blatant acts in recent memory of intimidation against a dissenter?

With all due solidarity with Creative New Zealand and how it came under fire, one could also question then manager of art development Cath Cardiff's expression of regret about the anger that the project had garnered: that anger was in fact integral to the project, and pointed to the agency's own value in promoting challenging work and art that is hard or downright impossible to sustain commercially.[9]

An opportunity went begging to make a case for public art and the social and cultural capital that it represents, even — if not especially — when it is at odds with the dominant ideology.

Who else are we expecting to fund such work, and can we really afford for it not to be funded? The questions raised by Wells are among the most important of our time: how to revolutionise society and the very concept of labour, no longer in the name of equity and justice, but for the survival of the species. Stanley Aronowitz and Jonathan Cutler wrote this more than 10 years ago: 'What has been called utopian in the past is now a practical necessity'.[10] To work less, so that we

[8] Unsigned editorial, 'A Blow to the Art', *New Zealand Listener*, vol. 227, no. 3677, 30 October 2010, 5.
[9] Cath Cardiff, quoted by Diana Dekker in 'I May Not Know Much about Art . . .', *Dominion Post*, 23 October 2010.
[10] Aronowitz and Cutler, *Post Work*, 69.

3 Grow Wellington, Film Well...
4 Creative HQ Ltd (Rece...
3 Wells group
 Litmus Ltd
2 Science Media Centre
 Telcoinabox
1 Heliocell & The Survey
 Dictation Distributors
 Truebridge Partners
 Property Manag...

Beneficiary's Office // Tao Wells

EDITORIAL

Vol 226, No. 3677. October 30–November 5, 2010

A blow to the art

When an artist bites the hand that feeds it, does he deserve that public funding?

Tao Wells and his installation.

Paul Henry, meet your new fellow inmate in the public-opinion dogbox: performance artist Tao Wells. To further bedevil our sense of the balance between free speech and public decency, Wells has accepted public money to create an art installation in which he disparages working people, and exhorts them to ditch their jobs, live off the state and become minimalist consumers. Officials deemed it art for the 37-year-old long-term beneficiary to glorify the notion of slacking and bludging off one's fellow citizens.

Besides the offence this will cause the many New Zealanders who have lost jobs in this recession, and the majority of workers who struggle to manage on lower wages than their overseas counterparts in large measure because New Zealand has such a welfare burden, Wells's installation raises two eternally combustible questions: what is art, and what art should the taxpayer fund?

The first is a genie long out of the bottle. Art is what anyone chooses to say it is. Take it or leave it. Talent, creativity and, as Wells clearly demonstrates, profundity of intellect, are no longer prerequisites for art. You may as well try to nail a jelly to the wall as try to define art nowadays. Indeed, if you nailed it to the wall of an art gallery, it might win critical acclaim.

The second question is hardly less ticklish. Great offence has been taken that Creative New Zealand saw fit to fund Wells up to $3500 to carry out what in most people's estimation is less an artistic endeavour than an act of political advocacy. Like the infamous *Piss Christ* photograph and the *Virgin in a Condom*, this, even if you grant it the title art, seemed more calculated to annoy and hurt the audience than do any of the nobler things art can do: challenge, inform, transport, inspire.

Yet British artist Tracy Emin's outrage-provoking unmade bed installation, bought by art patron Charles Saatchi for £150,000, proved to have a resonance for many Tate Gallery visitors after the initial outcry at its being shortlisted for the world-renowned Turner Prize. It was a documentation of a period in her life when Emin was feeling suicidal, and it is impossible to argue that the squalid, debris-strewn bed does not vividly convey despair. It's worth remembering that the Turner Prize's namesake, the great English romantic landscape painter JMW Turner, was widely thought to be having a laugh when his paintings first appeared in the late 1700s.

Still, however strong and noble the artistic tradition for subversion of society's norms may be, Wells's effort was puerile. He has been, as art critic TJ McNamara puts it, biting down hard on the hand that feeds him for some time now.

> **You may as well try to nail a jelly to the wall as try to define art. Indeed, do it in a gallery and it might win critical acclaim.**

There is no getting around the public sense of affront that anybody, be they artist or barbarian, should insist upon being kept by the taxpayer, and repay that beneficence by insulting those whose efforts pay their bills – let alone getting extra money to do so. Wells' benefit was stopped when news of his art grant reached Work and Income officials. But actually, our policy framework is legally ambivalent about whether people who choose to be artists should be forced to do another job if they can't make a living from their art.

The previous Government instituted an artists-on-the-dole system, which allowed artists to refuse other work and still keep their benefit. And although artists might disagree, the arts are well-supported publicly, with funding that was boosted considerably under Labour and not subject to cuts under National. Or not yet, anyway. British arts funding is being cut by 25% and, in a second blow, the BBC, a major patron of the arts in that country, faces a 16% funding cut.

Creative New Zealand must be left to make its decisions free from concerns about politics, but it does not exist in isolation from the current difficult economic climate in which the Government, businesses and householders are examining every dollar they spend. The most common questions of the day are "do we really need this?" and "is it value for money?" Tao Wells's latest work falls short on both counts. The risk for CNZ if it continues to make similar funding choices is that soon taxpayers may not be asking the question of the artworks, but of CNZ itself. ∎

all can work. To discriminate between the work that makes us richer, and the work that makes us poorer. To imagine a post-work society and create the material conditions for its existence.

Which takes us to the other crucial dimension of the project that an excessive focus on the media response can obscure, and that is the work that went into it. *Beneficiary's Office* was months in the planning and several weeks in the staging — indeed, the online media side of the project, via the website and The Wells Group's presence on Twitter and Facebook, remains ongoing. All of this work has cost the taxpayer $7000, an amount that is negligible not just in relative but in fact in absolute terms.

Consider the economic activity that the show generated, in the form of the work that it gave journalists and the media consultants of a few Right Honourables, and the very expensive prime-time news real estate it supplied with the requisite controversy. All this activity, all this *business*, is the stuff of which our GDP is made, which has the effect of undercutting the project itself, insofar as the establishment was never troubled by it: on the contrary, it fed on it. In this respect we should entertain the possibility that *Beneficiary's Office* has actually failed, or perhaps rather that the *public* — that ineffable entity that is always right, always decent — has failed it, by refusing to take up its challenge and by receiving it only as a media spectacle.

///

Midway through the life at 50 Manners Street of The Wells Group, the dispute around *The Hobbit* erupted. The media pivoted rapidly and seamlessly, sucking the oxygen of publicity away from the project. Never mind that work in the office continued, and continued to be documented. Never mind that the fundamental questions about the value of work posed by that industrial action actually vindicated the timeliness of Wells' endeavour (Barry Thomas aka b'art Homme chimed in on *Artbash* to call the juxtaposition 'a powerful moment in art history',[11] but few others appeared to notice it). In the meantime Wells continued to interview people and be interviewed, staged a march calling for a 16-hour working day, gave two performances of his play *Inuit Time*,[12] and published along with his colleagues a piece in the *Dominion Post* response to the critics.[13]

If the answers to the project collectively make up nothing less than a report on the limits of intellectual freedom in New Zealand — a report whose value we can point to without a moment's hesitation — it is harder both for the artist and for us, the public as critics, to know what to make of its extant traces, as well as the silence of the social actors who could not or would not participate. It will be exciting to see where Tao Wells is going to take this next, but the challenge of building on the meaning and value of this continuing and important work is ours as much as his own.

First published on the Letting Space website, April 2011.

11. b'art Homme, comment on b'art Homme, 'Creative Capital Council Evicts Artist Whose Art Was Too Close to Their Bones', *Artbash*, 31 October 2010.
12. Robyn Gallagher, 'Review: Inuit Time', *The Wellingtonista*, 19 October 2010, https://wellingtonista.com.
13. Tao Wells and The Wells Group, 'Love Your Labour — Don't Labour to Live', *Dominion Post*, 28 October 2010.

Corporation Wells // David Cross*

Maybe I am firing the cannon too early in reviewing Tao Wells' *Beneficiary's Office* at the end of its first week. After going blow for blow across all news and blog forums in the last seven days with our favourite flaming martyr Peter Jackson, Wells has faded as the tussle of multinational media conglomerate/Jackson versus 'recalcitrant actors union' pushes him, and his pro-unemployment message, out of the spotlight. But it's still early days. He may be back with another measured diatribe or carefully calibrated outrageous soundbite that gets upstanding citizens spitting out their cornflakes in perfect anger. He is certainly working away diligently, along with his team of media minders and office staff, in the corporate bunker that is The Wells Group HQ in Manners Street — planning, scheming and doing more interviews in a week than most artists do in a decade.

The set-up for *Beneficiary's Office* is straightforward. Choose a highly divisive issue such as unemployment, add the incendiary combination of artist as dole bludger and polemicist, say something that reinforces a barely concealed prejudice, mix it with a measured appropriation of corporate culture, then press send and wait for the ants to start jumping. It's as simple as just adding water for tabloid outrage, right-wing blogger overdrive and the instant creation of a new loser anti-hero. Step forward Tao Wells, the embodiment of all that is wrong with the bloated, 'away with the fairies' world of contemporary art.

While I am being a tad reductive in framing this operation in such straightforward terms, Wells is clearly treading on familiar agit-prop ground with a nod to the Yes Men, Renzo Martens and of course his revered forebear Joseph Beuys, whose utterances kept bourgeois Germans in a state of agitation. Yet what sets Wells and his corporation apart from these antecedents is his own very idiosyncratic persona, which is far less controlled and consistent. After carefully constructing his premise for this Letting Space project, the subsequent public face of the artist was far less structured and on message. Now, there is always the possibility in his responses to media questioning that he will say something contradictory about art and unemployment, or he might get angry. You can never be sure whether he is being stridently political or esoteric — or some strange combination of both.

This elusiveness is compelling. On the one hand we have Wells artfully posing in the *Dominion Post* as a simmering Lenin; on the other, we hear him on radio lose his cool and call a commentator 'an idiot' for trotting out the same distorted inaccuracy about the mythical 40k of Creative New Zealand money used for the project. He is both controlled and feral, consistent and redolent with contradiction, and this gives his artistic persona its bite.

The problem for the media is that they cannot quite stuff him in a box and keep him there. His messages are more complex than they can cope with, shifting from environmentalism to wanting Paul Henry's job. He is a left-wing firebrand who lobs in an aside that he is more like the tarnished *Breakfast* 'straight shooter' than we think. Professing in a midweek interview to not be politically correct, Wells places his spanner in the popular media's works; he consciously makes it difficult for them to nail him to the mindless, out-of-touch, pinko artist mast.

Not surprisingly, this is where the media lose interest. The Wells Group is

Artist paints noble picture of dole

Lane Nichols

AN OUT-OF-WORK artist is setting up a taxpayer-funded "beneficiaries' office" in downtown Wellington to promote the virtues of being unemployed.

He is part of a $53,000 performance art installation series paid for by Creative New Zealand and Wellington City Council.

Creative NZ is defending its decision to provide a $40,000 grant but said last night it was unaware of the installation's "precise content" when the grant was signed off.

Tao Wells, 37, advocates the opportunities and benefits of unemployment and says it is unfair that long-term beneficiaries are labelled bludgers for exploiting the welfare system.

Wells' installation, *The Beneficiary's Office*, urges people to abandon jobs they don't like rather than suffering eight hours of "slavery".

"We need to work less, so we consume less. The average carbon footprint of the unemployed person is about half of that of those earning over $100,000."

His Manners St office will run from Monday for at least two weeks and is open to the public. The project is part of the *Letting Space* public art installation series which uses vacant Wellington commercial spaces.

Backed by five "staff", Wells plans to promote his unemployment philosophy publicly and debate it with politicians and the gainfully employed.

He described himself as an unemployed artist with a masters degree who had been "off and on" the unemployment benefit since 1997. Wells said he was receiving welfare and admitted his benefit was at risk by him speaking out.

Late yesterday afternoon his benefit was cut off after Work and Income learned of the project.

His case has parallels with Wellington's "political busker" Benjamin Easton, who lost his benefit earlier this year after revealing he had not had a job interview since he went on the dole nearly three years ago.

Work in progress: Tao Wells is using a taxpayer-funded project to promote unemployment. "We should never be forced to take a job," he says. Photo: CHRIS SKELTON

WHAT DO YOU THINK?
Email
news@dompost.co.nz

Wells denied his pro-unemployment stance was hypocritical when he was being paid $2000 for the project. "We should never be forced to take a job. If you're forced to take a job it's a punishment. If a job's a punishment then society must be a prison."

Asked about the irony of taxpayers funding an art project that promoted unemployment, Wells said: "That's a huge argument, there's some huge ideas there. The bottom line is money. What I'm critiquing is the idea of work."

Creative NZ boss Stephen Wainwright said the agency's role was to encourage, promote and support the arts. Innovative new work, such as the *Letting Space* series, could act as a powerful form of social commentary and encourage debate.

The Beneficiary's Office is on at 50 Manners St, level 3, from Monday.

muddying the waters of what was initially an easy stereotype and the tabloid mindset simply cannot cope with the complexity. As the heat began to fade, midweek, the cooling was in part due to a greater complexity of responses to the work, which added layers of depth beyond the jingoistic 'cut off his benefit' rhetoric. The media began to suspect they were not able to control the story or Wells himself, and headed for the greener pastures of the anti-New Zealand *Hobbit* actors. Thus when Wells wrapped himself in a banner and held a book in the air at a large-scale union protest on Wednesday, there was none of the earlier frenzy. He had returned to being just another artist, little more than an eccentric curiosity.

Many will argue, 'So what?' We know how the popular media operates and Wells has simply used his cultural capital to poke the mongoose in the name of transgression. Furthermore, his inarticulate messages reveal a blundering attention seeker who has no critical programme beyond cultural antagonism. But this too is conveniently pat and straightforward. It neglects the moments of brilliance and poise that have surfaced in *Beneficiary's Office*.

The photograph of Wells in the *Dominion Post* may be the most compelling artist portrait in recent memory. It is beautifully controlled and menacing: the suit, the crazy hairstyle, the amazing stare. It's like he has distilled the swagger of the Italian Futurists in their disturbing and contradictory business attire and given it

a modern spin to scare the bejesus out of Peter Dunne's middle New Zealand. The image says, 'I am one of you, but I am also your worst nightmare.' This massively complex photograph also cuts to the chase of the enterprise. The Wells Group wants to open up the chasm of critical discourse that is usually papered over in the popular media by a featherweight bandying about of ideas.

While the provocation has been made with a blunt instrument and in a seemingly scattergun way, Wells' corporation has offered a shot of electricity into the tepid zombie that is mainstream public debate. People are actually debating unemployment and globalisation across many forums, taking the discussion well beyond its incendiary starting point. While we should wait to see how far this goes, it is a promising beginning for what is more a mom-and-pop than corporate enterprise.

Whether the corporation can sustain interest or relevance in the coming weeks, as the media spotlight drifts away, is now the challenge. In the banal world of 24-hour news cycles the soufflé is unlikely to rise twice. The work will no doubt shift gears, most likely to focus on the office itself as a site of dialogue and exchange. One suspects that Wells and his team will relish the chance to argue in a more nuanced way with visitors about why unemployment is the logical lifestyle of choice for a sustainable twenty-first century. Meanwhile, Wells can take some pleasure from the fact that his face is now embossed on the dartboard of every right-wing blogger/media pundit in New Zealand and that he markedly, if briefly, raised the collective blood pressure of the nation. Not a bad week's labour for an unemployed, dole-bludging artist.

** First published in* EyeContact, *October 2011.*

Love Your Labour — Don't Labour to Live //
Tao Wells and The Wells Group*

Slaving all day, coming home and forgetting about it, cannot be the future of work. You don't like your job? Can you change the conditions? Or perhaps you love your job, especially the wealth and status it affords you. Do you know your neighbour across the tracks? You know that the gap between rich and poor cannot be bridged by moving to a gated community. Gated communities are like castles. Is this our best idea?

 Surely an advanced society would see us work less, enabling the exploration of previously unimagined states that developments in our society have rightly afforded. It is not a matter of when: it is now. We know humans are at perilous economic and environmental crossroads and yet individually we feel the pressure to work harder to earn money to consume more, in the effort to help. How worthless. Everyone rips off a system to get the best out of it; to master something is the natural human way. However, both employers and employees are feeling punished, creating winners and losers at either end of the financial pyramid. This is something we can easily do something about.

 We believe we should work less so we consume less. An economy that offers rampant consumerism as the only solution to our communal problems is irresponsible. As a society we are faced with a seemingly insurmountable mountain of problems. Problems that, because of a singular focus on money, are left unaddressed. Let's pick an issue at random: this morning while waiting for the train, we counted the cars that went by in both directions. Out of 100 cars, only nine carried more than one person. If you were the manager of a company paying for that level of wasted energy (which, of course, you actually are) you'd be fired for the promotion and maintenance of such an incredibly inefficient system. So why are we even talking about building new roads? Is it because we as a society pay exorbitant amounts of money to live in a perpetual dream, hoping that we will be the one in the late-model Mercedes?

 In contemporary society it is the media moguls, politicians and financial company directors who define the frames through which we interpret reality. They've assumed the grand artist's status with their financial bonuses, sewing up the game and locking the rest of us out. We are all artists, each and every one of us. We always have been. We've simply ignored the responsibilities to each other that this demands. As celebrated German artist Joseph Beuys said, 'Let's talk of a system that transforms all the social organisms into a work of art, in which the entire process of work is included . . . something in which the principle of production and consumption takes on a form of quality. It's a gigantic project.'

 By asking, 'Is this art?' we assume that something is definitively 'not art' and avoid the more constructive question: 'What is this the art of?' Mainstream media works in this way. The function and purpose of asking 'Is this art?' is to stop us from thinking and engaging with the challenge of new ideas. Of course these ideas threaten the current running show. Like glass ceilings and iron curtains, these fake barriers are put in place to extinguish healthy debate and enforce a so-called 'common sense' understanding of who we are.

Taking a break on welfare doesn't have to be economic suicide for a country. To take a break and gain perspective is what we need a great deal of people to do. The winners of the 2010 Nobel Prize in Economics have argued for people to receive collective wealth while finding a satisfying job. We all want to be productive and we also want to decide what our production is.

We need to trust people to get on with what they need to do instead of producing controls and limits that clearly are not working. We belong to a global culture of shopping addicts who need to be given the chance to find a more sustainable fashion of existence. We believe it is valuable and we can afford to give people the time and resources they need to gain new perspectives. The carbon reduction alone created by this group of low consumers could pay for the time and the positive benefit to society. To figure out how to live constructively and be satisfied with your contribution — this gift of time is a wealth that makes GDP less significant.

What we have been advocating for is to do those things that we love, not because we are told that we love them, but because we have found real love there, enough to share. We need to explore the idea, intellectually, of embracing our collective welfare — by taking a break.

First published in the Dominion Post, *October 2010.*

Taking Stock

Eve Armstrong
20 November–
2 December 2010
Wellington

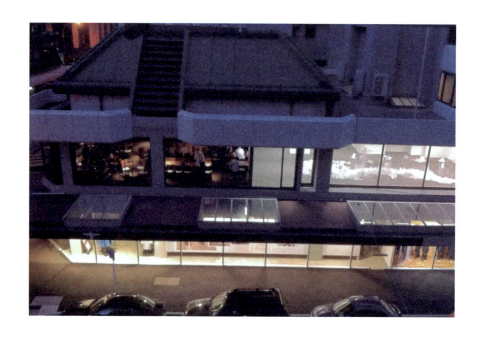

A sprawling sculpture over two Featherston Street storeys, *Taking Stock* offered a sublime landscape of translucent plastic in the form of a retail display. Playing with the seductive visual language of modern consumerism, Eve Armstrong presented a symbolic stocktake of the plastic packaging that increasingly surrounds our daily lives. *Taking Stock* was a reminder to 'take stock' — and treat with care what we are given. The project began with a call to the public for clear or milky-white packaging. Upturned Perspex plinths were set up as drop-off points at the Dowse Art Museum in Lower Hutt, Pātaka Art + Museum in Porirua, Mahara Gallery in Waikanae and Enjoy Gallery, Toi Pōneke and City Gallery in central Wellington.

Armstrong was specific about what she wanted — soft packaging was a no-no. Rigid clear plastic, that unnecessarily heavy-duty packaging that's become increasingly used to protect new goods, comprised much of the installation.

'You might also have milky-white or clear objects lying around home,' she wrote, 'old Tupperware, fridge drawers, vases, shelving, display stands, and brochure holders. We're also very happy to get off-cuts of Perspex, and seconds or excess plastic from factories.'

Empty plastic shells filled an empty retail space, highlighting the layers of waste in our commercial retail system. However, rather than resting on the didactic, *Taking Stock* showed a beautiful employment of sculptural language, with sophisticated compositional attention to the subtle layering of tones and multiple transparent forms, and mirrors and Perspex used to amplify light. While the promises and dreams we usually invest in new products were removed, magic remained.

Before the creation of the final sculpture, Armstrong paraded the donated plastics through the inner city from the gallery drop-off points to the display space on Featherston Street. The project coincided with Buy Nothing Day, an annual day of protest against consumerism.

The following year Armstrong was invited to restage part of the installation at City Gallery Wellington in *Prospect*, a survey of New Zealand contemporary art. This meant the plastic moved from factory to shop to home to gallery drop-off, through the streets to the Featherston Street site, then, for *Prospect*, back to a gallery space again, in a cycle of artistic reuse.

Since *Taking Stock*, recycling practices have continued to grow but the flow of plastic hasn't. Plastic bags have been banned in New Zealand supermarkets and soft plastic recycling collection points have been set up, but we remain high users of single-use plastic. A 2022 OECD report recorded that the world is producing twice as much plastic waste today as it was two decades ago, the bulk of it ending up in landfill, incinerated or leaking into the environment. Only 9 per cent is successfully recycled.[1]

1. 'Plastic Pollution Is Growing Relentlessly as Waste Management and Recycling Fall Short, says OECD', OECD, www.oecd.org.

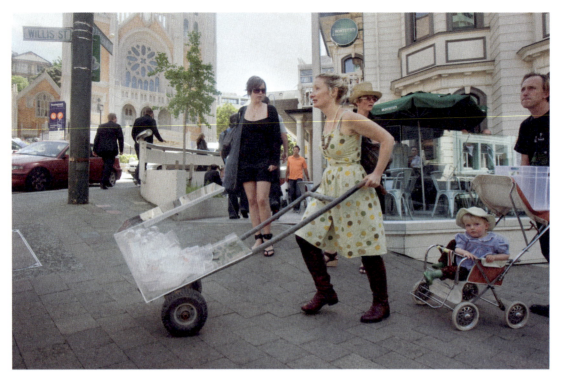

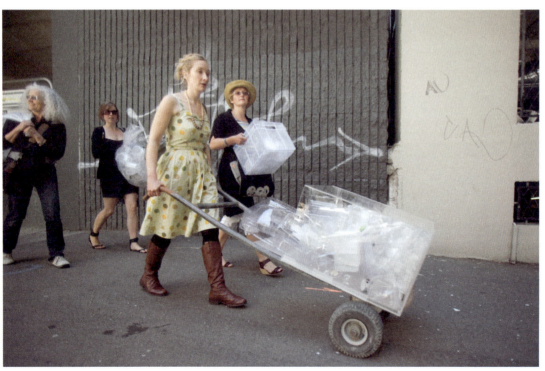

Parading the Streets // Sophie Jerram, Monday, 8 November 2010

Perhaps the British artist Richard Long, the king of walking art, has been the rural godfather of Letting Space this month. On Friday, 5 November, Eve Armstrong, rather like a courier, wielded an old-fashioned trolley as she gathered material — the detritus of her consumer identity — from collection points in central Wellington. With Gabrielle McKone and Natalie Ellen-Eliza, Mark and I bring up the rear of this small parade, slowly loading up the trolley with clear plastics, large clear Santa-sacks of takeaway boxes, syringe containers and biscuit wrappings.

The enigmatic intention of the parade seemed to make passersby smile or look twice. The objects we carried and the clothes we wore were not out of the ordinary, but the movement of these 'worthless' plastic goods, slowly accruing symbolic weight as they grew in mass, was clearly curious. We came across middle-aged men in blazers who were keen to ask what we were doing and how this project connected to art.

Wellington is navigable on foot and its cultural geography richly varied. We traced a rectangle from Featherston Street along Lambton Quay to the ASB Bank and Capital on the Quay, up Willis Street to Toi Pōneke on Abel Smith Street, back down Cuba to Enjoy gallery, along Ghuznee to the Film Archive (by now we were really beginning to spill) and down Taranaki, through Opera House Lane then across the side entrance of the Town Hall and into City Gallery, before going back down Victoria and along Featherston again.

The expectation of pleasant retail in the lead-up to Christmas is the context in which *Taking Stock* will appear. Eve will be weaving her straw into gold over the next fortnight.

Taking Stock // Eve Armstrong

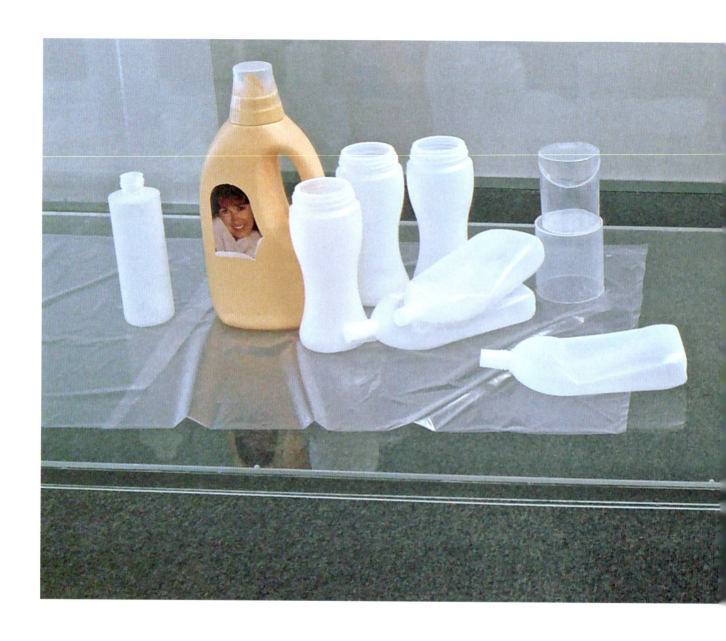

Taking Stock // Eve Armstrong

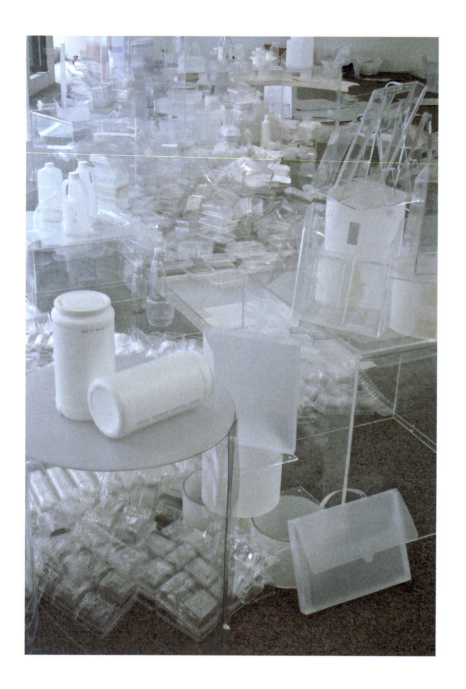

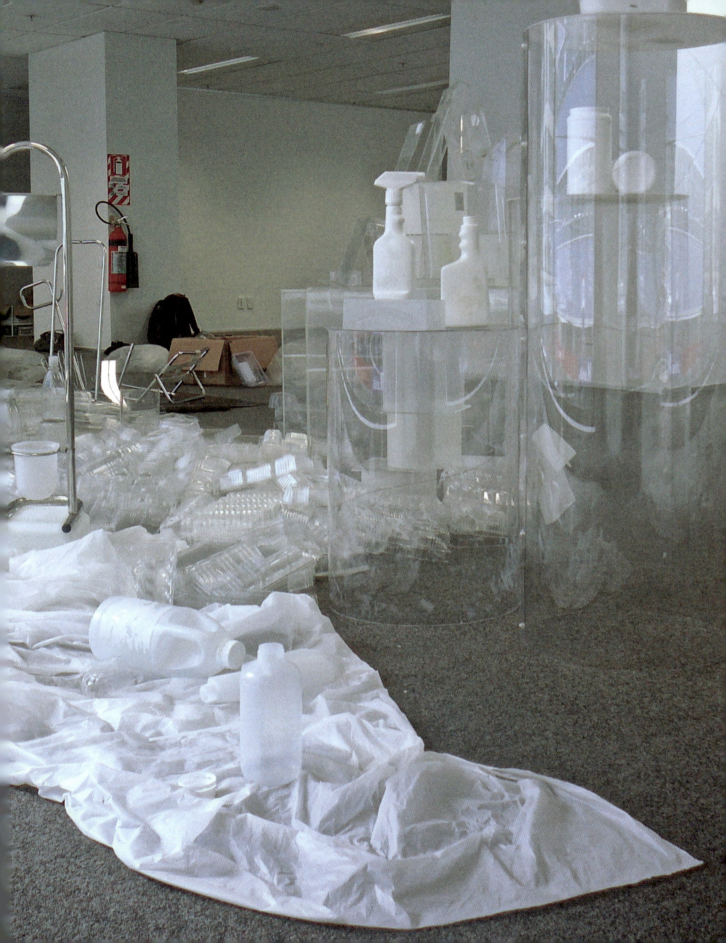

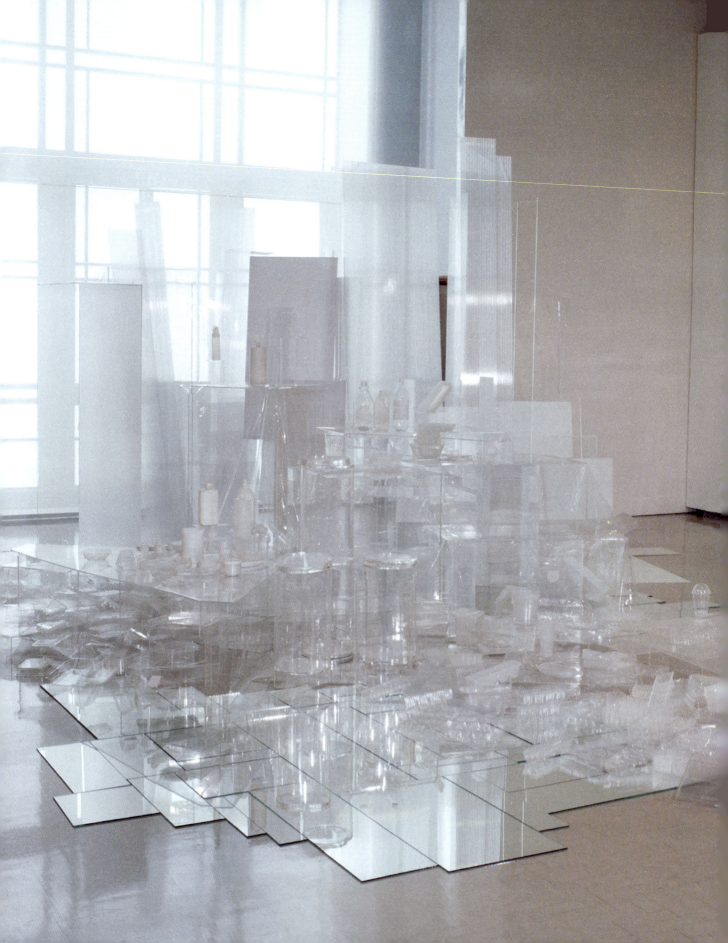

Downstairs, the colours of the exhibition are taupe, grey, tan, beige. Transparency and plastic are placed centre stage. Eve Armstrong's *Taking Stock* spills out from one wall of the East Gallery, an avalanche of clear containers, plastic sandwich boxes, liquid soap pumps and a Frappuccino cup, without straw. The work reminded me of the epic cascade of the White Terrace. On my visits to the gallery there was always a viewer skirting its edge, sometimes looking down into the mirrors that form part of its overflow.

Megan Dunn, *EyeContact*, 16 December 2011

Eve Armstrong, *Taking Stock*, 2010–11, mixed media, in *Prospect: New Zealand Art Now*, City Gallery Wellington Te Whare Toi, 2011–12.

The National Party wins 59 seats in the general election and works with ACT, United Future and the Māori Party to form a government // John Key continues as prime minister // Sir Jerry Mateparae becomes governor-general // A 6.3 magnitude earthquake strikes Christchurch, causing major damage and killing 185 people // Minister of Finance Bill English delivers the 'Zero Budget', planning $1.2 billion worth of cuts over four years // MV *Rena* runs aground on Astrolabe Reef near Tauranga, causing a large oil spill // Two further major earthquakes strike Christchurch in one day // Internet vigilante group Anonymous launches attacks on government websites in response to Arab Spring protests // A 9.0 magnitude earthquake and subsequent tsunami hit the east coast of Japan, killing 15,840 and leaving 3926 missing // Mojang Studios releases video game *Minecraft* // Prince William and Kate Middleton spend $1.6 million on wedding flowers // Sāmoa and Tokelau move west of the International Date Line, skipping 30 December // Anders Behring Breivik kills eight people in a bomb blast in Oslo, then 69 in a mass shooting on the island of Utøya // WikiLeaks and others publish 779 classified documents about Guantanamo Bay detainees // Occupy Wall Street protests begin // North Korean leader Kim Jong-Il dies // A litre of regular petrol is $2.06 // A litre of milk is $3.64

2011

Suburban Floral Association
8–19 March 2011
Auckland

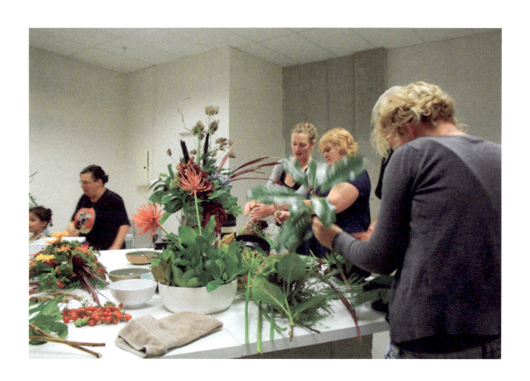

In 2011, Letting Space returned to Auckland for the Auckland Arts Festival, commissioning a work that spoke to the changes in the city since the first Letting Space projects of the early 1990s.

Monique Redmond and Tanya Eccleston's collaboration, Suburban Floral Association, brought the 'brightest blooms' of Auckland's established suburbs to a new town square alongside Newmarket's new railway station. Opened in 2010 in the face of the global financial crisis, a year later the concrete space was surrounded by mostly empty retail premises with apartments above. Despite the vacancies in Station Square, negotiations to use one of them were difficult in harder-nosed Auckland. Letting Space eventually liaised with the Newmarket Business Association, stressing the connection with the Auckland Arts Festival to help negotiate use of a shop with a cagey foreign owner.

Shopfront provided a warm, social green space in a grey square, and staged video screenings, plant installations, cutting swaps, flower-arranging workshops and talks. Members of the public were invited to bring along cut flowers and foliage, and to take away cuttings for their gardens or just watch the work change and grow.

Inner-city apartment living was still relatively new in 2010. Following suburbanisation and motorway construction after the Second World War, the population of Auckland's inner city had declined significantly, while the suburbs, and their gardens, sprawled. Changes in the late 1990s and 2000s rapidly repopulated the central city with local and international students as well as central-city workers.

The inner-city residential population grew 1000 per cent between 1994 and 2009,[1] and the residents' ethnicities diversified noticeably. There were also now many low-cost apartments like those above Station Square. As a prescient nod to urban gardening that would bolt in popularity around a decade later, *Shopfront* asked: Can the blooms of the suburbs help pollinate fallow ground in a recession-hit inner city?

In 2014, Suburban Floral Association produced the next iteration of *Shopfront* as *The Floral Show* at Fresh Gallery Ōtara in South Auckland, working largely with suburban and floral communities there.

1. Wardlow Friesen, 'The Demographic Transformation of Inner City Auckland', *New Zealand Population Review*, vol. 35, no. 1 (2009).

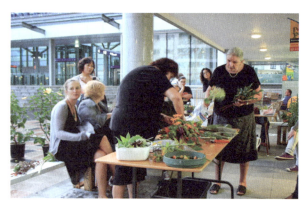
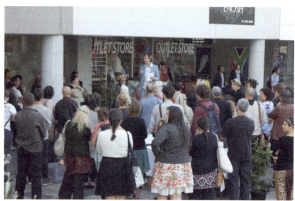

The Welcoming Committee // Hannah Zwartz*

Front gardens, once you start looking, express a household's personality. The more tidy, clipped and open to the street a front garden is, the more likely the front windows will have lace curtains drawn. You can tell which occupants read home improvement magazines or watch garden makeover shows. The more wealthy the area, the less likely it becomes that houses will be visible from the street. And the more colourful the flowers that are planted, the more likely it is you'll meet the occupant hanging round the letterbox for a chat.

Fashions in front gardens come and go — think 1970s golden conifers, 1980s standard iceberg roses with cottagey froth, or 1990s pebbles, grasses and yucca. But the plants themselves, once they get their roots down, hang around a little longer than last season's handbags. Front gardens can be read forensically, as living archaeology. You can pick the era, if not the exact year, when a garden was last given a makeover. You can guess when people felt settled enough to plant large trees.

Sometimes you can spot highly localised trends. One gardener gets a particularly beautiful tree or shrub (in my neighbourhood, a red-flowered waratah) and neighbours follow suit, either buying a specimen in imitation or obtaining one more directly by asking for a cutting — or taking one over the fence. Trading cuttings is one of the more social aspects of gardening, which can otherwise be a solitary pastime. Someone admires a plant in your garden, you propagate it to share, and so plants move up and down the street. Other plants, like buddleia or sycamore, come uninvited and their presence speaks of a lack of vigilant weed removal.

The garden, argues author Michael Pollan in *Second Nature*, is the coalface where nature and culture meet, and the two cannot be seen as totally separate or opposite, but intricately interconnected.[1]

The collaborating artists of the Suburban Floral Association, Monique Redmond and Tanya Eccleston, explore the social side of gardening in *Shopfront*. In particular they look at the suburban front garden, which they describe as a 'welcoming committee' as you roll up a driveway, with a constantly changing panorama across the seasons. 'Suburban florists go about their everyday, working towards the big event,' the two artists write, 'looking forward to the time where blooms congregate en masse, transforming suburban site into exhibition space.'

The contrast between a leafy front garden and uber-urban Station Square, where *Shopfront* is located, couldn't be stronger. The main entrance to the shiny new Newmarket railway station forms one side of the square, the other three sides are enclosed by rows of shops. These are brand new, mostly empty. Alleyways in two corners lead to Newmarket's main drags, Broadway and Remuera Road. '32 Specialty Shops', proclaims the real estate signage, but in reality there are three superettes selling fags, phone cards and Kronic joints; three nail bars; two hair salons; three small family-run cafés; and a shop with racks of Asian-imported garments.

It's mainly populated with teens from the nearby colleges — texting, swearing, spitting, sitting in each other's laps, snogging, shrieking, smoking.

[1] Michael Pollan, *Second Nature: A gardener's education* (New York: Grove Press, 2003).

This is their space, with little rushes of busyness twice a day as retail workers hurry across in high heels to catch their trains home. Above the Square, apartments rise. It could be an urban success story — the much-touted mix of living, cafés and shops — but it's barren and ugly, done on the cheap, windows too small and ceilings too low. Residents aren't allowed climbing plants, and tree roots would interfere with services to the carpark below. Instead, rising from grey concrete are a grove of weird stainless-steel fake trees, their glass umbrella coverings etched with fake leaves.

This barren retail environment is more interesting to work with, the Suburban Floral Association says, than a boutique character-filled street. Each day the artists improvise with their collection of plants and benches, like life-size Lego pieces, creating a social space that interrupts the traffic of people and play. The arrangements of plants and objects offer spaces for pause and conversation as much as they become, in part, obstacles to a direct route across the square. If Pollan's gardens are Second Nature, this artwork provides a Third Nature, one further step removed from wilderness.

Inside the store there is a video of a changing array of hibiscus blooms. Filmed in real time, the flowers nod, leaves gently waving now and then in the breeze: uneventful, but at the same time hypnotically mesmerising. It recreates perfectly, there in the concrete shell of a shop, the headspace of sitting on your top step with a cuppa, mind relaxed, looking at the garden.

Over the months leading up to the Auckland Arts Festival, the Suburban Floral Association struck and potted up hundreds of cuttings for 'Friday Night Takeaways'. Passersby could come and choose cuttings to take home, wrapped in newsprint like a parcel of fish 'n' chips. The Friday Night Takeaways trestle table is reminiscent of a cactus or dahlia society show, and people are touched to be given something to take home. 'A bouquet of cut flowers is itself an occasion, whether they are picked, bought, given or received; they are small exchanges, celebratory markers of other happenings,' Redmond says.

Likewise, people are invited to bring in flowers or foliage from their own garden, which are arranged in vases within the shop space (a flower-arranging workshop was also part of the programme). Jill from Gisborne, recently moved to the apartment complex and missing a garden, brings in a twig of Natal flame bush for us to identify in the gardening encyclopaedias on hand.

At night, *Driveby Shootings*, a set of 600 sequential images of hydrangea blooms, shot from a car, is projected onto the shop window. 'Our driveby photographs were collated to create a shared experience of something common though largely unappreciated — somewhat like another's front garden,' says Redmond.

///

Across Remuera Road, I go for a beer. Inside the front entrance of Mac's Brewbar is a trough of soil where ivy has been planted to climb up a trellis. But it's not thriving, and some designer has brought in plastic ivy, intertwined with the real, to give the illusion of lushness. Does anyone even notice? And what need is this greenery meeting? Outside on Nuffield Street, among the shops selling homewares, designer maternity wear and thousand-dollar handbags, large terracotta planters have been filled with trendy decorative lettuces. How long they will last before succumbing to bus fumes. Would anyone even think of eating them?

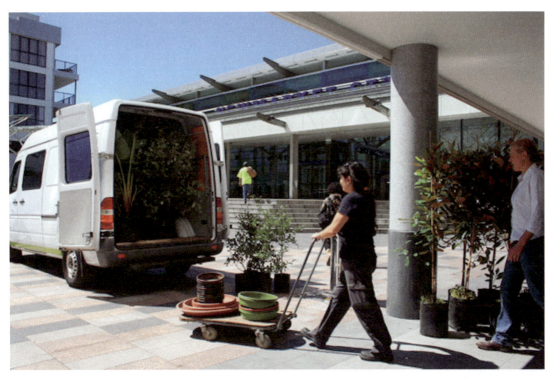

Shopfront // Suburban Floral Association

All gardens give an illusion of human dominance over the plant world (unless the gardener has given up trying). Front gardens are a public display of individual personality, but also a shared, social space. Not usually for sitting around in (that's done in the private backyard), but for chatting over the fence as you bring in the groceries or take out the rubbish.

Front gardens, like traffic islands, are an in-between land. They're not the street and not the house, not private and not public; designed to be seen from the street or footpath, yet buffering the house from public view. They're like a private park you're allowed to look at but not enter without a reasonable excuse for knocking on the front door.

In urban environments this luxury doesn't exist — every inch of space is filled. Suburban sprawl gets a bad rap sometimes, but perhaps the empty, transitional space of the front garden is something you don't appreciate until it's not there.

All gardens are temporary; some are more temporary than others. My first full-time job, aged nineteen, was as an 'office plant lady'. Watering can tucked over elbow, I came to know elevators, foyers and boardrooms all over town. Even the toughest plants, such as mother-in-law's tongues, needed regular replacement; air conditioning and fluorescent lights made them sick. It's difficult to keep plants alive in the concrete jungle.

Even in the sheltered ground of suburban front gardens, life can be fickle. The urban environment may be more extreme but it shows the same truths about gardens — they cannot exist without a gardener, a shaper and caregiver. Even with the best intentions and care, many plants still die. Only the fittest survive (and even those will eventually become compost).

The challenge of creating a garden from potted plants is one I'm familiar with. Sitting on the benches in Newmarket, I was also wrestling with my own technical and aesthetic challenge: constructing a sustainable show garden (surely an oxymoron) for Kāpiti's Sustainable Home and Garden Show. The trick, for me, is to create the illusion of a lush, benevolent paradise within the technical limitations of what can be transported and what can withstand the elements. Black plastic bags need to be covered and disguised to make the plants look natural and at home.

In a suburban front garden, the ephemeral and temporary nature of a garden is camouflaged. In *Shopfront*, by contrast, the temporary and changing quality of the event is out front and plain for all to see. The potted trees are mobile and ready for planting out.

Interactive artwork, like making a garden, carries risks. People may not interact, may not 'get it'; ideas may not 'strike' or find fertile ground. Plants, like ideas, can have a life of their own. They move in time, if not in space, and the garden changes over the seasons, decades and centuries. The gardener supports and creates, but is never in control.

** First published on the Letting Space website, August 2012.*

Shopfront // Suburban Floral Association

The Market Testament

Colin Hodson
11–25 April 2011
Wellington

Like a spooky portent of the global Occupy movement, *The Market Testament*, by artist and filmmaker Colin Hodson, occupied an entire vacant office building — Asteron House — at number 139 on Wellington's The Terrace. Hodson rigged up the fluorescent lights on Asteron's seven floors to turn on and off in tandem with the day's share-trading volumes on the New Zealand stock exchange, creating a giant kinetic sculpture.

The Occupy movement kicked off in September 2011 with Occupy Wall Street, an encampment in New York's financial district, expressing opposition to social and economic inequality and a perceived lack of real democracy. In New Zealand, Occupy protests set root quickly in seven different cities from October, and the Occupy Wellington encampment was to last until February 2012. A group of the initial Wellington organisers went on that year to form the Concerned Citizens Collective, establishing a community space at 17 Tory Street from which Letting Space operated for some years.

Asteron Life, an insurance company, had moved to a new build on Featherston Street in 2010 but the future of the old Asteron house on The Terrace was unclear. Hodson discovered the vacated building still contained the detritus and chummy mementoes of office work culture — it had the eerie sense of a place evacuated at the onset of a disaster. The whimsy of Hodson's idea to use the site for an artwork appealed to its new owner, director of Primeproperty Group Eyal Aharoni.

After Hodson installed the electrics he left the light display to run for two weeks. He understood the vacant office building as a symbol of an economic system run independently of human intervention and concerns. The work was viewable from both The Terrace and Lambton Quay, and a camera, set up in the window of the director's office at the Museum of Wellington on Queens Wharf, put a continuous live feed of the work out on the internet.

At the opening event for *The Market Testament*, a community of artists and friends gathered for one night on the top floor of the vacated building. It was an unusual setting for artists to find themselves in, as if they were the last ones left after the corporates had vacated the city — arguably the most memorable opening in Letting Space's history.

Earlier that year, the *Dominion Post* had reported that office vacancy rates in central Wellington were rising and were predicted to rise further — from 9.9 to 15 per cent in the two years to follow.[1] The increase, however, was ultimately short lived: the November 2016 Kaikōura earthquake had a dramatic impact on the number of inhabitable office buildings in the city; earthquake strength standards were revised following the quake and many buildings were not up to the new code. Indeed, in July 2021 the new Asteron Centre on Featherston Street was deemed earthquake-prone and had to be vacated by Inland Revenue staff.

1. Tom Pullar-Strecker and Tom Hunt, '$6500 Grant to Light Up a Building', *Dominion Post*, www.stuff.co.nz.

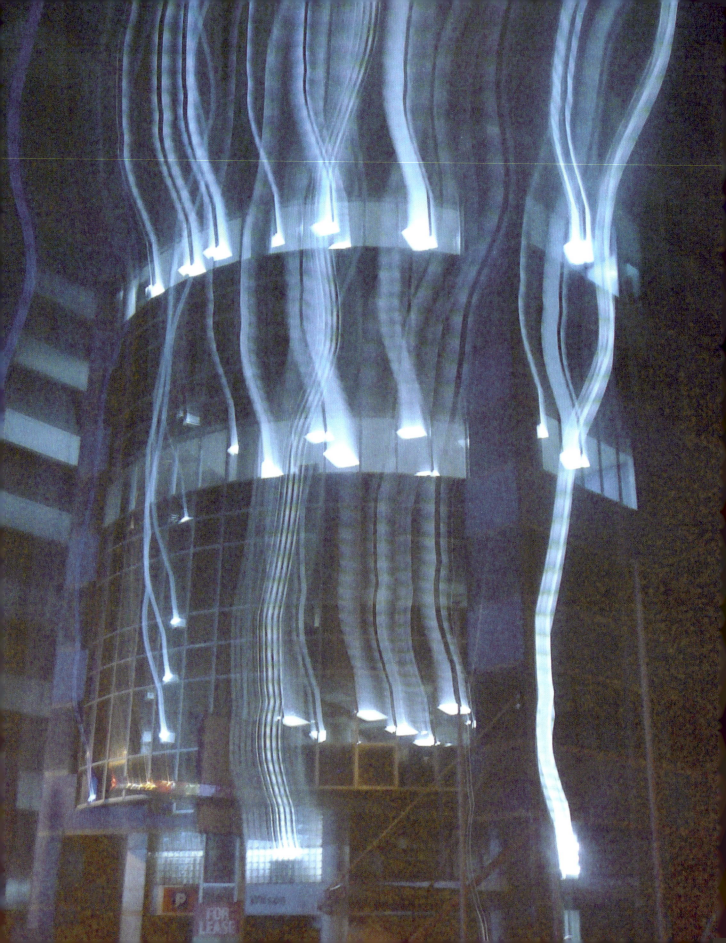

Hope Is Not About What We Expect // Martin Patrick*

> If art and politics meet at all, it's in the obligation to work concretely
> in the present toward an ideal that may never be fully attainable.
> — Barry Schwabsky[1]

Cinematic disasters come in cycles, as we alternately covet or reject our (post-) apocalyptic visions. We currently see a return of this phenomenon — *The Road*, *Contagion* and *Rise of the Planet of the Apes*. Perhaps more to the point here is the remarkable and straightforward documentary *Inside Job*, which painstakingly delineates the financial turmoil enveloping global markets and local households since 2008 (and earlier).

One could argue that 'real' devastation — whether economic, psychic or physical — bears no easy resemblance to fantastical obliteration in CGI mode. Our fears now are palpable, very real, but conveyed in more abstracted, oblique economic channels and forms. (And of course this is not to underestimate the long and difficult period of coping with the manifold effects of the recent earthquakes in Christchurch.)

Reports of the Occupy movement — spread virally, globally over the past months — eerily recall much earlier reports of social protest as spectacularly conjured events. Take author Norman Mailer's brilliant yet idiosyncratic account of the 1968 March on the Pentagon in Washington (later published as *The Armies of the Night*):

> Now the Participant recognised that this was the beginning of the exorcism of the Pentagon, yes the papers had made much of the permit requested by a hippie leader named Abbie Hoffman to encircle the Pentagon with twelve hundred men in order to form a ring of exorcism sufficiently powerful to raise the Pentagon three hundred feet. In the air the Pentagon would then, went the presumption, turn orange and vibrate until all evil emissions had fled this levitation. At that point the war in Vietnam would end.[2]

When reading journalistic reports of today's out-of-work artists, artisans and designers throwing their lot in to create responses to the current climate of extreme economic precariousness, I think of this proposed Yippie stunt, comprising an unequal mix of goofish mockery, creative imagination and deadly earnest utopianism.

Journalists of every persuasion are digging out their arsenal of tools to try to sum up and categorise an unfinished historical period. *TIME* magazine's choice of 'The Protestor' as its Person of the Year for 2011 is such an example. In writer Kurt Andersen's words:

> 2011 was unlike any year since 1968 — but more consequential because more protesters have more skin in the game. Their protests weren't part of a countercultural pageant, as in '68, and rapidly morphed into full-fledged rebellions, bringing down regimes and immediately changing the course of history.[3]

1. Barry Schwabsky, 'Signs of Protest: Occupy's guerilla semiotics', *The Nation*, 14 December 2011, www.thenation.com.
2. Norman Mailer, *The Armies of the Night: History as a novel, the novel as history* (New York: New American Library, 1968), 120.
3. Kurt Andersen, 'The Protester', *TIME*, 14 December 2011.

Andersen's slightly purple prose leans more toward the so-called Arab Spring than any perceived success or failure of the Occupy (Wall Street) movement, which some have said has succeeded mostly — and ironically — by becoming a 'brand name' itself. Andersen's mainstream, user-friendly rhetoric contrasts markedly with the fervent manifesto-style approach of writers Franco Berardi and Geert Lovink in their 'A Call to the Army of Love and to the Army of Software', a posted bulletin dated October 2011:

> . . . take to the streets and fight. Burning banks is useless, as real power is not in the physical buildings, but in the abstract connection between numbers, algorithms and information. But occupying banks is good as a starting point for the long-lasting process of dismantling and rewriting the techno-linguistic automatons enslaving all of us. This is the only politics that counts.[4]

Traces from all of the above have raced through my mind in the months after observing and reflecting upon *The Market Testament*.

///

A bunch of bland, boxy structures, arbitrarily generic, punctuated by little decorative flourishes (the colour of modernist glass and steel, the signage announcing their functions or corporate sponsors) — I don't know much about these edifices of the Wellington CBD. I tend to avoid them assiduously. I can count on the fingers of one hand the memorable times I've spent in their midst: health exam, bank visit, solicitor consultation. Perhaps the strangest, though, was when I was graciously invited to facilitate a discussion on — or I should say *inside* — Colin Hodson's work.

At 139 The Terrace I was ushered into the building after hours, up a lift and into a partially emptied floor of office cubicles. The remaining contents included some dismal grey desks, Formica tables and metal filing cabinets, along with a few bits of stray, printed ephemera and Post-it notes featuring once-urgent information. It was a haunted shell of a workplace.

The artist, curator, curatorial assistant and myself as advance party exchanged jokes, but for me spooky uneasiness prevailed. Most of what I remember is the slowly changing lights, staggering and stuttering in the typical way of antiseptic, fluorescent ceiling fixtures. They were being taken for a virtual test drive, flickering according to Hodson's computerised collision course while we talked.

One collision, so to speak, had already been had with the local media and respondents to the *Dominion Post*'s website, who offered surly, uninformed rants and accusations that *The Market Testament* was not art, etc.; it didn't seem 'very artistic at all'; it was 'wasting power'[5] — in short, a typically unproductive verbal impasse.

Hodson's piece brings to mind two notions originated by the artist Marcel Duchamp: the 'readymade' and the 'infrathin' (in French, *l'inframince*). In *The Market Testament*, the site becomes a readymade, an existing object to which new ideas are applied and associated. Moreover, the notion of the infrathin (far more obscure than the readymade in terms of art historical fame or ubiquity)

[4.] Franco Berardi and Geert Lovink, 'A Call to the Army of Love and to the Army of Software', *InterActivist Info Exchange*, 12 October 2011, http://interactivist.autonomedia.org.

[5.] Comments on Tom Pullar-Strecker and Tom Hunt, '$6500 grant to light up a building', Stuff, 12 April 2011, www.stuff.co.nz.

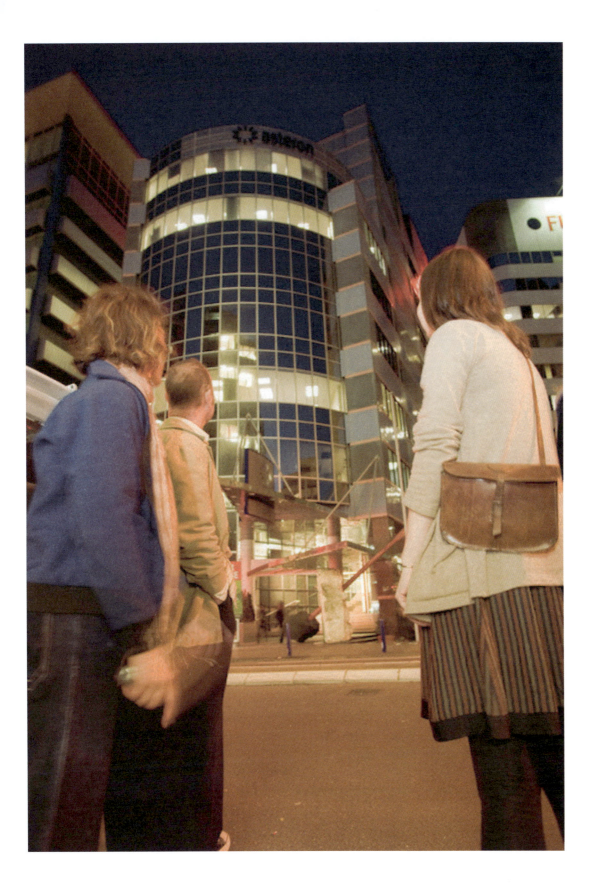

The Market Testament // Colin Hodson

was exemplified for Duchamp by a series of glancing blows at philosophical meaning, using literary phrases rather than visual figures: 'the difference between a shirt when it has been ironed and after being worn'; 'the gap between two sides of a piece of paper'.

Duchamp's compelling manoeuvre was to describe that which is almost imperceptible but wields a deceptively large significance. This is echoed in the ways *The Market Testament* addresses the seeming arbitrariness of the ascending and descending stock tallies, a steady hum underneath our daily activities. Here this is represented by flashing patterns of lights drawing from algorithmic signals pulsing through the hidden recesses of an office block — itself a time capsule, symbolic of the 1980s 'greed is good' mantra.

What's both fascinating and frustrating about *The Market Testament* is its elusive quality. It turns itself inside out from time to time, transforming the flows of unseen numerical data into the visible flickering of lights. Even if its logistics were completely revealed to me, could I or would I comprehend them? Instead, the work operates as a conjuring, a sleight of hand presented to the viewer, whose full comprehension is unlikely to aid it.

Hodson is a film director and actor as well as a visual artist — he is well versed in setting a scene, dealing with performance and thinking through the durational aspects of a work. A number of years ago he lived in New York and during that period worked closely with renowned experimental theatre company The Wooster Group, then including Elizabeth LeCompte, Willem Dafoe, Kate Valk and Ron Vawter as members, among others. The group's specialty was restaging, rewriting and utterly reconfiguring classics of the American theatre, such as works by Eugene O'Neill, while incorporating video, choreography, music and various postmodern style ruptures and interventions into the mix.

As in the case of many engaging temporal projects created recently, Hodson's work offers a snapshot of one particular moment at the same time it allows for the flow of events occurring prior to and after the event to prevent that glimpse from freezing totally. In fact, I'm learning more in retrospect from *The Market Testament* — continuing to consider the reading of it in mid-2011, just as the aforementioned protest movements were on the verge of commencing. In the maelstrom of events that continue to occur in these unpredictable times, and which can take a decisive toll on one's own capacity for optimism and fortitude, I often return to the following statement by writer Rebecca Solnit:

> . . . hope is not about what we expect. It is an embrace of the essential unknowability of the world, of the breaks with the present, the surprises . . . I believe in hope as an act of defiance, or rather as the foundation for an ongoing series of acts of defiance, those acts necessary to bring about some of what we hope for while we live by principle in the meantime. There is no alternative, except surrender. And surrender not only abandons the future, it abandons the soul.[6]

6. Rebecca Solnit, *Hope in the Dark: The untold history of people power* (London: Canongate, 2005), 163.

* *First published on the Letting Space website, April 2012.*

Office ephemera left behind in Asteron House, Wellington, April 2011.

Pioneer City

Bronwyn Holloway-Smith
17 June –
10 July 2011
Wellington

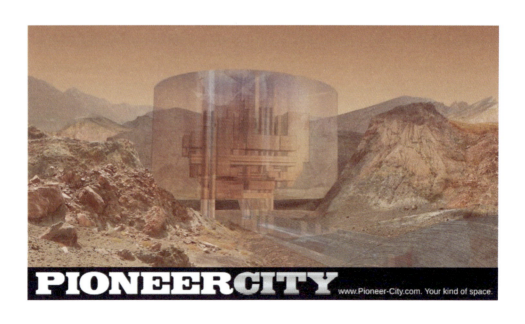

A new life awaits you in Pioneer City: a unique lifestyle in a stunning and innovative colony inspired by past, present and future. Seize the chance to begin again in this golden land of opportunity and adventure.

Nineteenth-century European settler immigrants to New Zealand took a leap of faith when they purchased land in Wellington, sight unseen. The twenty-first-century real estate industry uses similar strategies, with properties unbuilt or inaccessible advertised as meeting the desires of idealised lifestyles. Playing on these colonial and commercial tactics and touching on the colonisation of Te Whanganui-a-Tara Wellington, *Pioneer City* offered a leap into a tantalising future on Mars.

Bronwyn Holloway-Smith presented a showroom for her impostor firm, Colonial Real Estate, on the ground floor of the new Soho Apartments tower in central Wellington to advertise the opportunities awaiting prospective migrants on the Utopia Plains of Mars. The building owners, Cook Strait Holdings, were happy that Letting Space use the space for the exhibition, as it fitted with its own clean, futuristic aesthetic. Here, the public could browse depictions of their future lifestyles, scrutinise the architectural model of *Pioneer City*, designed with architect Rachel Logie, imagine themselves living there, and complete expressions of interest to be a Mars pioneer. If they had any further questions, Colonial Real Estate agent Helen McCarroll — played by actor Heather O'Carroll, who underwent real estate training for the role — was on hand to help out. The showroom opened to the public with a corporate launch, complete with bouncers. Pioneer-City.com remains an attendant website.

In 2010, Mars habitation was already very much on the agenda, with NASA scientists aiming for a human mission there within 20 years, alongside a host of other nations and super-rich guys competing to do the same. A Martian colony, reasoned Holloway-Smith, was not a question of 'if' but 'when'. Indeed, in 2022 NASA reconfirmed it plans to send astronauts to the red planet by the late 2030s or early 2040s; meanwhile, Elon Musk's SpaceX programme aims to set foot on Mars by 2029.

Back on earth: from the late 1990s, after decades of decline, Wellington's inner-city population started to grow again. With the economy picking up and Wellington newly branded the 'creative capital' — with an attendant, buoyant hospitality and creative industries scene — large residential towers and refitted office buildings became the new norm. The property market was booming.

For artists the situation was different — the large and affordable living and studio spaces they'd enjoyed (and which helped the city forge its creative branding) disappeared, forcing them out of the inner city. The problem was such that, after artist lobbying, the council established the Toi Pōneke Arts Centre in 2005, providing artist studios, offices and gallery space.

Pioneer City asked members of the public whether they might be one of the first brave, resourceful pioneers to take their residential hopes and dreams into space. To those filling in an expression of interest form, it also gently asked: What kind of future do we want for ourselves and the city?

Holloway-Smith first developed the marketing collateral for the Colonial Real Estate firm with Raewyn Martyn in 2010 for *Hue & Cry*. In the lead-up to the showroom opening, a billboard promoting the Martian real estate development went up in Ghuznee Street, commissioned by Bartley & Company. Holloway-Smith went on to develop a video promotion for *Pioneer City* with filmmaker Simon Ward that was screened on international Air New Zealand flights (thanks to curator Melissa Laing) and at the New Zealand International Film Festival. The project featured in *Among the Machines* at Dunedin Public Art Gallery in 2013, and in 2015 Holloway-Smith's *Pioneer City* flag won the National Contemporary Art Award hosted by Waikato Museum.

At the End of the Day // Murdoch Stephens*

17 June

Darling Laura

I believe in you and love you with all of my heart and want you to be happy. Do what makes you happy. That's an order.

I've enclosed something you might be interested in.

Mum

///

23 June

Dear Mum

Thanks for the vote of confidence. Was just telling friends you're the best. They all ask the stupidest questions. It's like how people talk about going on a trip to Africa. 'Isn't it dangerous?' I love how you instinctively avoid such tosh.

I know how you'll miss me, but that I have to follow my dreams. You know me like you knew my choice to teach science, to share the clarity of the world's healthiest method.

There's a debate on Friday about whether we, as a species, should go to Mars. I don't think it'll change anything, but let's see what the bright sparks have to say.

They say there's roughly a 40 per cent chance I'll advance from here. That means they've already said no to an awful lot of others from the first round. I'm confident. But not too confident.

Thanks for the article too. Isn't that always the way — you don't think about other planets all of your life, and then when you actually get the chance to be part of something like this, well, it's everywhere. Like love . . . I mean, it's like being in love. Like seeing his name everywhere. Oh Mars! Even sort of sounds like a man's name doesn't it? Or like a sheep.

And the feminine of Mars would be Marsha? I've never known a Marsha, nor a Masha, who I haven't liked.

I'm including a copy of the application form — look at the part where they ask about family. They're just like any other apparatus: aiming for control. But once I'm out there, on Mars, I'd like to see them try!

Love Laura

///

30 June

Dear Mum

Yesterday morning was my physical. The doctor kept asking these leading questions about why I don't have children, about depression and self-harm. I'm not sure if one of my referees said something odd, but I just played it cool. I said something like, 'Well . . . I've not even got a boyfriend, have I, so why would I have a child? I'm a science teacher, not your average baby factory.' He probably thinks I am some sterile wretch.

I went to that debate. It was just as I should have expected. Should have? I did expect it!

Why can't this mission be a cause for coming together and blessing? Why must it be just another chance for these same old bastards to air the same old grievances?

The statement for the debate was: 'Mars should not be settled until the main troubles of earth are under control'.

First up was the affirmative.

If you had been there you would have called him a liberal. He was one of those types of guys who wants to save the world from . . . well, from itself. At least, that's how he sounded. He was arguing in the affirmative so perhaps he was just a very good actor! He said that mankind had done very well in offering the technological possibility of colonising Mars, but that there's no real point if we were just going to ignore the political, economic and social factors that have made earth worth abandoning.

The guy was really popular. It was like his whole fan club had turned out or something. I couldn't tell if the crowd was just dumb or if they actually believed what this guy was saying.

The other guy, John I think his name was, representing the negation started quite well. But that's all he did. I mean, he brought up all of the points that I would have said if I were in his position, but he spoke like he hadn't actually considered going. He just provided this kind of wicker man of an opposition that the others could burn down on their next turn. He had the passion of plywood: layering of valid arguments, but useless cause it's so ugly.

The negation guy — the guy who spoke all of my arguments with zero temerity — was soon buried. He replied to any argument by waving his hand and claiming, 'At The End Of The Day There Is No Alternative'. He definitely shouldn't have used those words. Even I don't want to hear those words. No one wants to hear them. The crowd was pissed. The affirmative team were chuckling, stupid hopeless grins across their self-satisfied mugs. They're what's wrong with this country . . . but I won't get into that again!

So that was it: one side that was all meek and recalcitrant and the other, those who were supposed to be about frontiers and life existing elsewhere, could barely muster enough gusto to turn logic into a persuasive argument. I'd had a gutsful even before their seconds had their turn. I left.

Love Laura

///

12 July

Dear Laura

I wish that I weren't too old to go. Maybe I'm not. Maybe I'll apply too. It's starting to sound like the kind of life that, well, is a life.

Charlie is having tea with me tonight. Jeanette is at her sisters. I bet he'll think I'm mad. But he's always thought that. So maybe he'll think I'm sane.

Love Mum

///

14 July

Mum!

So you want to go too?

How about that! I'm still not over it. I hope I didn't say anything too stupid to you over the phone. And I hope that you're still as happy now as you were then. I couldn't bring myself to say it at the time, but I think that Dad would be happy with your choice. He'd have wanted you to go. Maybe we can take his ashes?

Do you remember that book of telescope photography of outer space that Dad brought back from his trip to Cairo? I still remember the photos of odd purples and greeny-blue gases. Oh, I know that Mars isn't there, but imagine it once we are in the ship. Will there be windows? I suppose not. That's a shame.

Ain't it great that the new world will have a need for us? Someone, somewhere has a use for teachers as much as for those over 50! I'm so glad they've announced this Guardian programme. We'll have so much fun! Especially once I find a nice Martian man . . . suspicions are that young, wide-hipped ladies have been given preference for the settlement.

Love Laura

///

16 July

Dear Laura

I do want to go. I thought that with your father's life insurance and my KiwiSaver money I'd be comfortable for the rest of my days. But that was just some sort of hibernation. Mars seems like a better option than knitting my days away in Te Kūiti with holidays to Raglan. Bah! Give me adventure or give me death. Or give me both!

Your brother says he has talked to you about an investment on Mars. He says that you are keen and if I sign up we could double or even triple our profit. I know that you are smart and can make up your own mind about this. I'm not much interested in these things, but if you and Cyrus wish to buy some Martian land for your future then I'll help. By the time the real profits are realised it'll probably be for your kids anyhow. For your Martian kids.

I just thought that it would be a lark to fill in the form. I thought that it would serve them right to have my withered old face among all of those young models in the advert. And that's all it is, right? I mean, they didn't even ask for a photo, so it is not like there will really be that many good-looking people on Mars.

Do you think there will be alcohol on Mars? Or will we take those synthetic drugs that they sell in the dairy?

Oh and I thought of this today . . . will there be a judicial system or will all the people just be, well, nice? I'll have to ask them.

Love

Mum

///

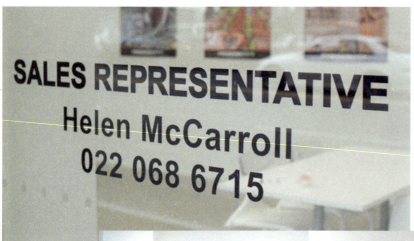

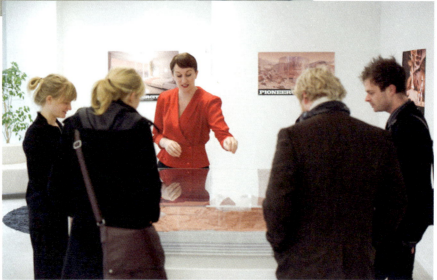

18 July

Mum

About the Mars property: I see your point. I'd appreciate it if you could make the investment. I'll transfer the money once the documents arrive.

When do you go in for your physical?

Love Laura

///

19 July

Laura

I'm in! I'm in! I'll give you a call.

Mum

///

19 July

Mum

SHIT! SHIT! SHIT!

Fuck them. If they don't know what's good for them then I'm not going. You know why they did it, don't you? Because I'm as barren as outer space. Bet you didn't know that, huh?

Well fuck THEM. I'll spend six months in Goa instead. There's still plenty to do on this earth. I will go to Goa for six months and show them how barren Laura Page is!

Come with me, Mum! Fuck them! Come with me! We'll get fluoro body paint and dance to techno and drink coconut juice from the coconut!

Love Laura

///

20 July

Mum — are you serious, Mum?

You're going to abandon me and Cyrus to this shitty earth? God knows it won't matter to Cyrus, but me? We need people like you here — what happens when the most sensitive, the most caring, those who are the brightest sparks for the future, take off to the middle of nowhere? My god, the shuttle probably not only doesn't have windows, but it'll probably explode on take-off!

You really think that this city is going to function once all the sheen and excitement wears off? The joy of Christmas doesn't last a week, and the joy of Mars won't either. You could do so much more here, if only you could transfer your passion to what is here and what is real, instead of fancying all these ideas of petri-dish justice.

Have you thought about that? Have you even thought about it?!

Laura

///

19 March, the following year

Laura

We've arrived! We stepped out of the ship's hatch and into, well, they could only be described as hutches. They're just like the rabbit huts you had when you were growing up, except here there is triple glazing instead of chicken wire.

Everything is going so well that some seem to be spooked by the easiness of it all. Some talk of the glory of God. I just try to keep my job as a Guardian. The general assembly has forecast that the first set of buildings will be running by September, that the bore water will be sustainable in four weeks and that we will be sustainable in terms of food before the second ration ship arrives in July.

Send me some news. Please, Laura, a little word means so much to me.

Love Mum

///

18 December, some years on

Dear Laura

From the heights of the apartment complex all escape is impossible. By day, the horizon dissolves into a haze as if the sun were turning the sand into glass. By night, all of the world, except the cold, the memories of Earth and the thick red walls, might be forgotten. You wouldn't like it here. I can't see how anyone can, beyond the first few seasons.

It's all so different from that afternoon when you and I chatted to that Helen McCarroll woman. Remember? Remember the sun shining off slippery Taranaki Street? Remember the way she smiled and nodded as she invited our hands to grasp a Mars Bar, to strip the cellophane, and to enjoy the dream of a better, cleaner world. Remember what you said afterwards? 'I'd like to see her there, without those heels or shoulder pads. I'd like to see her living the hard pioneer life.' And what did it mean? Nothing. It meant nothing. I bet she is still there, presenting her face to sell something to someone, to entertain. And I'm jealous of her and of easy days to be played away.

My complex is one of a series of 333 built by the Pioneer City Corporation. Our complexes keep their distance from one another. They were built that way, spread out at the distances a rover might cover in one day. While the traders of yore used the stars as a guide, we now live among the stars. And now that the navigation systems have stopped working, and we've forgotten how the stars might guide us, I don't know anyone who would risk travel.

I don't know much, really, about much. Knowledge tends to breed solutions. It is easier when you never knew anything else — things don't work because they've never been dreamed of, but here, like in the former Soviet Union, we're cloistered with these machines that once worked and are now a testament to our inability to inherit knowledge.

One thing that I do know is that a baby hasn't been live-born in 15 years. Perhaps that accounts for our gloom. Perhaps that accounts for the drops in productivity. Ha! Oh Laura, things are getting weary for this old husk.

Guests from the other settlements are no longer welcome. In the past, when the complex was open, rovers would drive in, yelling out their cordial greeting as much for the fresh air as to anyone who could have cared. They'd yell in their native languages. Their accents would remind us that things old and some new could excite. Those few words of welcome sustained us as would the leaves of permaculture.

This will be the last you hear from me. Imagine me in the old myth of the Inuit of Northern Alaska. I've somehow found my iceberg and I'm about to push off.

Love

your Mum

///

First published on the Letting Space website, November 2011.

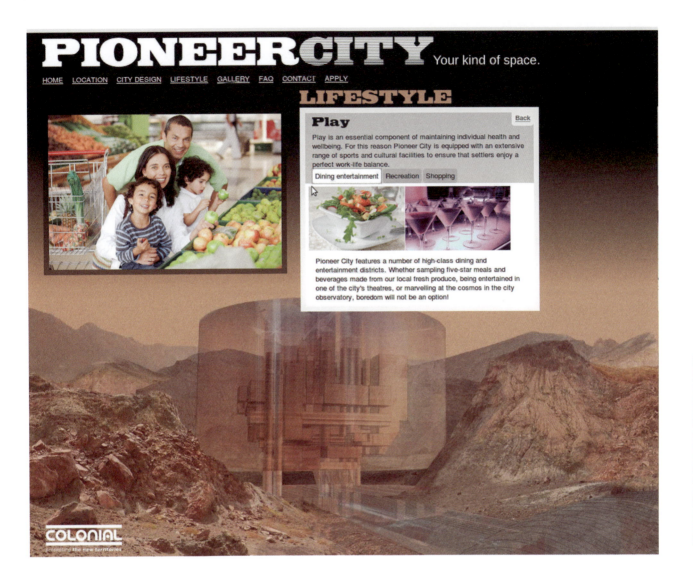

Pioneer City // Bronwyn Holloway-Smith

The US Department of Justice shuts down file-hosting site Megaupload // Police raid an Auckland mansion and arrest Kim Dotcom for internet piracy // The Easter weekend road toll period ends with no fatal road accidents // The National government aims to record a $197 million surplus in 2014/15, down from $1300 million in the 2011 budget // Mount Tongariro erupts, spreading volcanic ash as far east as Hawke's Bay // Weekday editions of the *New Zealand Herald* cease publication in broadsheet format // Analogue television signals in Hawke's Bay and West Coast switch to digital // Charles, Prince of Wales, and Camilla, Duchess of Cornwall, visit the country // The Crown signs a deed of settlement for all outstanding Treaty claims with Ngāti Toa Rangatira // Cruise ship *Costa Concordia* runs aground off Italy, causing 32 deaths // Port Said Stadium riot in Egypt kills 74 // Viral documentary film *Kony 2012* airs on YouTube // A pastel version of Edvard Munch's *The Scream* sells for US$120 million // Vladimir Putin is elected president of Russia // Middle East respiratory syndrome coronavirus is first identified // New particle consistent with the Higgs boson is discovered at the Large Hadron Collider // India blackouts leave 620 million people without power // Barack Obama is reelected president of the United States // A litre of regular petrol is $2.09 // A litre of milk is $3.49

2012

Free of Charge

Julian Priest
17–19 February 2012
Auckland

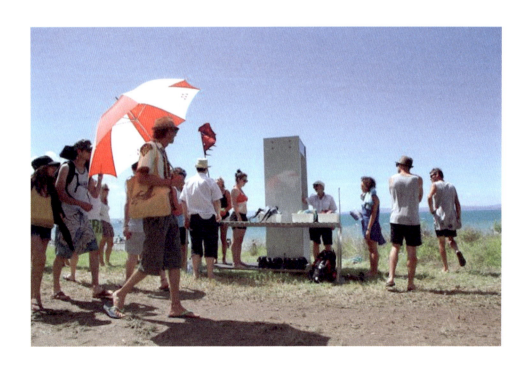

Since the 2001 terror attack on the World Trade Center in New York, tightened airport security procedures have become a necessary part of crossing borders. The machines that scan our bodies and our belongings have become synonymous with the queues that are their prelude, travellers waiting in orderly but tense lines to pass through to 'the other side'. Similarly, queues and the scrutiny of one's belongings are experiences not unusual for music festival goers.

In 2012 the annual Splore arts and music festival was held at Tāpapakanga Regional Park, an hour's drive from downtown Auckland and where attendees camp at a beautiful beach. Set on the foreshore during the festival, *Free of Charge* drew on the aesthetics of airport security screening procedures. However, instead of checking for banned or illicit items, Julian Priest designed a body scanner to check attendees for electrical charge and then 'ground' them, freeing them of any charge they had been carrying.

Personal items were separated from participants and rolled along a conveyor belt in plastic trays beside them. The work was designed to explore the ways in which we respond to authoritative infrastructures in our society.

As we move about in our daily lives, we collect small amounts of electrical charge from our proximity to electrical devices and electro smog. This may be removed by connecting our bodies to the earth — most directly, by standing barefoot on the ground. The idea of 'grounding' is promoted as a new-age health practice. *Free of Charge* didn't make or dispute any of these claims; instead, it created a subversive security apparatus that promoted wellness and reconnection with nature, aligning it with other alternative remedies on offer at Splore.

Splore was an early adopter of the cashless AWOP electronic wristbands common at festivals today.[1] Despite (or perhaps because of) the phrase 'free of charge' scrolling across the scanner's LED display, many participants were concerned about how entering the metal structure would affect the e-money device on their wrist.

Splore's public art programme provided various freebies amid festival-priced food trucks and bars. However, other free gifts being handed out at the festival had a less high-minded purpose — newly repackaged Telecom mobile company Skinny offered frisbees and inflatable lilos emblazoned with its logo, the distinctive orange creating a lasting association in the mind of attendees.

Free of Charge // Julian Priest

1. Russell Brown, 'Another Way to Pay: How AWOP annexed the summer festival experience', The Spinoff, 4 April 2018, https://thespinoff.co.nz.

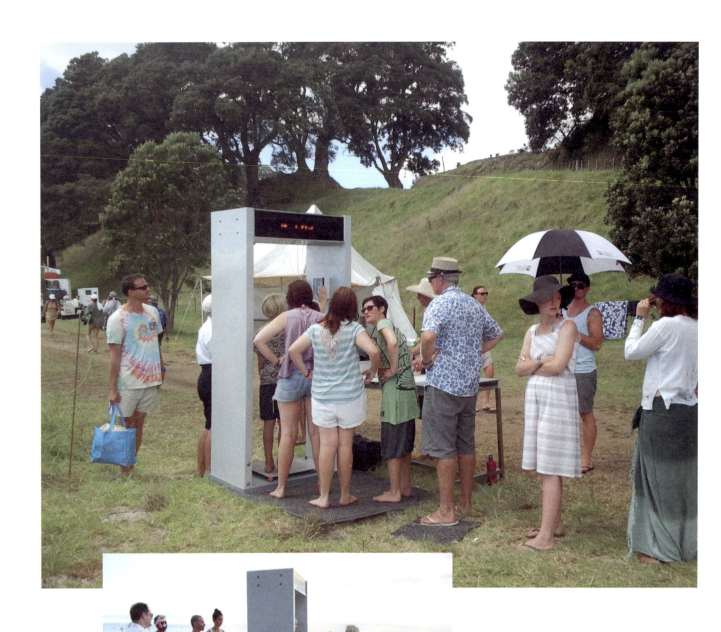

Facing the Same Barriers // Cathy Aronson*

Strange happenings take hold when you face the last barrier to your desired destination. As you offer yourself to be tagged and processed in the herd, your natural guards, body and verbal language are obliged to 'cease and desist' to please the security guard, your new buddy, mate, bro. You'll willingly, patiently explain why 'the apple is not a bomb'. With limited questioning, you'll 'let it go' when so close to your desired mission of 'letting go' for your holiday. A strange urge to 'please to deceive' sets in, even if you have nothing to hide.

Free of Charge artist Julian Priest calls this automatically accepting the socially constructed authority of the infrastructure. What do you give up when you're not questioning this context? As he puts it:

> By creating artworks that respond to infrastructures, I'm trying to encourage people to look more closely at what the social and political relationships are that are embedded into those things that we take for granted. What's really going on when you go through a security gate in an airport? Is it making you feel better or is it doing something else for you?[1]

[1]. Julian Priest, interview with Cathy Aronson, 'Processed to Proceed,' https://soundcloud.com/free-of-charge.

Dressed in their crisp white shirts, black cargo shorts and RayBan aviator-style sunglasses, the mock security guards at *Free of Change* were reassuring, briefly answering questions as visitors handed over shoes and objects and stepped barefoot onto a piece of airport-grade carpet, while queuing to go through what looked like a security scanner.

Positioned en route between festival zones at Splore, the queue for *Free of Charge* was different to real 'queue pressure' because of its opt-in nature, but the loss of control felt similar. In a festival environment, giving up the few small objects tethering you to the real world — whether an iPhone or a trusty lip gloss — takes on the same weight as surrendering a car-load, or suitcase, of belongings.

You don't want to be the prick who holds up the queue or ruins the vibe by questioning the thoroughness of the friendly security guards, so you can only watch as those perfect festival sandals (meticulously selected for their style, comfort and all-weather grip) join the tray of footwear on the roller table and trust that they will be waiting for you on the other side.

Despite the fact we constantly connect ourselves to electricity in some form via devices like cellphones and computers, for many of us the idea of placing our right hand and left bare foot on a metal plate (especially if dripping from a dip in the sea) may seem alarming, the perfect recipe for an electric shock. This is what we had to be prepared to do to enter *Free of Charge*.

After a few deep breaths, half looking forward to the process of becoming grounded, and half wanting to prove how chill I am, I was ready to find out and publicly reveal to anyone watching what my 'charge' is.

'You'll have a low charge, you live at the beach,' I was assured.

Sure enough, it was negative 5. But what does that mean? Am I negatively charged?

With many experiences, worldview, state of mind, scientific understanding (or lack of) and perceptions will define an interpretation of that experienced reality.

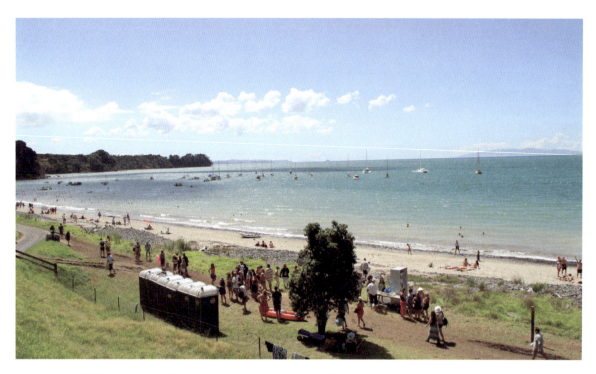

While some participants were suspicious of the scanner, others were simply curious and wanted an explanation of the mechanism or a science lesson on how the body stores electrostatic electricity.

To the paranoid mind, the scanner could be recording information. A group of teens wondered if it was a pregnancy tester.

While you didn't have to hand over your wallet to enter *Free of Charge*, the festival wristband, doubling as an electronic money chip, was the one item you couldn't remove. Entering a machine designed to balance your charge to zero — it was reasonable to ask if it would magically, electronically, zero your e-money balance too?

Other than when buying food, drinks, market wares or merchandise, the cloth band secured to your wrist, with its small rectangle plastic processing chip in the middle, was easily forgotten. It was a handy-dandy device which, with strategically timed top-ups, ensured you didn't need to worry about carrying around your wallet or forgetting, losing or breaking your bank card.

For the uninitiated festival goers who hadn't used an e-money wristband before, or for those just fond of cash, being tethered to a central-monetary cashless-transaction-system was an unsettling experience. The wristband's place in the worldwide order inevitably came up in musings around the hay bales in the tent city.

Now 'the man' not only knew your spending habits from the device on your wrist, but also how much charge you had. While the records might not personally identify you, you were now a statistic (for me, as part of the 40 per cent negatively charged) that might turn up in marketing information. Somehow, surely, they'd target you with energy drink advertising.

To many a festival goer, however, taking part in the artwork was just another fun frivolity to get inventive with — by stage-diving the roller table, trying to fit a

beach ball through the scanner, or taking bets and drinks on who would be the most highly charged person in a group.

///

For some participants, the process took on a deeper meaning. This group was not just unburdening themselves of a little bit of static electricity, they also wanted to unburden themselves of a bad energy or experience and let it be released into the earth. Participating in the artwork provided permission to be grounded, physically and psychologically.

Visitors may have arrived in many and varied states, but as soon as they stood on the metal plate waiting to be decharged, space was opened for short but rich conversations with the artist and Letting Space, who were the instructors and 'security guards'. In this regard, Priest sees the work as a pretext for conversation. As he says:

> The work had a kind of authority to it. If you're in a conversation with a security guard at an airport you're normally trying to make sure that you don't get deported or that you get onto your plane. In a way, you're quite open to having some kind of conversation with that person. You might answer a question that you wouldn't normally answer if just anyone asked you. So one of the things I really liked about it was that you would get these really rich micro-conversations with people coming through. It looked like a very authoritarian space, but it actually opened up a very rich dialogue without a lot of the preamble that you normally have to go through in order to get into a decent conversation with someone.

The artist and curators were also interested in the social and political relationships embedded in this beach festival location, especially in a country like New Zealand without land borders. Water is our border here. 'The beach location is basically responding to that border,' Priest says, 'trying to get people to think about what it means to cross a border and what a border is and who controls access to that place and why that structure exists. Why does every vacation start with a security check? I'd like people to think about that maybe.'

Placed on the grass verge of the foreshore, the rectangle metal frame, when not 'activated', played off the huge frames often seen around regional Auckland parks and 'beauty spots', and framed the silhouette of the Coromandel Peninsula in the distance.

Free of Charge played on the abstractness of borders as arbitrary defining lines. For frequent fliers, especially on stopovers, travel can be a blur of duty-free malls and lounges with their array of food, juices and liquor, and it's often only a few different faces and procedures at border patrol that remind you that you've crossed into another country. *Free of Charge* played on the arbitrariness of such borders, the abstraction of their defining lines. On the beach, we queued to cross the border at no charge, and only each individual could say if they felt a difference, before and after.

** First published on the Letting Space website, July 2013.*

Productive Bodies

Mark Harvey
12–16 March 2012
Wellington

The National Party came to power in New Zealand in 2008 promising to rein in 'bloated bureaucracy'. By October 2011, 2400 public service jobs had been cut, with a further 1000 jobs projected to go over the next two years.[1]

Productive Bodies was developed in response to Letting Space's call for a new series of public artworks based on a theme of 'community service'. Letting Space's challenge to performance artist Mark Harvey was to apply some of the ideas he'd worked on solo to train up an army of performers for Wellington's streets.

Productive Bodies aimed to make visible the increased load placed on communities to do unpaid work for the public good when public service cuts are made. Taking inspiration from *Beneficiary's Office*, Harvey looked to engender discussion on the value we place on different forms of labour, from parental care to paper pushing.

In February 2012, an invitation was put out to 'the unemployed, [those] made redundant, stay-at-home parents and artists to join in making art together'. For five days in March, as part of the New Zealand International Festival of the Arts, Harvey and a team of volunteers carried out public actions across central Wellington, playfully interrogating what it means to be productive.

Ideas for performance were workshopped every morning in a circle within the gallery spaces at City Gallery Wellington. Ideas were generated as a group and decisions made through consensus.

In the afternoons the group headed out into the city, working in streets, parks and the entranceways of key public facilities, such as Parliament, the Ministry of Foreign Affairs and Trade offices (offering assistance after recent dramatic job cuts) and on the forecourt of what was soon to become the Ministry of Business, Innovation and Employment (a merger of four previous departments and ministries).

The actions undertaken were diverse. Some were absurd, others patently useful: a people barrier protecting a tricky pedestrian crossing, a human wind shelter on the waterfront and a healing circle in the Ministry of Health's foyer. Workers were applauded as they entered and exited workplaces, and surveys were conducted, asking 'How could I look more productive?' Thinking about the notion of 'government care' and expressing Harvey's perception that we live in a time when we were expected to 'look busy', *Productive Bodies* highlighted bureaucratic waste and, conversely, the value of public research and policy.

The same week also featured a panel discussion at the Festival Club in which Harvey, academic Marilyn Waring and economist Susan Guthrie examined how we treat productivity, and a response to the project by Tao Wells at Enjoy gallery.

Productive Bodies // Mark Harvey

1. Andrea Vance, '"Timebomb" Set as Public Service Jobs Are Slashed', *Dominion Post*, 10 September 2011, www.stuff.co.nz.

What We Did Monday Being Productive Bodies // Letting Space, Monday, 12 March 2012

Today we asked a fireman if he'd like a fireman's lift. He said he was too busy getting to his next fire, but we did synchronise our watches with his. We welcomed people to 'our library' and thanked them for coming. We shook some hands and helped some people carry their books. We arranged chairs in Clark's Cafe in a neat long row, measuring space between them with our feet. When we were asked to move them back we did so.

We offered to read people poems from books by New Zealand poets in the library, and chose work by Jenny Bornholdt and Gregory O'Brien. Then we bumped into Greg himself on his way to a meeting at the Ministry of Foreign Affairs and Trade (MFAT).

As it happened, we had plans at MFAT too. When we got there, we found the staff well briefed on our arrival. Two security guards were on hand, 'for our protection' as much as MFAT's, apparently. (By the end of the session we had almost recruited one to be a member of our team.) For we came in peace: aiming to find the best ways to help people in the foyer. It was suddenly as if the civil service were overstaffed.

We pressed the lift buttons, opened doors and held the lifts. We mulled on whether it was of most help to get as many people into one lift as possible (efficient!) or to ensure they got a lift to themselves. Some of our team found congratulating and thanking people tricky — if their job was under threat would they feel like we were rubbing it in? If they were one of those doing the chopping, would they feel threatened? Most reactions were warm and amused, some bemused. It felt heartening.

As we walked away along Lambton Quay we all tried to nod and smile at people and make eye contact. At other times, we made way for people, stepping aside as a group to ease their passage.

At Midland Park we conducted research into handshakes as a group, giving people feedback on their grip and temperature. At other times, we provided a barrier between pedestrians and cars as they negotiated a particularly tricky pedestrian crossing.

We did the same over a narrow piece of Lambton Quay where lots of people jaywalked and assisted by carrying some people across the road. We handed out schedules for TVNZ7 and Radio New Zealand.

Productive Bodies // Mark Harvey

Economies of Happiness // Emma Willis*

In an early meeting of *Productive Bodies*, a performance volunteer and former government policy worker commented that she had left her job because she 'wasn't making a difference'. She felt that government decree and bureaucratic acquiescence meant her proposed contributions, based on research, were undervalued.

Her situation illustrates a problem and internal contradiction within the function of public service. While its role is to serve the public without political bias (in the government's own words, the public service is 'politically neutral, professional and permanent'),[1] at the same time it is the instrumental arm of government. The policy worker's attempt to serve the public was at odds, she said, with the department's need to serve the government, and thus her proposed contributions were ignored.

The John Key-led National government's cutting of public service research in 2011 illustrates a back-office shift away from a public service that thinks and acts for the good of the public, towards one that serves a political end. While this observation may seem naive, it points to a steady erosion of an ideology of care towards public welfare.

This erosion of government care reflects what Zygmunt Bauman in his essay 'Happiness in a Society of Individuals' calls an 'ideology of privatisation'.[2] This postmodern Western paradigm shifts the responsibility of care away from government as representative collective and back to the individual, positing each person as responsible for their own circumstances and survival.

The worst outcome for individuals who live by the terms of an ideology of privatisation is social exclusion, principally through exclusion from work. This can take one of two forms: to have one's labour excluded from the workforce, either through redundancy or failure to gain employment; or to have one's labour considered as economically valueless. Sophie Jerram, co-curator of Letting Space, comments on the problem of valuing people according to the value assigned to their work. '[With] people pushed out of jobs, what we're exploring is whether your worth has been reduced just because you haven't got a job,' she said in February 2012. 'We need people who are working on a part-time basis, because they're people looking after children and elderly residents. These people are contributing as much to society.'[3]

What Jerram's comments point to is a market-based valuation of individual worth. As Marilyn Waring commented at the artist talk for *Productive Bodies*, 'There continues to be the assumption that the only way in which work can be visible or valuable is if you treat it as if it were a market commodity or a market service and you attribute a value to it.'[4] Part of the work of Harvey's project was to reverse this ideology by bestowing esteem and appreciation on those not usually recognised with public accolades.

The project also performed its own unpaid public service through its acts of assistance: helping people across the road, and reading out Radio New Zealand and TVNZ schedules, for example. What made these acts so pointed, despite their absurdity at times, was the fact that they were being performed within the context

1. 'Public Service Commissioner — role and functions', Te Kawa Mataaho Public Service Commission, accessed 26 October 2022, https://web.archive.org/web/20220220142710/https://www.publicservice.govt.nz/about-us/sscer
2. Zygmunt Bauman, 'Happiness in a Society of Individuals', *Soundings*, vol. 2008, no. 38 (2008).
3. Sophie Jerram, in Talia Carlisle, 'A Creative Space for the Unemployed', *The Wellingtonian*, 27 February 2012, www.stuff.co.nz.
4. Marilyn Waring, Susan Guthrie, Mark Harvey and Sophie Jerram (chair), 'Being Productive', panel discussion at the Festival Club, New Zealand International Festival of the Arts, Odlins Plaza, Wellington Waterfront, 14 March 2012.

of the hollowing out of the service aspect of public service. The increasing burden placed upon voluntary community organisations to take up the role of caring for the most vulnerable members of our society reflects this transfer of responsibility.

Another consequence of the ideology of privatisation is a generation raised with a personal and collective anxious self-interest, in which the other becomes a figure of threat. Rather than an ethos underpinned by the belief that 'your gain is my gain', the idea that 'your gain is potentially my loss' comes to take precedence. This mindset is most obvious in the now-common rhetoric about 'angry taxpayers' and 'ordinary hardworking New Zealanders'.

The paranoia and distrust that this creates is divisive and undermining. The implications of this erosion of an ethos of collective wellbeing are alarming: the subprime mortgage saga in the United States that led to the global financial crisis disturbingly points to what happens when individual vulnerability becomes a tradable commodity.

In contrast, *Productive Bodies* framed productivity — usefulness, workfulness — within an economy organised around happiness. Importantly, happiness was both generated and shared (received) collectively.

The most spectacular example took place at Te Papa, where about ten participants stood outside the main doors, applauding those who came and went. A large group of school children observed with interest. Harvey invited them to be part of the action, and around 70 children joined in. The applause this large group created was a joyous chorus, and met with delight by those who, rather than escaping by the side exits, decided to walk down the aisle of applause.

This spectacle of applause demonstrated a politics of collective affirmation. Just as unhappiness comes from exclusion, happiness comes from inclusion. It seems reasonably clear that happiness that is a by-product of a society focused on public good, public care and public service takes an entirely different form than happiness stemming from material consumerism. It therefore seems there is an important link between creative action, an emphasis on presence and collectivism, and efforts to unseat the hold that the ideology of privatisation has on society.

Harvey's work performed an ideological shift in a way that was both demonstrative and inclusive, augmenting and subverting familiar social forms — such as applause or the handshake — and creating others. Through emphasising the generation of human warmth, it enacted small scenarios that championed surprise, laughter, affirmation and acts of engagement divorced from the normative socio-economic context of valuation.

Productive Bodies' labour was process-based, which quietly suggested that any assessment of productivity should acknowledge the significance of a wide variety of social contributions. Capital was generated through acts of esteem and care. Through performing acts of service, the project offered both a critique of privatised ideology and a playful model of an alternative economy that places happiness and care for the other at its centre. It asserted ways of being that, modestly, and for a brief duration, created sincere spaces of resonance and connection.

** First published on the Letting Space website, August 2012.*

Productive Bodies // Mark Harvey

Productive Bodies // Mark Harvey

Productive Bodies: Reflections //
Gradon Diprose and Lucy Matthews,
Friday, 30 March 2012

Gradon: Some of my favourite moments were when as a group we changed the dynamics of a space. It was pretty fun applauding people on the street and seeing people's reactions. Some people laughed, smiled and bowed. Some people even crossed the street to walk through our applause line. We smiled back and cheered them on. It got me thinking about the usually more reserved and disconnected dynamics which operate in public spaces and how easy it can be to create something different.

Another example of this was when we stood in a circle in the lobby of the Ministry of Health and spoke about our own fears for our health. Initially, I think we all felt a little oppressed by the heaviness in the lobby, but a conversation started quietly and before we knew it we were talking about the processes of ageing, illness, anxiety and the things we were doing to change our attitudes about these concerns. The atmosphere was something we all participated in creating, an effect generated through sharing our fears.

I felt like we were engaged in a politics of action through *Productive Bodies*. We weren't necessarily demanding that job redundancies in the public sector be reversed, although some of us may want that. Rather, we were trying to demonstrate other ways of being productive in society. Ways that may not be considered important or given as much value. Things like making people smile or walk away confused, making people feel strangely protected and slightly absurd in a 'protective human shield'.

There was also a certain pointlessness to some of our work, like collecting leaves off the grass in Midland Park, that made me think about the pointlessness of so much of my 'employed labour', such as the endless work emails and report writing that will be forgotten by next week.

Lucy: There is something addictive in reaching out and breaking out of our usual unspoken social code of practice within the city. This city place we have built around ourselves that cannot only keep us safe and productive but separate and closed. *Productive Bodies* for me was a process of unravelling social codes, supporting the city to be a community and inspiring a generosity of spirit in daily life. I walk away from my Friday with you all feeling like our connections and interventions had been mutually beneficial and I would gladly do it again just to see the secret, amused smile of a stranger.

Productive Bodies // Mark Harvey

The Public Fountain & D.A.N.C.E. FM 106.7

Tim Barlow & D.A.N.C.E. Art Club
16–19 May 2012
Taupō region

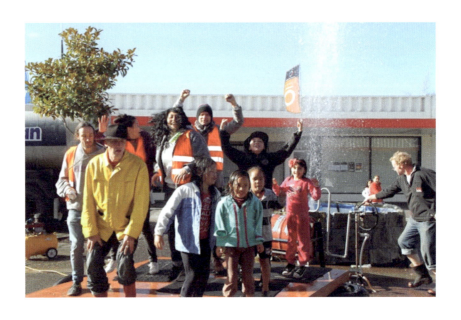

The Taupō region once was a geyserland: its lakes were a vital local resource for heat and hot water. However, although some residents continue to have geothermal bores for private use, the funnelling of geothermal energy into the national grid, alongside lake-level rise to assist hydroelectric power generation, has diminished local accessibility to this commonly held resource.

The world's largest singular binary geothermal power plant, Ngatamariki, was built by Mighty River Power between 2011 and 2016. It was one of four geothermal stations built in the Taupō region over those five years. In 2012, at the time of these Letting Space projects, the government recognised the value of geothermal power and was proposing the sale of Mighty River Power as a fully state-owned asset. The following year, 49 per cent of the ownership shares were sold to local and overseas investors and the company changed its name to retail brand Mercury Energy.

For the Erupt Lake Taupō Arts Festival in 2012, Letting Space was invited to commission two mobile projects that focused on the sharing of skills, knowledge and stories important to the community, by and with the community.

Wellington artist Tim Barlow and Auckland collective D.A.N.C.E. Art Club (Tuafale Tanoa'i aka Linda T., Vaimaila Urale, Ahilapalapa Rands and Chris Fitzgerald) took their projects to the Taupō and Tūrangi town centres and other small settlements around the great lake.

Water here bubbles from the ground and is used for geothermal and hydroelectric power supply and for hydration. It is also the source of the Waikato River. Our tour around the lake outlined this entire area as the rohe (territory) of Ngāti Tūwharetoa, as well as a fountainhead of water for much of the North Island.

Fountains were once common civic amenities and public sculptures in New Zealand, providing a place for public gathering and, sometimes, fresh water for all. They celebrated water's preciousness and abundance.

Despite its local water wealth, Taupō did not have a public fountain, so Barlow worked with local engineers to temporarily provide one. Powered by hydraulic energy — in this case derived from the public jumping or dancing on a wooden platform atop giant inflatable tyres to build up pressure — a geyser plume of geothermal water would erupt skyward from the pool. Barlow also created a public storytelling space in a vacant shop. Its programme, 'Stories of Water and Power', facilitated sharing between interest groups, scientists, storytellers, schools and the public about geothermal energy.

The Public Fountain also travelled to Tūrangi town centre, originally developed in the 1960s as part of the Tokaanu hydroelectricity power scheme. Water for the fountain was provided from the geothermal resource at Tokaanu township nearby.

The abbreviation in D.A.N.C.E. Art Club's name stands for 'distinguished all night community entertainers', and the collective describe themselves as 'celebrating the social dynamic as a creative platform'. Their participatory practice embodies hosting and manaakitanga as actions. Hospitality can be seen as the generosity between people that allows things to happen.

Based in a truck with a mobile transmitter, D.A.N.C.E. FM 106.7 was an all-in-one radio station, DJ booth and public-address unit — meeting, exchanging and micro-broadcasting across the region. Sites ranged from a rest home and kura kaupapa to small towns without their own community media, like Tokaanu. Four villages either created or irrevocably changed by hydroelectricity schemes were included. In the two town centres, the station provided sounds for Barlow's fountain-powering dance floor.

The Public Fountain & D.A.N.C.E. FM 106.7 // Tim Barlow & D.A.N.C.E. Art Club

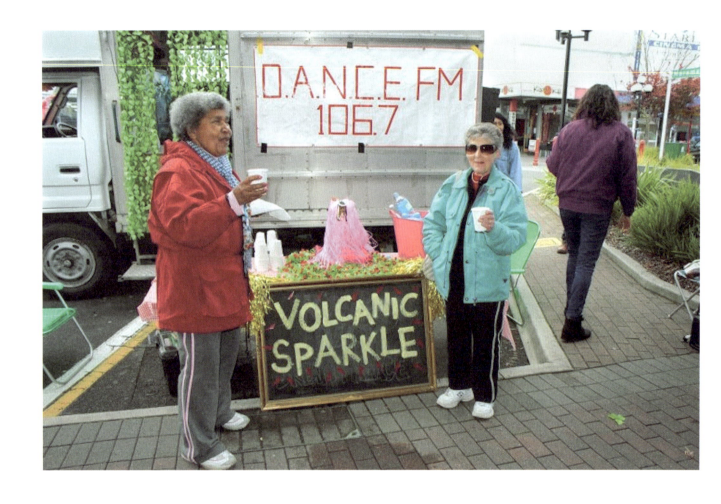

Getting into Hot Water in Taupō-Nui-a-Tia // Sophie Jerram and Mark Amery

Tuesday, 15 May 2012

Mark: Last day of prep and there's the tension of everything working: will the geothermal geyser erupt? Will D.A.N.C.E. FM's new aerial — care of kooky, charming (but utterly pro) local Timeless Taupo radio — see them on air? Now we know what it must have been like to work with Len Lye.

Tim Barlow has driven up polystyrene rocks as a surround for his fountain. They were destined for the set of the ill-fated Christian motion picture *Kingdom Come*. I paint the gapfiller Tim has used to stick the rocks together around the Para Rubber pool. It immediately has plenty of passersby fooled as being the real McCoy. The fountain is placed on a strange hexagonal lawn outside Whitcoulls — as close as the town centre has to a central gathering point.

We get the storytelling session 'shop' — running in a vacant space down one of the town's great alleyways, Marama Arcade — shipshape with furniture, a screen and visual material relating to geysers and public fountains. Tim receives some of the books that he's sent out into the community to collect stories in — beautiful objects themselves, in satchels.

By nightfall Tim has the steaming hot water pumped out of Ian Warmington's private geothermal bore and into Horomātangi Street by water truck. As soon as the hot water from deep under the earth's surface starts pouring out, the whole Letting Space Taupō collective leaps to one steamy conclusion: thermal pool time. *The Public Fountain* is thus christened by an autumnal hot-water dip in the main street of Taupō. Every town should have a public hot tub.

Sophie: One by one we get in. Swimming in the scalding hot water is pretty joyous in the drizzly rain.

Wednesday, 16 May 2012

Mark: D.A.N.C.E. FM 106.7's first broadcast is from the Rifle Range Pensioner Village on the suburban rise above Taupō town centre this morning. Nice and high for broadcasting, if cold and grey. It's a slow tentative start because we were thought by the residents to be council officers coming to discuss the prospect of the village being closed down . . . After a rousing mihi, a cuppa, Maila Urale's freshly baked scones and D.A.N.C.E. FM being cranked up on the ghetto blaster with some mellow country sounds, the mood warms up with lots of great kōrero and sharing of people's life experiences.

The radio truck is parked outside, so the residents go and broadcast their life stories to their neighbours inside the hall, 50 metres away, and across wider Taupō.

Sophie: Tim's first storytelling discussion in the shop is a cracker. Jenny Pattrick's story of a Pākehā woman who divined geothermal water and started to glow in the dark crowns it for me, and (yes!) when the session is over we get to experience the fountain in full eruption.

Mark: I loved the whole model of community storytelling sessions in a shopping centre. Dylan Tahau of Tūwharetoa kicked off with the indigenous geothermal stories that are a fundamental base of people's connection to this region.
The whole session really brought home how important stories are to connecting us, and especially for this community to express their ownership of natural resources and their sense of belonging.

By the end of the session, Tim's fountain had been joined by the D.A.N.C.E. FM truck on Horomātangi Street, giving jumpers on Tim's platform some sounds to leap to. The guys set up a stall handing out more scones and a specially composed soda drink called 'Volcanic Sparkle', featuring a cola syrup homemade by some artist's friends in Auckland. An impromptu community shopping centre block party vibe soon developed.

Sophie: Unfortunately not all the commercial neighbours are thrilled and I get into a bit of damage control with Westpac Bank.

Thursday, 17 May 2012

Mark: Tim's fountain comes to life today with hordes of kids here for the schools' storytelling sessions. It's 'fly by the seat of our pants' running the sessions — our intrepid Massey intern Laila O'Brien gets the kids drawing their ideas for getting a geyser pumped up and GNS scientist Paul White is brilliant, talking about the geysers that once dotted this area and why they've now disappeared.

Sophie: Mark and I arrive at Wairakei community — where energy station builders were originally housed — at 2pm, to find the school hall in full disco with D.A.N.C.E. Art Club running their How To Be a DJ workshop. It's great to discover the little kids' dancing styles. I wish we had organised a better place that wasn't entirely controlled by the school, but this is one electric session.

Driving to Mangakino in three cars, everyone takes a different route and we feel strangely lost. But when we arrive it's like we've warped into another plane. Lake Maraetai at dusk is beautiful and the welcome from Garry at the Bus Stop Cafe (an old Bedford bus) and the 25 locals is magic.

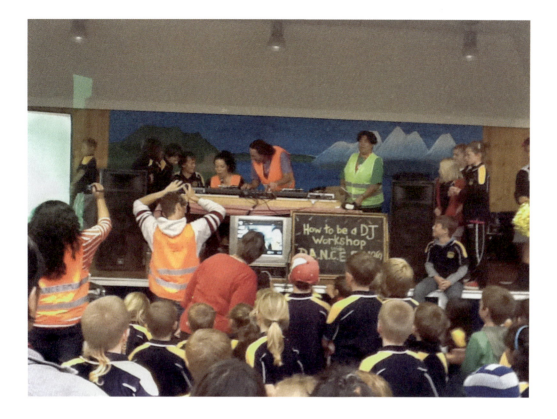

Friday, 18 May 2012

Sophie: Driving to the Waitahanui kura around the lake, Mark and I miss the community pōwhiri but are welcomed beautifully just the same. D.A.N.C.E. are broadcasting from this small local school for the morning and welcoming the local kōhanga reo.

Mark: Waihatanui is beautiful. It's nice to see face painting enter the relational aesthetics vocab (lol). Just a joy to spend time broadcasting with these gorgeous tamariki. It feels like we've been here for days, we're made to feel so welcome.

Sophie: I drive back to Taupō for the final Marama Arcade discussion and it is a corker, creating a sense of hope for collaborative geothermal use and management. That afternoon we're on the road again to Tokaanu, where Linda T. does a great set into the dusk in the carpark of the Tokaanu hot pools.

Mark: A savoured memory is cruising round steamy Tokaanu with Sophie (this takes two minutes from one end to the other) listening to Linda T. play Ardijah and checking out when D.A.N.C.E. FM fades in and out of signal. Linda T. is DJing from the heart of the local Māori geothermal resource. The rest of the club are, predictably, having a nice, long, well-deserved soak.

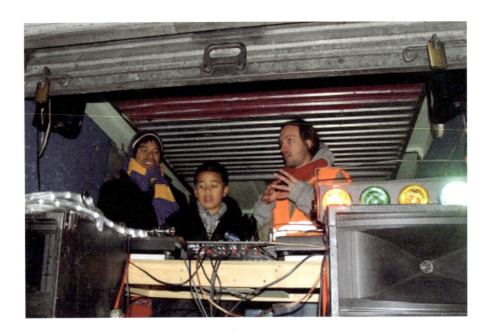

Saturday, 19 May 2012

Mark: Tim has summoned up some extraordinary untapped reserves to pack down the fountain in Taupō late Friday and move it to Tūrangi. Astonishingly, it's up and going by about 10am, and seems to be spurting at ever-increasing volumes in a town centre begging for some kind of kinetic water feature. Tūrangi tamariki enjoy a day of getting wet, and the plume rises high into the crisp blue sky.

The D.A.N.C.E. Art Club truck is parked close to the fountain ('water on my decks!' squealed Linda T. at one point) — meaning D.A.N.C.E. FM have a dance floor! Young and old alike are busy all day jumping to good sounds on Tim's platform. Tūrangi gives the work a good stomping over.

Meanwhile the radio station also serves as Tim's public forum today, with Anna from the Department of Conservation and David Livingstone from Tokaanu interviewed on air about the geothermal resource.

At the end of the session Tūrangi pays the ultimate compliment when one of the kids rushes over to the local hall to turn the power back on for the fountain, after Tim had closed it off.

Sophie: Wrapping up at 2pm we drive hard out to Taupō for the Festival of Lights.

It is cold. Ahi Rands and I go for some kai as the others prep for the evening party. It's tremendous — the D.A.N.C.E. Art Club pulls out all the stops to interview families walking through the park at night. Tim turns up after packing down the fountain in Tūrangi to celebrate the final night.

Mark and I find a natural hot pool at the park down by the river — it's very, very nice to relax into!

The Public Fountain & D.A.N.C.E. FM 106.7 // Tim Barlow & D.A.N.C.E. Art Club

Shout Out // Mark Amery*

Redemption Song

Radio still enjoys some remnant of popular reputation as a free, live medium embodying independence. The individual hits the open road, as it were, turns on the radio and scans through the stations. In this moment they may feel as free as a bird, taking sounds from the air, as a wayfarer might collect water from a stream as some given public right. The airwaves as some inalienable social commons.

There's a lot of rock'n'roll appeal to all of this, and indeed radio was founded with a degree of idealistic fervour — seen as full of social and political potential. The truth about the freedom of the airwaves, however, has turned out to be far more piratical. This collective medium got caught up in a generation's neoliberal zest for their freedom as individuals at the cost of public good.

The first song ever broadcast by pirate radio station Radio Hauraki, from international waters outside the then New Zealand three-mile limit, was Matt Monro's 'Born Free' in 1966. Until 1962, control of the airwaves had been with the government department New Zealand Broadcasting Service (NZBS), and it remained tightly regulated by the New Zealand Broadcasting Corporation (NZBC). In contrast, pirate radio could broadcast whatever it wanted.

Radio, the pirate jocks proved, could be irreverent and fun. The first student station, now Auckland's bFM, began as a 1960s capping stunt, transmitting from a boat as 'Radio Bosom'. The freedom of the seven seas, however, also involves looting and plundering: what looked in the sixties like a movement with community-based ideals was claimed by the baby boomers for private ends. Today, Radio Hauraki is a mainstream rock radio network, peddling iconic souvenirs of freedom between the ads.

As academic Brent Simpson writes, when the commercial radio network in New Zealand was finally deregulated in 1989 it enabled the majority of radio broadcasting to become a financial commodity, 'largely controlled by a co-operative duopoly consisting of on the one hand APN News and Media in partnership with the Australian Radio Network, and on the other, MediaWorks, owned by Australian private equity corporation Ironbridge Capital'.[1]

If the New Zealand radio story ended there it would be a sad one, yet there has been recent growth in an on-air commons on the outer margins of the radio band.

Māori and the Fifth Labour Government were key to further development of the spectrum. In reaction to dissatisfaction with free-market reforms, broadcasting minister Steve Maharey lobbied for more public engagement and increased access to communications technology to ensure equal accessibility. This came after a decade of government treating the spectrum solely as a tradable commodity in an open marketplace. During that time, however, iwi had engaged in a hard-fought battle to claim rights in the spectrum — eventually leading to the exponential growth of iwi radio as a platform for keeping te reo Māori alive and providing communities with their own broadcasting.

Today, Community Access Radio, first established in the 1980s, is alive and well across the country. Student radio survived commercialisation, and iwi

1. Brent Simpson, 'Low Power FM in New Zealand: A survey of an open spectrum commons', in Matt Mollgaard (ed.), *Radio and Society: New thinking for an old medium* (Newcastle upon Tyne: Cambridge Scholars Publishing, 2012), 165.

stations now abound. Lesser known, however, are the hundreds of local, low-power FM (LPFM) micro-broadcasters in the frequency ranges at the edges of the official FM broadcasting band. From Eketahuna Radio to Raglan Radio, they serve smaller communities and are often strongest where communities have a sense of self-sufficiency.[2]

These frequency ranges are called the guardband, separating the official FM broadcasting band from other spectrum users such as taxis and aeronautical operations, and operate between 88.1 to 88.7 and 106.7 to 107.7. Find a free frequency and you can transmit at a maximum power of half a watt — enough to reach a kilometre or two in radius. There is minimal regulation of the LPFM spectrum in New Zealand (a general user radio licence was established in 2002), creating what Simpson labels an 'open spectrum commons'.[3]

It was a guardband frequency that D.A.N.C.E. Art Club borrowed for a week of mobile broadcasting in May 2012 as D.A.N.C.E. FM 106.7. The loan was arranged by fellow station Timeless Taupō 106.4, which operates from an old state house in Taupō. From the street it appears no different to other houses — an apt symbol for the mainstream invisibility yet public pervasiveness of community radio. The equipment and truck D.A.N.C.E. used was owned by former inner-city Auckland guardband station Fleet FM.

As the internet has become commercialised, the guardband range of the radio spectrum, like a vacant inner-city block, still offers significant creative freedoms — freedoms that too few artists have exploited. There is a thriving radio art network in New Zealand and internationally,[4] but what distinguishes D.A.N.C.E. Art Club's project is its focus on the social bandwidth and the physical, collaborative nature of what radio does for communities.

With D.A.N.C.E. FM 106.7 there was always an exchange going on: a giving of gifts. It was an exploration of how the act of social exchange in two groups of people meeting might be re-energised outside of traditional social structures. For sure, familiar structures were employed (a mihi at a rest home, a pōwhiri at a school), but there was also a sense of having to invent new ways to exchange based around the formality of creating something together.

As the popularity of podcasts attests, radio remains an important media in a visually saturated world. It's a social medium where talk can occur more freely, not limited to shorter visual attention spans. It remains a space with potential for freer discussion and genuine dialogue. 'Radio,' affirms the European artist-run organisation OKNO, 'has the potential to be a completely liberated, mobile and inhabited mass media.'[5]

This is what D.A.N.C.E. Art Club capitalised on — recognising that, as temporary public work, radio offers the ability to freely move to different locations. What the work lacks in bronze-clad permanence it makes up for in its potential reach into people's lives.

Such mobility is not a new thing. Back in 1939, the National Commercial Broadcasting Service temporarily added a mobile station, 5ZB, to the dial, touring the North Island in a refitted mobile railway carriage for three months. Similarly, between 1946 and 1947, a mobile recording unit was created to travel to parts of the country without easy access to a radio station. Performers in those areas were recorded on the spot and the results broadcast from central stations, an idea

2. Various databases of such stations can be found online, but these are rarely complete or up to date.
3. Simpson, 'Low Power FM in New Zealand', 165.
4. Memorably, microcasting legend Tetsuo Kogawa visited New Zealand in 2006, demonstrating how to build your own microtransmitter.
5. www.memoir.okno.be.

The Public Fountain & D.A.N.C.E. FM 106.7 // Tim Barlow & D.A.N.C.E. Art Club

inspired by the success of mobile recording units overseas during the war and intended to 'assist cultural development and national pride in post-war New Zealand'.[6] As with D.A.N.C.E. FM, the purpose of these mobile stations wasn't just about transmitting content to the masses from one national node — it was also to gather community stories and performances.

D.A.N.C.E. FM touched on a technological divide that already exists and remains hidden from the eyes of those in power. Rifle Range Pensioner Village residents visit the town library to read the newspaper and surf the net. What will happen when more and more internet content falls behind a paywall? Increasingly, the digitally well-connected assume that all are as linked in as they are; that audio and video is constantly streaming and news through our web feeds constantly breaking. It is easy to forget that information is power, and when you don't have it, you get left behind.

///

Ghost Town

Mangakino, a small town 40 minutes' drive from Taupō, has a curious transitional history. It was constructed in 1947–48 as a temporary township, its centre designed by public planner Ernst Plischke. 'It was, until recently,' wrote Larry Finn in *Te Ao Hou* in 1952, 'just taken for granted that the bulk of the population would be moved elsewhere when the present project was completed.'[7] Today, there's a small resident community, but the town attracts many visitors for the fishing, and Lake Maraetai is a place where powerboat enthusiasts gather and tourists can take a steamboat ride.

On an evening in May, it has the air of a ghost town. When D.A.N.C.E. Art Club played The Specials' track of the same name I worried it might be a little close to the bone. The young people we speak to express a wish to leave the town as soon as they can. But for one evening outside the Bus Stop Cafe, they get to do shout-outs to their friends and families tucked up at home, and 'do the bus stop' (an old Fatback Band disco track with moves) to the D.A.N.C.E. Art Club's instruction.

Similar to the London of Margaret Thatcher to which 'Ghost Town' referred, none of the locales that D.A.N.C.E. Art Club chose to broadcast in were experiencing boom times. When the truck turned up at Rifle Range, residents were worried that the group was from the local council, and had gathered them together to inform them that their retirement village was being closed.

D.A.N.C.E. FM visited three towns developed between the 1940s and 1960s as part of public work plans to house workers on hydroelectric power schemes. They claimed the airwaves against the background of heated national debate about who could claim our water (and, by proxy, the geothermal resource), with the impending sale of state-owned asset Mighty River Power.

With their sturdy state houses and large public areas, Wairakei village and Tūrangi also bear the hand of government planners. Tūrangi town centre in particular still feels like an ill-fitting civil servant's suit.

On the last day of D.A.N.C.E. FM's broadcast, a party was set up in the middle of Tūrangi. Tim Barlow's work *The Public Fountain* provided a dance

6. Richard Huntington, 'New Zealand Radio History', Old Radio, www.oldradio.com.
7. Larry Finn, 'The Future of Mangakino', *Te Ao Hou*, no. 2 (Spring 1952).

floor and water feature, and D.A.N.C.E. Art Club the tunes and public address system. On air, Barlow discussed the issues surrounding control of nearby Tokaanu's geothermal resource with a Department of Conservation staff member and a representative of Tokaanu hapū Ngāti Kurauia, watched by a local audience and hopefully listened to by some further afield. Together in Tūrangi these two art projects temporarily extended the existing public space, physically and in the airwaves, while simultaneously airing issues of control and ownership of local resources.

In a time of constant exchange over the internet, and a flood of reality and talent shows on television, you would be forgiven for thinking radio or alternative documentary works like D.A.N.C.E. FM 106.7 unnecessary. Yet the more these formats become standardised and franchised, the more the specific contexts for the community-based voice become stripped away and homogenised. Such work has never been more necessary, as communities struggle with access to the mainstream and isolation in its slipstream.

First published on the Letting Space website, November 2012.

Shock and Salve: Bathing in the healing waters // Tim Barlow*

1. In 2011, the National government announced plans to partially privatise some state assets, which included the sale of nationalised power companies. These included Mighty River Power, which owned and operated a geothermal electric generation facility in the Taupō region. The private power generation company Contact Energy also operated multiple geothermal plants and had been for a number of years at the centre of litigation by local organisations including the Taupō District Council and Waikato Regional Council over land subsidence, noise and river pollution. Contact was also moving ahead under new fast-track resource consent rules to establish more wells and generation plants.
2. I came across the 'shock vs salve' debate in a 2015 essay by Kirsten Lloyd, 'Being With, Across, Over and Through: Art's caring subjects, ethics debates and encounters', in Angela Dimitrakaki and Kirsten Lloyd (eds), *Economy: Art, production and the subject in the twenty-first century* (Liverpool: Liverpool University Press, 2015), 140–57.

The intention of *The Public Fountain* was to intervene in the geothermal politics of the Taupō region[1] through a mechanism that combined both shock and salve.[2] The public were invited to jump up and down on a dance platform connected to the geyser fountain until enough pressure built up in a pressure cylinder for the erupting geyser to be manually released. The work was intended to provide an absurd yet engaging sideshow spectacle that, through explosive noises and splashes, disrupted the everyday high street activities. The fountain was built with local ingenuity, incorporating expertise from engineers and with geothermal water tankered in from a private bore.

Contrasted with the fountain was a programme of more traditional community art activities. These included daily storytelling workshops in which a range of scientists, businesspeople, activists, iwi representatives, writers, youths and others were invited to share their own perspectives on the impact of geothermal development. A set of blank books was dispersed into the community in which people were encouraged to write their own stories, then pass the book on. The forums were open to the public and based on general themes such as 'development', 'creativity' and so on. On the fifth day, *The Public Fountain* became mobile and travelled to the township of Tūrangi on the southern shores of Lake Taupō. The materiality of geothermal water has long been embedded in cultural practices. The historic hot pools were, and still are, sites of healing, bathing, cooking, socialising, relaxing and cleansing. I thought the artwork should function as hot pools had functioned for hundreds of years in Aotearoa, as a site of public assembly, conviviality and salve.

On the first of three research trips to Taupō, a Ngāti Tūwharetoa representative told me there was some ill-feeling among the iwi related to the previous use of the Erupt motif (the erupting geyser) for the Taupō Erupt festival without consultation and without being informed by Tūwharetoa beliefs. I considered seeking official iwi approval for the fountain project, which raised questions about whether we were aiming to right historical failings by the festival organisers and highlighted the challenges for social art projects within a celebratory festival context.

Another issue that became evident was the long-running history in the region of public fountain politics. Various community, council and local sculpture trust members in Taupō had been lobbying for a major permanent public fountain. A group in Tūrangi had also developed plans for a public fountain, but their vision had grown exponentially in ambition and cost, to the point of losing community traction. It was thought *The Public Fountain* might revive enthusiasm for past costly and divisive fountain proposals. The project therefore tapped into civic efforts and politics of which I had initially been unaware. It became clear that public fountains are still a vanity symbol of civic pride and cultural maturity. They also provide a community focal point, tourist attraction and gathering place.

Beyond this local history, other local politics around geothermal development, ongoing national asset sales and the alleged detrimental effects of

the energy industry, I created *The Public Fountain* as a strange civic re-creation of something that had been lost from the Taupō region: the geyser. The world-famous Wairakei Geyser Park near Taupō township had lost its geysers following the start of geothermal energy production in Wairakei in the 1960s. Mining geothermal aquifers for electricity production has been shown to deplete the pressure and field over time.

Further, the private energy company Contact Energy had offered to mitigate the destruction they were accused of causing. This mitigation included the creation of artificial silica terraces and scholarships for local Māori. There is a deep paradox here: geothermal resources that have been taken away are being seen to be partially given back.[3] Interestingly, the owner of one of the fake geothermal attractions was interested in acquiring my fountain device after the festival.

I intended *The Public Fountain* to sit in an uneasy position as a reminder of what had been lost in the name of the public good of energy production while itself being potentially complicit as a civic event and healing 'attraction' — as well as being genuinely mechanically intriguing and fun to ride and operate. The public did seem to enjoy pogo-ing up and down on the platform in an attempt to inflate the pressure barrel. In social art practice, the strategies of 'disruption' and 'amelioration' are often considered antithetical. This project employed elements of both shock and salve as it bathed in a pool of tense, real-world contradictions around resource depletion, private and public goods, and the questions of how these are activated and perpetuated in public space.

** Adapted from 'Caring Deception: Community art in the suburbs of Aotearoa (New Zealand)', PhD thesis, 2016.*

3. Contact Energy had also been lobbying for controls and regulations of local use of the geothermal resource. Many locals with private bores for their own hot-pools or home heating systems would not publicly discuss how many bores or to what uses they were put. Private bores seemed to form a site of resistance to corporate control.

Open Plan: An Art Party

**Gap Filler,
The Playground NZ
& Letting Space**
3 November 2012
Wellington

By the end of 2012 there was a sense of shared endeavour in public space across three new independent public art platforms that had emerged in New Zealand since 2010: Gap Filler in Christchurch, which emerged dynamically after the 2010 and 2011 quakes; The Performance Arcade, from performing arts company The Playground NZ, temporarily housed in shipping containers on the Wellington waterfront; and Letting Space.

All of them worked across live arts disciplines and communities in radical new ways, building on fledgling networks in New Zealand and with international colleagues to make contemporary work in public spaces. The work of all three platforms was relational or participatory in nature, in contrast to the static sculpture-on-a-plinth tradition. And all three platforms considered 'the city as a theatre', to borrow a phrase from The Playground's Sam Trubridge and to mimic the old adage 'all the world's a stage'.

In November 2012, the three organisations came together for a discussion at City Gallery Wellington followed by a performance party at the Sustainability Trust, with Wellington welcoming Gap Filler founders Coralie Winn and Ryan Reynolds.

Looking back at the event from a decade later, Open Plan: An Art Party seems an interesting snapshot of the live art scene in Wellington in the early 2010s. Artists were encouraged to develop short or ongoing performances that occurred in and around guests, who were equally encouraged to perform.

Actions from a number of Letting Space artists extending their current work were included. Tim Barlow, for example, handed out towels soaked with geothermal water from Tokaanu which he'd simmered on a barbecue, while D.A.N.C.E. Art Club's Linda T. conducted video interviews. Other memorable performances included the confrontational work of Samin Son, based on his Korean military training, and experimental musical performances from Seth Frightening and All Seeing Hand, which recalled The Performance Arcade's live music sessions. Urban Dream Brokerage artists often gave quieter performances among the gathering: James R. Ford's anti-performance, for instance, involved playing the rhythm video game *Guitar Hero* in a sealed glass room.

Other artists included Beth Sometimes, Everybody Cool Lives Here, Siân Torrington, Mary Whalley, Meg Rollandi and Thomas Press, Victoria Singh, Bronwyn Holloway-Smith, Colin Hodson, Julian Priest and Claire Harris.

Open Plan: An Art Party

Performances by James R. Ford, Victoria Singh, Samin Son, Tim Barlow and Beth Sometimes.

Open Plan: An Art Party

Urban Dream Brokerage

2012–18
Wellington, Dunedin,
Porirua, Masterton

In 2012, Letting Space established Urban Dream Brokerage (UDB) in Wellington as a permanent programme to enable arts and community-led producers to develop participatory projects in vacant spaces. It was a mechanism by which Letting Space could help others to claim space, grow and offer more diverse public common spaces.

Between 2012 and 2018, with funding from local councils and chambers of commerce, UDB negotiated with 45 property owners for the temporary use of empty spaces for more than 100 projects. To property owners, UDB argued that having their property in use would help to maintain their asset and draw attention to its commercial potential while also playing a part in the public good of the city.

From a political hair salon and a citizen-led cinema to an 'imaginarium' or creative playspace for all ages, the projects of UDB explored new ways to use urban space that avoided financial transactions between providers and participants. Local inspiration for UDB came from 17 Tory Street, an open community space established in Wellington in 2012, where the group Concerned Citizens Collective said yes 'to as many ideas as possible' and shared management of the space with those keen to participate.

Letting Space set up a system for UDB in which anyone could submit their ideas. Proposals needed to be 'innovative, accessible and participatory': innovative — meaning that an idea shouldn't replicate what already exists in the city, be it shoe shop, theatre or gallery; accessible — in that it should provide space open to the public; and participatory — where possible, it requires the involvement of the public to actualise it.

Using this open-call approach, UDB wanted 'to empower citizens to claim their own space' and 'to help enable the creation of more "bumping spaces" for people to meet, share and grow'.[1] Further, UDB 'tried out new interactions, new ways of sharing and grew new skills. Being responsible for a space and having to be open to interacting with the public in new ways is a great way to develop skills, a practice or a vocation. For every project it meant participating in more visible ways in the streets of our towns and cities. To — ideally — be part of a wider community, rather than siloed in existing art or community spaces.'

All projects operated on rolling licences with many projects lasting days, others weeks, months and years. The few that continue in 2023 are Masterton's Come Sew With Me, a space for collective-care sewing together with a private sewing machine museum, and CoLiberate, a social enterprise that offers training in how workplaces can best respond to mental health issues.

In late 2018, Letting Space's Wellington branch of UDB closed its doors, only to be re-established in 2020, as shopfront vacancies increased in the city as a result of Covid-19 disruptions (see page 311). Meanwhile, in Dunedin, the brokerage was picked up by local producers and continues as Dunedin Dream Brokerage today.

In 2020 Letting Space published *Brokered Dreams: 98 uses for vacant space: Urban Dream Brokerage 2013–2018*, documenting the many projects the brokerage had supported in Wellington, Dunedin, Porirua and Masterton.

1. Letting Space, *Brokered Dreams: 98 uses for vacant space: Urban Dream Brokerage 2013–2018* (Wellington: Letting Space with Wellington Independent Arts Trust, 2020).

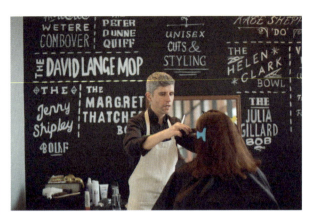

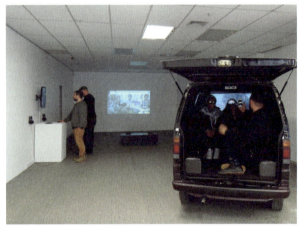

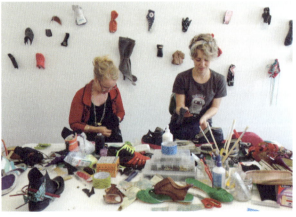

A Selection of Urban Dream Brokerage Projects, 2012–18

The Waiting Room
Victoria Singh's 2014 project *The Waiting Room* was a playful opportunity for the public to practise waiting and reflect on the passing of time. In a space dressed like a doctor's waiting room, participants were invited to record thoughts about the waiting they did in their own lives, and these documents were presented publicly during and after the project's brief tenancy of an empty shop on Cuba Street, Wellington — which was itself waiting for a new, less temporary, occupant.

Imaginarium
Located in the former Whitcoulls outlet on Wellington's Courtenay Place, Amy Church and Hayley Jeffrey's 2014 *Imaginarium* made space for undervalued ideas by inviting the public to create and play without rules or restrictions. The result was an interactive community-generated art installation made from cardboard, fabrics and paint which developed organically over its time in residence and provided a backdrop for dance, drama and music.

Homies Cosy Teahouse
Homies Cosy Teahouse in 2014 offered a safe and comfortable place on Manners Street in Wellington for young people to drink coffee, gather, relax and upskill. Created by Naomi Smith and run by a group of self-directed volunteers, *Homies* experimented with structures of social enterprise and ideas of the gifting economy, offering a menu without fixed prices in the name of financial equality. As well as the café, *Homies* also organised gigs, workshops, markets and film screenings.

Political Cutz
To encourage political participation ahead of the 2014 and 2017 general elections, Barbarian Productions and Maverick Creative offered free haircuts and cheap coffee in exchange for political discussion at pop-up hair salons in central Wellington locations. Using the tools of participatory theatre and the aesthetics of the 1980s salon, the two iterations of *Political Cutz* aimed to 'maximise the opportunities people have to engage, and make sure that communities who usually don't find their voices counted see this as a place to go'.[1]

Surveillance Awareness Bureau
Curated by Modelab, the *Surveillance Awareness Bureau* took over a vacant central Wellington office space in 2015 for an exhibition of surveillance alternatives proposed by artists, designers, scholars and journalists. Alongside the public programme of international and New Zealand contributors, the exhibition highlighted the critical discourse around systems of surveillance, exploring issues such as privacy, liberty and control.

Frankenfoot — The Redux
Inspired by the 1984 film *Toxic Avenger*, *Frankenfoot — The Redux* (2017) provided a workshop and gallery space for making and exhibiting reassembled shoes at the end of their life cycles. The project was a collaboration between shoemaker Louise Clifton and artist Rachel Blackburn. Aptly sited on a commercial high street in Dunedin, *Frankenfoot* sought to elicit critical discussion about wasteful consumer habits.

1. Political Cutz 2017, https://www.urbandreambrokerage.org.nz.

Wellington hit by weather described as the worst since 1968 *Wahine* storm // Meka Whaitiri wins Ikaroa-Rāwhiti by-election // Same-sex marriage becomes legal // David Cunliffe is elected Labour Party leader // Mark Lundy's conviction for killing his wife and daughter is quashed // Poto Williams wins Christchurch East by-election // The upper North Island becomes the last region to complete digital television transition // New Zealand's population reaches 4,500,000 // 230,000 children in New Zealand live in households with incomes below low-income thresholds // In the previous six years, poverty grew 2.5 times faster in New Zealand than the OECD annual average // The bottom 10 per cent have increases of 1.1 per cent // Nelson Mandela dies // The Boston Marathon bombings kill three people // KidsCan provide food for teachers to give hungry children in 330 schools // Police identify 35 'persons of interest' in Operation Clover investigating a teen group online boasting about having sex with drunk, underage girls // First production of human embryonic stem cells by cloning // Edward Snowden discloses operations by US government mass surveillance programmes and is granted temporary asylum in Russia // Lorde's 'Royals' is number one in the US charts // 38 people are killed in Christmas Day bombings in Iraq // *The Hobbit: The Desolation of Smaug* is released // A litre of regular petrol is $2.10 // A litre of milk is $3.46

2013

Studio Channel Art Fair

7–11 August 2013
Auckland

Recorded by a small television crew, *Studio Channel Art Fair* was a public media project on 'the business of art and the art of doing business' on the Letting Space Vimeo channel. Twenty-one 10-minute interviews, recorded live during the Auckland Art Fair, remain online and are available to be shared freely under a Creative Commons licence.

The last New Zealand television programme focusing on the arts, *New Artland*, finished in 2009. Prior to that, interviews with artists were a staple on our screens. They told a wider society that artists mattered.

New Artland was one of a raft of new programmes produced for the 2007 launch of TVNZ6, a digital-only, commercial-free public service channel instituted by the Labour government. TVNZ6 ceased broadcasting in 2011 with the new National government's commercially focused broadcasting policy, which also resulted in the closure of TVNZ7 and regional television.

At the same time, there was a world-wide explosion of user-generated moving images online, with YouTube (launched 2005) and Vimeo (launched 2004) growing enormously in use in the 2010s. Social media platforms Facebook and Twitter both launched in 2006, and by 2010, as Letting Space relaunched, Facebook had 500 million users.

Meanwhile, art fairs grew significantly in the new century, finding a new role in the global market. The Frieze Art Fair launched in London in 2003 and the Auckland Art Fair followed in 2006. With increased international travel in the art world, such fairs, run by private enterprise, became important places of circulation for artists, curators, collectors and critics. There are now a number of Frieze fairs globally.

With Letting Space's Mark Amery and Sophie Jerram both presenting and producing, *Studio Channel Art Fair* aimed to highlight aspects of the art market that are less visible to the public. Artist Cushla Donaldson was invited to curate a series of table sculptures to accompany the interviews, gatecrashing the fair with a range of artists whose work was not offered for sale. This was not a shopping channel.

Interviewed were photographer Sait Akkirman, art fair director Jennifer Buckley, curator Ron Brownson, artist and teacher Scott Eady, artist Judy Darragh, dealer and collector Lisa Fehily, academic Heather Galbraith, collector and writer Sue Gardiner, critic John Hurrell, artist Lonnie Hutchinson, curator and dealer Paul McNamara, dealer Anna Miles, collector Richard Moss, dealer Matt Nache, dealer Anna Pappas, artist Reuben Paterson, collector Dick Quan, ex-dealer and collector Marshall Seifert, dealer Jonathan Smart, artist and dealer Francis Till and curator and artist Tracey Williams.

The artists who exhibited tabletop works were Erin Forsyth, Amber Wilson, Lonnie Hutchinson, Ryder Jones, Bob van der Wal, Ella Scott-Fleming, Eddie Giesen, Cushla Donaldson and Reuben Paterson.

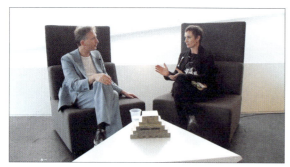
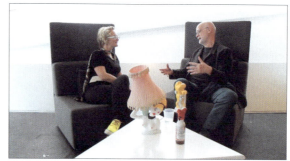

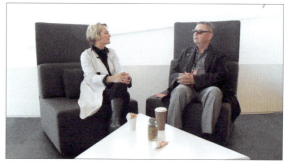

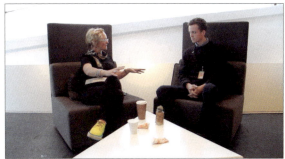
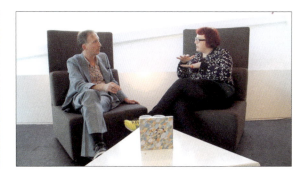

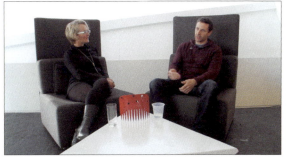

Transitional Economic Zone of Aotearoa

24 November–
1 December 2013
Christchurch

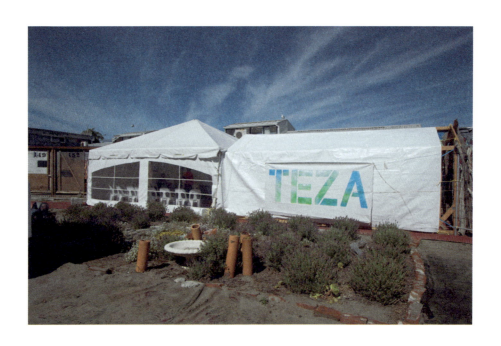

The 2010–11 Christchurch earthquakes caused the deaths of 185 people, major damage to land, buildings and infrastructure, and ongoing trauma and upheaval for residents. Urban revitalisation became a major focus. While the government's rebuild blueprint controversially took much time to develop and be implemented, a wellspring of community-led projects shot up like green shoots among the rubble. Christchurch was acknowledged internationally as a leader in demonstrating how transitional art and social projects play a vital role in redevelopment and healing.

It was in this context that Letting Space announced a Transitional Economic Zone of Aotearoa (TEZA) in the eastern seaside suburb of New Brighton. It was a hub for new projects by a dozen artists from around New Zealand working collaboratively, involving the participation of scores of New Brighton residents and Christchurch communities and groups. It looked to bring strength from around the country and highlight Christchurch's social innovation. Letting Space itself had commenced just prior to the earthquakes and, after the quakes, quickly became friends with the remarkable programmes that emerged, such as Gap Filler, The Social and Life in Vacant Spaces, a parallel vacant space brokerage.

TEZA explored how a group of artists might visit and exchange with others for the local good. Turning on its head the capitalist idea of a 'special economic zone' (SEZ) — where regulations are lifted to allow a foreign company to extract resources at the local community's expense — TEZA was a site for new systems of exchange, aiming to leave a community with more than was taken.

After the February 2011 earthquake, much of the central city became a red zone, a place of public exclusion, until February 2013 when it was officially renamed the CBD Rebuild Zone by government agencies. This zone gradually shrank in size and the last cordons were removed on 30 June 2013.

The government and its cultural programmes centred the majority of their focus on this central business district. But to the east, a 630-hectare residential red zone, once wetland along Ōtākaro Avon River, suffered extensive liquefaction and was deemed unfeasible to rebuild on. The Crown demolished and removed over 8000 properties, and the area is now in the process of returning — at least in part — to nature.

New Brighton lies beyond and partially in that red zone. This suburb has both a strong sense of independent identity and its own particular set of problems. Climate change-induced sea-level rise posed increasingly urgent issues; post-earthquake government school mergers caused much distress; and the suburb's shopping district had never recovered from the introduction of weekend trading in the 1980s. Prior to that, New Brighton was itself a special economic zone: a group of shops given dispensation to be open on a Saturday and to which Cantabrians flocked. In its 1974 heyday the Commonwealth Games were held at New Brighton's now-earthquake-ruined Queen Elizabeth II Stadium.

The site for the first Transitional Economic Zone of Aotearoa was a vacant lot that had become a community art and event space a year earlier: the Creative Quarter, run by Renew New Brighton. A temporary encampment for TEZA was established on a piece of running track recovered from the QEII stadium. Its design and build was directed by Wellington-based artist Tim Barlow, who had scoped out a variety of potential Christchurch East sites and partners following a large art and design hui at The Physics Room in March 2013.

During the TEZA week a team of writers, editors and photographers documented proceedings, creating a daily online publication, the TEZA Transmission.

And the week coincided with New Brighton receiving wider national focus: a by-election was taking place for the seat of Christchurch East, after former MP Lianne Dalziel had stood down to become the city's new mayor. This resulted in visits to the TEZA

village, from politicians including the deputy prime minister and minister of finance, Bill English, to that week's winner, Poto Williams, later a Labour Cabinet minister.

///

The TEZA concept had not begun as a response to Christchurch — the city is just one of the places this temporary experimental zone has moved to. The idea for a Transitional Economic Zone of Aotearoa first took root in Istanbul in 2011 during a discussion at the International Symposium on Electronic Arts (ISEA) by a group of New Zealand artists including Sophie Jerram, Julian Priest, Julian Oliver, Te Huirangi Waikerepuru and Te Urutahi Waikerepuru. There, says Jerram, they noted a lack of contact between the local community and the travelling artists. What would it be like, she and others thought, to create a place for artists with a shared tikanga — not taking energy but giving it?

TEZA was thus a response to the hyper-capitalist model of artists moving around the globe to different events but with limited local engagement. The idea was to ask how a group of New Zealand artists might travel under a singular identity and work meaningfully in a place as outside agents; how they could work outside the gallery and assist with social change for people who themselves feel in transition.

TEZA is also an experiment in how a distinctly New Zealand autonomous zone might operate, navigating issues of foreign intervention and the assertion of tino rangatiratanga over tribal boundaries. Inherent is an exploration of biculturalism — how a travelling group might work with those who hold mana whenua where the temporary encampment rests.

By 2013, TEZA had been two years in development, with some initial projects by Simon Kaan, Kura Puke, Julian Priest and Kim Paton appearing in 2012 at the ISEA conference in New Mexico, where, working with Barlow, a desert encampment had initially been envisaged but was never funded.

'TEZA is pronounced "teaser",' wrote Murdoch Stephens in an early Letting Space blogpost.[1] 'A teaser is that which previews the event and which promotes the event. While a SEZ might tease that a brighter future is just around the corner if a sacrifice is made today, TEZA offers a definite end to the economic zone.'

[1]. 'TEZA: The Transitional Economic Zone of Aotearoa', Letting Space, www.lettingspace.org.nz. The comments were attributed to Richard Meros, Stephens' nom de plume.

Creative Quarter, New Brighton,
November 2013.

Alternating Currents Christchurch

ATTENTION MIGRANT-SETTLERS ARTISTS COMMUNICATORS & COMMUNITY BUILDERS
–Let's work together and become the media!

You are warmly invited to participate and contribute to an 'open source platform' for creating print and online media that captures and makes visible the thoughts, feelings, ideas, fears, dreams and wishes of diverse migrant-settler communities in Christchurch and their fresh contribution to its future.

We start with a series of three presentations and talks between artists, designers and local migrant-settler communities occurring at the TEZA: Transitional Economic Zone of Aotearoa hub, 101 NEW BRIGHTON MALL, New Brighton, 5:30-7pm, TUESDAY 26 NOVEMBER to THURSDAY 28 NOVEMBER. Then 12 noon on SUNDAY 1 DECEMBER we launch a poster and publication programme born of these exchanges.

This is an opportunity for open dialogue, networking and creative exchange of ideas around themes of migration, settlement, visibility and voice in the city and their interaction with the media, both existing and to be formed. Conversations will be captured through different collective media means during the discussions and then developed into a graphic campaign: a series of large-scale posters created and installed onsite in New Brighton (and beyond) during TEZA, and the production of a print and online publication. This project aims to establish ongoing networks and dialogues between the arts community and migrant-settler communities.

Representing
TUESDAY 25 NOVEMBER 5:30-7pm
How do we frame ourselves and how are we framed? How are migrants represented and visible in our media, in our art, our advertising and on our streets? We are interested in hearing from individuals and migrant organisations with views and/or experience in this.

Connecting
WEDNESDAY 26 NOVEMBER 5:30-7pm
How can we connect with each other through art and media? How can we create our own independent media voice, and also what kind of voice can we expect to have in the mainstream?

Creating
THURSDAY 27 NOVEMBER 5:30-7pm
What stories, messages and ideas are worth sharing? What sorts of media and forms are available to us? What do we need? (Posters, artwork, zines, newspapers, radio, blogs, podcasts etc) Who are our audiences and how could we reach them?

TEZA ALTERNATING CURRENTS
Poster & Publication Launch
SUNDAY 1 DECEMBER 12 noon

To contribute come to one or all of the workshop discussions, all are welcomed. Please email kerryannlee@gmail.com to register your interest in attending or enquire.

TEZA
www.teza.org.nz

A New Hypermedial Space // Sally Blundell*

Think of the Vatican, says performance artist Mark Harvey. Two dozen primary school children stare blankly from the mat in a classroom at Freeville Primary School in New Brighton, Ōtautahi Christchurch. He brings the subject closer to home. Imagine a group within a larger group. It has its own rules. It does not have to abide by the regulations of the larger group. The children nod. They understand fairness. They recognise its absence.

Harvey is in the classroom to introduce his project *Productive Promises* in collaboration with *The Freeville Project*, a photographic venture by artists Tim J. Veling, David Cook and the University of Canterbury School of Fine Arts involving pupils from Freeville School, one of several schools in Christchurch's post-earthquake landscape about to be merged out of existence. Veling and Cook documented the school's buildings and playing fields, and invited children to imagine with pen and crayon a future beyond the immediate prospect of piled rubble. The result, collaged over the school-scapes, is a joyous panoply of bouncy castles, shark pits, zombie houses, petting zoos and ice cream shops. It's a bold and optimistic series of panorama, indicative of a vital sense of agency in a school and suburb battered by two decades of economic decline, three years of earthquakes and ongoing bureaucratic zoning and insurance inertia.

Compiling an inventory of TEZA is tricky — the commissioned projects welcomed collaborations, the initial core of artists welcomed others to work with them and the TEZA site opened itself up to projects and participants as the week progressed. It was an occupation, a transitional exchange system, an equitable, sustainable and culturally responsive alternative to special economic zones — which is where the Vatican analogy comes in.

Special economic zones are geographical regions developed specifically to boost exports, attract foreign investment and provide jobs through the relaxation or non-enforcement of national laws related to taxes, quotas, import and export duties, environmental protection and labour regulations. Like the Vatican, they enact their own legislation, not for the protection of the Holy See but for the protection of the rights of large multinational corporations able to roam the planet for the cheapest and least restrictive 'economies' for their 'investments'. Bearing the cost, however, are the local communities. While some international buyers insist on safe working conditions and reasonable wages, the International Labour Organization warns that too many SEZs continue to be hampered by 'low wages, poor working conditions and underdeveloped labour relations systems to minimise production costs'.[1]

The main arterial routes leading to this seaside suburb are buckled and raw. Access is unpredictable. Since the earthquake of February 2011 about half the suburb has been red-zoned, and whole streets of vacated houses await demolition.

Here, in an existing but under-used vacant site called the Creative Quarter in New Brighton Mall, squeezed between the Work and Income New Zealand offices and an abandoned finance operation, awash with self-sown alyssum, tyre-rimmed gardens and a gallery of street art, TEZA bloomed for a week.

A square white tent became a hub for food, workshops, discussions and planning. A counter on the roadside informed passersby what was going on.

1. 'Export Processing Zones Growing Steadily', International Labour Organization, 28 September 1998, www.ilo.org.

Activities and conversations spilled out onto the street. People hung around to see what would happen next or pitched in as needed.

Members of the Positive Directions Trust (PDT), a local initiative of high-vis-jacketed men entrusted with keeping order in the streets, helped artists Tim Barlow and Te Urutahi Waikerepuru erect *Te Ao Mārama* ('the world of light'), a large tipi-shaped structure covered with a translucent bioplastic and harakeke fibre, serving as an illuminated anchor to the TEZA site. Constructed over the week, it took many forms; at one point, lying on its side, it was reminiscent of an eel trap or hīnaki as would have been used in nearby Ōtākaro Avon River.

On day one, rehearsals began for Phil Dadson's *Bicycle Choir*, a sound-based reclamation of a public commons involving artists and local residents singing, on bikes, through the local streets. It was a collective gesture, noisy and defiant, a physical remapping and re-energising of a suburb still caught in economic and geographic limbo.

Hinatore, by Kura Puke and Stuart Foster, comprised a fine after-dark constellation of sound-carrying LEDs. On approaching the lights, viewers/participants could tune into recordings of local histories and Māori stories. The tiny glow-worm-like lights conveyed a sense of enchantment, the audio a close, intimate conversation. The duo — with collaborators — also trialled sound-carrying laser lights, visible late at night at the end of the TEZA week, across the suburb and Port Hills.

The Freeville Project resulted in two exposed walls further down the mall covered in large photographic collages of school pupils and their dreams for Brighton (Veling's mother once taught at the school, Cook's grandfather was a GP here — such connections, like Dadson's sound map, are important). The selection of the site was appropriate — local organisation New Brighton Project wants to make use of it in the future, and the wall-to-wall gallery of young people served as a vital reclamation of public space in their suburb.

Harvey's *Productive Promises* comprised small, often impromptu group gestures of celebration and generosity: a gift of a paper spinning top, a shared umbrella in the rain, a skipping game, a rubbish removal working bee, a street march declaring 'We Love New Brighton'. At Freeville, Harvey worked with the students to stage a Thank You march around the streets circling their school. No sales pitch, no political point-scoring, no expected return. Work doesn't have to produce money, he says. It can produce happiness.

Closer to the shore the mobile and miniscule *Picture House* — an A-frame billboard painted by Miranda Parkes and converted into a cinema for two by Heather Haywood and Tessa Peach — presented a series of short films curated by CIRCUIT Artist Moving Image embracing the ethos of the transitional (*Picture House* was previously situated around various former cinema sites in Christchurch) and the power of small. Further along the shore, a tall structure made almost entirely of beams of light, *AIO* by Waikerepuru and Kiwi Henare, shone into the night-time sky.

Kerry Ann Lee with Kim Lowe produced a zine, *Alternating Currents*, conducting workshops and interviewing locals about what they liked about — and hoped for — New Brighton. The publication was compiled over a week, again tapping a well of optimism in a suburb neglected by civic leaders and struggling with a recent history of population flight and disinvestment.

He Maamaa Whenua,
Kura Puke and Stuart Foster,
New Brighton, November 2013.

Sophie Jerram, Mark Amery and
Gabrielle McKone (above) and Phil Dadson
facilitating school workshops,
New Brighton, November 2013.

In the city, on the historically important banks of Ōtākaro Avon River, Simon Kaan and other Kāi Tahu artists presented *Kaihaukai*, acknowledging and reinstating the importance of this site as a mahinga kai (food and resource gathering place) and kāinga nohoanga (village settlement) to early Waitaha, Ngāti Māmoe and, later, Kāi Tahu. Like the other TEZA initiatives, it was a work about exchange, this time through food.

Less visible but created over the week and months preceding TEZA, Kim Paton launched *Deadweight Loss*. Following on from her Letting Space project *Free Store*, Paton has done extensive research and related work into waste forecasting, particularly in relation to the exchange systems for food, including a blog profiling 'economics for human beings', with contributions from guest writers.

///

In each iteration, in each small, social, open-ended activity, TEZA worked to provide a platform for local voices and participation, privileging the local through face-to-face interactions; working within the curatorial framework to encourage a level of community participation that remained unscripted and negotiable; encouraging 'thinking of new worlds, new possible politics, new ways of being'.[2]

Within the tent on the TEZA site Richard Bartlett from the Loomio co-operative presided over a series of discussions led by selected artists and Letting Space curators, and involving local Christchurch initiatives such as FESTA, Gap Filler, Rekindle, Renew Brighton and the Coastal New Brighton Timebank.

The contrast to free market ideals, wiped clean as they are of all historical or cultural context, was sharp. Where SEZs facilitate fluid, often short-term relationships between commercial enterprises and 'economies' to allow for the easy transition of big business from one low-cost zone to another, TEZA engaged in small-scale, local interactions in which inter-human relations are both the medium and the outcome.

Where SEZs privilege the demands of a homogenous global marketplace, TEZA incorporated manifestations of indigeneity, giving space and recognition to local character and mana whenua. Throughout the week Māori tikanga was followed: food was blessed, visitors welcomed and the mana of those living there was honoured.

SEZs are construed to implement a system of exchange based on low costs and high profitability (buy low/sell high), whereas TEZA presented an alternative system of exchange that prioritises creativity, ideas, hope and human relationships over and far above financial gain.

The goal of relational aesthetics, defined by French curator and writer Nicolas Bourriaud as a 'set of tasks carried out beside or beneath the real economic system', is pertinent here. The role of art, Bourriaud writes, is not to form imaginary and utopian realities but to present, to enact 'ways of living and models of action', to inhabit the world 'in a better way'.[3] Working within the modes and models of relational aesthetics therefore creates free spaces — not just interludes in the normal rhythm of everyday life but re-reckonings of how that rhythm might change.

Public art is usually something chosen somewhere else. It lands in communities, justified by a mass of research and curatorial and artistic expertise,

2. Nicholas Holm, 'The Distribution of the Nonsensical and the Political Aesthetics of Humour', *Transformations*, no. 19 (January 2011).
3. Nicolas Bourriaud, *Relational Aesthetics*, trans. Simon Pleasance and Fronza Woods with Mathieu Copeland (Dijon: Les presses du réel, 2002).

for the assumed benefit of an unwitting, at best 'consulted' community. TEZA modelled the reverse, realising works that engaged with — and were shaped by — the local community, challenging the global homogenisation of artistic practice and the reification of the finished object with a reconnection to specific, local human experience. There are similarities here to performance and post-object art from the 1970s in which artists were seen as affective labourers, agents for change working outside the white box.

The open-endedness of TEZA's approach impacted on its delivery and its criteria for success. While TEZA acknowledges the support of Creative New Zealand, Renew New Brighton, Chartwell Trust, Canterbury Community Trust, Massey University, University of Auckland, Life in Vacant Spaces, The Physics Room and others, it relied on community engagement and reciprocity, a small but effective wave of celebration, in order to enact or even suggest the possibility of change.

In pursuing that goal, this small sliver of land in central New Brighton became a hypermedial space, an in-between place. Here, outside more established boundaries, collective experiences of place, cultural difference and group identity could be re-examined and redefined.

Clearly this wasn't just selected artists arriving in Brighton to 'do good'. Christchurch, its eastern suburbs in particular, has heard such motivations before (TEZA coincided with the Christchurch East by-election — candidates from all parties descended on the mall and, unwittingly perhaps, the TEZA hub). After the earthquakes, residents of Christchurch came to celebrate transitional projects, vitally important interventions raising spirits and re-energising abandoned corners of the city. But the activities associated with the TEZA 'occupation' were couched in a wider framework of discussion and experimentation. It became a place of negotiation, confronting and acknowledging difference and finding new strength or hope within those differences.

Can a small group of artists impact a community already dealing with a complex array of geographic, social and economic issues?

The success of TEZA, says Sophie Jerram, should be judged primarily by the quality and degree of engagement with the local community. This criterion demands a focus on process, rather than a critique of a completed object or outcome. In her evaluation of relational/social art practice, UK art writer Claire Bishop suggests that projects appearing under that label can appear patronising to the 'beneficiaries'[4] — but at no point did TEZA imply a known remedy for New Brighton's ailments or even suggest that such an outcome was required.

Criticality is a moot point here. In terms of social engagement, some passersby did not want an origami spinning top. Some did not want to join in the Thank You protests. Some, encountered in a local café, were suspicious of the Merrell shoes and intellectual discussions.

But where TEZA succeeded was in opening up a new space between the parameters of a top-down orchestration of a programme of events and the practices of a community well able to identify its own needs and opportunities. This is where the core idea of exchange is so important — far more important than the idea of a viewer who, in relation to TEZA, may or may not exist.

While 'giving' by itself implies an unequal relationship between the benefactor and the recipient, the enactment of discussions, workshops and

[4]. Claire Bishop, 'Antagonism and Relational Aesthetics', *October*, vol. 110 (Autumn 2004): 51–79.

Transitional Economic Zone of Aotearoa 2013

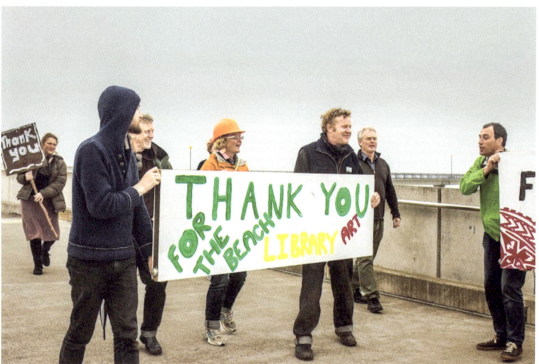

Above: Te Huirangi Waikerepuru, Kura Puke and Te Urutahi Waikerepuru, Rāpaki Marae pōwhiri, November 2013.
Below: *Productive Promises*, Mark Harvey, New Brighton, November 2013.

events requires an equal degree of looking, listening and engagement, leading to the perhaps unexpected recognition of a specific social economic system in which things are already happening. And in New Brighton, local initiatives were already well under way. Local street artist Pops (Richard Baker) had implemented a massive mural operation. A community garden and timebank was in action, and Renew Brighton, New Brighton Project and the New Brighton Business Association were in full flight. The vital role of the Positive Directions Trust guys within the functioning of this small community has already been recognised.

Establishing a 'zone' with due regard for such enterprises may have presented curatorial challenges. Yet in confronting these issues, TEZA opened up new conversations and the expectation of a new sense of agency for and within the community. As Richard Bartlett said in launching the Creative Summit, 'Anyone affected by a decision should have a say in it. Art is democracy in action.'

If TEZA is to be considered in terms of process, it was apparent that throughout its week-long occupation, two processes were happening at once. The TEZA website hosted an outpouring of analysis, discussion, reviews and documentation. On the streets of New Brighton, children drew, passersby told their stories, people skipped, local artists talked about their practices, a giggly young woman who'd had too much to drink joined in an evening celebration of *AIO*. Both processes staked a place, a time, an event in memory.

///

How do you gauge the success of such processes? For French philosopher Jacques Rancière, politics occurs when the disavowed 'radical equality' of all speaking beings interrupts the normal flow of things. Was TEZA political? No one stormed the offices of the Canterbury Earthquake Recovery Authority or the Earthquake Commission. No one laid siege to the demo crews. But in giving expression to a shared and equal capacity for creativity, festivity and a belief in the potential for change, these participatory processes and collaborations did achieve a sense of 'radical equality'.

Connections were made with and — more importantly, perhaps — between local artists and initiatives. At the last meeting, Tim J. Veling advised TEZA artists to be careful. We come in with energy and vigour, he said, then we leave. 'Echoes of conversation need to continue.'

They do. Just weeks after the Letting Space people rolled up their tent, Brighton artist Kim Lowe issued an email enquiry to those who attended TEZA to see if anyone wanted to get together 'to make some things and . . . carry on with some TEZA-like discussion/projects'. The answer was yes.

In one of the Creative Summit discussions, London-born street art guru Pops quoted anthropologist Margaret Mead: 'Never doubt that a small group of thoughtful, committed citizens can change the world; indeed, it is the only thing that ever has.' TEZA endorsed that possibility through art. In trialling systems of cultural exchange that provided a free platform for the expression of voice and creativity it fulfilled its intentions. The conversations, the echoes, have not dissipated.

** First published on the Letting Space website, March 2014.*

TEZA Transmission 2013: A diary with responses

Sunday, 24 November
— Pōwhiri and welcome

Michelle Osborne: We start with a pōwhiri at the Wheke Marae under blue skies, the sea mist in New Brighton having given way to searing sun over the Port Hills. In Rāpaki Bay all is tranquil. While the good weather may not last, it's certain that the heartfelt welcome from Ngāti Wheke and their wonderful hospitality will sustain us.

Letting Space: This was our pōwhiri to welcome the group to the whānau; a ribbon of mist came up the harbour to greet us. The new marae Te Wheke opened just before the first Christchurch earthquake, providing shelter during the second.

Our party was led by Parikaha kaumātua Dr Te Huirangi Waikerepuru and his daughter Te Urutahi Waikerepuru, with Kura Puke and Tengaruru Wineera of Taranaki. There's a connection here. Rīpapa Island in the harbour was used temporarily in 1880 as a prison for 150 of Te Whiti's followers of passive resistance. Taranaki iwi provided harakeke to complete the weaving in Te Wheke.

Meanwhile, at the TEZA hub as the evening drew in, Tim Barlow begins construction on *Te Ao Mārama* with Te Urutahi and others. As she writes, '*Te Ao Mārama* will be illuminated in the evenings to reflect new learnings gained and shared.'

Michelle: Back at the TEZA wharenui, Phil Dadson initiates a *Bicycle Choir* practice. There are warm-ups with free-flow sounds made. The idea is to vocalise around a note and listen to each other for harmonies. The theme of dissonant voices becoming sonically unified is then taken further (quite a bit further as it turned out) in the form of a lively and mobilising 'get on your bike canon' which had a tricky little rhythm known as a hocket (a Dadson specialty). We do our best. I go to sleep that night humming in my head — one, one, one, one, uni-fi-ca-tion.

Monday, 25 November
— Opening night

Letting Space: After days of hot, sunny weather, the rain came in on Monday, but we were brightened by the arrival of Heather Hayward and Tessa Peach's *Picture House* and Sharon with the bright bins from Our Daily Waste. Friends new and to be made continue to arrive from Christchurch and around the country. Rain has not dampened spirits and it has been a time for realising that our strength lies in this as a development time together.

Michelle: At the TEZA hub the ground is wet though not muddy — this is the beach after all — and I pick my way across the back of the site from Beresford Street, having come from the bus stop. The wharepaku is on the far left side and there's a definitive track winding through from continuous use, which is a reminder of its former life as the Creative Quarter of New Brighton. There were already some important community structures in place here which have been enhanced for TEZA. Mall-side is the wharekai and meet and greet structure (a tent) and wharenui with a kūaha or entranceway (two connecting tents, one long for walking through). More centrally there's an off-the-grid office (solar-powered) and a wharetoi (a gallery or studio space which will be used by those who come as the week evolves).

Pride of place, however, is given to the wharepou *Te Ao Mārama*, which at present lies elegantly on its side, its wooden supports giving it the appearance of a hīnaki, a description everybody is quite pleased with.

There are deeper issues of occupation being explored here. The artists draw from both historical and contemporary Māori architectural practices especially, including temporary and improvised built forms of 'occupation' which have been conventionally dismissed in architectural discourse.

Letting Space: Having been welcomed to the rōpū at Rāpaki Marae on Sunday, on Monday members of the New Brighton community also wished to acknowledge our arrival with a pōwhiri. This is our opening night and we gather with friends from Christchurch and around New Zealand in anticipation.

Michelle: It's a little after 7pm and the karanga has started. We move slowly across the site, bumping umbrellas, to the kūaha adorned with driftwood, filing men first into the warmth of the wharenui.

Letting Space: Phil Tekao from Positive Directions Trust, which has become very much part of our whānau, welcomes us on. He's followed by local councillor David East. We're overwhelmed by the energy being given to us from New Brighton and find ourselves working hard to match it, to see true collaboration.

Michelle: The orations are inspiring and moving and this time we sing our waiata in a rather more accomplished fashion. Later, Te Urutahi Waikerepuru reminds us that abundance is always within us and not reliant on external factors.

 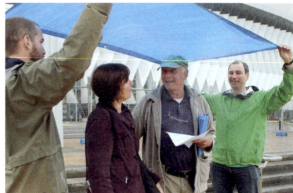

Day 1: Tuesday, 26 November
— Optimism doesn't need a permit

Michelle: It's 10am and artist Mark Harvey is keen to get started with *Productive Promises*. We head straight to a private vacant lot to move accumulated rubbish off into public space for the council to pick up at the behest of a concerned citizen. Mark suggests a protective shield, and we manage to nobble Nanaia Mahuta as she comes out of the Labour Party office. She cooperates amiably, pulling her suitcase behind her as we circle around and walk her to her car.

This playful process encourages us to think creatively about ways of being productive together. Ways that would bring a sense of confidence and happiness in New Brighton as a place to live and visit.

The weather's still wet and we take to providing shelter for people and chatting to them as they walk along. Our new participants include Hannah with baby Knox. It's the modesty of Mark's ideas which make the project so appealing. A strong conceptual base, including a 'Nietzschean understanding of experimentation', underpins his way of working. Nonetheless, the quote for the project comes from his mum: 'We should all be trying to find our happy work.' But what does that mean? The artist is not unaware of the slippage, especially post-quake in the eastern suburbs.

I'm standing by the entranceway to the New Brighton Library, which is currently under repair. Umbrella in hand, I watch Mark carefully assist an elderly gentleman down some broken steps. It's a surreal art/life moment. The job done, the artist bounds back up energetically and repeats the process again. In its repeating, the action becomes more playful and when assistance is not really required, even a little idiotic. This is the artist's oeuvre.

By the afternoon we are a bigger group. We ask people to suggest a logo for a T-shirt, which we then write on the pavement in chalk. 'New Brighton Up and Coming!' 'Bright Skies in New Brighton!' There are some nifty drawings of whales too. We ask, 'Do you have anything to add?'

Letting Space: While *Productive Promises* got under way, this first morning also saw David Cook and Tim J. Veling putting in some hours with the help of students from the University of Canterbury. They worked at Freeville School and on our office shed (as of today, running on solar) and have been manhandling scaffolding to begin erecting the students' work further down the mall.

At lunch we had a great gathering of 25 to welcome artists Kim Lowe (New Brighton), Margaret Lewis (Auckland) and Michelle Osborne (Auckland). All three gave presentations. Margaret's session involved creating a fence out of wool as a group while discussing the topic of the day, 'Optimism Doesn't Need a Permit'. Useful sentiments in a patch of bad weather.

Today we also kicked off Kerry Ann Lee's *Alternating Currents* project with the first of three discussions. Richard Bartlett began the first presentations and discussions around our themes at 8pm, and Heather Hayward and Tessa Peach opened *Picture House*. We trialled an experiment, taking two people at random out of the discussion and into *Picture House* for a quick burst of art video inspiration. Conference break-out and speed dating service all in one.

To Reckon With: A response // Melanie Oliver*

> To reckon with the complex experience of social work
> means reckoning with its force as both support and constraint.
> What a pleasure; what a pain.
> — Shannon Jackson[1]

1. Shannon Jackson, *Social Works: Performing art, supporting publics* (Routledge: New York, 2011), 247.

New Brighton Mall was a happening place in the 1960s. Its Saturday trading, the unique permission for this block of shops to open on a few sacred weekend hours drew crowds from all around Christchurch. With the introduction of Saturday and then Sunday trading to the rest of New Zealand from the 1980s, retail activity at New Brighton Mall sharply declined and the area has since struggled to maintain its former vibrancy. Situating the Temporary Economic Zone Aotearoa project in the heart of this derelict shopping precinct thereby invokes a history of commercial exchange as a lure for people to come together, highlighting our traditional reliance on consumption as the means to create a sense of community.

The first evening discussion, 'Optimism Doesn't Need a Permit', failed to articulate much other than that this was a room of committed optimists, and I suppose it was a warm-up rather than a setting-of-tone for the week. Hope is a beautiful thing, yet unless it is grounded in focused action, critical reflection and addressed to the issues at hand, a Pollyanna attitude is not necessarily constructive.

In contrast, the individual artist responses to the TEZA provocation have each developed specific projects with groups in New Brighton. Given the nature of their works, the artists all face the particular difficulties of finding, creating or working with a new community. They must also tackle the usual challenges for relational projects that demand flexibility in authorship, a collaborative outcome and considerable energy to negotiate and engage with people. There is an openness and personal commitment to these small communities, though, and as they develop, the projects follow a series of threads that reflect the diversity of interests and individuals.

A debate has arisen on Facebook focused on who can, is or should be associated with TEZA, revealing a disjunction between insiders and outsiders, intimates and strangers, in relation to this event. The selected community engagement projects, curated by Letting Space, were accompanied by an open invitation to the public, albeit with a specific focus in mind. However, simply dropping into the TEZA site, either physically or online, is not an especially fruitful way to experience any of the works or the project as a whole. Observing is not enough here, yet to participate requires slowing down — potentially frustrating for those accustomed to a certain way of encountering and spending time with contemporary art, and confusing for those who aren't.

Instead of an easily digested moment, what TEZA seems to have successfully achieved is meaningful engagement with local organisations such as Renew New Brighton and the Positive Directions Trust, acting to provide support, visibility, connection and recognition within a new context. A number of young men from Positive Directions Trust, as well as the Labour MP Shane Jones, attended the Tuesday lunchtime speaking session. In addition to this, Metiria Turei and some Green Party folk were on-site in the afternoon, obviously expecting to find either good photo opportunities or a sympathetic audience. The appearance of these political representatives suggests that TEZA has navigated institutional structures in a way that enabled its concept to be considered seriously beyond the frame of art, as both support and constraint.

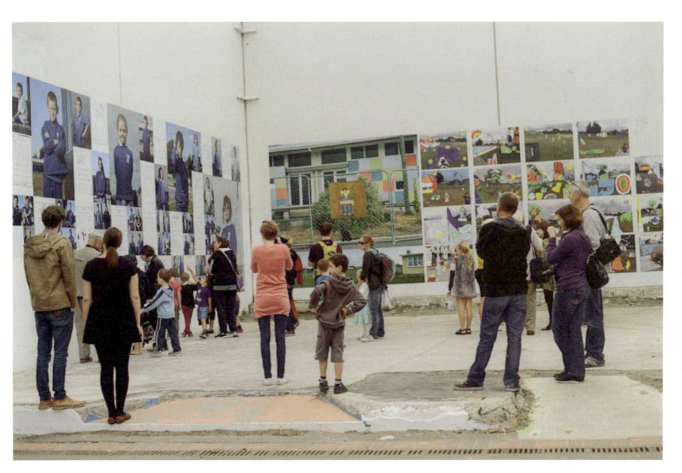

The Freeville Project, Tim J. Veling and David Cook, New Brighton, November 2013.

** First published on the TEZA website, November 2013.*

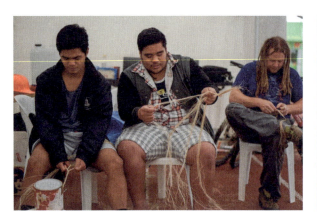

Day 2: Wednesday, 27 November — Nature knows no waste

Letting Space: This morning we farewelled Letting Space co-producer Helen Kirlew Smith. You might not have heard much about Helen thus far, but she's been tirelessly working through logistics that saw everyone arrive, accommodated, fed and the site looked after.

Also in the morning Mark Harvey launched his first Thank You protest for New Brighton.

At lunchtime we were blessed with a visit from Stuart Griffiths from Dunedin, a mentor to a number of our artists. We had a great lunchtime session with Tim J. Veling and David Cook on their *Freeville Project*, and then we welcomed Wellington artist Kalya Ward, who discussed her current evolving work on Ōtākaro Avon River and its play with her memories of Christchurch as a former resident now working at a distance.

Our final presentation was from Ash Holwell on his work with a natural history museum in Europe. Ash also launched a blog, *The Textural Noise Zone of Aotearoa*, based on work he is completing at TEZA. And Green Party co-leader Metiria Turei with New Brighton candidate David Moorhouse hung out in the afternoon.

Meanwhile, Kim Paton has been busy adding content to her new website as part of her project *Deadweight Loss.*

The muka-implanted bioplastic coating for *Te Ao Mārama* started to go on this afternoon and Tim Barlow also held a bioplastics workshop (these continue for the next three days).

Our theme for Wednesday, appropriately, was 'Nature Knows No Waste', and the evening discussion involved Our Daily Waste, Space Craft (WikiHouse), Free Store, RAD Bikes, New Brighton Community Gardens and others.

And in the evening, in the wharetoi, Stuart Foster and Kura Puke trialled elements of *Hinatore* — sound-emitting trails of LED lights.

Day 3: Thursday, 28 November — What are you worth?

Letting Space: Thursday began with a school coming to us, and us going to them. Entirely on their own initiative, Central New Brighton School students arrived unannounced with 'thank you' signs, so we headed off down to the mall on one of Mark Harvey's Thank You marches. We ended up at the pier only to find — you guessed it — some politicians.

Then it was into the van on a field trip to North New Brighton and Freeville School. Something like half the families of the school have houses in the Red Zone, and the school is soon to close and be merged. Tim J. Veling was our guide, having already spent extensive time here with the students developing works in which they consider the future of their school site. A quick workshop with students ended with another Thank You march, around the block, to a chorus of barking dogs.

Lunchtime presenters included Gradon Diprose (recently arrived from Wellington to join us), Heather Hayward and Tessa Peach (Makeshift), and Audrey Baldwin (The Social).

The afternoon was notable for the raising of *Te Ao Mārama* (now clad) with the help of a crane (provided generously for free by Elevate). Proceedings were watched by quite a crowd, including Labour candidate Poto Williams and Audrey from the community garden.

Phil Dadson headed out on some solo vacant space aural performances, while Tim J. Veling, David Cook and their group of Canterbury students continued the mammoth effort of installing their collaborative work with Freeville School students in a vacant space at the bottom of the mall.

A highlight of the evenings discussion, 'What Are You Worth?', was Ash Holwell's contribution of a Red Zone-foraged salad and flowers, a parting gift as he left the zone.

After dark things got busy with light works — the first testing of Te Urutahi Waikerepuru and Kiwi Henare's *AIO* happening down by the pier, with a few friendly locals joining in. It was magical to come out of the discussion and see three lights piercing the cloud cover above.

TEZA Tour of Duty: A response //
Andrew Paul Wood*

TEZA is not necessarily the easiest thing to describe. It reminds me somewhat of the Festival in Charles Stross's novel *Singularity Sky*: an anarchic, nomadic civilisation of uploaded-minds-cum-an-alien-godlike-information-plague. One that, originally intended to repair galactic information networks, drifts from world to world and, in return for information, can literally give you whatever you want, resulting in total social, economic and political disruption. The Festival also contained (in stored form) a species that has evolved into a niche, as critics providing commentary. A defence system of automated Bouncers. The chaotically dangerous fringe which uses the planet itself as an artistic medium and thinks nothing of inducing a solar flare to paint an aurora.

TEZA, of course, is far from omnipotent, lacks these scary elements and is considerably more sensitive to its place in its host community, which even before the ground intervened was caught in a downward economic spiral.

The intention seems to be to use artistic strategies to engage with the local community — creating a temporary special zone with its own rules of interaction and transaction. The vibe is optimism, sharing on all levels — provocative and perhaps a wee bit utopian. The theoretical structure might be loosely described as ironic pragmatist à la Richard Rorty in that no one is out to solve the world's problems or even offer Band-Aids. Rather, the intention is to provoke thought about possible outside-the-box strategies for making change, and the role of the arts in disrupting the received assumptions and hidebound socio-economic systems.

To the more central suburbs, New Brighton is a bit of an unknown quantity — 'here be dragons' and all that — which is a shame because it's actually very nice and not at all the Zombie Apocalypse of popular imagination. I arrived part way through a very stimulating discussion about art, media, communication, fanzines and identity, facilitated by design lecturer/zine queen Kerry Ann Lee and local printmaker Kim Lowe. The evening culminated in an amazing, informative presentation/discussion about nature, waste and recycling by a number of specialist businesses and community groups including Our Daily Waste, RAD Bikes and New Brighton Community Gardens. This was an eye-opener for me, finding out that some of the things we do under the impression that we're helping the environment are in fact not sustainable and mostly feel-good, but perhaps lead to a more enlightened approach in general.

In and around this were opportunities to watch Steve Carr's short film *Burn Out* in the mobile and miniscule *Picture House*, and a wonderful nocturnal artwork, *Hinatore* by Kura Puke and Stuart Foster, in which glow-worm-like strands of LEDs encoded in their natural frequency various enigmatic soundtracks to be picked up on headphones. It was magical.

Thursday was even more intense, starting at 10am with an impromptu visit by Central New Brighton school for a Thank You protest. It was an incredibly sweet, warm fuzzy march up to New Brighton Pier and the library, better than Prozac. Later in the day a similar march took place at Freeville School in North New Brighton. The engagement was fantastic, more like a Wiggles concert than

an arts project — but overshadowing the fun was the knowledge that both Central New Brighton and the unique and progressive Freeville were targeted for closure by Hekia Parata. In both cases the kids made their own signs announcing all the things they loved and were grateful for about New Brighton.

The truly wonderful rooster Phil Dadson perambulated around being Phil Dadson. A pre-eminent New Zealand sound artist, the protean Dadson's involvement took many forms, whether leading his bicycle choir around New Brighton Mall or popping up unexpectedly to deliver what sounded like Tibetan chants or Mongolian throat singing. The man is a national treasure.

Thursday evening concluded with another Creative Summit talk on how we value work, artistic practice as work, and ourselves. It included great projects like Gap Filler and the Coastal New Brighton Timebank. Timebanks were a new concept to me — basically member-run labour exchanges that measure by time worked rather than labour outcomes. It was during this part of the evening that I started feeling a little uncomfortable. Here we were in New Brighton, one of the lowest rungs of Christchurch's economic ladder, but the issues and philosophies being discussed very much came out of a well-meaning but relatively comfortable, middle-class and educated worldview held by people with access to systems and knowledge unavailable to the folks outside the tent — poverty fetishism is always a risk. That's not to undermine an important and worthwhile discussion, but I did question the relevance to the context of our host community. A minor cavil, perhaps, but one that all such projects should be conscious of.

Can art/artists save the world? I don't know, and I doubt it, but they can contribute to that saving by opening minds and hearts and changing worldviews — no artist has ever been afraid of a blank sheet of paper. Events like TEZA are an important way of doing that. Goodwill should be considered a sustainable, renewable resource, and one rather suspects that TEZA was doing a better job of outreach than many of the politicians then in town for the by-election in Christchurch East.

First published on the TEZA website, November 2013.

What Are We Worth?: A response // Gradon Diprose*

When I was a kid my parents used to take me on Christian beach missions. We'd show up in a small beach town, pitch our tents and try to evangelise to all the holidaying families through rock music, puppet shows and bible crafts. When I first got to the TEZA site I was faintly reminded of these missions — from the tents to New Brighton Beach to the desire expressed in many of the TEZA projects of connecting with local people. Claire Bishop has suggested that in certain social/relational art, the artist or curator can come across a little like a patronising cultural elitist fuelled by the self-belief that their particular project is a worthwhile intervention in a certain community.[1] In other words, they can act a bit like a Christian evangelist.

How do you trace the effects of participatory social art projects, like TEZA, that blur conventional distinctions between 'art' and 'community'? The nature of most social art projects often makes this tricky. Unless you are doing constant, tedious surveys of participants and the 'community', how would you ever know? Increasingly, I wonder whether such questions around effect and impact reflect two other interrelated issues. First, the wider audit and evaluation culture enshrined through neoliberal discourses tied up with funding criteria. And secondly, whether these questions are actually more about justifying our own anxieties around the usefulness of this kind of work in wider society.

During a session on Thursday evening, artist Kerry Ann Lee led a discussion on 'how to make art and media together'. She posed a number of questions, but what interested me most was her question about what people wanted for New Brighton. One woman suggested that even having such a conversation was difficult. Yet people talked about a whole range of issues, from generational disputes between different New Brighton community groups, rebuilding issues associated with new flood planning restrictions (linked to climate change predictions), to what to do with grey silt in one's backyard. One person mentioned a radio host who had suggested 'putting a bomb under New Brighton'.

What struck me about this conversation were the ways in which people talked about the need for a new place story for New Brighton that exceeded anything too specific or fixed. A place story that went beyond the historical narrative of consumption and weekend shopping and exceeded the somewhat classist nature of east Christchurch versus west. For some in the session, it seemed important to just state: 'New Brighton will never go away'. In other words, we will endure and not be annihilated.

In another session, 'What Are You Worth?', a range of artists including Mark Harvey, Ryan Reynolds and Kerry Ann Lee spoke personally about the ways more dominant societal discourses devalue their labour as artists and how they negotiate this. This session provoked discussion around how certain forms of labour are valued more than others and how alternative exchange systems like timebanks can work in practice.

The TEZA projects appeared to be as much about process as anything: the process of being in a certain place with others, listening to artists talk about their work and hearing people's hopes for and frustrations about the places they value. Given the current political climate in Christchurch and wider Aotearoa

1. Claire Bishop, 'Antagonism and Relational Aesthetics', *October*, vol. 110 (Autumn 2004): 51–79.

New Zealand, characterised by a distinct lack of listening from politicians, I would suggest that these listening spaces facilitated through TEZA are more significant than they might first appear.

As a cultural geographer, I found it fascinating to see some of my discipline's key concerns around identity and place playing out through Kerry Ann's project and others. Yet I was also uneasy, knowing that for some New Brighton people — those living in quake-damaged homes and battling EQC for payouts — such discussions might seem insubstantial. However, I am also mindful that reflecting on one's frustrations, losses and hopes and to have this witnessed by others can be incredibly important. The democratic spaces I participated in and observed at TEZA were much more open-ended than the beach missions I went on as a kid. For this reason, I suggest, the projects generally managed to avoid the evangelistic overtones that writers like Claire Bishop are so critical of.

First published on the TEZA website, November 2013.

Day 4: Friday, 29 November
— What does occupation look like?

Letting Space: A busy day. Mose from Positive Directions Trust commandeered a space, spending the day painting. The Positive Directions crew got a morning briefing from Jay, before heading out (and the tireless Jay got a kip after doing the night shift on site security). Mark Harvey tried out some skipping strategies. And let's not forget the politicians — Renew Brighton's Rebecca May came face to face with Labour hopeful Poto Williams during a Thank You protest.

The lunchtime presentations were by artist Trudy Lane (our latest arrival), Matthew Galloway, Kura Puke and Stuart Foster.

Late in the afternoon we were invaded by 60 teenagers, brought by the Youth Alive Trust. Broken into three lively groups, they worked with Phil Dadson, Mark Harvey and Tim Barlow in turn, moving from a bioplastic workshop in the wharepou to a music-making circle and out into the street to try out productive strategies.

We launched Kim Paton's *Deadweight Loss* website on Friday at 6pm. 'Launch' is a fancy word for a beer at the pub during happy hour with some really cool postcards.

Take away the art projects and you still have a core part of the project — the exchanges that occur between those moving through. The site is a valued public thoroughfare so there is a sense of ownership, and when you're hosting at the front of the site it's a constant steady stream of interesting public conversations of great diversity.

Photographer Roger Bays wanted to project images he had taken of the creative work surrounding the TEZA site, so Tim Barlow set him up with a bioplastic screen to reverse-project on to the Positive Directions Trust's caravan window.

For the evening discussion, 'What Does Occupation Look Like', we welcomed Simon Kaan and Ron Bull Jnr straight in from Kaiapoi, where they had workshopped with Ngāi Tūāhuriri, including making flags, some of which were added to our entrance. The discussion also involved presentations from Tim Barlow and Barnaby Bennett. The day ended with a karanga from Te Urutahi Waikerepuru and a welcome into the illuminated wharepou, with Te Urutahi and Kiwi Henare's *AIO* now shining over it.

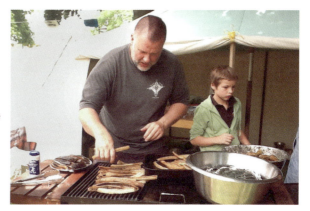

Day 5: Saturday, 30 November
— Let's bring art and people together

Letting Space: On Saturday TEZA spread its physical boundaries, with activity occurring in three different places at once. While the New Brighton occupation continued, the *Kaihaukai* food exchange project led by Nathan Pohio, Priscilla Cowie and Ron Bull Jnr saw Kāi Tahu gently reoccupy Market or Victoria Square in the Christchurch CBD. Set on Ōtākaro Avon River, the square was once a marketplace, fed by the gardens at Rāpaki. One of our crew spotted a big, fat tuna lazily swim up the river as he crossed the bridge to the nearby Pallet Pavilion. *Kaihaukai* began with an enriching mihimihi full of stories of kai gathering. Vivian Russell recalled how back in 1970 much of their food came from the local awa.

Back at the beach the giant wall occupation in the mall that is the culmination of *The Freeville Project* was celebrated with an opening at New Brighton market, with words from local councillor (and former Freeville board chair) David East and a participatory performance by Random Acts of Music.

Mark Harvey worked with the children on some productive tasks. Today he also canvassed locals on what they wanted to see improved locally and provided these to Councillor East.

Parents and children from Freeville continued to visit their work throughout the day.

Back at Market Square, TEZA participants reported eating one of the best lunches ever. It included whitebait fritters (from whitebait caught locally), pāua from all over, cockles from the peninsula, tītī from down south, tuna from Kaiapoi and a cross-indigenous collaboration stemming from the first iteration of *Kaihaukai* in New Mexico — tītī and corn stew. River sticks were painted, harakeke woven and as part of the *Local Time* project Nathan Pohio brought spring water from Kaiapoi. Kaan and crew had asked guests to bring non-perishable food so this could be taken back with us to New Brighton to the food bank, and we went away with boxes.

Back at camp, Phil Dadson held a music-making workshop with Coca-Cola bottles sourced from the sustainability hub at the University of Canterbury in the morning. The nor'wester got up, which led to *Te Ao Mārama*'s skirts being rolled up, providing yet another change in this work. We also helped Heather Hayward shift her and Tessa Peach's *Picture House* to a stunning location under the New Brighton Pier.

As the wind died, the bicycle choir rode out in the golden evening light, followed in a car by an intrepid camera crew. They sounded out with their voices along the beachfront, through supermarket carparks and into suburban streets surrounding the mall. We got a round of applause from Poto Williams and her team as we passed the Labour Party HQ, just ahead of the news that she'd won the local by-election.

The walls in the Creative Quarter and surrounding area are decorated with a huge range of mural works, which provided a suitable setting for a stimulating evening discussion about the relationship between art and community. The first half of the conversation was dominated by the arts fraternity, the second by the community.

As if hearing the call, a group of musicians and drummers took over *Te Ao Mārama*, and the light work *AIO* created a cone over it. Others wandered in between, down to Heather and Tessa's work at the pier, and to the pub.

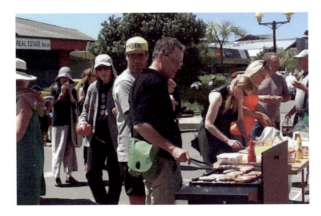

Day 6: Sunday, 1 December
— Putting the new in New Brighton

Letting Space: Our final daily theme was 'Put the New in New Brighton', a day of bringing everything together, to facilitate our departure and to lay the ground for the project's legacy. Suitably, the day began with the assembly of a new barbecue.

A nicely timed Facebook contribution arrived from Dan Arps: Lawrence Shustak's design, circa 2000, for a geodesic dome to cover New Brighton.

At lunchtime, a large group gathered for the launch of *Alternating Currents*, the zine produced by Kerry Ann Lee with Kim Lowe containing the culmination of three discussions during the week with contributions from the local 'migrant-settler' community and local museum.

Local muralist Pops invited us to contribute to a nearby wall. Nathan Pohio added colour to a representation of Sonic the Hedgehog.

The barbecue got cranking.

And — clearly having got the message we wanted people to take things into their own hands — a group of local kids held an inaugural Stretch Club out on the pavement with the extended TEZA whānau.

We then gathered for a last discussion on 'the new'. We considered both the challenges and opportunities for New Brighton offered by having visitors from many places together.

Our visit concluded with an emotional poroporoaki, as many new friends said goodbye and started to turn towards their homes.

Love and Criticality: A response // Ali Bramwell*

I was present for three of the Creative Summit evening meetings at TEZA and each had a distinct atmosphere and function. It is often overlooked how group chemistry alters a conversational dynamic, but here the process was clear. The conversations were presided over by Richard Bartlett, with his very able and mature facilitation skills, and punctuated by the different perspectives of various visiting experts (who often didn't stay very long on-site). The TEZA crew seemed to have an increasingly familial bond, and a core group of local producers — surprisingly consistent loyal participants (with all the time and energy that commitment requires) — also attended. In the last meeting on Sunday, Mark Amery spoke about how, for him, there were two parallel processes going on all week, one that was intellectual and the other emotional. I'm not sure that these two things are ever entirely separable, nor is it necessary to do so, however this observation reflects a key area of dialogue that occurred.

The Creative Summit on Friday evening interrogated the notion of occupation. Tim Barlow spoke about the ethics, theoretical concerns and negotiations underpinning how the physical architecture of the TEZA site was developed in relation to honouring previous histories and local kaupapa. While introducing their project *Kaihaukai*, Simon Kaan and Ron Bull Jnr each skilfully picked up and responded to several threads Barlow had raised. They discussed marae architectures as warm and living social structures built from what is already existent, and spoke of an inherent connectivity built through shared stories and histories wider than definitions based on traceable genealogies. Bartlett talked about the history of using occupation as a protest strategy and spoke with quietly persuasive passion and conviction about his own transformative experience shifting from observer to active participant during the Occupy movement of 2011. He spoke in terms of re-emerging realities, positing alternatives by example, gentleness and optimism in the face of monolithic and resistant forces.

The final presentation of the evening was a thoughtfully structured presentation by Barnaby Bennett, framed as 'Loving Your Transitional Monsters'. Bennett positioned TEZA as the most recent iteration of a two-year-old history of transitional projects in Christchurch.

Gradon Diprose made a comment in his Transmission response that anticipated one of the threads of discussion that emerged in the summit on Saturday evening: how the languages of funding work to create institutional disparities of value for community-focused projects as opposed to Proper Art (irony alert).

Warren Feeney opened the Saturday-night discussions with some reflections on the theoretical histories that contribute to the persistently un-useful duality of high art versus populism. In the process he attracted passionate rebuttals to things that he neither said nor intended. His contribution was valuable and necessary, providing an engaged and educated perspective on local funding structures and their evolving rationales that would have otherwise have been missing.

The discussion was frequently heated, with passion and exhaustion underpinning much of what was said — perhaps inevitable towards the end of a week requiring an unsustainable amount of attentiveness and emotional, intellectual and practical output from all participants and facilitators (a micro-

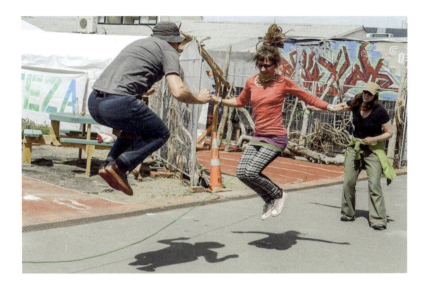

Productive Promises,
Mark Harvey, New Brighton,
November 2013.

example of the normal professional realities for community producers). Burnout of key individuals is the plague of community groups across the board, threatening the continuity of almost all long-term projects. In a more general sense, the current National government's unsustainable leveraging of volunteer labour and charitable groups to pick up the slack in community care is (or should be) part of the broader conversation here.

Bartlett, with a light but effective hand and a stroke of brilliance, turned the conversation. It was threatening to become a producers' lament-fest about the inherent unfairness of suits (aka: THEM), who consistently fail to understand the value of artists' altruistic sacrifice. Bartlett manoeuvred things back to the core value system of the project as a whole: the New Brighton community. All of the locals present spoke in turn, introducing their various roles, investments, losses and experiences in their community. Hearing their humility, honesty, indomitability and quiet fortitude expressed was a genuinely humbling and moving experience.

During the entire conversation, a drummers' circle had occupied *Te Ao Mārama* nearby, so the intense talk was against the soundtrack and backdrop of a handover that was already in progress, foreshadowing the moment TEZA would leave — the New Brighton Creative Quarter reverting to a blank canvas, ready for its next iteration.

The final Creative Summit on Sunday, 'Putting the New in New Brighton', completed the handover. The conversation was occasionally tearful and often moving, but also concrete. By explicit design, the presenters were all local producers. While I was not present at the beginning of the project, I'm willing to suggest that it was a conversation that would not have been possible at the beginning of the week. The room was full of the active cultural producers of New Brighton, those with institutional affiliations and those without, and everyone now knew each other's names. This fact alone speaks to the extent to which TEZA accomplished its goal to be effective and establish a genuine reach, as a human expression of lasting warmth and as a project with both agency and critical traction.

**First published on the TEZA website, December 2013.*

Thursday, 5 December
— He maamaa whenua

Letting Space: Over the nights of Sunday 1 to Wednesday 4 December, light sounding by Kura Puke and Stuart Foster for *He Maamaa Whenua* (sound-carrying lasers) occurred as a finale to the TEZA event. Frequencies of karanga were sent through light from New Brighton Pier to the horizon and on the Port Hills near Castle Rock. Sound was also transmitted from Sumner Hills to a tree in Southshore Spit Reserve, an area sinking in saltwater.

Monday, 9 December
— Life after TEZA

Kim Lowe: On Monday last week the Creative Quarter was a hive of activity with volunteers cleaning up the site and having a barbecue. By Thursday it was deserted and New Brighton was back to quiet streets and the usual few souls mostly not wanting to engage. On Sunday both Callum and Ren turned up to take their stretch class but they missed each other by five minutes and there were no other takers. The streets are quiet but the TEZA free wifi is still working. To keep the TEZA momentum going and the spirit of optimism alive, a group of us have decided to get together to make things and keep talking art and issues.

Te Urutahi said that when it comes down to it all, we are just stardust. So if you think of it like that we aren't actually making more stuff, we are just rearranging what is already there. Hopefully the kids will get into it too and get off their screens.

He Maamaa Whenua, Kura Puke and Stuart Foster, New Brighton, November 2013.

Transitional Economic Zone of Aotearoa 2013

At the election, the Fifth National Government secures a third term, supported by confidence and supply agreements with ACT, United Future and the Māori Party // The Conservative Party and Internet-Mana fail to attain 5 per cent of the vote or an electorate seat // The Duke and Duchess of Cambridge and Prince George visit // Nicky Hager's *Dirty Politics: How attack politics is poisoning New Zealand's political environment* is published // A gunman shoots dead two people and injures a third at a Work and Income New Zealand office in Ashburton // The West African Ebola virus epidemic begins // Legislation passes granting Te Urewera the rights of personhood (governed by Ngāi Tūhoe and a Crown board) // Severe flooding damages thousands of properties in the Northland and Auckland regions // Malaysia Airlines Flight 370 disappears over the Gulf of Thailand with 239 people on board // Russia formally annexes Crimea // The Ministry of Women's Affairs changes its name to Ministry for Women // Microsoft ends extended support for Windows XP // The Royal Thai Army overthrows the caretaker government of Niwatthamrong Boonsongpaisan // Malaysia Airlines Flight 17 crashes in Ukraine after being shot down by a missile // Scotland votes against independence // A litre of regular petrol is $2.08 // A litre of milk is $3.69

2014

Please Give Generously

Judy Darragh
13 December 2013–
2 May 2014
Auckland

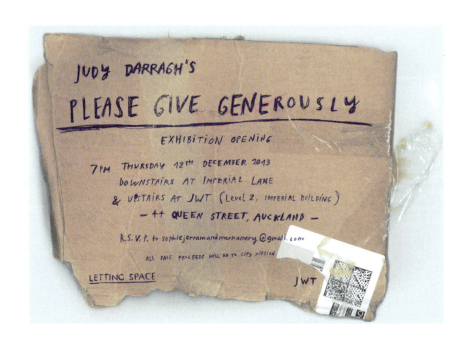

The difference between private commercial property and public space can be paralleled by that between the visual cultures of advertising and art. The two are not supposed to be seen to mix; the truth is more complex. Given that Letting Space was already working outside the boundaries of galleries in vacant commercial spaces, with artists questioning such boundaries, a commission of three temporary projects initiated by JWT Advertising for its new Auckland offices held appeal.

Letting Space sought proposals from a range of artists, looking for projects to exert some positive change beyond the bounds of the company with a nod to advertising's pervasive visual presence in the city. It commissioned works from Judy Darragh, Bronwyn Holloway-Smith and Vanessa Crowe.

The offices were near the bottom of Queen Street, in an area notable for both its high-end retail stores (Gucci and Louis Vuitton) and presence of beggars. A bylaw had recently been passed that allowed beggars who were considered a nuisance or intimidating to be moved on. Just off Queen Street, in the ground floor of the Imperial Lane building, was a newly created accessway.

In this context Darragh's *Please Give Generously* raised questions around generosity and the best ways to support each other. Continuing her habitual use of found materials, Darragh made posters out of repurposed begging signs, purchasing them from people on Karangahape Road.

These were on display in the Imperial Lane accessway. Upstairs in the JWT offices, a large glass vitrine presented a 'china cabinet' of sculpture. Bowls and other receptacles were presented at different heights, held up by eccentric wriggling supports adorned by visual motifs that whimsically evoked the human body.

All these works were for sale, but there were no set prices nor commission taken. Purchase was made from Darragh by 'making an offer' and all proceeds went to Auckland City Mission. Ironically, one of the posters was stolen, then later returned. Darragh likened the act of giving to 'a helping hand' and providing 'a foot in the door', and so the public was welcomed at specified hours to visit the offices.

The still-life genre has often used the motif of bowls and vessels full of the earth's bounty to represent the spirit of living, generosity and the 'fruits of our labour'. In Darragh's work the 'begging bowls' were empty, asking us how we should show generosity to others.

In 2019, Auckland councillors voted to remove references to intimidating behaviour around begging in the bylaw, aiming to minimise safety risks to vulnerable people in public places.

Please Give Generously // Judy Darragh

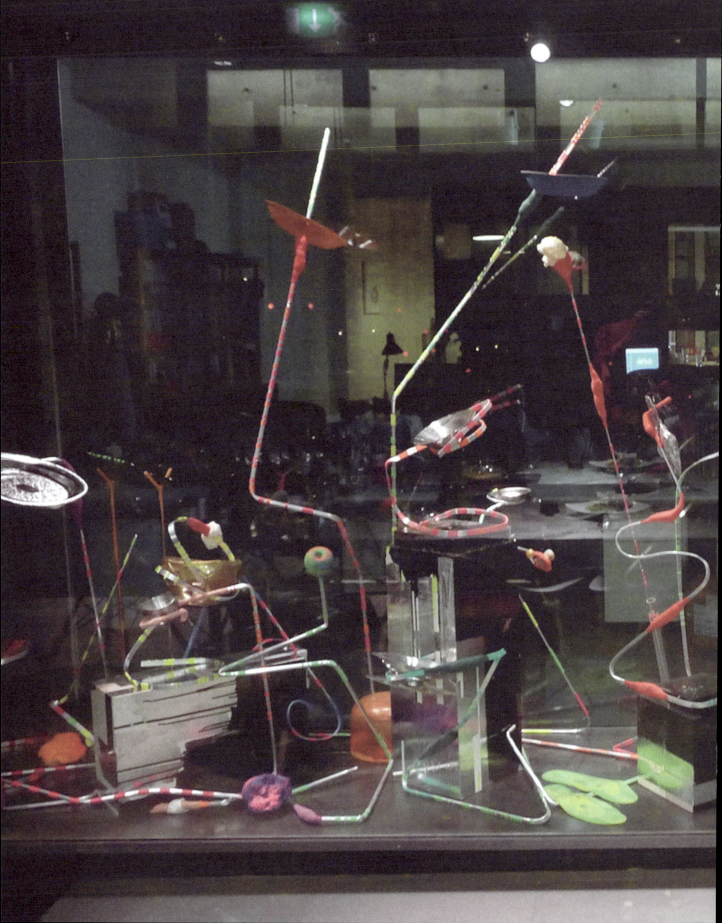

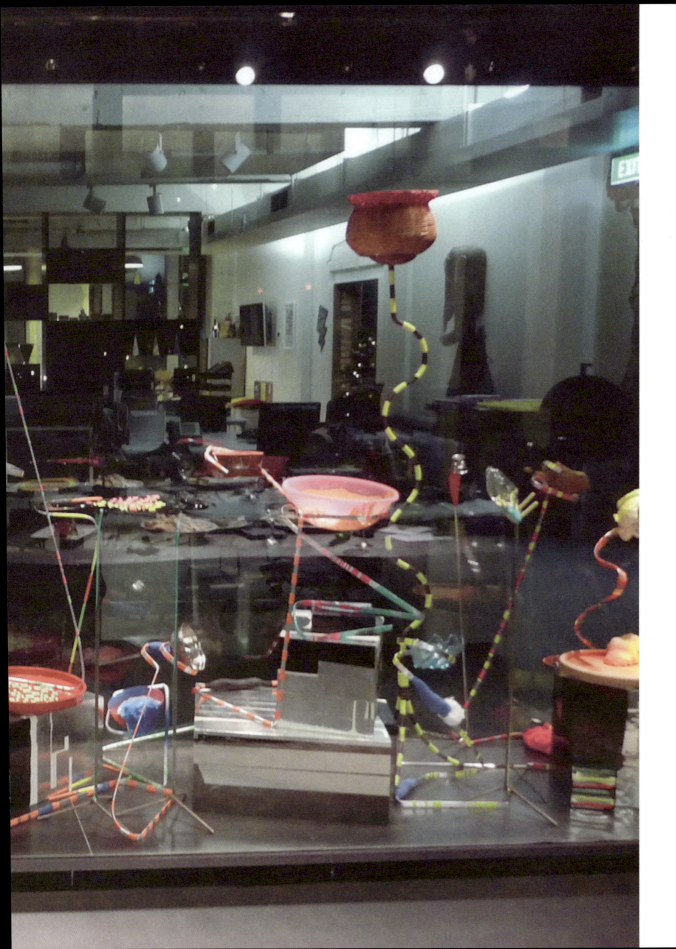

Please Give Generously // Judy Darragh

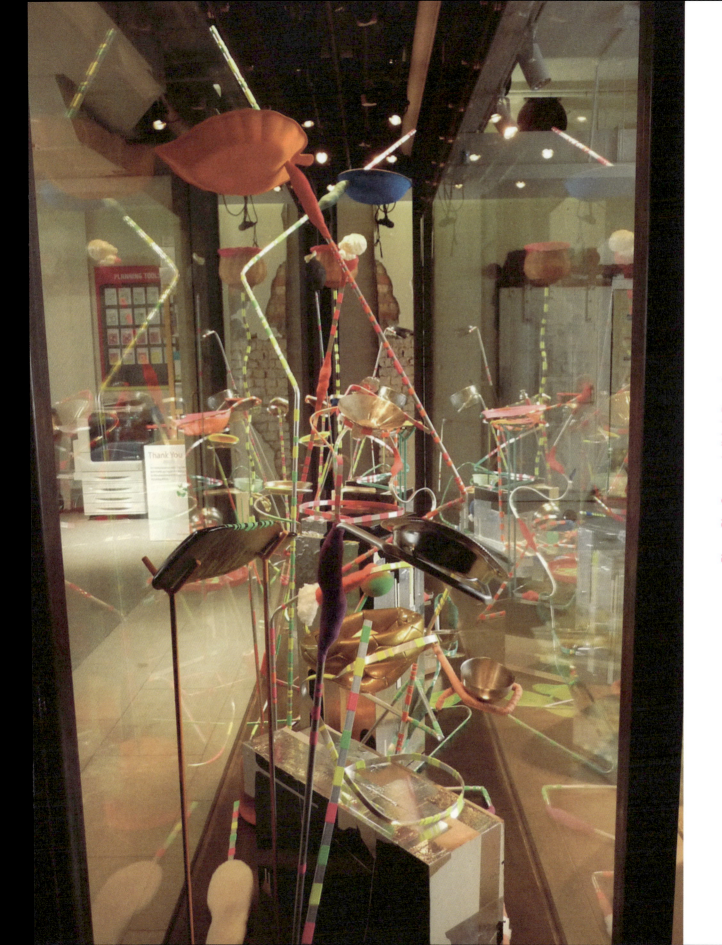

Please Give Generously // Judy Darragh

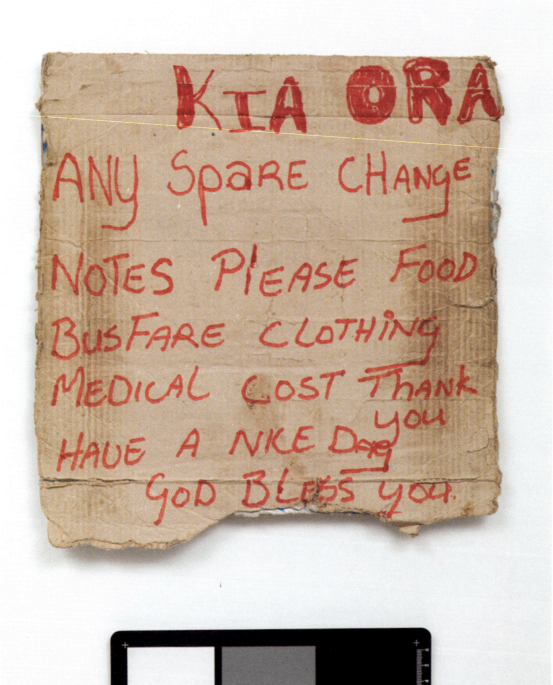

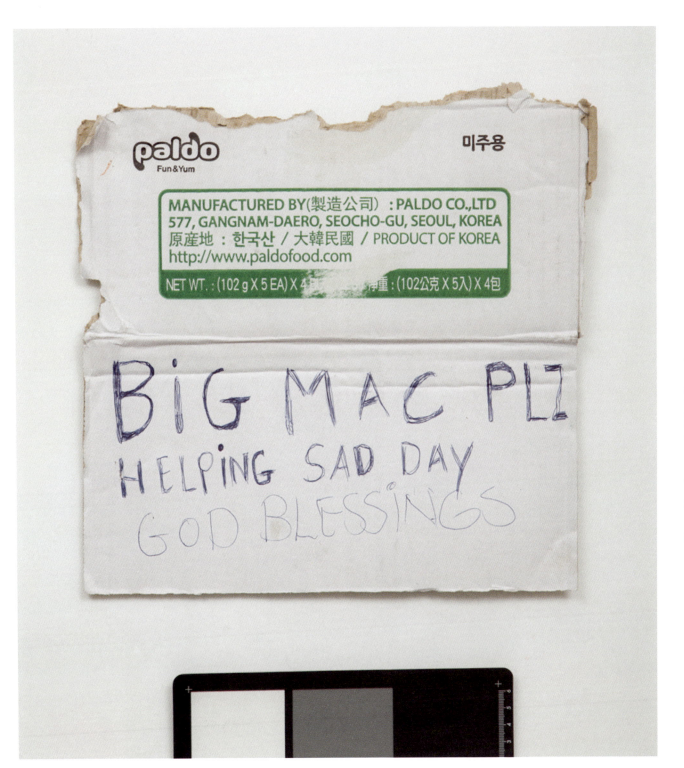

Please Give Generously // Judy Darragh

Te Ika-a-Akoranga

Bronwyn Holloway-Smith
May–October 2014
Auckland

Bronwyn Holloway-Smith led a project to clean, digitise and return to public space a long-forgotten public ceramic mural after she discovered it had been removed and stored in cardboard boxes in a disused telephone cable station near where the cable entered the country at Takapuna beach.

While researching the history of New Zealand's primary internet connection to the world, the Southern Cross Cable (SX), Holloway-Smith unearthed the mural. The work was *Te Ika-a-Maui*, created between 1961 and 1962 by the artist E. Mervyn Taylor for the opening of the Commonwealth Pacific Cable (ComPac). Comprised of 414 ceramic tiles, the mural depicts Māui fishing up Te Ika-a-Māui the North Island. As noted in the *Daily News* on 9 July 1962, 'there was an analogy, [Taylor] thought, between the "fishing up" of New Zealand by Maui and its modern counterpart where the new cable again draws New Zealand out of the Pacific into the telephone systems of the world.'[1]

ComPac was a major submarine telecommunications system following the Second World War, built between 1961 and 1963 to connect a network of Commonwealth countries, reinforcing geopolitical ties. At the time, the cable was a feat of finance and engineering: spanning 22,500 kilometres and containing 17,700 kilometres of telephone cable, it linked Scotland, Canada, Hawai'i, Fiji, New Zealand and Australia. Its establishment was celebrated through public ceremonies in Auckland and Wellington and spawned two films and commemorative stamps. The mural was part of a strategy to engage the public imagination in this major project, financed by the public purse.

In 1984 ComPac was decommissioned, but its now disused landing station remains. The station, and the wall where the mural once stood, is no longer publicly accessible — a high-security fence put to an end to that. Arguably of equivalent public significance (carrying 98 per cent of New Zealand's international internet traffic until 2017), the SX project opted for a more discrete presence in public space.

Playing with the tension between public and private space and physical and digital methods of engagement, Holloway-Smith undertook a restoration project to make the mural publicly accessible once more. Several working bees were held to clean the tiles; participants included Taylor's family. Each tile was then photographed and the images were released online under a Creative Commons licence, enabling those on the internet to reconstruct their own version of the mural. Concurrently, photographic prints of individual tiles were posted to JWT's Auckland office, where trained staff gradually constructed the mural in their glass cabinet, piece by piece, like a jigsaw.

Ultimately, the mural was returned to the public space when reinstalled in Takapuna Library in 2019, a site significant for its proximity to the SX (and ComPac) beach landing site.

1. 'New Zealand Murals', *Daily News*, 9 July 1962.

A Story About the Southern Cross Cable and a Public Mural, 1962–2019 // Bronwyn Holloway-Smith*

1962 E. Mervyn Taylor completed a mural for the New Zealand Post Office. It was installed in the foyer of the ComPac (Commonwealth Pacific) Cable Station in Northcote, Auckland, to mark the opening of the Tasman section of the undersea cable, which entered the country at Takapuna beach.

 The building was open to the public, with a simple visitors' book on hand for those entering the building.

 The Hauraki Gulf Cable Protection Zone, which protects a large area of seabed from fishing and anchoring, was established in northeastern New Zealand's Hauraki Gulf. (Date unknown.)

1984 The ANZCAN cable was laid along the same route from Australia and New Zealand to Canada as a replacement for the ComPac cable.

1987 The New Zealand Post Office became a state-owned enterprise, split into three units. Telecom New Zealand took ownership of the cables.

1990 Telecom New Zealand was privatised and sold to Bell Atlantic and Ameritech. Entries trailed off in the ComPac landing station visitors' book.

 The cable station complex was secured. (Date unknown.)

1993 The PacRim East cable linking Auckland and Hawai'i was laid.

1996 The Submarine Cables and Pipelines Protection Act came into law.

1999 The Southern Cross Cable landed on Takapuna beach. It runs to a cable station constructed next to the ComPac cable station.

2002 The ANZCAN cable ceased operation.

2010 WikiLeaks released documents showing more than 300 foreign sites that are critical to US national interests. The only two New Zealand sites on the list are the two landing sites of the Southern Cross Cable.

2013
March JWT Advertising approached Letting Space to make a series of work for private offices. Letting Space responded with a plan for commissioning three public artworks that traverse both public space and the private zone of JWT offices.

June Bronwyn Holloway-Smith proposed to examine the landing sites of the Southern Cross Cable for her Letting Space commission, as well as to complete a PhD on the same topic.

Aug The artist and Letting Space visited the North Shore, Auckland, including the now security-fenced perimeter of the cable station in Northcote.

2014
Jan–Mar The artist heard that there was a ceramic mural inside the cable station and requested permission to photograph. She was informed that it had been removed due to damage and deterioration.

April The artist located a small colour photograph in Archives New Zealand. After the artist enquired about the remnants of the mural, the Southern Cross Cable Station manager located a set of three cardboard boxes containing the tiles.

	The work was discussed with the E. Mervyn Taylor estate and current assumed owners Telecom. An initial set of tiles travelled to Massey University, Wellington.
	Conservators at the Museum of New Zealand Te Papa Tongarewa viewed a sample of tiles and advised on the best restoration approach. Restoration and digitisation commenced.
May	A fishing dragnet was purchased by the artist. The dragnet is a nod to the Hauraki Gulf Cable Protection Area (the net is the kind used to catch snapper, the most popular fish species caught in the gulf) and, puns aside, made reference to discussions of catch-all internet surveillance.
	The first set of tiles was individually photographed, edited, printed in duplicate and laminated. Negotiation was made to allow the artist to have the remaining tiles relocated to Wellington for restoration work.
	The net was sent to Auckland to be hung tautly by Letting Space project coordinator Harry Silver.
June	The mural unveiling process began, whereby the artist mailed a parcel each week to Kirsten Brown at JWT Auckland.
	Each parcel contained a group of reproductions of the tiles to be hung on the fishing net as per coordinates given. The second set was hung on a net in the artist's temporary studio in Wellington.
	Additional restoration assistance came in the form of a team of volunteers.
July	The artist released a first batch of tiles online, under a Creative Commons Attribution 4.0 International License, allowing the public to share and adapt the tiles for any purpose, even commercially.
Aug	Telecom New Zealand became Spark, thereby removing any nominal ties to the original New Zealand Post Office. The artist continued to release batches. The picture was almost complete.
Sept	Pulitzer Prize-winning journalist Glenn Greenwald, WikiLeaks founder Julian Assange and whistle-blower Edward Snowden took part, via the internet, in an event at the Auckland Town Hall titled the Moment of Truth. Greenwald and Snowden suggested New Zealanders were subject to mass internet surveillance with the full knowledge of Prime Minister John Key. The surveillance was said to take place via a tap on the Southern Cross Cable.
Oct	The JWT-commissioned component of the work closed with a presentation and the reproduction of the complete mural online and in the JWT cabinet.
2018 Mar–Jul	Holloway-Smith's installation *The Southern Cross Cable: A tour* was exhibited at City Gallery Wellington as part of *This Is New Zealand*.
2019 March	*Te Ika-a-Maui* was reinstalled as a public artwork inside the Takapuna library. This location is not far from the cable's landing site and featured the fully restored *Te Ika-a-Maui* mural.

Te Ika-a-Akoranga // Bronwyn Holloway-Smith

** First published on the Letting Space website, September 2014.*

Te Ika-a-Akoranga // Bronwyn Holloway-Smith

A by-election in Northland is won by Winston Peters of New Zealand First // Ted Dawe's book *Into the River* is briefly banned after outcry from a Christian group // Auckland woman Sara Jawadi calls for interest-free loan options for Muslims // Prime Minister John Key announces he will change immigration rules to attract skilled migrants and entrepreneurs // *3 News* presenter Kanoa Lloyd posts on Twitter that it is weird to get weekly complaints about her use of te reo Māori // A mistake by Work and Income New Zealand resulting in benefits being paid a day late for almost 20 years is revealed // A Sikh student having a coffee with his professor is mistaken for a terrorist after earphones are mistaken for bomb wires // Australia's tough new rules on immigration result in hundreds of New Zealanders being detained, and several deported // New Zealand is named as the second-richest country in a global report // A series of massacres in Nigeria kill more than 2000 // Two gunmen belonging to Al-Qaeda kill 12 and injure 11 at the Paris offices of satirical newspaper *Charlie Hebdo* // Ancient city sites in Iraq are demolished by the Islamic State of Iraq and the Levant // Cuba becomes the first country to eradicate mother-to-child transmission of HIV and syphilis // The Health and Safety at Work Act 2015 requires workplaces to look after mental as well as physical health and wellbeing // A litre of regular petrol is $2.11 // A litre of milk is $3.41

2015

Moodbank Wynyard

Vanessa Crowe
18 March–
6 May 2015
Auckland

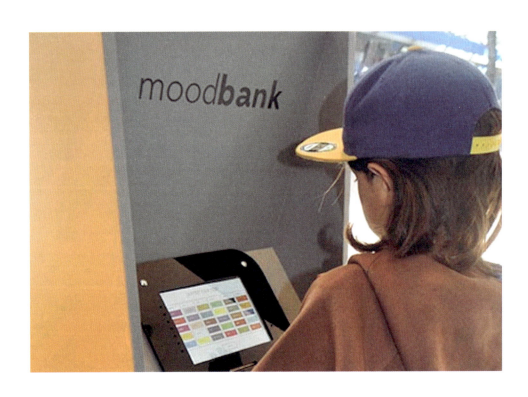

The third JWT commission, *Moodbank Wynyard*, took place on the Auckland waterfront. It was originally developed by Vanessa Crowe and Sarah Elsie Baker in 2013 as an Urban Dream Brokerage project in an old ASB Bank facility on Manners Street, Wellington. With the help of corporately dressed banking staff, and featuring bespoke *Moodbank* furnishings and design, visitors could visualise, deposit and exchange emotions to create a wall map of drawn feelings. The public also contributed submissions online to help build a database of the city's mood.

Moodbank enabled the public to creatively explore the complexity and colour of their emotions by naming them, drawing them and depositing them, physically with bank tellers and digitally through an ATM. The *Moodbank* website allowed the public to make online deposits. The project was also advertised on the electronic New Zealand stock exchange ticker that wraps around the NZX building — likening shifts in our collective mood levels to the fluctuations of stock prices.

The project began at a time when contemporary consumer culture was increasingly interested in tracking people's moods to help sell them products.

For the Auckland work with JWT, Crowe initially developed a proposal for their Queen Street offices. However, this ran into a conflict of interest with one of the advertising firm's clients, Sovereign Insurance, for whom a 'NZMoodmap' campaign had been developed — the very project that reflected the corporate consumer mood-tracking concerns that had inspired Crowe and Baker to create *Moodbank* in the first place.

Moodbank Wynyard was located in the Wynyard Quarter, a newly designed recreational, residential, business and hospitality area. A site at the heart of Auckland's attempts to create a new downtown image, it proved an interesting intersection for observing the city's simultaneous interest in business and community development. *Moodbank* operated next to the Wynyard Quarter kiosk, which provided information on events, facilities and new housing, the colourful multi-storey ASB Bank building looming behind.

The project employed the database of more than 1000 moods collected in Wellington. As well as the *Moodbank* ATM, a display of graphs and deposits played in a gap in a shipping container previously provided for an ATM machine. Here, Wynyard's moods were shared with its community.

Crowe went on to produce *Moodbank Aotea* with the support of the Aotea Centre and Digital Art Live in Auckland, and *Moodbank Whangārei*, in 2016, supported by mayoral candidates Ash Holwell and Matt Keene. In 2021 the ATM machine returned to Wellington for three months as part of Urban Dream Brokerage youth commission *Commonspace*.

Since *Moodbank* was first developed, banks have increasingly encouraged the use of online apps and EFTPOS to conduct digital transactions and New Zealand banking. In 2021, *Consumer* reported that 366 bank branches had closed nationally between 2010 and 2020.[1] In the year 2020 alone, 84 branches and 249 ATMs were closed.[2]

1. Nikki-Lee Birdsey, 'Bank Branch Closures: Are banking hubs the answer?', *Consumer*, 5 July 2021, www.consumer.org.nz.
2. Rob Stock, 'Big Banks Close More than 460 ATMs and Bank Branches over 18 Months', Stuff, 27 June 2021, www.stuff.co.nz/business.

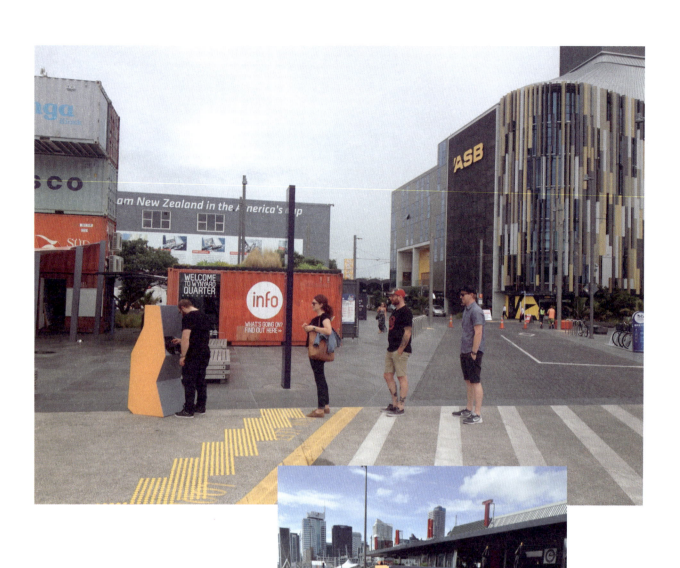

How Do You Feel and What Is It Worth? //
Vanessa Crowe and Sarah Elsie Baker*

Vanessa Crowe and Sarah Elsie Baker: The story of the *Moodbank* began in Sarah's office when we started talking about domestic life and how certain practices made us feel: how cleaning could sometimes be a torturous chore and at other times a cathartic experience. Vanessa reached into her bag to grab her laptop and opened a document in Illustrator in which she had been colouring a grid according to her daily activities and how those tasks had made her feel. Vanessa reflected on how the process had helped her deal with the range of emotions she had been experiencing in her daily life. We thought about how it would be interesting to get other people to complete a similar activity and see how they felt.

Over time we talked more about how commercial organisations and governments were becoming interested in emotion, but also about how the grid that Vanessa had drawn was a much deeper engagement with mood than those in the commercial realm.

We began reading more about emotion and cultural contexts, as well as observing how mood was created in city environments. We looked at how moods were established through aesthetics in bank interiors, observing the conventions and processes of exchange. We speculated on trends in contemporary industrial, graphic, interior and critical design and observed the overlaps with contemporary art practices. In particular, we were influenced by Emmanuelle Moureaux's design of the Sugamo Shinkin banks in Tokyo and a colour palette pulled from a trend-forecasting page. We decided that we wanted to create a strangely familiar experience, one that positioned the visitor in contemporary consumer culture as well as taking them outside of that culture in order to encourage reflection.

Sarah: Contrary to most narratives of modernity, emotional life was always central to capitalism. It was in the early twentieth century, however, that emotion became a conscious object of knowledge in the realm of economic production and consumption.[1] The emotional wellbeing of employers started to be seen as a route to greater efficiency, and the emotional desires of consumers were thought of as key to the promotion of goods. While much has been written about both these areas, less research has focused on the emotional labour of 'citizen-consumers'. For example, how appropriate and inappropriate emotions are produced and managed in the spaces of consumer culture.

In the process of planning the project a number of events confirmed that our focus on the value of emotion was both timely and necessary. The Bank of New Zealand started to use face-mapping technology to predict financial behaviour according to the emotional responses of their customers. Whether it was a marketing gimmick or more sinister, spy-like software, the existence of the BNZ EmotionScan highlighted why it was so important to reflect upon the commodification of emotion.

After confirming funding with Wellington City Council for the first iteration of *Moodbank* in collaboration with Urban Dream Brokerage, the council generously said that it would negotiate with the New Zealand stock exchange to see if we

1. Eva Illouz, *Cold Intimacies: The making of emotional capitalism* (London: Polity Press, 2007).

could post data from the Moodbank ATM on the stock market ticker in Wellington. I was surprised that NZX would even consider the idea. Less surprisingly, NZX decided that it did not want 'negative' emotions on the ticker, feeling that the stock market should be associated with 'positive' feelings.

This reaction reinforced much of the reading I had been doing at the time, particularly the arguments of Sara Ahmed in *The Promise of Happiness*.[2] Ahmed writes of how in many Western nations the discourse of happiness has become prevalent. For example, there is now a UN International Day of Happiness and a world database of happiness. In New Zealand a study at the University of Canterbury attempts to measure 'gross national happiness' instead of 'gross domestic product'.[3]

While happiness studies attempt to go beyond economic productivity and have a focus on sustainability and wellbeing, Ahmed argues that they reproduce a number of problematic assumptions. She writes that happiness research is problematic because it assumes happiness is 'out there' and can be objectively measured. It presumes that if people say they are happy, they are happy, that self-reporting is uncomplicated, and that feelings can be conveyed by language alone. It does not allow for ambivalent feelings, and infers that negative or neutral emotions are not as valuable as positive ones. This is highly questionable; many political movements have struggled against the hegemony of happiness rather than for it.

While government research into wellbeing has become more varied, the continuing prevalence of positivity underlines the way that neoliberal governments often reinforce capitalist agendas of growth. So, to counteract the 'hegemony of happiness', Vanessa and I decided that we wanted to acknowledge all emotions equally at the bank, to use visual methods, and to allow customers to deposit contradictory emotions at the same time.

Social networks such as Facebook and Twitter have become the perfect spaces for market research focused on emotion and sentiment analysis, and there is now a wide range of software designed to measure attitudes. This turn to measuring and causing affect by commercial organisations has been called 'affective capitalism'.

///

Vanessa and Sarah: Soon after the Wellington branch closed in March 2014, Vanessa was invited to present a *Moodbank* project as part of a commission by Letting Space and JWT Advertising in Auckland. The brief asked for a project that would engage with the public commons in the Imperial Building on Queen Street, where the JWT office is located. We proposed a project titled 'Imperial Moods' that would situate the Moodbank ATM on the first floor of the Imperial Building, so that building users could deposit their moods and in turn find out how other people within their building were feeling, hopefully creating a sense of communal exchange and opportunity for reflection in an otherwise busy space.

Vanessa began working on a new Moodbank ATM interface that allowed users to choose from the entire catalogue of 1016 moods collected from the Wellington branch.

In a meeting soon after the project was given the go-ahead, it was

[2]. Sara Ahmed, *The Promise of Happiness* (Durham: Duke University Press, 2010).
[3]. 'UC Investigating NZ's Gross National Happiness', University of Canterbury, 16 April 2013, www.canterbury.ac.nz.

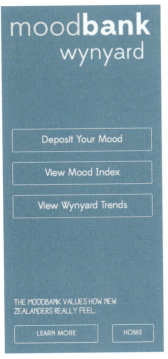
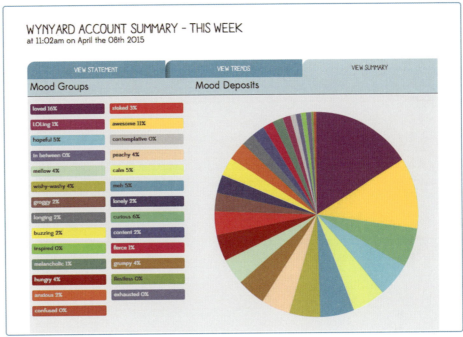

mentioned that Sovereign Insurance had just become one of JWT's clients. Similarities between Sovereign's NZMoodmap campaign and the *Moodbank* concept and aesthetic were noted.

 For us, the launch of Sovereign's NZMoodmap was interesting in that it validated our position that mood and finding out how people feel is of value. However, NZMoodmap's 'happiness hotspots' provided an example of how value (ultimately economic value) is assigned to happiness over and above other experiences.

 The premise of 'Imperial Moods', on the other hand, was to offer another angle to the growing discourse on mood value, countering our cultural hunger for happiness with an abundance of other feelings. JTW pulled the Imperial Moods Project to avoid upsetting their new client, but they still agreed to fully fund *Moodbank Wynyard*.

** First published in Vanessa Crowe and Sarah Elsie Baker,* Moodbank: How do you feel and what is it worth?, *March 2014.*

Projected Fields

Siv B. Fjærestad
From 19 April 2015
Wellington

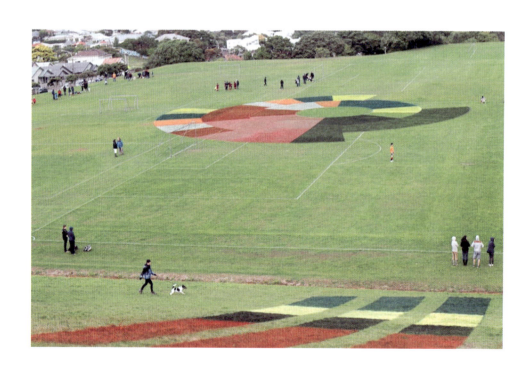

Projected Fields enabled the creation of a site-specific field painting laid over large parts of Macalister and Liardet Street parks in the southern suburbs of Te Whanganui-a-Tara Wellington. This painting provided a backdrop for performances and actions inspired by activities in the park and, for residents on the hills above, a literal landscape painting hanging outside their windows.

Playing fields and parks are common ground for a range of public activities, organised and unorganised. *Projected Fields* involved contributions from local communities, sporting groups and businesses, seeking to extend what we consider painting and public art to comprise. It asked questions about who and how we use our public commons.

Artist Siv B. Fjærestad worked with Letting Space to conduct surveys with park users over many months, setting up physical survey pick-up points and hosting a coffee caravan during sporting fixtures. Looking to reach out to the diverse communities of park users and surrounding neighbourhoods, Fjærestad gathered both statistics and stories (many hosted on a *Projected Fields* blog)[1] to help inform her visual language for the project.

The history of the site was referenced by an undulating line marking a buried stream and a block of colour revealing the foundations of a former fever hospital. As if the groundsperson had got creative with their painting machine, the visual language of the work explored the field markings seen on recreational grounds, overlaying textures, perspectives and representations of natural, human-made and digitally rendered scenery.

Projected Fields considered how human systems such as sports field markings, paths and signage enable, limit and otherwise choreograph our movements and actions in parks and commons areas. 'Grass is a social material,' wrote Fjærestad. 'It is probably the most common natural material and source of experience in every community throughout New Zealand. The sports ground and commons present a different and interesting playing field for making art because it is governed by how various communities, clubs and individuals use it. The park is perceived, used and interpreted differently at different times of the day and week.'

The project also featured a huge community picnic, with everything from field-painting trials and a dog-walking parade to a history booth, Zumba, tai chi and the team game kī-o-rahi extending uses of the park. And, unlike most temporary public art projects, *Projected Fields* remained in place for many months, slowly fading and complicating the field markings for players during the winter football season. Recreation and art mixed.

1. Projected Fields, https://projectedfields.wordpress.com.

Draft of field painting plan for *Projected Fields*, Wellington, 2015.

Landscape Painting // Kerryn Pollock*

Present

In 2015, attentive travellers moving along Adelaide Road — a major arterial route connecting Wellington's inner city and southern suburbs — would have noticed a series of enormous paintings on the grass of Macalister Park, Berhampore. Like colourful crop circles, precisely measured and laid out, they appeared on the slopes and playing fields of the connected Macalister and Liardet Street parks during a grey week in April. Unlike crop circles, they were not the work of alien visitors from outer space or more terrestrial beings with a penchant for mystery; rather, an artist, Siv B. Fjærestad and her team of volunteers made them.

Projected Fields took Letting Space out of buildings and into the 'burbs. It was born out of Siv's time in 2012 living near the parks, walking there each day with her young son and two dogs. She watched how people used the parks and navigated their way through their varied topography. She observed how the painted marks outlining the boundaries of sports fields often determined where people walked, as if they too felt obliged to adhere to the rules governing football and cricket. Dogs and children meanwhile had no such self-imposed restrictions, ranging wherever they chose.

Macalister and Liardet Street parks provide a layered landscape of flat playing fields, grassy slopes and hills threaded with bush. Siv noted the way that painted lines glimpsed through a view shaft between trees or truncated by the brow of a hill became divorced from their sporting origins, no longer simply denoting a rigid boundary over which a foot must not step or a ball fall, but carving up the landscape in a more abstract way. Marks and shadows cast by trees and clouds added natural shapes to the mix.

During the winter months, walkers left their footprints in the dew-laden fields. Those with a particular destination beat a straight trail as they short-cut across the grass; others out for a wander left a more serpentine line.

People's paths brought to Siv's mind English artist Richard Long's *A Line Made by Walking*, a seminal work of land art made in 1967. Long trudged up and down a field in a straight line, flattening the grass and creating a distinct, if temporary, impression of his path through the field. His intervention gained a form of permanency when he photographed the line.

Taking its lead from these lines, Fjærestad's *Projected Fields* sought to capture in visual form the myriad ways people used the parks, present and past. Fjærestad began by gathering information from users of the park both in situ and online: what types of activity they did at the park, at what times. This produced data sets that lent themselves to graph-like representation on a grand scale. Giant pie charts painted on to the grass indicated how often respondents used the parks and what new activities and events they'd like to see held within them. A stacked bar chart on a steep slope at Macalister Park's northern end revealed how much time a typical couple with young children spent on unpaid work and leisure activities. The bar chart looked like a huge slide, referencing a favourite community activity on the slope: whizzing down it on flattened cardboard boxes and Corflute signs.

Other paintings told of past uses and hidden features: sombre brown blocks laid over cricket pitches marked where a plague hospital had been built in 1900; the line of an underground stream was traced from one end of the park to another. It probably didn't matter if viewers were not immediately aware of what exactly the paintings signified; the lines and shapes were intriguing and encouraged further investigation.

Just as intriguing were the things the paintings didn't record. A survey is a good way of eliciting information and stories, and it produces an organised set of data that lends itself to the kind of visual exploration *Projected Fields* was, but it has its limitations. Only people who like doing surveys will participate and, unless they are unusually frank, they'll only share the stories they want to tell.

Question four of the survey said: 'Please tell us a story: this could be a positive experience or happy or meaningful memory from the parks. It could be yesterday or from childhood. It could be an anecdote about the parks or the people who use them, or a reason why you feel these park areas are important to you or the larger community.'

The question asked for affirming stories and memories, things that stuck in the mind and provoked a smile when recalled. 'Meaningful' doesn't have to mean positive, but the celebratory tenor of this question encouraged people to share the good times. Public parks are important to people because they provide an accessible space for enjoyable recreational activities. They facilitate togetherness by hosting sports games and community events. They are precious public resources open to all. They are also a venue for illicit activities, hinted at by broken booze bottles and used condoms. Parks are sometimes forbidding places at night, low on lighting and full of darkness and menace. Fun can be had in the dark, but so can bad times.

Projected Fields didn't set out to tell these darker stories — the fundamental intent was to celebrate the parks as public commons — but they are the flipside to tales of scoring the first goal of the match and games of hide-and-seek.

The project culminated in a community picnic in April 2015. A large crowd turned up on a windy but sunny day to join a dog walkers' parade, watch a tai chi demonstration, fly a kite, listen to poetry, do Zumba, share memories at a history booth and learn how to play kī-o-rahi, a traditional Māori team game, which a central design was inspired by. The paintings were walked on, sat upon, run along and cartwheeled over, subverting the do-not-touch rule of most art in galleries. Just prior to the picnic, they survived an accidental mowing by a council tractor, an incident a little reminiscent of the time Damien Hirst's installation of coffee cups and full ashtrays was tidied away by a London gallery cleaner.

Projected Fields' closing date was open-ended, contingent upon the action of the weather. The paintings faded as autumn turned into winter. Some were churned out of existence by football boots when winter sports returned to the park; others in quieter areas slowly dwindled to nothing in the wind and rain. The parks eventually returned to their usual state; the paintings that told some of their stories were a moment in time that passed.

Projected Fields community consultation and field painting tests, Wellington, 2015.

Past

Coincidentally, *Projected Fields* happened at the same time that nearby Berhampore School was commemorating its centennial. I was part of a group researching the suburb's history for a book. The fever hospital depicted in the work was one of my discoveries.

A friend, surveyor and history enthusiast Ben Zwartz, volunteering on *Projected Fields*, told Siv about the hospital. Overlaying an old survey map over a Google map of the parks, we worked out exactly where the hospital had been. In painting its footprint, Siv activated our discovery in a far more tangible way than merely writing it up in a book could.

The painted outlines of the hospital opened a window into an unexpected past. Some may have wondered what other stories the parks had to tell. Like an anniversary, *Projected Fields* provides an opportunity to tell some of these.

Macalister and Liardet Street parks lie on the lower slopes of the Tawatawa ridge. Few know the ridgeline by this name anymore. Before Pākehā settlement it was partially clothed in native forest and used by Māori as a bird-hunting ground. The lower section of the ridge became part of the town belt when Wellington was founded in 1840, preserving it from development, though not from deforestation.

Berhampore started its transition from farm to suburb in the late nineteenth century. What is now park was a scrubby, open wilderness. The fever hospital was built by the council in 1900 after bubonic plague reached New Zealand. Berhampore was still in Wellington's hinterland. Going by horse or foot along imperfect roads were the only forms of transport.

The plague never even made it to Wellington. Victims of other infectious, but more commonplace, diseases were treated at the hospital instead, as were injured soldiers during the First World War. Later, the shabby buildings were rented cheaply by local families. They were knocked down after a fire in 1929.

Berhampore boomed in the 1900s and grew full of working-class families, whose children extended their playtime range well beyond their backyards. They roamed throughout the town belt when not at school, only coming home for tea in the evening. The land was criss-crossed by streams running down from the ridge, their waters full of eels, freshwater crayfish and watercress.

The underground stream traced in *Projected Fields* hinted at this watery past. One stream ended in Stanley Street, just below the present-day parks. Kids dammed the stream with rocks and branches, making small pools on which to sail toy boats. All of Berhampore's streams are now gone, many encased in pipes and transformed into stormwater drains. The boggy parts of the golf course are all that remain above ground.

In this way we have a drain that was once a stream — a natural feature turned into a piece of civil engineering. The parks themselves have their genesis in a similar act of transformation. In 1940, a large rubbish tip was constructed on the town belt next to Liardet Street. The land there was hilly and cut through by a deep gully. A stream ran along the bottom of the gully and horses were grazed on its slopes. It was nothing special, but the locals are unlikely to have welcomed the council's decision to put a tip, with its attendant smells, rats and methane fires, there.

During the Second World War, American soldiers were stationed in Wellington. Before they left in 1944, they dumped a load of unwanted military

equipment in the tip — treasure for local scavengers who were used to picking over more mundane rubbish. Even more unlikely was another deposit of 1944: the body of Nellikutha, a Wellington Zoo elephant.

The 'Bradford system' of municipal waste disposal was used at this tip. This involved dumping rubbish into a gully, squashing it down and covering it with soil. This created a flat, ComPact surface that could eventually be turned into a park. The tip was closed in 1950 and Macalister Park, named after former mayor Robert Macalister, opened for play in 1957. The top part below Vogeltown became known as Liardet Street Park.

For 30 years, play was undisturbed. Then, one morning in April 1987, a groundsman turned up for work to find a huge sinkhole around 9 metres deep had suddenly appeared in the middle of a football field at the Liardet Street Park end — right where the tip used to be. Old tyres and bricks protruded from the crumbling walls of the shaft. The weather was bad and the hole grew deeper in the rain. Council engineers concluded it was caused by a collapsed stormwater drain, but suspicious locals blamed the council for allowing development over a tip. Houses next to the park had subsided in previous years and one owner was paid compensation by the council. No more sinkholes appeared, however, giving credence to the engineers' report.

The parks were also the site of an event that exposed a different sort of gulf. Macalister Park was directly across the road from Athletic Park, the home of Wellington rugby and a favoured site for anti-apartheid activism during the South African rugby team's tour of New Zealand in 1981.

The second test was held at Athletic Park on 29 August 1981. Berhampore's surrounding streets were blocked with rubbish skips and the Adelaide Road side of Macalister Park was blocked with a dense thicket of barbed wire. Protestors gathered on Finnimore Terrace at the top of the park and made their way down through the trees to Adelaide Road. Police with shields and batons were waiting for them on the other side of the wire. The protestors pulled out the waratahs holding up the fence and trampled over the wire in a great mass, spilling out onto Adelaide Road. This is what those who were there on that historic day remember when they think of Macalister Park.

///

Landscapes are composed of layers, seen and unseen, remembered and forgotten. They host human stories that become layers of history as time passes. *Projected Fields* linked landscape with memory. It played on the idea of layers in a literal sense — paint was applied again and again until the earth was thickly coated with bright colours. It also became a layer of history itself, another story to be recorded and then rediscovered in the future.

By encouraging viewers to seriously consider what it was they loved and valued about these parks, *Projected Fields* perhaps acted like an aide-mémoire for the future, cementing in the mind favourite activities and new ideas that might otherwise have been forgotten. It both recorded memories and created new ones. What will the children who played on the painted grass that day in April 2015 remember about this place when they are grown up?

Projected Fields // Siv B. Fjærestad

*First published on the Letting Space website, April 2016.

Transitional Economic Zone of Aotearoa

21–29 November 2015
Porirua

Porirua People's Library, Kerry Ann Lee,
Porirua, November 2015.

In 1945, the government shifted its state housing development focus from the Hutt to Porirua, planning for it to be a satellite town for Wellington. Growth was so rapid that by 1965 Porirua had achieved city status, with a corresponding growth in industry and a Pacific Island population. It had quickly become the second-largest Pacific city in Aotearoa. Porirua today is characterised by its young and very diverse population, and also by its extremes. Across its different suburbs it has some of the Wellington region's highest and lowest income earners.

Mana whenua in Porirua are Ngāti Toa Rangatira, who signed a Treaty of Waitangi settlement with the government in 2012, claiming the return of land on which they have since commenced development. Previously, land reclamation to build the new city centre and sewage outflow, including from the nearby old Porirua Psychiatric Hospital, caused significant damage to the harbour, an important food resource for iwi.

By 2015, the city centre's main shopping area Cobham Court (opened in 1966) was widely acknowledged as lacking vibrancy, with many vacant shops, little community space and a predominance of loan shops and discount stores. Like many similar-sized urban areas nationally, it had been decimated both by the rise of big-box retail development on the inner-city fringe and the concentration of retail in the 1990s into the enclosed North City Shopping Centre, owned by an Australian private investment organisation.

In early 2015, Local Government New Zealand suggested 'special economic zones' could be created around provincial towns to help regional development and commissioned a report. At the same time, Letting Space declared Porirua its second Transitional Economic Zone of Aotearoa (TEZA). Early in the year, Letting Space developed relationships with social enterprises, community organisations and artists spread around the city, connecting these groups and individuals to artists from the wider Wellington region to create projects. Following hui at Takapūwāhia, Cobham Court and Maraeroa Marae, a new network developed projects over the year, focusing on social innovation, collaboration and alternative forms of exchange.

In June, Letting Space established a satellite Urban Dream Brokerage programme with support from the Porirua Chamber of Commerce, working to place a dozen local projects into vacant Cobham Court properties. This included a temporary Pacific village workshop and presentation space, representing different Pacific Island groups over a six-week period and run by Strong Pacific Families; and Toi Wāhine, a Māori women artists' space, which ran for several years. These and the TEZA projects often utilised a rabbit warren of spaces owned by the property group that runs the neighbouring North City mall.

In August, Letting Space took possession of a large two-storey property in Cobham Court, brokered through the Urban Dream Brokerage mechanism. Between 1976 and 2009 it had been the site of New Zealand's first McDonald's restaurant — many Porirua residents remember 'Happy Meal' childhood birthdays here. It is now a Cobb & Co. In the absence of a signposted community centre in central Porirua, Letting Space advertised it for open community use for workshops, talks, coffee groups and exhibitions.

During the TEZA week in November, more than 40 workshops, performances and events were hosted around downtown Porirua, centred around a busy former bar space in Cobham Court. Projects included Jason Muir and Barbarian Productions' hair salon, which offered free cuts in exchange for conversation, and Vanessa Crowe and Jennifer Whitty's *Sharemart*, which featured a pink catwalk upon which to strut upcycled creations made with local seamstresses. Tim Barlow established a mobile 'quick response' community centre while Kerry Ann Lee initiated *Porirua People's Library*, its collection built up of local stories gathered in workshops by Pip Adam, Sarah Maxey and others.

Under the direction of David Cook, young photographers from Whitby and Cannons Creek schools worked together to share their visions for the city. Paula MacEwan ran citizen funeral workshops and Kāwika Aipa provided workshops on healing, including lomilomi (indigenous Hawaiian massage). Artist Ash Holwell swapped roles every day for a week with Porirua residents ranging from local MP Kris Faafoi to a Mana College student.

 Discussions were held at lunchtimes and in evenings, drawing together local, national and international thinkers, both at the hub (where artists worked in teams to host the public, provide food and run a media centre) and key local spaces. The events of each day were again documented by writers, editors and photographers for the online TEZA Transmission.

And the week ended with two busy festivals developed locally over the year: the Tītahi Bay Boatshed Festival and the Conscious Roots Festival at Hongoeka Marae, which both ran again the following year.

Art or Community Service // Reuben Friend*

Reflecting back on my childhood, it pains me now to say that I am from 'South Auckland'. Not because of any shame or middle-class desire to distance myself from my past, but because it feels like a cliché, as if succeeding in any given industry is somehow more miraculous coming from a certain part of town.

I know that today I am very fortunate to be where I am, happily perched in my alabaster alcove, my white-walled and glass-encased director's office, looking out the window at the visitors entering our beautiful cultural facility here at Pātaka Art + Museum in Porirua. That is, until this morning, when I heard breakfast TV host Paul Henry ask award-winning Tītahi Bay opera singer Amelia Berry how she had managed to become so successful, having come from 'Porirua' . . . and once again the familiar 'provincial cringe' pinches at my side. What is it about labels that makes their stigma so hard to overcome?

I remember Peter McLeavey, the late legendary Wellington art dealer, speaking to me about this once. He recalled a story from many decades ago about two Mongrel Mob members from Porirua who somehow ventured into his Wellington art gallery during the installation of a McCahon exhibition. Upon entering the gallery, these burly Māori men were instantly taken aback, as if somehow repelled from the gallery by an invisible cultural forcefield. Or perhaps it was more like an economic electric fence, one that delivered culture shocks, striking the heart with the fear of feeling out of place. From this experience McCahon created the infamous *Am I Scared* painting, inscribing on it a message (scared, eh boy?) that still rings true to me.

Today, I see a very different cultural dynamic playing out here in Porirua. Today at Pātaka, the wealthy white businessmen sit comfortably in their suits, sipping short blacks, beside a group of leather-bound blacks happily sipping their flat whites. Boombox-wielding youngsters practise their pre-rehearsed freestyle cyphers, shuffling blissfully past John Key's bodyguards on security detail ahead of the prime minister's breakfast here.

Despite this breaking down of boundaries and barriers, there remains a stubborn, persistent attitude that Porirua is somehow less. Much like 'South Auckland', it is not the label 'Porirua' that pains me. I'm cool with the label. But I'm more than ready to do away with the baggage and assumptions that take 'realistic expectations' and twist them into a passive-aggressive euphemism for 'knowing your place'.

Porirua is a young, burgeoning city. Close to 20 per cent of the community is under the age of 25 and our much-loved mayor and deputy mayor are both well under the age of 40. At only 50 years of age, this city is home to an eclectic mix of culturally and economically diverse communities. Here long-established family homes in Waitangirua and Cannons Creek sit nestled in among the newly minted, white-cubed subdivisions of Whitby and Grenada North.

While many of the industries upon which this city was founded have long since closed or shifted shop offshore, the new influx of residents and industries beginning to take root here signals a positive revitalisation of the city centre and suburbs. Overall, there is a very real sense of a dynamic community with as many strengths as problems.

Above: Formerly New Zealand's first McDonald's, Porirua, November 2015.
Below: *Young Visionaries*, David Cook and Leala Faleseuga, Porirua, November 2015.

Despite this cultural and economic milieu, provincial cringe clings to the label 'Porirua' like tissue paper caught in the wash. No matter how many cycles it goes through, the fluff finds a way to linger longer than expected on one's attire. If you live with the fluff long enough, though, you learn to pay it no mind.

I've been rocking the 'fluff' here in Porirua for the past few years, and one of the biggest things that hits me every time I come back home from overseas is the dilapidated state of the Cobham Court shopping area — an area affectionately referred to as 'the Canopies', despite the recent removal of the actual canopies.

Synthetic cannabis hit the area hard a few years ago and the outside mall shopping area took a major dive. Begging for spare change to feed addictions became commonplace and many shops folded with the decline in cashed-up clientele. We now have a reef of washed-up 'vacant' stores that ooze with a palpable sense of disheartening dereliction. Visually and emotionally, it weighs heavy on the hearts and minds of our community, becoming one of the major points of contention in the neighbourhood over recent years.

The centre is now undergoing a major redevelopment which local business owners are hoping will encourage higher-profile stores and clientele back into the city centre. Much like the McCahon situation at McLeavey's, hopes and anxieties run high on both sides of the economic fence.

///

In the middle of this maelstrom, some sophisticated strangers strolled into town. Riding abreast their award-winning reputation for complex and innovative urban art projects, they strode into the city centre with a gusto that took much of the community by surprise. The Letting Space team brought with them their much-admired philosophy of 'social agency' and 'anything-can-be-art'. On arrival, they managed to stir up difficult conversations that many stakeholders are either too polite or too politic to discuss on the public record.

For the past month I've been absolutely fixated on these outsiders — these lovely Pākehā outsiders — working their magic in and on our community.

I've been a fan of Letting Space since first visiting Tao Wells' *Beneficiary's Office* in Wellington, only to be greeted with a sign reading 'Off to play golf'. The Porirua iteration of the Transitional Economic Zone of Aotearoa project has been a welcome, albeit often confusing, chance for our community to come together to talk about our favourite subject, ourselves. Much like a close friend who's too close to your situation, sometimes a friendly stranger is just what you need to get some perspective.

With the TEZA team initially claiming as their base the abandoned McDonald's building in Cobham Court — a building rich in resonance; the symbol of a once-thriving community centre — an interesting development occurred. Art providers and community service providers, art audiences and community members began to overlap. Social agency through art and community activation is not a new proposition for art insiders, but the concept of art–community collaboration fell awkwardly on our community, like a club-footed runner in a three-legged race.

During the launch of the Porirua Urban Dream Brokerage at Old McD's (as it is nostalgically known in the community), I witnessed a great turnout from

our community — a mix of artists and social agitators, all gathered to help make positive change. As heartening as this sight was, I had a real sense that the overarching project was lost on most of those in attendance. Many people I spoke with didn't understand how the project constituted art. Old chestnut expectations of paintings on walls, sculptures on plinths and 'traditional' weaving on display loomed large in the minds of those present, many of whom pulled me aside, asking me to explain the project to them. As conversations revolved around the room, it became abundantly clear that most of the people who attended this event were from social service providers — those members of our community offering food, clothing, shelter and financial assistance under the umbrella of charities, social welfare groups and government assistance agencies — with only a sprinkling of artists and activists in the mix.

My initial hunch was that these groups perceived the project not as art, but as a place where gambling addiction groups, food distribution agents and other well-meaning providers could meet for free to work in the community. When Old McD's was reincarnated as a project site, the events that took place there failed to excite the wider community. Still half-confused about the project in general, members of the community offered me bemused commentary — oh yes, they had noticed people shuffling around the still half-empty, still-rundown construction-site-of-a-building. There was an exhibition by a Korean artist in residence, a wearable art show and an inhabitation by Te Wānanga o Aotearoa, but these failed to convince the stakeholders, and Old McD's closed its doors to Letting Space.

Store owners chimed in, concerned that some of the community art activities taking place in the newly established TEZA venues were exacerbating the unrefined, construction-like feel of the area. The retailers want higher-profile stores moving to the area to encourage more business and foot traffic. The community also needs increased business, to provide jobs and pay council rates so money can be funnelled back into the community.

///

Having spent the past few weeks coming in and out of various other TEZA projects hosted in recently reinhabited stores — Kerry Ann Lee's *Porirua People's Library*; the Strong Pacific Families workshops; the Porirua Arts Council pop-up gallery, Pop d'Art; Vanessa Crowe and Jennifer Whitty's *Sharemart*, and more — I've had a new question come to mind. Regardless of whether a community understands the conceptual premise of a relational or community activation project, does that take anything away from its overall success?

The question I now ask is: What measures of success should be applied to this project?

Unlike Wellington, with its skyscrapers and bustling city centre, small retailers here make a huge impact on the surrounding areas. Therefore, if we were to measure the success of TEZA Porirua in terms of individual art projects, I would say that Letting Space has brokered some quaint little projects that have activated small pockets of our community in a pleasant but fleeting manner.

If, however, we measure the success of the project in terms of the critical dialogue and self-analysis that it has elicited in our community, then I cannot think of another medium through which such conversations could be better facilitated.

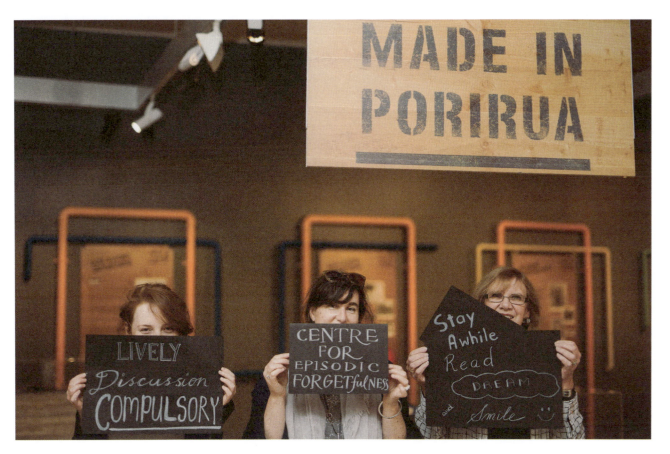

Porirua People's Library, Porirua, November 2015.

Conscious Roots Festival, Hongoeka Marae, November 2015.

TEZA Porirua has been a subversively powerful force in the community: a stealthy sleeper-project, distilled in plain view of the community, germinating slowly, a solution brewing questions as it matures.

Just because a community doesn't quite 'get' the concept of an art project (like the way that people who make assumptions about Porirua don't 'get' it either) doesn't mean that it is not a success. The real art here is that of the Letting Space team. This is their art: social agency through community activation and empowerment.

I think we have to stop thinking about Letting Space as curators or art agents, and legitimately consider Urban Dream Brokerage itself as an art. The project has activated our community in a way that no one else could or would have. It is these agitations and the discussions they provoke that make the work so amazing, complex and indeed timely. Letting Space has offered a forum through which we can gather and filter our collective thoughts.

At the time of completing this text, I have again been whisked away to Australia, unable to attend the recent Kava Club event at TEZA. But even here, four hours' flight from Porirua, I have bumped into a group of Wellingtonians participating in the SaVAge K'lub installation and performance at the Queensland Art Gallery | Gallery of Modern Art. As they mention to me that they were disappointed to miss the Kava Club in Porirua, I start to feel lighter, as if some of the provincial 'fluff' had fallen off my attire, smiling a big smile from South Auckland to Porirua, all the way across to Australia.

Ngā mihi, Letting Space. Ngā mihi aroha.
Nāku noa nei, Reuben

First published on the TEZA website, November 2015.

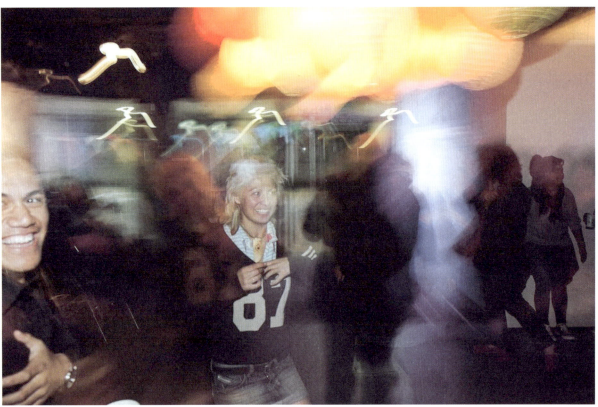

TEZA Transmission 2015: A diary with responses

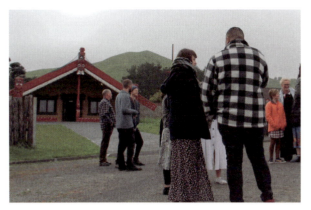

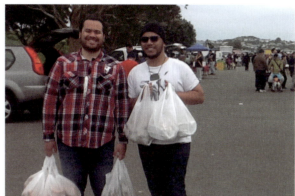

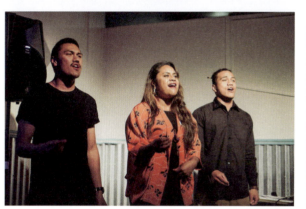

Day 1: Saturday, 21 November

Kāwika Aipa and Herbee Bartley went to Waitangirua Market to shop for Kava Club's opening-night project, Hearty Party.

As part of the artists' orientation, Steve Wilson gave a tour of Te Rito Gardens. The gardens are located on old Porirua Psychiatric Hospital land and provide an opportunity for people to learn the life skills of growing food and becoming sustainable. While there, the kids made pizza with Simon Gray ahead of our first Creative Summit discussion led by Wiremu Grace (co-organiser of TEZA's Conscious Roots Festival).

A waiata welcomed everybody into the TEZA hub (designed by Debbie Fish) ahead of the Kava Club's Hearty Party, a Porirua spin on their celebrated Chop Suey Hui featuring local rap artist Rory Allgoods, Solomon Esera, MC Tupe Lualua and DJ Kwibbs. Afterwards, 'Karaoke Korero' was followed by 'Siva for My Supper'.

Who Is It For?: A response // Lana Lopesi*

Porirua was one of a number of places my dad grew up in. He lived in a state house on Warspite Avenue and went to Cannons Creek School. His memory of Porirua is waiting for my grandfather to beat up my grandmother, then going on the bus back up to Auckland, till a week later they would be back in Porirua again, waiting for the cycle to restart. Eventually they settled in West Auckland.

Regardless of my dad's connection to this place, I am in no way local and neither is TEZA. Driving past patched members on the way to the Waitangirua Market on Saturday morning to see TEZA artist Simon Gray's stall, I can't help but question what we as TEZA know about the varied Porirua lived experiences.

The TEZA team, without a doubt, are well-intentioned and conscious of their positions as outsiders. Mark Amery recently wrote, 'who are we as outsiders to come in and make the space? The reality is that it's precisely because we don't come from one local agenda or group that we have the ability to at least trial opening out new common ground for the wild flowers to spring up in.' Still, I feel like a cultural tourist, reflecting on stereotyped references of the community and waiting to see how the community will react to these various projects across the city. If we did have a shared local agenda, we would already know more about what the community wants and needs (and if they want or need us at all), rather than designing projects based on our own assumptions and subsequently looking for community buy-in.

Gray's *Bread Makers of Porirua, Unite!* could be a model for community art making in a suburb other than your own. Rather than waiting until the TEZA week to get the ball rolling, Simon put together sourdough starter packs with locally sourced ingredients which he has already distributed all over the city.

When I arrive at the markets, they're full of roti wraps, like having a curry but in wrap form. Genius! I sit down to eat my brunch and am joined by a beautiful couple who insist I try their dumplings. In their hand is a flyer for the *Active Citizen's Funeral* by Paula MacEwan (who also runs Koha Shed Cannons Creek). So there I am, staring at this woman's moko kauae, eating dinner for breakfast, brainstorming how we would like to go. Death, a strangely unifying and comforting subject.

Faith Wilson (collaborator for TEZA's *Porirua People's Library*) and I then head for the Oasis Community Centre, a space right in the mall where you can have tea, a sit down and a chat. They also offer services like helping to write your CV. The centre has good relational aesthetics without trying. On our way in, we bump into Katarina, who gives us a flyer for that same space. Holding a TEZA programme, she asks if we were involved, telling us that Simon dropped a sourdough starter kit at her house a couple of weeks ago. When we walk in, our brunch dates are already sitting there. More women follow, insisting we eat their panikeke. The breaking of bread in Porirua was already happening. There was a wealth of hospitality, generosity and no fixed expectations for your time or your conversations — instead it was a fixed safe space, whether you wanted it or not.

The first Creative Summit of TEZA was at Te Rito Gardens (following a tour of the Porirua Hospital Museum and gardens themselves). Simon was there again; he had made his bread into pizza. We are all so polite — a critical and open discussion between 25-ish strangers is a hard thing to ask. Wiremu Grace talks about how the

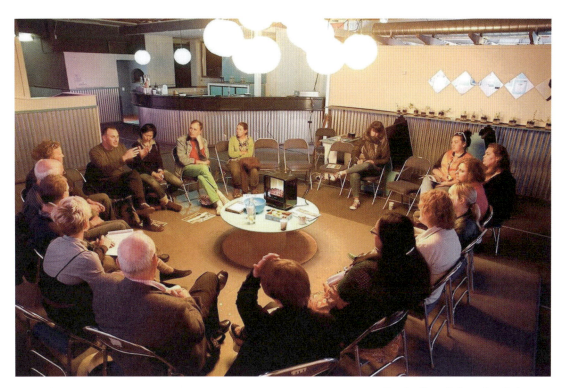

Creative Summit discussion, Porirua, November 2015.

land itself was once stolen and is currently being sold back to Ngāti Toa, but the general conversation revolved around mental health, the role of safe places, providing people with purpose, and rongoā. Thinking of my autistic brother, I couldn't help but wonder who are we to decide what an individual's purpose is, and if it is appropriate to talk about people and not with people.

A quick rush back to the TEZA hub and voilà, the whole project was launched. Yet again, there was Simon, with even more bread, which was quickly followed by karaoke, chop suey and punch, thanks to the Kava Club. I'm new to Chop Suey Hui and this deluxe edition was something special. While slightly under-populated, the hosting was on fire. The night opened with a local rapper and ended with a local DJ; both played with conviction. I was into it.

During the TEZA project presentations, Kerry Ann Lee (of *Porirua People's Library*) asked the audience how many of them work and live in Porirua. About 10 hands went up. Again that raised a flag for me — are we talking about the community and not with it?

I also wonder: When we vacate our temporary space and go back to our day jobs who will it all have been for? Despite these ponderings, I'm already booked in for a new do at the *All Good? Pop-up Hair Salon*. And the space that's been created for artists, all with social interests, is beyond valuable.

** First published on the TEZA website, November 2015.*

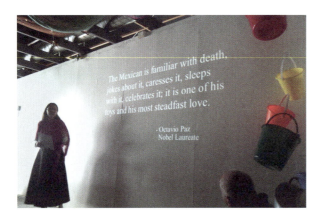

Day 2: Sunday, 22 November

Sunday was a sunny, more relaxed and less jam-packed TEZA day before the big week. Paula MacEwan ran her fourth *Active Citizen's Funeral* discussion down at the TEZA hub. People offered practical solutions in preparing for funerals and how to deal with death.

Sharemart started to gain a community in Hartham Place, with lots of people in the space repairing their clothing and looking to upcycle old New Zealand Post uniforms. A Porirua Guardians uniform (belonging to the lovely people who patrol the streets) was even repaired. One visitor, Queenie, has been working hard for two days straight remaking three blazers for herself and her daughters.

Kāwika Aipa taught the basics of traditional Hawai'i healing and massage practice in the TEZA hub for his lomilomi workshop as part of *Mai ngā kôrero ô neherā, e hui pālua*. A collaboration between Aipa and Te Korowai Aroha (a kaupapa Māori, whānau-based community service organisation in Porirua), *Mai ngā kôrero ô neherā, e hui pālua* explored traditional and contemporary indigenous bodywork and healing practices from Aotearoa and Hawai'i cultures.

David Cook and Leala Faleseuga have begun their collaboration with the young of Russell, Cannons Creek and Discovery schools in Whitby — spanning Porirua's highest and lowest suburbs, sitting next to each other — to help them share their visions for the future.

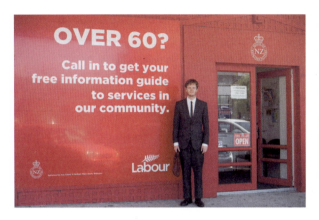
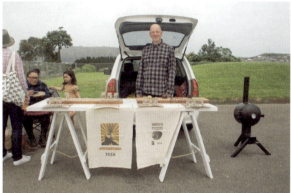

Day 3: Monday, 23 November

Today Ash Holwell traded roles with MP for Mana Kris Faafoi, as part of his *Ako Ako: A role-swapping adventure*. Ash shared Kris's duties through the morning, including the weekly staff teleconference, interviews on Newstalk ZB and Beach FM and visiting his parliamentary office. In turn, artist-for-the-day Kris Faafoi started work on setting up a radio station for Tītahi Bay at the TEZA hub.

Meanwhile, out in Hartham Place, Mark Harvey started the Volunteer Refinery with cardboard and participation, creating 'a centre of excellence for volunteer training'.

As part of his *All Good?* hair salon, Jason Muir got creative with hair for a TV3 story.

Tim Barlow was off to Cannons Creek to set up his *Just in Time* quick response community centre: a pop-up caravan towed by an old Hillman Hunter. The *JIT* unit can be delivered for urgent community meetings; it was intended as an emergency community space.

Back in the city centre, it was blessing time at the Strong Pacific Families space, where the local Tokelau community is hosting activities and art all week. In attendance were Moses Viliamu, a Tokelau Porirua-based artist from TEZA, and Seanoa Faraimo.

The evening Creative Summit session had presenters including visiting Thai artist Sutthirat Supaparinya.

The Fruit of Diversity: A response // Rangimarie Sophie Jolley*

For some strange reason, the vast and ever-expanding universe that is Porirua is forever being swathed in the old brown cloak of 'poverty, diversity and ghettoisms'. It baffles me that we live in a country which, in attitude, juxtaposes the affluent and the stricken, yet we seem surprised when a single community is able to nourish both.

Meet the new face of Porirua. His home has brick walls covered in 'tasteful graffiti art' or vibrant murals, a reliable public transport system to weave through expanding roads, the white hill of Whitby that hides behind a brown Creek of Cannon, a stinking inlet that adds a few million to his property view but robs his grandparents — 'the tūturu locals', as he calls them — of the taste of home.

His face is clean shaven and fresh, lips curled to a smile, his eyes gleam the reflective dance of a sunny wave as it wafts on the Whittaker's breeze. His shirt is stained with the grease of a pie from Waitangirua, his jeans streaked green from a childhood of skidding down hills in Tītahi Bay.

This young man would be intrigued by the TEZA project. He might have taken his aunty to Whānau Kotahi in the Porirua CBD this week and dropped off bags of clothes. They would have stopped and chatted and discussed the developments. His eyes might have wandered across the rocks to behold a strange man . . . a man covered in cardboard and duct tape.

He certainly wouldn't have approached, but he would have listened and watched. He would have heard the man call, 'Can you give me a hand?' to the strangers walking past. He might have laughed quietly, both dismissive and admiring. His aunty would hurry him away as the TV3 cameras showed up, another 'uplifting brown communities through art' angle for the masses. Perfect shot.

That afternoon he might have called his sister, a purple-haired, green-eyed goddess currently of Aro Valley. Her conversation with him, his pleas for a visit and that degree in social economics might lead her to the TEZA hub of a Porirua afternoon, partaking in a lunchtime discussion pertaining to the struggles of living and thriving in the artistic realm.

She might have sipped on a guava/banana/acai berry smoothie as her tummy rumbled for the real taste of home and her mind revelled in the encouraging messages of the people still seemingly trapped within it. She might even have asked herself why she needed to leave . . . was it to be free? Her wanderings might take her along the pink pathway in *Sharemart*; she might have held hand-sewn bags equal to those in the best Cuba boutiques. 'My Instagram followers would love this!' she'd snap, sharing the joy of rediscovering pride in her home.

After dinner with the family that night, the siblings might decide to detour on their way home, eager to participate in another of the summits to be held in the TEZA hub: a solid serving of environmentalism on the degustation menu. They might have smirked at the constant polite references to the darker of the two as a representative of the 'mana whenua'.

The pair might have nodded in agreement as a room full of enlightened strangers discussed the meal of every hui-ā-iwi they had attended since birth.

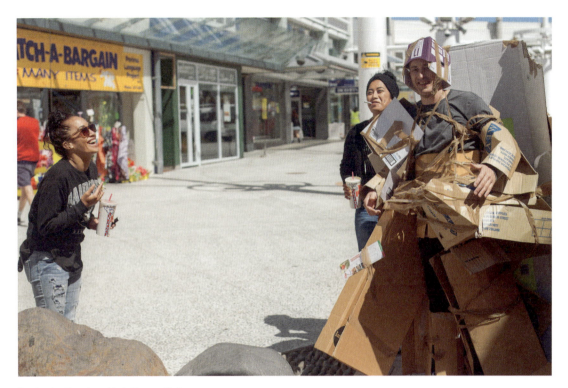

Productive Promises, Mark Harvey, Porirua, November 2015.

They might even have been relieved and proud that this conversation was happening in places other than the marae, because they knew that these people would be listened to, when they claimed the faces of change.

Theirs may be a true reflection of the need for a TEZA project. I am confronted by the thought that communities aren't as black and white as we might like to assume. Where the roaring greens of Paekākāriki met the slow waves of Elsdon we were treated to a diverse spectrum of art. Porirua should be proud of the seed it has planted and the fruit it has on display this week, if only because it depicts the true projection of its diversity.

These projects each contain unique aspects of human character and expression, regardless of social standing, race or financial distribution. Porirua is a nest of creative hives and to celebrate it as such is so refreshing, especially in the face of what I would deem to be traditionally monotonous ideals. In a hopeful country where the middle ground is white, it excites me to see Porirua as the azure hub on a brilliant horizon.

Tino nui te mihi kia TEZA.

*First published on the TEZA website, November 2015.

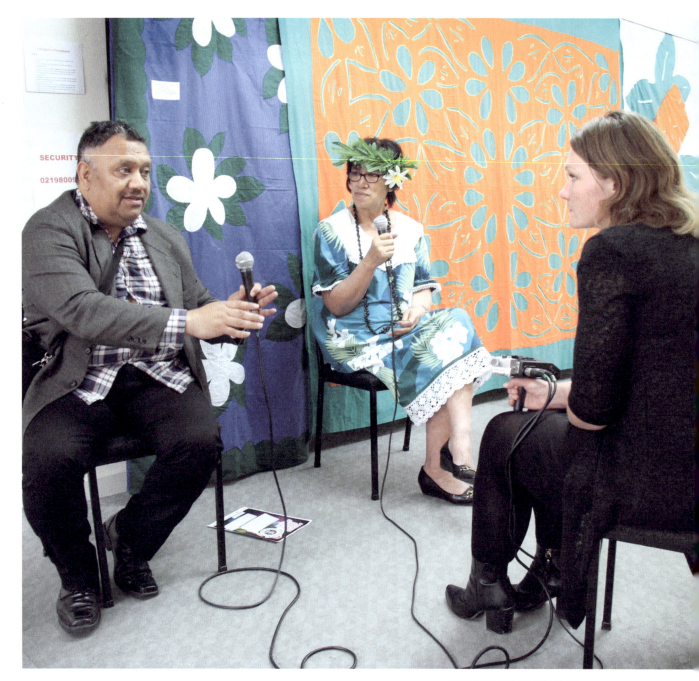

'Porirua People's Radio' with Stronger Pacific Families, Porirua, November 2015.

Day 4: Tuesday, 24 November

Tuesday was our busiest day yet, with hundreds of people coming through the TEZA hub. By lunchtime we were thrilled to see how we could accommodate no less than six different activities in the hub at once, all exchanging with one another. At the same time, around the corner in Hartham Place there were another four events happening.

Ash Holwell was on his second role-swap day of *Ako Ako*, taking the role of Nick Lambert, a machine operator at wallpaper manufacturing company Aspiring Walls. In his role as an artist Nick worked with Tim Barlow to lime render (a type of plastering) a sculpture as part of *Just in Time* and helped to make salad at lunchtime with Porirua food gardener and teacher Alicia Rich. In the afternoon he completed his own project, installing a basketball hoop in the Lydney Place laneway.

Mark Harvey continued to work in the mall with locals. Tim Barlow brought *Just in Time* to the laneway.

In Cobham Court, as part of *Porirua People's Library*, Pip Adam began her lunchtime *The Made-Up Times* workshops — inviting people to create the newspaper they want to read.

At the hub, Kāwika Aipa with Te Korowai Aroha ran a weaving workshop, working with native plants sourced from the laneway.

For Alicia's salad-making workshop at lunch she collaborated with students from Trade and Commerce hospitality training further down the laneway. Shared lunch followed.

As part of *Porirua People's Library*, People's Radio has had Access Radio in the hub recording local stories. Today they were joined by the Colombian community involved in *Sharemart*.

Meanwhile, the *All Good?* hair salon opened for the first time. One customer, a mother of 11, had never had a professional haircut before. The Volunteer Refinery meanwhile moved to Pātaka, next to Ai Weiwei.

Doing Critique: A response // Murdoch Stephens*

I joked with the TEZA crew on Tuesday about my scathing/scything critique-to-come. But I have no blade to apply to this project. Like a number of contemporary thinkers, I want to liberate 'criticality' from the idea of casting judgement. Being critical might imply negativity but doing critique is a whole other thing.

'Doing critique' is woven into the way Mark, Sophie and the Letting Space crew have constructed TEZA. These people are not dupes whom we can deploy our critique against, as if flicking on a light and welcoming them to some new understanding. Those involved with TEZA are the first to ask the critical questions: Who is the artwork for? What's the role of class, race and space within the project? The TEZA crew have embarked on this project not in spite of these difficult questions but because of them: they want to participate in these discussions and don't mind being the flint on which others' critical knives are sharpened.

Porirua has North City. It is where the people are. There are scents — baking bread, perfume and disinfectant — and there is soft lighting. There's no wind and you can park free for 240 minutes. They're tender guests: no gang patches, no skateboarding, no photography and no list of these laws — if you don't know how to behave, you're not welcome. It is the perfect site for those who play by unspoken rules.

Few come out onto the bricks of Cobham Court, where the Porirua City Council have tried to make the atmosphere lighter by taking away the canopies. Now it is lighter but also windy. It would be safer to take the car.

Retail spaces are being gutted and this is not going to stop. Our city landscapes are fundamentally changing and there are going to be plenty of losers — those who don't understand the new sensitivities of the economic zones of our urban centres. We saw it in the 1980s with the expansion of the mall — every product was available in one place. The Warehouse did to small New Zealand retailers what Walmart did to the mom-and-pop stores of America.

The big businesses — the Warehouses and Walmarts — have survived the transition to the digital age. But only just. They offer their wares online, but it may be too little too late. Trade Me and other nimble online retailers from abroad have captured significant market shares. Online sales will expand, the big box stores won't last.

When I read Reuben Friend's analysis of the wariness the business and shop owners of Porirua felt towards TEZA, I read of a group of people who feel the steady decline in the value of their assets and who have no idea about what they can do to halt it. In times like that — as the boat is sinking — we cling on to whatever seems the most stable. For those with a stake in retail property, the stable thing is a phantom: the idea that the 'downturn' is temporary. That all it takes is a little extra effort from real estate agents and vacant commercial spaces will be filled again with long-term tenants.

For three and a half years I've been involved in running a community art space in central Wellington. With the building due for earthquake strengthening, there has only been one really serious lease enquiry in all the years of our

occupation. It is in spaces like this that the TEZA crew have honed what it means to produce good city atmospheres.

In special economic zones, the laws of a country are limited in a prescribed area so that business may thrive. The most formal SEZs tend to be manufacturing zones near export hubs where taxes aren't paid and unions aren't welcome. But there are other examples of less formal SEZs — consider the duty-free section of the airport, where consumers pay no tax on tobacco and alcohol.

TEZA is nothing at all like a SEZ. It is a parody of those sites of privilege and exclusivity. TEZA is more like the temporary autonomous zones chronicled in Hakim Bey's book *T.A.Z.*, in which he offers a history of 'pirate utopias' — small, temporary enclaves that attempt to claim and use a space for a small period of time. As Bey writes, 'The TAZ is like an uprising which does not engage directly with the State, a guerrilla operation which liberates an area (of land, of time, of imagination) and then dissolves itself to re-form elsewhere/elsewhen, before the State can crush it.'[1]

For TEZA there's no such feeling of being about to be crushed: access to the empty shopping spaces has been negotiated for a limited period of time; the liberation in question is a gift from those who own the buildings; the guerrilla operation is the benign promise of Art.

Some shop owners understand that they are in the business of creating atmospheres — they welcome attempts to liven up the space. But others are like those libertarians who want nothing to do with collective living, imagining their responsibility ends at the front door.

TEZA does not have the technology or resources of North City. Would it be better for it? Or is there something necessarily windswept and wastrel about the project?

If North City is the air-conditioned, domesticated future city-state, then TEZA has set up in the wastelands of those banished from the city. Not everyone fits into the curated pseudo-commons of the mall.

It's not a big deal to walk among these dim storefronts of retail past outside North City, to navigate the wind and sun. But those inside North City do not want it. There are few exits — quite literally — to the North City: exits are bad for business, threatening to atmospheres of contentment. We can take the escalator up and down, we can walk around the building's gentle curves. But search for an exit and you'll soon find yourself lost. The building whispers, 'Why leave, why leave?' It is right: the atmosphere inside is just right.

We of the thick skin might be of the mind to say, 'it's not so bad outside', but most of the population are a long way from wanting a life that is not so bad. North City doesn't advertise that. They advertise the best of all possible worlds. We're becoming accustomed to curated atmospheres — philosopher Peter Sloterdijk asks us to think of the rules of the human zoo, and climate control will be the applied science of the twenty-first century. Domestication and house training await.

**First published on the TEZA website, November 2015.*

1. Hakim Bey, *T.A.Z.: The Temporary Autonomous Zone* (Seattle: CreateSpace Independent Publishing Platform, 2011).

Day 5: Wednesday, 25 November

As part of *Ako Ako*, Ash Holwell swapped roles with Tracy Wellington, the chief executive of Kiwi Community Assistance, a food and resource recovery agency that assists people in the community.

The morning at the TEZA hub began with a visit from a group of young students from Corinna School. They got in on the action at the Strong Pacific Families art and craft workshops showcasing the Tokelau community in Porirua.

Meanwhile, visiting artist-for-the-day Tracy Wellington got stitching with *Sharemart* shop manager Lotte Kellaway to make a bag.

What Do Artists Know About Economics?: A response // Max Rashbrooke*

> The only reason to learn about economics is to stop economists pulling the wool over your eyes.
> — David Norton, Emeritus Professor of English, Te Herenga Waka Victoria University of Wellington

What is economics? What is it for? And how much of it do we want? These questions lingered throughout my day at TEZA. There were suggestions, hints, thoughts about new ways of doing economics scattered everywhere in its programme.

The artists were asking questions, as artists do, and should, rather than searching too hard for immediate answers. A question can be a bridge between you and the person you disagree with. And I think that many people cynical about TEZA's purpose — the people who aren't at all convinced about volunteering, the sharing economy, post-capitalism or the wider project of redefining economics — would have bridged the gap between TEZA and themselves by asking, in a slightly hostile tone: Yes, this is fine, *but how is it all to be paid for?*

Even though the TEZA spaces were in a shopping precinct, surrounded by layers of concrete, they felt like spring. Ideas were popping up everywhere, and not in a central, organised structure like a tree trunk, but independently, unpredictably, like blades of grass.

I test-tasted bread with Simon Gray as he talked about working on school gardening projects and trying to make schools self-sufficient. I helped Mark Harvey create bizarre, inventive cardboard-and-sticky-tape costumes for a bunch of schoolkids, as a way of thinking about volunteering and what it brings to people on both sides of that exchange. I visited *Sharemart*, which promised 'a new economic model' for clothing, based on exchange, repair and reuse. I went out to the old Porirua mental hospital grounds and talked to Tim Barlow about artisanal workers, industrial workers and the now-defunct Todd Motors plant.

All these projects were joyous, creative and clever. They stood on those merits alone. They were all also questioning the dominance of market systems, the exchange of buying and selling in our modern lives. But there were other questions that I felt needed asking. I also felt that free-market economics would have posed some difficult questions for them.

Getting schools to grow more vegetables is something I wholeheartedly support, but there is a good reason that schools and other small groups don't invest much time, often, in growing vegetables. Anything done by amateurs in small chunks will produce less of what we want in a given time than something done by professionals at scale. Leaving gardening to the professionals — division of labour in other words — opens up the time for us to do other things that we might want to do.

Sharemart faced similar issues. One of its staff members noted that people coming there to have clothes repaired were supposed to stick around, so as to learn from the seamstresses and exchange something meaningful, but they would often just 'drop and run'. Again, it was about division of labour: leave someone to

Conscious Roots Festival led by
Linda Lee and Wiremu Grace, Hongoeka
Marae, Porirua, November 2015.

do something efficiently, and you can use that time to earn an income, or do something else that you value. It's also about cost: people often don't get clothes repaired because it's cheaper to buy new ones.

TEZA, of course, is arguing that we need a different kind of economics: but what kind, exactly? Clothes are cheap in part because when you throw away old ones, you pay almost no price, in rubbish bags or tip fees, to compensate for the environmental costs of this pollution (the externality, in economic terms, that you impose on everyone else). So is TEZA saying that if we put a proper price on pollution — and, not incidentally, carbon — then throwing away clothes would, rightly, become more expensive than repairing them, and that would get us to our desired outcome? Is the answer, in other words, to be found in extending the reach of economics, applying price mechanisms in a fairer way?

Similarly, with self-sufficiency in schools, one could argue that the many benefits of growing your own vegetables outweigh the efficiency benefits of leaving it to the big boys. This would imply that learning for its own sake, protecting the environment, taking ideas from other disciplines such as sociology and philosophy, have primacy. This would be a deliberate plan to reorient economics around different goals.

Barlow's mobile community centre sparked even bigger questions, thanks to the fact it was towed by, and paid homage to, a Hillman Hunter from the old Todd Motors factory. Todd Motors used to be an essential part of Porirua life, employing thousands of people, and its disappearance still reverberates harshly through the community. But it disappeared because New Zealand simply couldn't produce cars that were as cheap and reliable as Japanese imports, and the country overall chose — and benefited from — those imports, even if Porirua suffered.

Barlow isn't suggesting that we revert to protecting a car industry. But then what *do* we do? Again, do we try to concretely measure the benefits of having local industries — the spillover effects, the savings from not having people unemployed, and so on — in a way that allows us to better make the case for them? Or do we say that we, the people, acting through government, have a better view of how the economy could work than when we, the people, act as consumers, buying and selling things?

These are all difficult questions, and if we, the broader movement in which TEZA is embedded, cannot answer them, cannot come up with a new and coherent economics, we will probably be unable to explain to the sceptics how everything is going to be paid for.

At one point during my day at TEZA one of the artists said to me: 'Economics is so cool. It seems like an imaginary system.' And to some extent it is. Its supposed precision and predictive power are certainly illusory, and it's good to be able to challenge its more ridiculous claims. But the non-imaginary part of economics simply helps us answer the question of how we can best do what we want, given limited resources. And that is one of the hardest questions to answer.

First published on the TEZA website, November 2015.

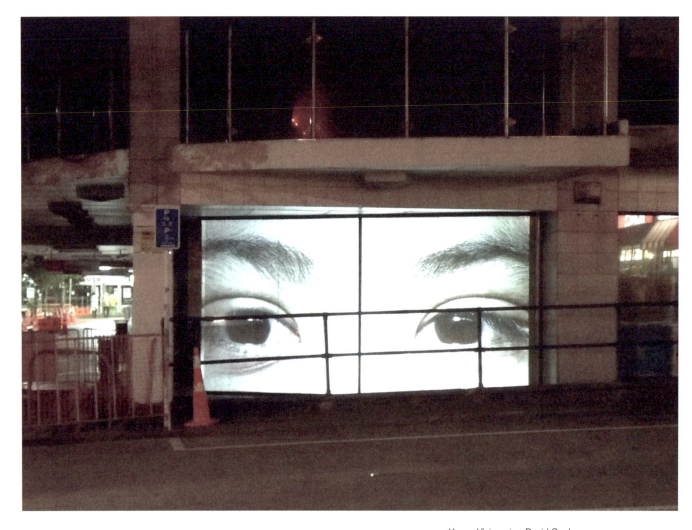

Young Visionaries, David Cook and Leala Faleseuga, Porirua, November 2015.

Day 6: Thursday, 26 November

At the *All Good?* hair salon, Barbarian Productions' Thomas LaHood awaited customers.

Shay Green, artist for the day, made bread as part of his exchange with Ash Holwell. In turn, Ash worked his way up to stablehand at Wellington Riding for the Disabled, and at the end of the day the two debriefed. In a backspace behind *Sharemart*, Ash projected a film of him and Kris Faafoi having dinner and talking through their experiences of swapping roles on Day 3.

David Cook and Leala Faleseuga installed *Young Visionaries* at the old McDonald's with Jung Shim Kreft, Georgina Conroy and George Staniland (Massey interns and TEZA photographers). The windows of Old McD's now contain the students' portraits and visions, created in workshops earlier in the week.

A Free Range Raps and Monologues workshop kicked off at the TEZA hub as part of *Porirua People's Library*, with guest Te Kupu. Chiang Mai-based Belgian writer and activist Michel Bauwens joined TEZA for a discussion titled 'New Economy Thinking', and Richard Bartlett from the worker-owned Loomio collective facilitated a wide-ranging discussion on economic alternatives to the cash economy.

The day ended with Cycle-Powered Cinema out in the mall, care of Gap Filler in Christchurch, who joined us via Skype from their fifth-birthday celebrations. We screened a documentary about Gap Filler's Pallet Pavilion, all powered by bikes.

Community and Accessibility: A response //
Gem Wilder*

I talked a lot about community to some of the great people I met at TEZA on Thursday. I told them about how I'd joined my local neighbourhood Facebook group, and then very quickly left, feeling disillusioned. There had been so much talk about the types of people living in the community, so much negativity towards people who were different. The group's members couldn't understand that these people they were so afraid of were also a part of their community — they were too caught up with what the community in their heads looked like. It looked like themselves, and no one else.

I go to numerous literary events, and more often than not they are exclusively white. White writers speaking to a white audience. I talked about this in my discussions on Thursday, about how so often creative events are inaccessible. There are huge swathes of people they simply do not reach. 'Who do you think isn't being reached here?' I'm asked. I think.

On Tuesday I'd seen people drawn into conversations on their lunch breaks while walking past TEZA participants. When I sat on Cobham Court with Pip Adam, writing an article for *The Made-Up Times*, people were able to offer a quick headline as they passed by. Pip went into some of the surrounding shops to talk to the local business owners and their staff. The workers who couldn't get away from their stores had TEZA brought to them.

On Thursday morning I sat in while groups from Corinna School made salads with Rosalind McIntosh. Children are rarely welcome at creative events unless those events are catered to them specifically.

That afternoon I took part in the Raps and Monologues workshop run by Pikihuia Haenga, Amelia Espinosa and Te Kupu. After introductions and some quick writing exercises we adjourned to work on our pieces while Te Kupu headed off to pick up his seven-year-old daughter from school. When they returned she participated in the workshop, reading her own original writings along with the rest of us. Children were not confined to a quiet corner until their parents were finished partaking in the day's activities. Parents were not restricted by childcare hours. Everyone was welcome. Everyone was catered to. Accessibility.

I don't want to paint a picture of a utopian community. I can't ignore that TEZA is taking place in Porirua, and yet the vast majority of people I interacted with had come from out of town specifically for the event. Does that matter?

That evening, I realised that TEZA is not primarily about creativity. Creative thinking is a major foundation of the week, no doubt, but the clue is right there in the name: Transitional Economic Zone of Aotearoa. This is about economics, a fact I have managed to conveniently ignore because I thought I had no interest in economics. I'm as guilty as anyone of creating an imaginary community, blind to what I don't want to see.

At that evening's Creative Summit, 'New Economy Thinking', I listened as people shared their desire for a new economic system, one that values things such as time, knowledge and even mood over money. The conversation was unsettling.

The Made-Up Times, Pip Adam, as part of *Porirua People's Library*, November 2015.

I couldn't help but think of the book *Who Cooked Adam Smith's Dinner?* by Katrine Marçal, which discusses how Smith, the father of modern economics, neglected to take into account the labour of his mother, who prepared his meal every night, when constructing his economic theories. I thought about who we might have been forgetting in our discussions.

I heard about the supposed 'poverty of soul, mind and spirit' that people are suffering from, and then heard about the large amounts of labour that people are already performing free of charge. I heard about how beneficiaries are supposedly 'rich in time' and wondered who we were talking about, and not to. There was hope in these conversations, but there was also a sense of the enormity of the task at hand. No one seemed to have the answers we were all so desperately searching for.

From what I can tell, TEZA isn't about finding answers. It is about asking questions. It is about suggesting alternatives. And it is about bringing together a community. Not necessarily a geographic community, but a community of like minds. I wanted to write about the community I saw in my head before experiencing TEZA. Instead, I am grateful for the community that I built for myself with each conversation I had, each question I asked, and each workshop I participated in.

First published on the TEZA website, November 2015.

Transitional Economic Zone of Aotearoa 2015

Above: *Ako Ako: A Role-Swapping Adventure*, Ash Holwell, November 2015.
Below: Titahi Bay Boatshed Festival, 2015.

Day 7: Friday, 27 November

The *Young Visionaries* projection ran through the night in the windows of Old McD's, marking the end and the start of each day.

A quieter, gentler morning at the hub. Outside, flags featuring prints of tuna made by tamariki in Kaiapoi during the 2013 TEZA project *Kaihaukai* have flown all week. Today they travel to Tītahi Bay and Hongoeka Marae.

Cassidy Browne worked on editing the TEZA Transmission. Ash's role-swap for the day was to be a student at Tītahi Bay School.

It was a busy day for *Porirua People's Library*. Over at Pātaka, Sarah Maxey ran an alternative signs workshop, and the results sneak their way into the gallery and nearby public library. Margaret Tolland and Kerry Ann Lee were out and about around Porirua with a mobile zine table. Pip Adam worked on *The Made-Up Times*.

A productive discussion on different models for independent artist-run spaces was held at lunchtime, with recent and planned experiences in Porirua and contributions from the wider region. Kim Lowe Skyped in to talk about setting up her space Toi Te Karoro in New Brighton after the 2013 TEZA.

The community was completely aglow at the first Tītahi Bay Boatshed Festival — the bay vibrating with kinship for two and a half hours, before the rain sent us scurrying into a boatshed to watch old movies of Porirua, care of the Film Archive.

Day 8: Saturday, 28 November

The final weekend of TEZA was wet. The rain washed things clean overnight to bring on a sparkling weekend for the Conscious Roots Festival at Hongoeka Marae, overlooking the heads of Porirua Harbour. Kaupapa Māori researcher Jessica Hutchings was one of the many speakers in the wharenui.

At lunchtime some of us travelled back to central Porirua for the official launch of *Young Visionaries* at Old McD's with the principals, teachers, students and their families of Discovery and Russell schools.

Then back to the pā, where after nightfall we followed navigation by the stars with Toa Waaka. Linda Lee did poi while Matiu Te Huki played.

Getting Back to Our Roots: A response // Chloe Cull*

On Saturday I drove out to Hongoeka Marae for the Conscious Roots Festival. This saw the bringing together over two days of those with a shared ethos regarding food production and the environment. Local farmers, healers, artists and avid gardeners contributed workshops and stalls (either for free or koha) on a range of topics, with the central focus of maintaining a healthy mind, body and natural environment. Throughout the day upwards of 120 adults and children enjoyed the events and the sun, allowing for multiple parallel sessions to be intimate.

The programme was jam-packed and I looked forward to many of the workshops and activities: composting and bee-keeping, a 'wild walk' (I didn't know what this was and unfortunately never got to find out, but it sounded cool), food-foresting, bread-making, live music, children's activities and lots of food. The hāngī with a selection of healthy salads was a highlight — slow-cooked lamb from a local farmer and Simon Gray's bread with organic butter had me going back more times than I care to admit. The general vibe was relaxed, generous and festive and the many children appeared to be having the time of their lives.

I seemed to be the only person concerned with the timetable and the specific workshops. Many of those advertised seemed not to take place, or perhaps I just couldn't find them. It didn't matter, there was still plenty on offer, but my take-home knowledge (apart from a fantastic lesson with Simon about sourdough) was limited. I was ready for some of my own ideas and values to be challenged while also going home with new skills, but this might have been a little ambitious.

Conscious Roots was definitely successful in terms of the enjoyment of all on the day. What it can offer the wider community, however, I'm not sure. That's the beauty of Simon Gray's bread-making initiative, for example: it's simple, accessible, portable, and the idea has longevity, even without Gray's presence.

Legacy and longevity have been a primary concern for the TEZA administration and contributing artists in the development of this year's programme. For example, 13 of the 14 projects have been present in Porirua for upwards of three months leading up to TEZA, all were highly collaborative and four projects were Porirua-initiated. The arrival of TEZA on Porirua's doorstep wasn't a complete culture shock for the residents — local artists worked alongside the visitors to ensure a gradual and thoughtful introduction of the initiatives into the community.

Whether TEZA has sparked renewed passion and motivation in Porirua's creative community is the real question, because surely TEZA's endgame is for the community to one day lead these initiatives themselves. Based on the local projects during TEZA, there is no doubt that they are capable.

*First published on the TEZA website, November 2015.

Day 9: Sunday, 29 November

The day began at Hongoeka Marae, sunny and relaxed with lots of healing, good food and kōrero at Conscious Roots. Kāwika Aipa provided lomilomi as part of the rongoā session.

Back in the Porirua CBD it was the last day for *Sharemart*, with a patch fixed for a local by Vanessa Crowe. Around the corner at the TEZA hub, *Porirua People's Library* had a launch. Many were issued with membership cards. Then, as the final part of the *Active Citizen's Funeral,* Paula MacEwan hosted a playful TEZA funeral.

As we reflected at the poroporoaki, TEZA felt more like a beginning than an ending. With the new shoots of Alicia Rich's wheat beds outside the TEZA hub two weeks after planting, we raised a toast to Porirua's beautiful future.

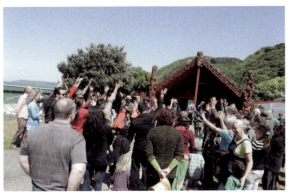

A protestor throws a dildo at Minister for Economic Development Steven Joyce and shouts, 'That's for raping our sovereignty' // David Bowie dies // The Green Party calls for a moratorium on new consents for water bottling plants // 400 litres of water are produced for every litre of milk // The Trans-Pacific Partnership is signed, despite protests // The first Syrian refugees enter New Zealand after the government announces it will take additional people // Prince dies // John Key is thrown out of Parliament after a heated exchange over the Panama Papers show New Zealand at the heart of a tax-avoiding money-go-round // Auckland's Te Puea Marae offers shelter to the homeless, helping 181 people, including about 100 children // Muhammad Ali dies // Britain votes to leave the European Union // Union leader Helen Kelly dies // Former prime minister Helen Clark makes a bid to become the United Nations' first ever woman secretary-general // Donald Trump wins the US presidential election // The first woman major-party candidate for president, Hillary Clinton, wins the popular vote by nearly 3 million ballots // A 7.8 magnitude earthquake isolates Kaikōura and causes major damage as far as Wellington // Leonard Cohen dies // Fidel Castro dies // Ray Columbus dies // Marti Friedlander dies // Bunny Walters dies // John Key resigns // At least 3000 asylum seekers die trying to reach Europe // A litre of regular petrol is $1.76 // A litre of milk is $3.20

2016

Bill English is prime minister // Women's March protests respond to Donald Trump's inauguration // Michael Parekōwhai's *The Lighthouse* opens on the Auckland waterfront // Nicky Hager and Jon Stephenson's *Hit & Run* claims six civilians were killed in a raid on Afghan villages by the New Zealand SAS // Tasman Tempest brings a month of rain to Auckland and Coromandel in 24 hours // Five Eyes representatives hold a secret meeting in Queenstown // A suicide bombing at Ariana Grande's show in Manchester kills 23 // New Zealand records its first mainland case of myrtle rust // The Crown apologises for atrocities committed at Parihaka in 1881 // Whanganui River becomes the first waterway to get legal personhood // London's Grenfell Tower fire kills 72 // The government invests $5 million in a campaign to win the America's Cup // Green Party co-leader Metiria Turei reveals prior benefit fraud and resigns // The five Silver Scroll songwriting finalists are all women // National claim Labour's alternative budget has an $11.7 billion 'fiscal hole' but economists can't find it // The Labour Party and New Zealand First form a coalition government, with support from the Greens // Jacinda Ardern is prime minister // #MeToo // A Papua New Guinea court forces Australia to close its Manus Island immigration detention centre // A rāhui is declared by Te Kawerau ā Maki over kauri dieback // A litre of regular petrol is $1.89 // A litre of milk is $3.22

2017

Groundwater: Common Ground Arts Festival

25 February–
4 March 2017
Hutt Valley

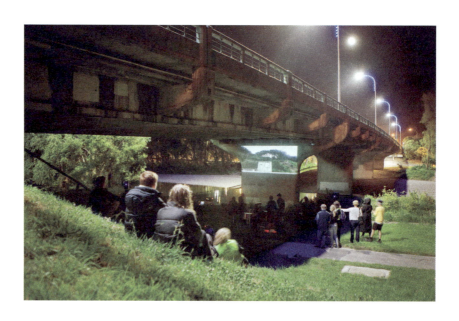

The Hutt Valley provides water to most of the Wellington region. Water supply to the Hutt, Wellington city and Porirua comes through pipes from the Waiwhetū aquifer, a giant natural underground reservoir. It starts well up the valley in the suburb of Taitā — where water drains into it from the great Te Awa Kairangi Hutt River — and extends under the floor of Wellington Harbour to Matiu Somes Island.

The Common Ground Arts Festival was first established by Hutt City Council in 2015 as a biannual festival dedicated to temporary public art with a focus on social arts practice. After working as advisors on the first festival, Letting Space was invited to develop the 2017 iteration.

It seemed natural to commission and programme events under a theme of 'groundwater'. This highlighted the waterways beneath our feet — a shared resource considered 'common ground' for our wellbeing. And yet despite how integral it is to our lives, there is limited understanding of where the water that flows from our taps comes from.

In a format similar to the 2013 and 2015 TEZA festivals, five major projects were commissioned for Groundwater, the 2017 edition of Common Ground. Each addressed different local water issues. A Common Ground hub occupied an entire vacant shopping arcade in central Lower Hutt, brokered for Letting Space by Hutt-based broker About Space. Here, Groundwater artists were given vacant retail spaces, which were activated daily by a schools programme and public conversations held in the evenings. With a giant tuna parade, other installations, a Dowse Square opening event and live cinema screenings, Common Ground spilled out into the city.

Access to the common wealth of the Waiwhetū aquifer and its beautiful water is provided by publicly located taps in Lower Hutt and Petone. Previously, local iwi Te Āti Awa had its access to the Waiwhetū Stream bores sealed. A project to reopen one was a key part of the background to Waiwhetū resident Johanna Mechen's work *Waimanawa* with kaumatua Teri Puketapu. Mechen's video work was placed on the ground, with viewers oriented as if looking down into the aquifer. It was accompanied by stream walks facilitated by Angela Kilford and Aliyah Winter.

Bore sites at Taitā and Matiu island were the start and end points for a drone-filmed moving-image work, *The Rising Gale* by Murray Hewitt, which was screened with accompaniment from local community group performances at key Hutt water sites across the festival's duration.

Groundwater came at a time when conversations about water quality, ecology and its ownership were increasing publicly. That included urgent discussion of the pressure that intensive dairy farming was putting on the water table, and the degradation of waterways caused by decades of farming and industry. In the 2010s, there were also public concerns regarding commercial licences being provided for the bottling of water and the introduction of residential water meters to charge residents for their actual water usage (as seen in the Kāpiti region in 2014).

For Julian Priest's commission *Citizen Water Map Lab*, members of the public were encouraged to collect and contribute samples from their local waterways to be tested. At Korokoro Stream, Kedron Parker established the *Inanga Love Park*, raising awareness of the precious ecology of a stream that runs from a regional park through an intensive patch of industrial and public transit infrastructure and on to the sea.

The Hutt is also a site of much public concern regarding climate change, centred on the flooding of Te Awa Kairangi. Gabby O'Connor worked with local school students on the banks of the river to create *Drawing Water: Low Lying*, a mapping of flood levels with rope.

Groundwater: Common Ground Arts Festival

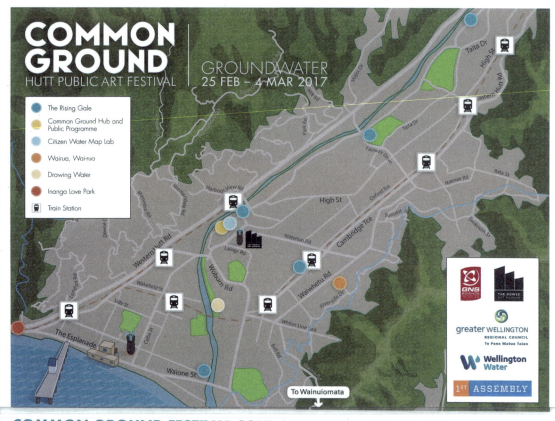

COMMON GROUND FESTIVAL 2017 CALENDAR: FREE EVENTS

SAT FEB 25

8–11AM	Visit Common Ground activities – Riverbank Market, Lower Hutt
11AM	Festival Launch – all welcome with water for some fun – Dowse Square
11AM–4PM	Visit the Citizen's Water Map Lab – Lower Hutt CBD
12PM	Summer in Dowse Square
2–3.30PM	Inanga Love Park Community Picnic – The Esplanade, Far west end, Petone
4PM	Drawing Water: Community Opening – Strand Park, Lower Hutt
4PM	Wildthings.io: Walkshop – Meet Cornish Street, Korokoro Stream
7PM	Wai-rua, Wairua: Come for a walk and film screening – Te Maori, Waiwhetu
9PM	The Rising Gale: Live cinema event with Taita College Poly Club – Riverbank opposite Nash St, Taita

SUN FEB 26

11AM–12.30PM	Wai-rua, Wairua: come for a walk and film screening – Te Maori, Waiwhetu
11AM–4PM	Visit the Citizen's Water Map Lab – Lower Hutt CBD
1–2PM	Drawing Water: Join artist Gabby O'Connor – Strand Park, Lower Hutt
2–3.30PM	Wai-rua, Wairua: Come for a walk and film screening – Te Maori, Waiwhetu
4PM	Wildthings.io: Walkshop – Meet Cornish Street, Korokoro Stream
7PM	The Rising Gale: live cinema event with Damien Wilkins, Helen Heath and Gem Wilder – GNS Science, 1 Fairway Dr, Avalon

MON FEB 27

9.30–11AM	Terrific Tuna Puppet Show
11AM–12PM	Readings and talks for the young – Common Ground Hub, Lower Hutt CBD
11AM–4PM	Visit the Citizen's Water Map Lab – Lower Hutt CBD
1–2PM	Drawing Water: Join artist Gabby O'Connor – Strand Park, Lower Hutt
1–2PM	Activities with the artists
3–4PM	Tell your stories – Hutt People's Radio
3.30–5.30PM	Help create a giant Tuna Puppet
7–9PM	Discussion: Korokoro Stream, sensitive urban design and restoration – Common Ground Hub, Lower Hutt CBD

TUES FEB 28

9.30–11AM	Terrific Tuna Puppet Show
11AM–12PM	Readings and talks for the young – Common Ground Hub, Lower Hutt CBD
11AM–4PM	Visit the Citizen's Water Map Lab – Lower Hutt CBD
1–2PM	Drawing Water: Join artist Gabby O'Connor – Strand Park, Lower Hutt
1–2PM	Activities with the artists
3–4PM	Tell your stories – Hutt People's Radio
3.30–5.30PM	Help create a giant Tuna Puppet
7PM	Discussion: What Do Artists Contribute? – Common Ground Hub, Lower Hutt CBD

WED MAR 1

9.30–11AM	Terrific Tuna Puppet Show
11AM–12PM	Readings and talks for the young – Common Ground Hub, Lower Hutt CBD
11AM–4PM	Visit the Citizen's Water Map Lab – Lower Hutt CBD
1–2PM	Drawing Water: Join artist Gabby O'Connor – Strand Park, Lower Hutt
1–2PM	Activities with the artists
3.30–5.30PM	Help create a giant Tuna Puppet
7.30PM	Discussion: The Local Politics of Water – Common Ground Hub, Lower Hutt CBD

THURS MAR 2

9.30–11AM	Terrific Tuna Puppet Show
11AM–12PM	Readings and talks for the young – Common Ground Hub, Lower Hutt CBD
11AM–4PM	Visit the Citizen's Water Map Lab – Lower Hutt CBD
1–2PM	Drawing Water: Join artist Gabby O'Connor – Strand Park, Lower Hutt
1–2PM	Activities with the artists
3–4PM	Tell your stories – Hutt People's Radio
3.30–5.30PM	Help create a giant Tuna Puppet
6.30–8PM	Discussion: Our Stories of a River and Aquifer – Common Ground Hub, Lower Hutt CBD
8.30PM	A Rising Gale: Live cinema event with sound artist Jason Wright – Gear Island Water Treatment Plant, Hutt River end Jackson Street, Petone. Limited places – book lettingspace@gmail.com

FRI MAR 3

9.30–11AM	Terrific Tuna Puppet Show
11AM–12PM	Readings and talks for the young – Common Ground Hub, Lower Hutt CBD
11AM–4PM	Visit the Citizen's Water Map Lab – Lower Hutt CBD
1–2PM	Drawing Water: Join artist Gabby O'Connor – Strand Park, Lower Hutt
1–2PM	Activities with the artists
3–4PM	Tell your stories – Hutt People's Radio
3.30–5.30PM	Help create a giant Tuna Puppet
5.15–6PM	The Rising Gale: Live cinema event with Hutt Valley Community Choir – Waterloo Railway Station
7.30PM	Discussion: Advocating for Water – Common Ground Hub, Lower Hutt CBD

SAT MAR 4

8–11AM	Visit Common Ground at Riverbank Market, Lower Hutt
11AM–12PM	Nan and Tuna – Puppet Show – Common Ground Hub, Lower Hutt CBD
11AM–12.30PM	Wai-rua, Wairua: Join a walk and film screening – Te Maori, Waiwhetu
11AM–4PM	Visit the Citizen's Water Map Lab – Lower Hutt CBD
12–1PM	Summer in Dowse Square Join a parade with giant Tuna!
2–3.30PM	Wai-rua, Wairua: Join a walk and film screening – Te Maori, Waiwhetu
7–9PM	Common Ground Closing celebration – Riverbank, Melling Bridge, Lower Hutt
9PM	The Rising Gale: Live Cinema Event with performance by Ssendam Rawkustra and MixMusicMania – Riverbank, Melling Link Bridge, Lower Hutt

FOR MORE PROGRAMME INFORMATION

www.commongroundfestival.org.nz
Facebook commongroundartfestival
Twitter @Lettingspace #commongroundartfestival
Instagram @Lettingspace

Transformative Practice and Open Gestures //
Bruce E. Phillips*

The willow trees blur and the rocks morph as I glance at the river from my car window. The Hutt River near Wellington appears little more than a passive channel that divides State Highway 2 from suburbia. But what do I know? I have never lived in its vicinity. I have never walked along its banks or floated on its surface. Nor have I ever pondered its existence before. My perception of the river has been entirely mediated through the window of a vehicle hurtling down the road.

For someone with a more specialised understanding, like a hydrogeologist, the Hutt River is the visible veneer of an immense cyclic distribution system of water, earth, biological life and human infrastructures.[1] A historian or kaitiaki could add further insight, explaining that the Hutt River has numerous names including Te Awa Kairangi, Te Wai o Orutu and Heretaunga — names that reflect the changing Māori presence in the area.

The vast gap in perception, between my naivety and someone with an expert understanding, is symptomatic of how modernity and urbanisation have ideologically and physically separated much of our population from the natural environment. As the ecological implications of our modern lives catch up with us, it is becoming increasingly important to understand these vast environmental systems.

This is the main motivation that drove Groundwater, the 2017 edition of the Common Ground Arts Festival. It used contemporary art to help the public engage with, better understand and value the region's waterways, above and underground. Hutt City Council initiated Common Ground in 2015, and to curate this second iteration they invited the organisation Letting Space, which took on the challenge of uniting artists, communities, iwi, schools, scientists and public officials.

Letting Space chose to focus on commissioning five main works by artists, with a further nine projects coming from an open public call. These were linked together through a hub created by Letting Space. Seventy-six events took place over eight days in late February to early March 2017. All drew on various aspects of scientific method, baskets of indigenous knowledge and social history to highlight ecological problems affecting fresh water.

While nobly motivated, Common Ground's ambitious aim and busy programme automatically raises many questions: Is the curatorial approach of the limited-time, 'parachute'-type event the best platform from which to achieve quality public engagement? Can art truly be an effective tool for increasing public awareness of other disciplines? Doesn't this reduce art to having a didactic role by being an aesthetic hand puppet for scientists and policy-makers? Or, alternatively, if an artwork is largely poetic and abstract, confounding rather than clearly communicating, will it fail to create socio-political change? While these are important questions, they all stem from an underlying discomfort that should be challenged. This is especially important in regards to events such as Common Ground, where the curatorial and artistic focus has an earnest desire for social change in relation to a consequential topic.

1. 'What Do Artists Contribute? River and flood management, science and planning', public discussion, Common Ground Hub, Centre City Plaza, Lower Hutt, 28 February 2017, https://soundcloud.com.

Groundwater: Common Ground Arts Festival

Unscripted and negotiable

I rest under the arms of a great tree that drinks from nearby Waiwhetū Stream. As I sit here, a calm but solemn voice talks to me from above. It is the voice of local kaumātua Teri Puketapu and it accompanies an intriguing video work by artist Johanna Mechen.

Puketapu begins his whaikōrero by drawing a parallel between the Māori concept of mauri and atoms, before going on to discuss the history of the local people, the stream and the aquifer that they once drank from prior to being forced to connect to the town water supply. He states that the stream was once a great source of kai for local Māori, abundant with eels, freshwater crayfish, mussels and watercress, but now it is a fettered watercourse that has a sad history of pollution.

Mechen's footage contributes abstract contemplation as Puketapu speaks — mist clinging to the bush in nearby hills, light refracting off the stream, moisture seeping through sand, and water being tested and dated in a laboratory environment. Puketapu clarifies that the iwi is required to regularly test the purification standards of its one remaining artesian bore that taps into the Waiwhetū aquifer.

Puketapu's words and Mechen's imagery swirl around my mind as I leave the video to participate in a performance associated with *Wairua, Wai-rua* — a walking tour of the stream by artists Angela Kilford and Aliyah Winter. The artists lead me and about 15 other visitors through a type of ecological whakapapa of the stream. They share a chart (opposite) that illustrates ecological systems mixed with customary Māori narratives to show how humans are tethered to the environment in a complex, non-hierarchical way.

As I gaze at the chart, I find it indecipherable to my Pākehā mind. I am made very aware of my embarrassing lack of knowledge of the area and Te Āti Awa's history and my comprehension of Māori concepts in general.

The problem of parachute art projects has been thoroughly debated, particularly in relation to the biennial fervour and fast-paced exhibition production that arose in the 1990s. We could classify this type of practice as being in sync with global capitalism that demands, as the geographer Doreen Massey claims, a type of space-time compression that homogenises perspectives and privileges contemporaneity.[2]

In curating a number of temporary public art events, Letting Space inherently comes up against the problem of space-time compression. Yet arguably, it maintains its focus by building in various aspects of multidisciplinary collaboration and sincerely developing local connections.

This curatorial approach grew from Letting Space's TEZA projects from 2013 and 2015, which aimed to establish an alternative temporal space that emphasised the social economy of giving (rather than taking) through a shared kaupapa between artists and communities. This methodology emerged from quality time spent meeting with locals and by using those conversations to identify what the visiting artists could contribute. As Sally Blundell has described, this created 'face-to-face interactions . . . that remained unscripted and negotiable'.[3] With TEZA, Letting Space directly explored ideas of parachuting in, of otherness, of how a group of artists from elsewhere could be of use.

Common Ground was not designed in this way. Yes, as with TEZA, all of the

2. Doreen Massey, 'Global Sense of Place', in *Space, Place, and Gender* (Minnesota: University of Minnesota Press, 1994).
3. See Sally Blundell, 'A New Hypermedial Space', page 163 of this volume.

Wairua, Wai-rua, Angela Kilford and Aliyah Winter, Hutt Valley, February–March 2017.

Groundwater: Common Ground Arts Festival

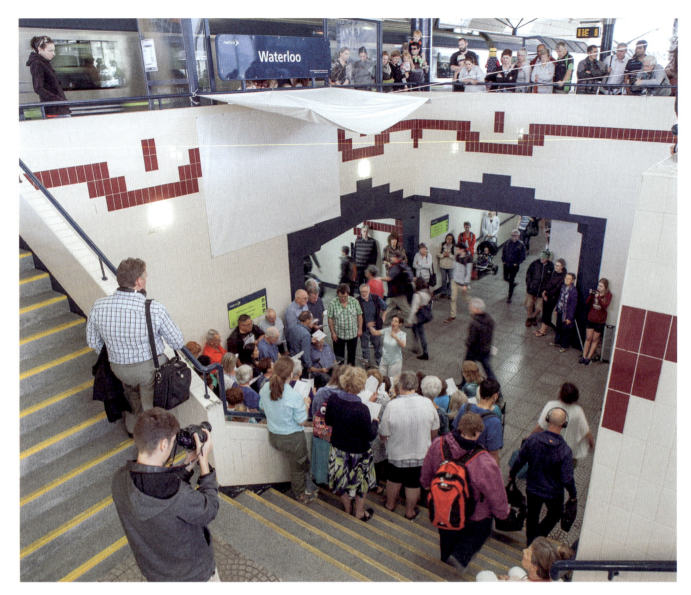

The Rising Gale, Murray Hewitt, screening with Hutt Valley Community Choir at Waterloo train station, Hutt Valley, February–March 2017.

invited artists are formally educated practitioners who maintain careers that participate in and navigate the specialised discourse of contemporary art and maintain a meaningful connection to those outside of it. But the TEZA New Brighton artists came from other cities, whereas the Common Ground artists are all based in Wellington or the Hutt region. While some may view this choice as parochial, it has considerable advantages. Since the artists were already somewhat familiar with the area, Letting Space could ensure that the artworks could gain a certain degree of competence in response to place by tapping into already established community relationships while also satisfying the space-time compressed framework that temporary events inevitably require.

That is not to say that the artists and Letting Space were infallible. In an email, artist Johanna Mechen explains that despite her living right next to Waiwhetū Stream, there was discomfort in her telling a story that wasn't her own:

> . . . the Te Atiawa Tribal Council may have been OK with my film as they saw it, but they are not totally comfortable with me telling aspects of their story (around water, land and loss) . . . [because] it is so painful, and not all here agree on how it should be told. Which was why Teri was clear that he did not speak for his whole community.

The complication of representation and the privilege of authorship speak volumes about the complexities of what is commonly referred to as 'community' — a label that infers harmonious consistency but is in fact made of vibrant inner contentions that require constant negotiation.

Other aspects of Common Ground's curatorial framework also sought to address the complexity of community and how it intersects with local ecology. Most notable was the open call for additional projects, which provided an opportunity for diversification beyond the potential biases of the curators, as did the series of public discussions that brought together invited panellists, including artists, scientists, ecologists, community workers, educators and many others who, rather than being given a pedestal, were asked to sit within a large circle together with the audience. The audience members were encouraged to introduce themselves and contribute as much as those invited.

This approach resembles curator Mary Jane Jacob's notion of 'generous and open gestures' that respect and seek out the knowledge of the audience.[4]

A politics of art and a poetics of politics

The afternoon light chimes through water-filled bottles and jars. They are labelled with marker pen and assembled in rows — each vessel waiting their turn to be processed in Julian Priest's work *Citizen Water Map Lab*.

Driven by a desire to demystify the scientific method, Priest's lab encouraged urban exploration, asking locals to seek out their nearby streams — some more like a concrete drain or culvert than a rocky riverbed. Once in the lab, visitors put on plastic lab coats and helped Priest test for levels of *E. coli* and turbidity.

Being able to engage and educate the public in ecological concerns has become a crucial tool for scientists at a time when they feel increasingly sidelined by politicians and disinformation. This is despite the fact that fresh water is a

4. Mary Jane Jacob, 'Cultural Gifting', in Liesbeth Bik and Jos Van der Pol, *Bik Van der Pol: With love from the kitchen* (Rotterdam: NAI010, 2005).

critical topic globally, as sea levels rise and threaten to diminish the already small percentage of drinkable water on the planet. In New Zealand, the pollution of fresh water has been fervently investigated, with accusations levelled at the dairy industry, urban runoff and industrial pollution. The unprecedented commercial access to artesian water supplies has also been a hot topic, as has debate surrounding the rights of Māori to own and govern natural resources.

These issues have been in discussion for many years, but in 2017 they seemed to be reaching a political tipping point as the country prepared for national elections. However, even with the hype and increased awareness, many people, myself included, remain detached from waterways and lack the understanding of the natural world that would enable us to engage.

In this sense, Priest's lab was established not only to experiment on local water but also to intervene into local consciousness. Via this lab, waterways have the potential to become transformed in the participant's mind from an abstract concept to a tangible part of their physical reality. As Priest comments, 'Water stops being part of our world — we get abstracted from it.' *Citizen Water Map Lab* helped to create embodied local knowledge and heightened awareness of the inert urban and fragile natural environments.

Some might see artworks such as Priest's as indistinguishable from a scientific pedagogical agenda. Indeed, despite the clear necessity to increase public awareness, the utilisation of art by other disciplines and political movements is contentious. It strikes at the heart of what role art and the artist have within society. Art critic and curator Nato Thompson explains that this debate stems from an ideological divide between the didactic and the ambiguous:

> Work that is too deeply locked into a language of aesthetics is dismissed as too referential, too elusive, and too inaccessible to a general audience by those whose primary concerns are activism, while art that is prescriptive is too clichéd and banal for audiences whose primary concerns are art.[5]

In light of this reasoning, some might argue that the more captivating works of art are those that locate a point of resistance between the didactic and ambiguous. As the theorist Jacques Rancière writes: 'The problem is therefore not to set each back in its own place, but to maintain the very tension by which a politics of art and a poetics of politics tend towards each other.'[6]

A compelling example of this is Gabby O'Connor's work *Drawing Water: Low Lying*. Using coloured rope, this large-scale drawing traces the water levels of historic, recent and predicted future floods of the Hutt River. Since its establishment, the Hutt Valley's urban environment has been prone to significant floods, and stopbanks were built as early as 1898 to protect properties. O'Connor's drawing, at 1:1 scale, scrawls across one of these vast stopbanks.

I stand on the drawing's highest mark and marvel. At this flood line the river would have swelled at least 5 metres higher and 50 metres wider than its current form.

Yet this site-specific drawing is more than just data visualisation at actual scale. The work is the result of a collaborative workshop established by O'Connor, scientists and a local school that provided an opportunity for the students to learn about the river's flood history. The children's rope lines scribble along the grass.

5. Nato Thompson, *Seeing Power: Art and activism in the twenty-first century* (Brooklyn and London: Melville House, 2015).
6. Jacques Rancière, *Dissensus: On politics and aesthetics* (London/New York: Continuum International Publishing Group, 2011).

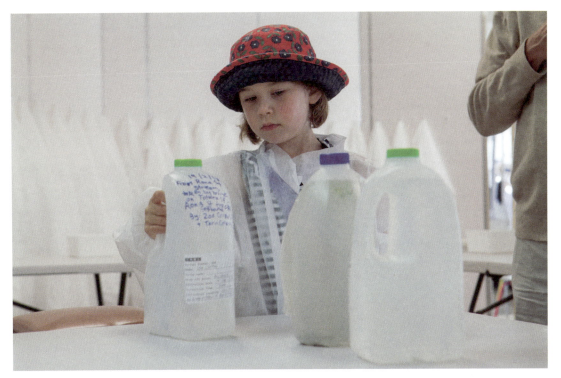

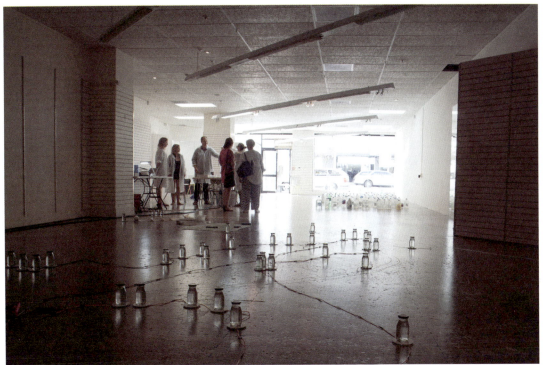

Citizen Water Map Lab, Julian Priest,
Hutt Valley, February–March 2017.

The artist's rope lines survey the bank's contours. I consider this intergenerational mark-making exercise and I try to imagine the challenges that these children will inherit as sea levels rise and the frequency of extreme weather events increases.

I also try to envisage encountering this colourful tangle of red, blue and yellow rope without any of this knowledge. There is no key given so that others can interpret the finished mapping or learn that it is the result of an educational exercise. The data has been intentionally withdrawn to encourage speculation and contemplation. This ambiguity creates a dualism in the work. It is at once an artwork created with political purpose with a specific meaning to those involved and yet for others it remains a deliberately ambiguous and whimsical gesture.

This balance between the didactic and ambiguous is no easy strategy for artists to pursue, especially when given a directive of positive public engagement by the Letting Space curators who expressively hope 'to enable social change'. In saying so, Letting Space has proven able to support their artists to tread this fine line so that art can be art while also being useful to society.

Negating inhibitions and prohibitions

I am lost. I have found the stream but as soon as it appears from the pristine bush-clad hills it disappears underneath light industrial property, a four-lane highway and railway track. This makes it near impossible to find the *Inanga Love Park*, an artwork located on a bend of Korokoro Stream.

By backtracking to the opposite side of the highway, I finally find the artwork off to the side of a footpath and underneath the highway overpass. *Inanga Love Park* is a collaborative initiative by artist Kedron Parker and artists Bruce McNaught and Bruce Mahalski, ecological engineer Stu Farrant and ecologist Paula Warren. It consists of an information display and some restoration of the stream's banks to aid the life cycle of īnanga.

Commonly known as whitebait, īnanga are juvenile fish that swim from the sea up streams to spawn among the vegetation that flank riverbanks. Prior to the project, the stream's bank was eroded and occupied by a pile of gravel laced with rubbish and weeds. Despite being only 200 metres from its natural source in Belmont Reserve, this portion of Korokoro Stream is somewhat of a non-site due to being ignored amid confusion between government agencies about who is responsible for its guardianship.[7] Through a collaborative effort of landscaping and planting by the *Inanga Love Park* team, this section of Korokoro Stream is now more welcoming to īnanga continuing their life journey.

Layers of overlapped posters, casually pasted to the huge concrete foundation of the highway overpass, inform passersby of the rich alluvial biological life and human social history of the stream. This poster paste-up brings together stories of the Love whānau, the Korokoro as a body of sacred water and early colonial settlement with its history of intense industry. Here a lateral mode of thinking, more associated with creativity than the sciences, is encouraged. It invites people to critically connect the dots for themselves.

It is this ability to create a space of active engagement, be that participation or simply critical thinking, that enables Letting Space and the Common Ground artists to resist the problems of the parachute project and the dichotomy of the didactic versus ambiguous.

Further embracing the potentiality of the open gesture is Murray Hewitt's *The Rising Gale*, a video project and series of live screening events. Working with drone operators, Hewitt tracked the length of the Hutt aquifer — a vast catchment of underground water stretching from Taitā through to Wellington Harbour — by filming from a Taitā bore site,

7. 'Korokoro Stream, Sensitive Urban Design and Ecological Restoration', Common Ground Hub, Centre City Plaza, 49 Queens Drive, Lower Hutt, New Zealand, 27 February 2017, https://soundcloud.com.

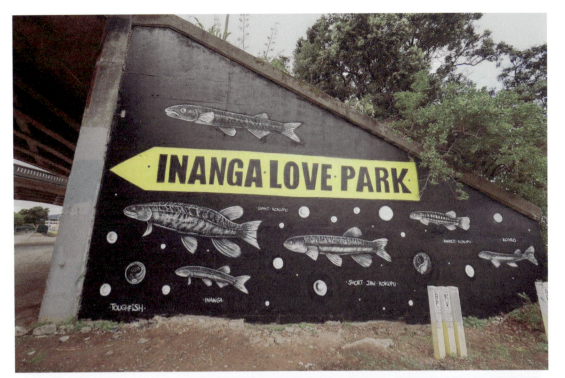

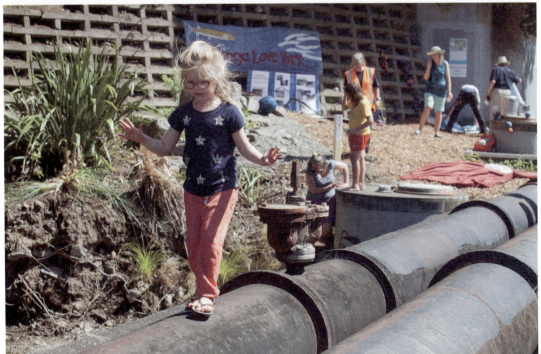

Inanga Love Park, Kedron Parker and collaborators, Hutt Valley, February–March 2017.

Groundwater: Common Ground Arts Festival

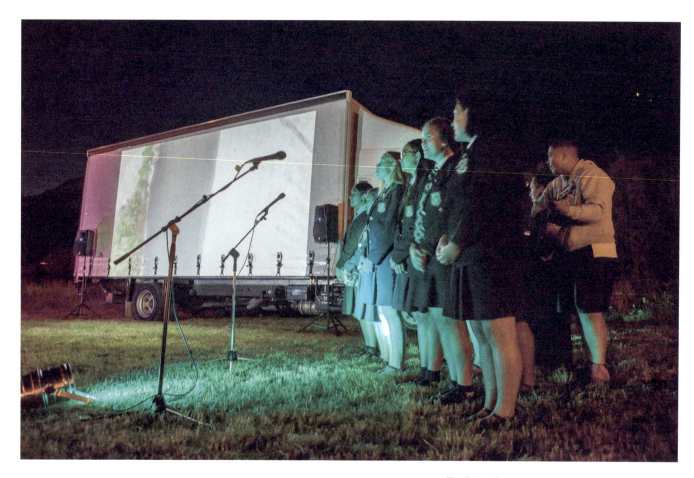

The Rising Gale, Murray Hewitt, screening with Taita College Poly Club at Te Awa Kairangi Hutt River, Hutt Valley, February–March 2017.

down the river and out into the harbour to a bore and pumping station on Matiu Somes Island.

Just as we cannot see the radio waves that control these nimble wee aircraft, so too we cannot see the great forces of earth and water that lie beneath the river. How profound this is — that so much of our lives is governed by forces beyond our perception. As the drone passes overhead what we can see are trees, flocks of birds, the many streams that feed into the river and, mostly on the fringes of the frame, human infrastructure in the form of houses, paths, bridges, roads, railway lines and carparks. At the camera's height people are infinitesimal.

Live screenings of the film took place at different aquifer bores at Taitā, Avalon (a cinema at GNS Science), a water treatment plant in Petone, the Waterloo railway station (the main bore for the Hutt Valley water supply) and a riverside spot under the Melling Link bridge at the festival's end. At each screening Hewitt invited locally based or locally born performers, musicians, sound artists and writers to perform soundtracks or spoken word to complement the video. Using the footage as the compositional structure, the differing accompaniments fused local energy, knowledge and voice to that which is seen and unseen.

As critic Thomasin Sleigh writes, the diversity of performers and their creative responses reminds us that 'communities are malleable, slightly incoherent, and . . . can't be easily categorised by the area in which they live or the landscape that they relate to'.[8]

The willow trees blur and the rocks morph as I glance at the river from my car window. The Hutt River is no longer a passive landscape to drive by. I now recognise the river through the lens of a rich history, a complicated present and an uncertain future. Common Ground has changed my perception.

First published on the Common Ground website, June 2017.

8. Thomasin Sleigh, 'Murray Hewitt's *The Rising Gale*', CIRCUIT Artist Moving Image Aotearoa New Zealand, 11 April 2017, www.circuit.org.nz.

Common Ground Hub Pop-Up Projects

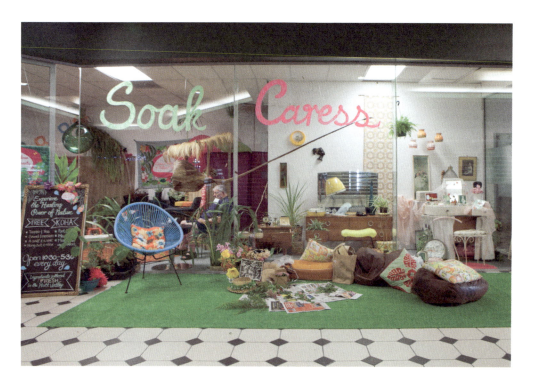

Liana's Parlour of Natural Beauty
A pop-up beauty parlour where the hair dryers blew only the gentle soothing sounds of the nearby bush, and Liana Stupples offered a range of health and wellbeing treatments from local nature highlighting the holistic benefits of caring for our water catchment.

Aftermath
An interactive installation with Josephine Garcia Jowett that considered access to fresh clean water through the presentation of plastic bags of water as it is sold in her native Philippines.

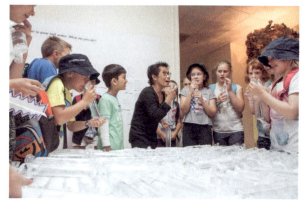

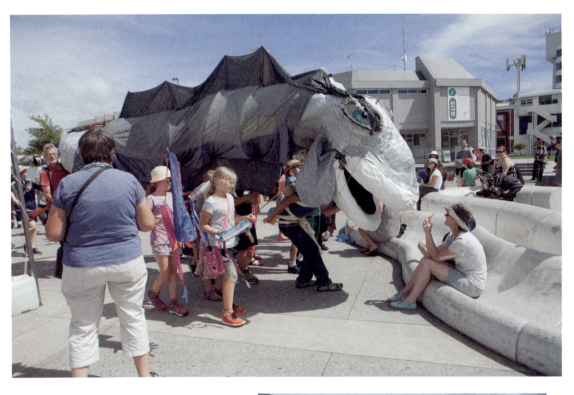

Terrific Tuna!
A puppet theatre space in which Stringbean Puppets presented a puppet show about the longfin eel and held workshops to construct a giant eel puppet.

Hothouse Indicator
Andrea Sellwood's installation of salt crystal trees in a greenhouse in Dowse Square and accompanying workshops explored the ways in which plants absorb water and extra salinity as rising sea levels taint our freshwater reservoirs.

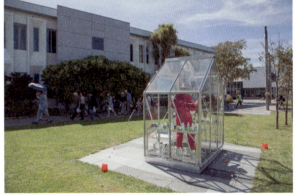

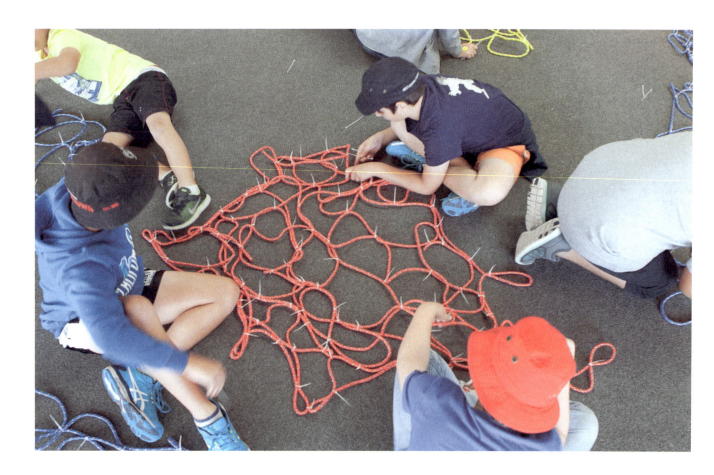

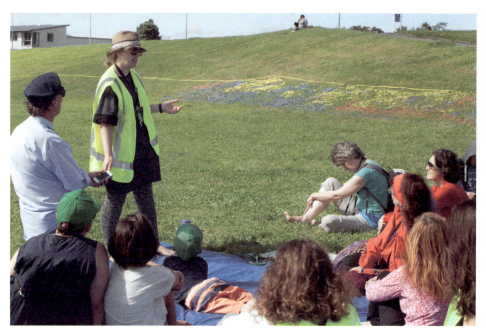

Drawing Water: Low Lying,
Gabby O'Connor, Hutt Valley,
February–March 2017.

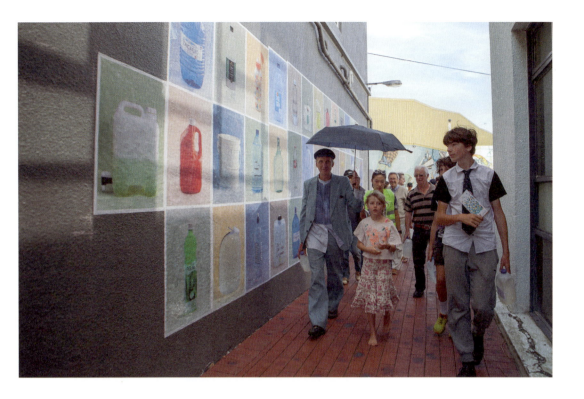

Vessels
Dionne Ward's photographic documentation of the vessels used to collect fresh water at local Hutt aquifer taps.

wildthings.io
Birgit Bachler's guided bush workshops explored the design of an 'internet of things' with water ecosystems.

Film stills from *Waimanawa*, Johanna Mechen, Hutt Valley, February–March 2017.

The Groundwater at Common Ground //
Moira Wairama*

I was born in Wellington but have lived most of my life beside Te Awa Kairangi, the river that as a child I knew only as the Hutt River.

As children, together with my sisters, our cousins and friends, the river was our playground and everyone swam there, often at the famed Taitā Rock swimming hole. Later, my own children swam at water holes at the entrance to Stokes Valley and under the Silverstream bridge. Now my mokopuna and our whānau whanui drive up to Akatarawa, Te Mārua or Kaitoke, where the river water is still clean enough for people to swim safely.

The focus of the Common Ground Arts Festival was the groundwater of the Hutt Valley. The festival enabled a diverse group of artists working in collaboration with scientists and environmentalists to present art projects and performances. They also provided workshops targeted mainly at tamariki from Hutt schools, and evening discussions around the Hutt's groundwater, its past, present and future condition, and the numerous stories the river has accumulated from local people over the years.

> *Awa, Awa kairangi,*
> *Wai makariri, toka mahana*

In December last year artist Gabby O'Connor came to our kura (Te Ara Whanui Kura Kaupapa Māori) to do work with our tamariki. Together they created rope designs which would be part of a giant flood map to be laid on the grassy floodbanks of Strand Park on Te Awa Kairangi.

At the time it was hard to envisage what this artwork would look like. It was not till I went to Strand Park and saw the combined rope art from various schools, delineating the area of land that would likely be under water in the future, that I began to understand what this work was about.

Sitting in the sun on a blue tarpaulin at Strand Park viewing Gabby's rope map, we listened to locals, scientists and river workers talk about the floodwaters that with some regularity covered the very place where we sat, and which had only recently threatened the sturdy Ava rail bridge which crossed the river nearby.

I immediately thought of my Uncle John, born in Petone and now resident in the large retirement home close to the river on the other side. He had told me stories of his boyhood catching herrings in the river and swimming in the floodwaters — 'it was deeper after a flood and more fun to swim in'.

I also thought of the large college and another retirement village which bordered the side of the river where we sat. What would a future with higher floodwaters mean for these people?

> *Awa, Awa kairangi,*
> *Pūkeko ki te taha, kōkopu ki roto*

I had never been to the area where *Inanga Love Park* sits: beneath the Petone flyover, next to the railway tracks and close to where Korokoro Stream meets the waters of Te Whanganui-a-Tara.

Luckily, Paula Warren's amazing multi-sized felt balls were decorating the wire fencing to alert me to the right path. Following it, I found two young men, aided by an enthusiastic young boy, red-cheeked with exertion, pasting up huge information posters on the grey concrete walls of the flyover support. I stopped and began reading about the history of the local iwi, the Love family, Korokoro Stream and its inhabitants — especially the īnanga.

Walking on, I found local whānau, council workers and artists enjoying picnics and sharing information and stories about the Korokoro Stream restoration work. Artist, environmentalist and scientist Paula Warren happily enlightened me about the situation of the banded kōkopu and īnanga while I admired her beautiful papier-maché kōkopu, pūkeko and tuna. Sadly, none of the real-life models were in attendance — however, we did spy a hungry mullet in the stream, no doubt also looking for īnanga.

Awa, Awa kairangi,
Rere mai i Tararua, rere atu ki te Whanga

Saturday night beneath the stars, I joined people beside the river beyond the stopbank across from Nash Street in Taitā. We gazed at images projected on the side of a large truck parked by the strategically lit river bore. The evening chill had people drawing up their collars as we continued to fiercely believe this was summer.

A group of rangatahi from Taita College dressed in formal school uniforms emerged from their ghostly white school van and moved to stand before a microphone, preparing to join the night stars in song.

As Murray Hewitt's mesmerising drone-filmed footage of Te Awa Kairangi flowed across the truck screen, a single voice also flowed into the night and was then joined in harmony by other voices. Waiata in te reo Māori and Pacific tongues married well with the meandering images of the real river. Only a short distance from where we sat, its waters were sinking down into the aquifer that supplies the Wellington region, flowing slowly and silently into a series of underground basins beneath the whenua and out past Matiu island. As organiser Mark Amery spoke of creating art in unexpected spaces to help us look differently at places we take for granted, the river sang its own song in the background.

I thought of Kupe and his people who travelled up this river many centuries ago — a river now bordered by houses, parks and cities, reshaped not just by nature but by the corsets of stopbanks constraining her floodwaters.

In the future, what changes to the river will these singing students observe, what stories will they relate about the night they sang the river?

Awa, Awa kairangi,
Wāhi pāpaku, wāhi hōhonu

The Common Ground hub and its surrounding art exhibits, performances, workshops and discussions magically appeared inside the Centre City Plaza, a shopping mall in central Lower Hutt. Empty spaces were transformed and I was reminded of why councils should spend money on arts projects and how artists and scientists working together can create work that delights as well as educates us about our own environment.

During the festival I was fortunate to accompany tamariki from our kura, who excitedly sampled Liana Stupples' natural health and wellbeing treatments

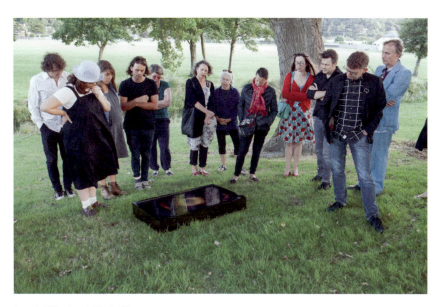

Angela Kilford and Aliyah Winter,
Waiwhetū stream walk with installation
of *Waimanawa*, Johanna Mechen,
Hutt Valley, February–March 2017.

before attending Anna Bailey's delightful bilingual puppet show featuring a water-splashing tuna.

Watching the community-members-turned-scientists testing water collected from local waterways, delivered in 2-litre containers as part of *Citizen Water Map Lab*, I felt ashamed about how little knowledge I had regarding the health of Te Awa Kairangi.

When I walked Waiwhetū Stream with two of the artists of the *Wairua, Wai-rua* arts project, Angela Kilford and Aliyah Winter, I was heartened by the story of how that stream was being restored. The accompanying film by Johanna Mechen, with voiceover memories and comments from local kaumātua Teri Puketapu, alerted me to how complacent I was about my own waterway, Stokes Valley Stream, which feeds into Te Awa Kairangi. I thought of the runoff from the hills by Silverstream and the effect the Silverstream tip may be having on the river, the increasing incidents of algal bloom and the constant reshaping and dredging of the river to suit human habitation, often with little regard for the river's natural inhabitants.

Common Ground left me with questions. What did the river need from us to stay healthy? What knowledge or actions do I need to help my river stay healthy? I intend to find answers, not only for the river's benefit but also for myself and my descendants.

Awa, Awa kairangi,
Ko tōku awa, ko te Awa kairangi

** First published on the Common Ground website, May 2017.*

Film stills from *The Rising Gale*,
Murray Hewitt, Hutt Valley,
February–March 2017.

Murray Hewitt's *The Rising Gale* // Thomasin Sleigh*

Each screening was radically different from the others. At the first, *The Rising Gale* was screened next to a borehole in Taitā (where the valley's expansive aquifer is first fed by water entering the ground from the river), and projected onto the side of a truck in a paddock next to the river. The night was cool; there was a light wind and a very small crowd. The Taita College Poly Club choir sang beautiful waiata into a patchy PA.

The second screening was in the gloriously 1970s auditorium of the GNS Science building in Avalon, where writers Gem Wilder, Damien Wilkins and Helen Heath read writing about Te Awa Kairangi. The third, my favourite, was at the Gear Island Water Treatment Plant on a still evening, the sky flecked with stars. The film was projected onto a concrete wall with a roaring, glitchy sound accompaniment by local sound artist Jason Wright. The fourth was with the Hutt Valley Community Choir during rush hour at the Waterloo railway station — this screening unfortunately suffered from technical difficulties, as it was too light to see the projected film. The final screening was down underneath the Melling Link bridge, the river itself slinking by, with anarchic, atonal live band accompaniment (bass, xylophone, percussion, brass) by Sendam Rawkustra and Mixmusicmania.

In the auditorium of GNS Science, Wilkins read a scene set on the banks of the Hutt River from his recent book *Dad Art*. One of the book's characters asks, sceptically, 'What was Michael hoping for from this trip? To look at the Hutt River as if it might mean something to his father and to him?' The internal monologue of this character acknowledged the difficulties of metaphor and seemed to relate to the inquiry of *The Rising Gale*: If the Hutt River means something, signifies something, what is it and how can we talk about it? And how can the artist say what this river means, when it means so many different things to so many different people? Water is rife with history and metaphor (what is more poetic than the idea of water slowly moving underground, seeping through layers of rock, and appearing near Matiu Somes Island, 20 years after it first entered the ground?), so how do you approach such a potent subject?

Hewitt's response was to begin with silence. The drone footage of the river was rigorously simple and minimally edited. The film dispassionately tracked the river, which, seen from above, was abstracted by the mapping — like after take-off in a plane, when you look down and the land looks alien, too ordered; chaotic life reduced to blocks of colour and the smooth patterns of roads. In this video, too, the river and its banks slid past and became simple strips of colour. The landscape was blank, history-less, mute: a canvas to be projected onto.

With this backdrop, each of the performers with whom Hewitt worked, and each of the five locations where the film was screened evoked a story of a different river. Te Awa Kairangi became multiple and continuous. For the Taita College students who sang at the first screening, I expect that the river is part of their everyday lives as Hutt Valley teenagers in 2017. I don't speak te reo Māori, so I couldn't understand all that was said, but the river that their evocative waiata conjured up seemed alive and quotidian, rather than a metaphor for history.

Conversely, the river the older writers spoke about at GNS Science was examined through the distance of memory. All three had grown up in the Hutt

and the river is part of their tūrangawaewae. In the austere concrete surrounds of the treatment plant, the audience was reminded of the practicalities of the large aquifer that runs underneath the valley. In the film accompanied by Jason Wright's soundtrack, the river appeared as a slick skin to the unseen, subterranean activity that bubbles underneath. For the Hutt Valley Community Choir, the river was source and inspiration for an aquatically themed selection of songs and their sense of connection to their peers and their environment.

And there, beside Te Awa Kairangi itself, the final performers Sendam Rawkustra and Mixmusicmania introduced chaos, randomness and chance. As a whole sequence, *The Rising Gale* demonstrated the multivalence of metaphor and how the Hutt River extends outwards, literally and figuratively, into people's lives, homes, creative activities and histories.

///

The itinerant and heterogeneous nature of *The Rising Gale* also unpicked the idea of 'community' upon which Common Ground, and other festivals of its ilk, operate. The ways public art speaks to, and often attempts to speak for, the communities in which it takes place during temporary public art festivals can often be didactic. Collaboration is hard. And collaboration in a restricted timeframe is even harder. Hewitt, who has the benefit of living locally in Moera, worked with a range of groups and individuals — these were no art-world insiders or solely members of that amorphous group, the 'creative class' — and gave space and voice to their divergent responses to his work.

During each screening, the central film oscillated between foreground and background, sharing the focus and audience with the other performers. Hewitt seemed to actively acknowledge the limits of his own point of view and suggest that communities are malleable, slightly incoherent and porous. Groups of strange humans can't be easily categorised by the area in which they live or the landscape they relate to.

The Rising Gale also pulled scientists and groundwater experts into its inclusive events. At GNS Science, a groundwater modeller gave the audience a brief but fascinating explanation of how the Hutt River and the aquifer interact and the methods scientists use to measure this interaction. Similarly, at the Gear Island plant, a staff member from Wellington Water talked the audience through the aquifer's supply and distribution networks and how and where the water gets treated. In some ways, these brief contributions acted as gallery wall labels, but were elegantly intertwined with the roving and collaborative nature of the work.

So often, site-specific art exhorts you to learn something about a place: an overlooked collective history, an impending environmental threat or an element of built heritage, and this pedagogical element can often sit awkwardly within the work. *The Rising Gale* certainly sought to expand our understanding of the Hutt River and its relationship with the aquifer and harbour, but this aspect was deftly contributed by the intros from water scientists and infrastructure experts.

Part screening, part gallery public programme, part lecture, part poetry reading, part gig, part choral recital, *The Rising Gale* drew a myriad of groups and people into its remit and is testament to Hewitt's and Letting Space's skills as collaborators and organisers.

Inanga Love Park, Kedron Parker and collaborators, Hutt Valley, February–March 2017.

Groundwater: Common Ground Arts Festival

**First published in CIRCUIT, April 2017.*

Unsettled

Rana Haddad & Pascal Hachem
3–12 May 2017
Wellington

Following a meeting between Sophie Jerram and Rana Haddad at the University of Copenhagen in 2016, Letting Space held its first international residency with Lebanese artists and architects Haddad and Pascal Hachem, also known collectively as 200Grs.

Urban Dream Brokerage provided a workshop space in lower Tory Street to create the material for Haddad and Hachem's work and to engage with others. The substance of the work, however, was created in the streets of Wellington city where the duo performed, pushing a huge roll made from second-hand clothes and creating a virtual pathway.

The work came from their physical exploration of Wellington. On arrival, Haddad and Hachem were immediately conscious of an 'unresolved' feeling to the city. Surprised by the number of second-hand shops and the rate of homelessness in an affluent country, they chose to engage with old clothes. After spending a week in the city, the resulting project *Unsettled* reflected Wellington's uneasy currents and underground streams.

Haddad and Hachem also gave public talks at City Gallery Wellington, Massey University College of Creative Arts and Victoria University of Wellington.

Unsettled // Rana Haddad & Pascal Hachem

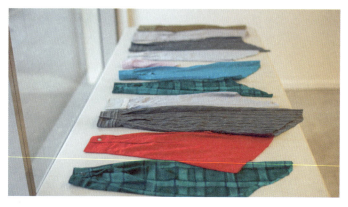
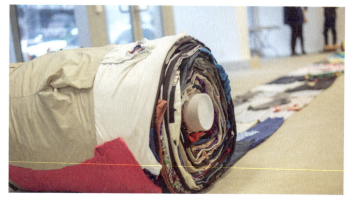
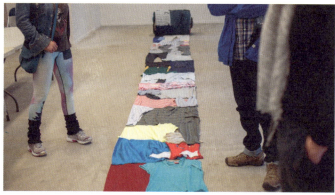
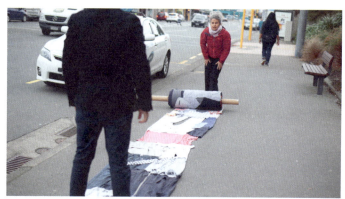
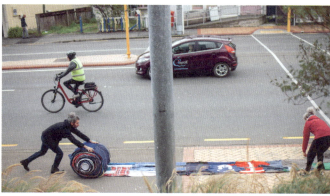
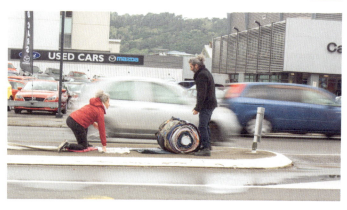
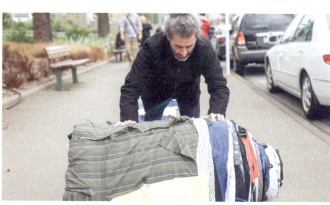
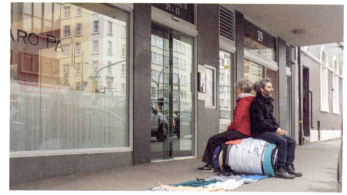

We Are Tamed by Unsettlement // Sophie Jerram

During their time in New Zealand, Rana Haddad and Pascal Hachem told us about their work in Lebanon — how their practice reacted to the polarised socio-political and economic factors that engulfed the fragile state, forcing them to become activists in the city of Beirut.

In Wellington, their work addressed 'the stagnating and missing flow that made the city, which seems to have been avoided and dismissed today from everyday life'. The performance involved bringing giant roll of clothes to the source of Te Wai Puna, the underground stream next to Wellington Hospital, like the 'longest blanket for homeless people', a visiting observer quipped. The piece was then rolled from the hospital, tracing the stream under the asphalt. Doctors, patients and staff came to watch, join in and ask where they were going.

A second performance was made down the stream line closer to the harbour, on Taranaki Street. Engaging with local kaumātua and chair of the Tenths Trust, Liz Mellish, at the Wharewaka function centre, Rana and Pascal asked about the history of the streams and the possibility of revealing their passage to the harbour. Liz suggested that 'when you daylight the streams, you daylight the people'.

Rana later explained that after Lebanon's civil war (1975–1990) and two wars with Israel, its people were sensitive to undercurrents of disturbance. 'We are tamed by unsettlement. We found it easy to feel that the ground is not so stable underneath. There are a lot of contradictions in Wellington. We saw that the same city which resources you with nature (abundant green space), denies you access to the freshwater streams. The proportion of homeless who were Māori in the city was apparent to us immediately. It cannot stay like that.'

Rana and Pascal are incisive and rapid creators. It was unnerving and rewarding seeing how quickly Letting Space's first international residents noticed Wellington's social and geographical imbalances. We also discussed the ongoing Syrian war with them, hearing about the thousands of people flooding across the border to be accommodated by Lebanese settlement programmes. Homelessness on the street, as they saw in Wellington, was apparently less visible in Beirut.

Rana and Pascal describe themselves as products of the long-running Lebanese civil war. 'We choose to look at Beirut as it stands today: a city riddled with danger, yet ripe with potential. Learning to embrace whatever experience that comes to us.' There is an optimism to their thinking and to their temporary, playful and political installations.

///

Speaking to Rana five years later, the optimism is gone. The devastating central-city explosion (of a fertiliser plant) of 4 August 2020 'removed the soul of the city'. Inflation is rampant; electricity is no longer available; residents rely on generators. Rana does not hold out hope for the political leadership to fix the situation, but she still believes that the new generation will find a 'way to conquer', even if she might not see it herself.

Rana and Pascal continue to make work as a response to political and geographic tensions. Pascal has moved to France, Rana continues to create in Lebanon, and together they continue to exhibit internationally: in February 2022 their work *History is what you make of it* was presented at Dresden's Kunsthaus. Rana suggests their work is now less centred on construction and reflects more on loss. Making work is their way to have a voice. 'This is how we resist.'

Unsettled // Rana Haddad & Pascal Hachem

Our Future Masterton — Ahutahi ki mua

May–December 2017
Masterton

Our Future Masterton — Ahutahi ki mua came from the premise that communities will feel pride in their towns when they have the opportunity and space to realise their dreams and ideas for their place.

Letting Space partnered with the Toi Āria design research centre at Massey University and the Masterton District Council on the development of a citizen-led design strategy and 50-year vision to assist in the public reimagining of Masterton's town centre. The concept, as council chief executive Pim Borren stated, was putting 'more of the ownership and control of planning for our future in the hands of the full diversity of the people who will inherit it, not just council staff or any particular interest group in Masterton'.

The project established an Urban Dream Brokerage programme of projects in public and vacant commercial spaces, a series of community workshops to develop the strategy aimed at different sectors of the community, and a pop-up hub in Te Patukituki o Wairarapa, a fledgling creative space for Māori in central Masterton. A Masterton local, Anneke Wolterbeek, was employed to broker spaces.

The community hub opened monthly with a programme of activities so the public could gather to discuss ideas, celebrate Masterton's assets and share visions for the future of Masterton through hands-on interactives. It became a space for partnerships to grow.

With a local advisory board as well as Wolterbeek working with Wellington staff, the Masterton Urban Dream Brokerage hosted seven projects, including a block party involving the community in spaces across the northern end of the town; a community portraiture project, pasted on walls downtown; and a community creation space for local sustainable Wairarapa fashion. One project, the community sewing space and sewing machine museum Come Sew With Me, became permanent and celebrated its fifth birthday in December 2022.

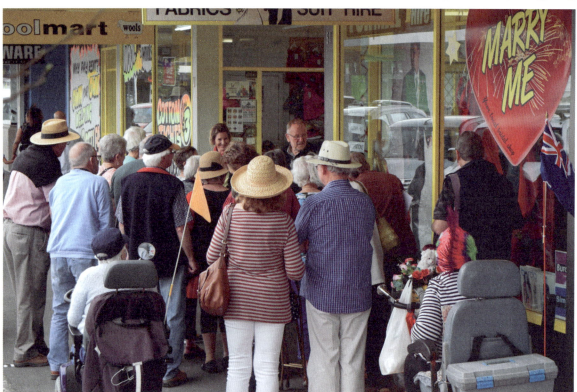

'Block Party', Masterton,
May–December 2017.

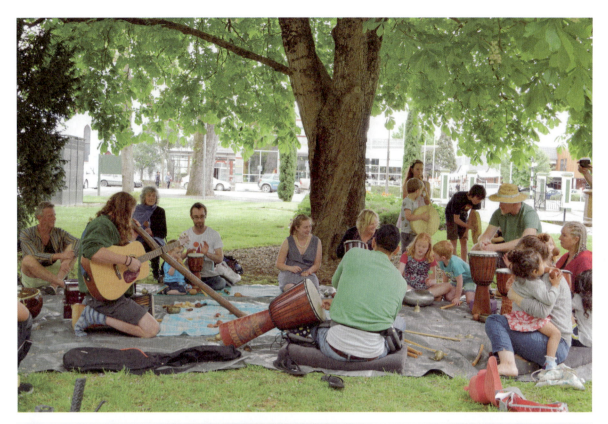

Our Future Masterton — Ahutahi ki mua

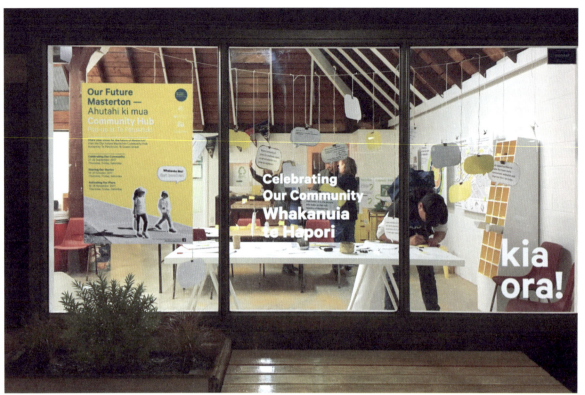

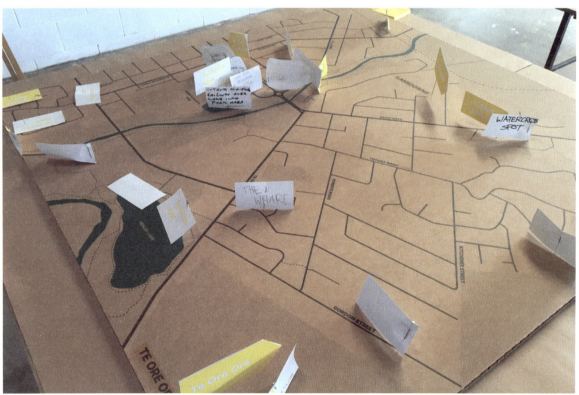

Our Future Masterton — Ahutahi ki mua
strategy planning session,
May–December 2017.

Our Future Masterton — Ahutahi ki mua

A Place for Local Making,
Xin Cheng and Adam Ben-Dror with
Grace Ryder, February–May 2022.

After

///

In early 2019 — after the closing of Urban Dream Brokerage in 2018 — Letting Space organised a symposium for independent artists at Victoria University of Wellington. *Taking Our Space in the City* collectively mapped independent arts spaces and their needs and explored ways to share resources.

As everyone slowly emerged in the middle of 2020 after the first Covid lockdown, it was clear there were more retail vacancies in the Wellington central business district, as had occurred in the recession after the global financial crisis. Accompanied by a drive from Wellington City Council to welcome people back, inner-city residential construction was growing alongside a housing crisis that was putting new pressures on the city's young and most vulnerable. Jason Muir of Maverick Creative — who had previously brought the city the pop-up political hair salon *Political Cutz* and the *All Good?* salon in Porirua — relaunched Urban Dream Brokerage with Letting Space mentorship. Working with him was Linda Lee, another artist and producer Letting Space had previously mentored.

Funded through the council's post-Covid city recovery fund, Tipu Toa: Build Back Better, Letting Space was given the task of selecting six public art commissions for vacant space, to be produced independently with Urban Dream Brokerage support over 2021 and 2022. This resulted in a more hands-off approach from Letting Space; in most cases other curators were selected to help develop the projects.

Led by artist and critical engineer Julian Oliver, with Sophie Jerram as a curator, *Electromagnetic Geographies* developed artists' skills in revealing unseen networks and explored the usage and ownership of the digital spectrum. Oliver had previously workshopped ideas with Letting Space from his pre-Covid base in Berlin.

Commonspace, developed by youth arts collective Mouthfull, created a space of 'being and belonging, learning and connecting, through de-siloing knowledge and cross-pollinating disciplines' for an inner-city community of people aged 16 to 25. Mouthfull hosted hundreds of micro-events over four months. *Moodbank*'s Vanessa Crowe assisted as a curator.

For *Rongoā-Marae-Roa-a Rangi: He Moemoeā*, Tanya Te Miringa Ruka created a rongoā teahouse close to the site of Te Aro Pā — an installation space inspired by the 'pluriversal nature of the ngahere (forest)'. Acknowledging the wairua of the city, Ruka's project mapped the inner city with the mātauranga Māori concepts of māramatanga, kaitiakitanga and manaakitanga.

In the lead-up to Christmas 2021, Bek Coogan presented an alternative nativity scene, *The Original Homeless*, as a response to the housing crisis. She employed shards of rimu sarking destined for landfill, calling to 'the underlying truth of the ecological impacts of settler-colonial land ownership'. Asking for public participation in photo shoots (akin to a Santa's grotto) Coogan reflected on how the human right to a home has been 'consumed' and 'disrespected'.

The second part of this commission was a project from Heleyni Pratley, which ran between October and November 2022. *A Work About The Housing Crisis With An Indoor–Outdoor Flow* used reflective discussion and art-making with the public to open up the complexities of the housing crisis. An indoor 'Housing Crisis Community Reflection & Assessment Centre' invited the public to participate in video interviews, which were then projected back to the community on a 'Housing Bubble Sculpture'.

Above: *Commonspace*, Mouthfull Collective, July–October 2021.
Below: *Inhabit*, Holli McEntegart, 2022.

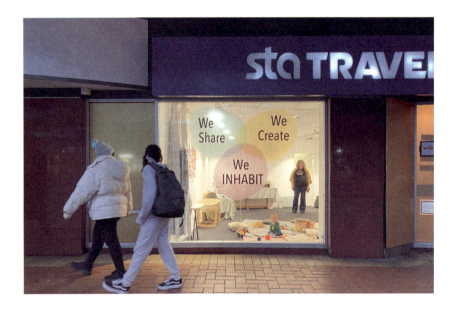

Above: *The Original Homeless,* Bek Coogan, Wellington, December 2021.
Left: *A Work About The Housing Crisis With An Indoor–Outdoor Flow,* Heleyni Pratley, Wellington, October–November 2022.

Electromagnetic Geographies,
Julian Oliver, Wellington, 2021.

Also in 2022 came *A Place for Local Making*, a 'co-creative hub for open-source making'. Artists Xin Cheng and Adam Ben-Dror assisted by curator Grace Ryder welcomed anyone to join them in an exploration of resourcefulness. They explored new uses for surplus materials and electronics, playing, making and thinking with them and transforming them into useful or enjoyable things. Local 'maker-carer-user-hackers' who repair and repurpose were invited to share their creations.

In the final 2022 commission (and as we write, Urban Dream Brokerage continues work in Wellington on its planned 2023 programme), artist, mother and full-spectrum doula Holli McEntegart's *Inhabit* brought together mothers and their infants in a Courtenay Place location. The work examined how community, cultural and whānau postpartum care has changed in Aotearoa, with participants sharing experiences in real time and as oral history. Mothers facilitated a variety of workshops, sharing knowledge and making their work visible to the passerby. Anne Noble assisted as artist-curator.

Reflecting on *Inhabit* as art as expanded social practice (in a written conversation with McEntegart), Noble commented:

> Letting Space and Urban Dream Brokerage have made a really remarkable contribution to the Wellington art scene. Letting Space positioned itself as an entity that sits outside the conventional domain of the gallery, where the artist is mostly defined as a producer of objects and artefacts. They offered an experimental space and an invitation to artists to expand the ecology of contemporary art and provide support for them to provide a new kind of experience for communities and publics to engage with contemporary art.
> I see *Inhabit* as a perfect example of the kind of project that Letting Space and Urban Dream Brokerage were established to nurture, enable and support.

Letting Space producers Sophie Jerram and Mark Amery at Transitional Economic Zone of Aotearoa, Porirua, November 2015.

Human First, Artist Second: A conversation //
Mark Amery and Sophie Jerram

Sophie: The point of establishing Letting Space in 2010, a retake on the 1992 project, was not (for me) to curate art for the art world. It was to respond to the economic and environmental crises of the world through the genius of thoughtful creators to create dissensus, using agonistic approaches.

The audience for these projects (to me) were the worlds of business, sustainability and community makers. That's why we invited commentators from the worlds of economics, journalism and activism to respond. It's why mainstream media response was important. Of course, artists attended the projects, too, as did art curators such as Heather Galbraith.

The intervention into the political, the disruption and the introduction of 'unnatural' others — like property owners — these were all in the original vision.

Heather asked in her essay what would happen in terms of cultural and artistic value if Kim Paton's *Free Store* were 'taken up, formalised and made part of an official service delivery' — and the store was in fact taken up, formalised by young Christians and made permanent on Willis Street in 2011. Probably some of the novelty and artistic interrogation was lost, but the cornerstones of Kim's idea — the respect for the customers, the recognition of waste in the food system, the inversion of usual charity thinking by removing the 'need' determination — have been retained. The power of the idea can be heard in interviews with Sinéad Browne, who was so inspired by the Willis Street *Free Store* that she went on to create her own series of projects in the United Kingdom.

By moving away from the critical edge of the usual art spaces, we took a risk that Letting Space wouldn't find an audience. The projects might fall distant from both the 'critical creative impulses' of art making (to use Heather's phrase) or the economic drivers of social enterprise. Yet we continued generating work, hoping to reveal some kind of pattern through continued meanderings between art and social/environmental issues. We have seen similar strategies in the work of groups like Creative Time in the United States (founded in 1974) and Led by Donkeys in the United Kingdom (established in 2018).

Only a few years later we were working on making Urban Dream Brokerage a permanent fixture. It was not accepted into green business advisory Ākina's accelerator programme for social enterprise because they couldn't see the way the project could develop commercially. I now take some pride in that. Despite several years of trading, we were working directly in opposition to the market. We weren't testing a market idea, we were *provoking* a social idea. We didn't necessarily fit anywhere because we created Urban Dream Brokerage, and Letting Space more broadly, to be its own environment.

Mark: I love your definition of your intentions with Letting Space. Looking back from more than a decade later, in the 2010s there was this new scurrilous set of individualist capitalist enterprises that presented themselves as more sustainable but that didn't look after people — the start-ups and pop-ups charged by new mobile technology. Think Uber and Airbnb, the huge growth

in Google- or app-based navigation of the world and social media, all in the digital cloud, which had no local grounding and didn't encourage people to work together. These trends needed a counter, a disruption. Democracy felt truly under threat by global private forces, and the global financial crisis sounded a warning.

To address what constitutes the 'art world' — in my mind that construct is made up of galleries, private and public, and the network of fairs and auction houses. It is not first and foremost artists.

We'd both been involved in, or on the periphery of, the largely artist-run Artspace and then Teststrip in Auckland in the early 1990s. There was afterwards a big growth in non-artist-run galleries and their staffing, including the role of curator. I realise now that working in public space was an opportunity to rethink, or re-establish, relationships between artists, curators and producers in spaces that were not owned by institutions — they were shared spaces from the get-go.

We weren't being oppositional to the gallery, but rather trying out a parallel practice. I recall being really struck and inspired by two works at the Auckland artist-run space Gambia Castle: Daniel Malone's *Black Market Next to My Name* and Tao Wells' *Three Ideas for the State*. They powerfully asked questions about the gallery as their framing, leading to musing on what the effects were when such artists left that insulation.

I recall early on how steadfast you were about us not staging projects with or in the galleries, as was habitual. We made a very considered move for Mark Harvey with *Productive Bodies* to workshop his public actions in City Gallery Wellington, and then go out and interact with other public good infrastructure — from pedestrian crossings to Parliament grounds to the central library.

The two TEZAs in Christchurch and Porirua stayed clear of the usual public art orbit defined by galleries, setting up in contested, more difficult ground. No wonder it was so hard not to fail! (By the time we got to Porirua I had Samuel Beckett's words in my head: 'Try again. Fail again. Fail better.')

Just as the gallery system had ballooned, so the art being exhibited in public galleries had also changed since the 1990s, including more installations and photography, then video and multi-platform work. But these dynamic forms seemed to me a little trapped in the gallery compared to the ambitions and achievements of my teenage artist heroes like Len Lye and Phil Dadson, who thrived in a cross-arts mesh. I grew up with Dadson's From Scratch and The Front Lawn — truly interdisciplinary cross-media art projects that reached across arts audiences — and an interconnected but independent web of performing arts practice and artist-run spaces.

The mainstream art world increasingly looked like it was giving in to global capitalist concerns. More fairs, more travel, less connection to its own ground, totally wedded to growth — a word I recall you ensuring we didn't use. Art locally and globally was an event, was big business. No wonder we copped questions from our essayists about staging events in unusual locations. The idea that the art gallery provided necessary insulation for artists seemed hotwired into New Zealand contemporary art after the 1970s — yet the times had changed dramatically.

As you indicate, I think far more influential on Letting Space was the climate change emergency. The 2000s had seen a rise in public awareness (Al Gore's *An Inconvenient Truth* came out in 2006), but there was still a lot of denial in conservative ranks when we started.

You and Dugal McKinnon had just done a series of talks between artists and scientists — Dialogues with Tomorrow — that was ahead of its time. It was inspiring and visionary and showed the way for Letting Space.

The Letting Space projects maybe anticipated that new buzzword, 'sustainability', just as both of us had young families and were getting involved with community projects and more sustainable practices in our own neighbourhoods — Vogelmorn Bowling Club, Paekākāriki FM, community gardens and so on.

Yet on a national level it felt like the powers that be were shutting discussions about sustainability down. It's hard to remember now, how a lot of the climate change conversation disappeared from the mainstream.

Sophie: Yes, John Key's government really closed down the whole sustainability approach, including the sustainability.govt.nz portal. It had been a big part of the Clark government's strategy. In 2009, there was a goal to lower carbon use and aim for zero waste within government. When the government and its direction changed, there was massive grief in the green activism movement.

Mark: It felt like the one thing that you could do was try to effect change in the way you operated locally — your carbon footprint. Out of all that quiet grassroots work came the advocacy of a new generation, perhaps — the school climate change movement from 2018 on. That felt like a different period, where young people who grew up with the stonewalling felt a call for change was needed.

Sophie: Yes, the last major Letting Space project was Common Ground in 2017, and that was pretty environmentally aware.

Mark: Which brings us to something Pip Adam said after reading a draft of this book: 'What I love about the narrative of Letting Space as a whole is the way that it starts in buildings and then it goes deeper and deeper into the land. I feel that the projects about water show this and the whakapapa of the land. This in my mind is the shape of the book.'

Sophie: I really love that she saw that, because that's certainly where I've ended up: that we need to be in dialogue with the land and not just occupying buildings.

Mark: I think we first had some of these realisations through TEZA, particularly in New Brighton, where the ground had literally opened up, liquified. Where there were few buildings. There was the Red Zone and that devastation, but also the urgency of climate change. Sea level rise is a really big deal there, in terms of the water table.

Then there was engaging with the work Kāi Tahu were doing there — the *Kaihaukai* project during TEZA that reconnected past to present in the city felt like such vital work. People were connecting with the whakapapa of a place that was having to revisit its design and the relationship between people and the environment. That was very special to witness, but there was a discomfort in being an observer.

Sophie: We could fly in and enjoy it and then fly out again. By almost camping on that site, we were exposing ourselves to the difficulties. We were, someone put it (it might have been Ryan Reynolds from Gap Filler) trying to rough it like

Letting Space producer and Urban Dream Brokerage broker Helen Kirlew Smith in the secured site for Eve Armstrong's *Taking Stock*, Wellington, November 2010.

many of the Christchurch people, by being on that site. You can see it as an act of empathy, or class it as a type of disaster tourism. I don't know.

Mark: I was as inspired by my involvement in Paekākāriki Playcentre's parent-led organisational structure as by any participatory art practice. The Letting Space projects dealt broadly with waste within systems, but increasingly they became community network structures. Your involvement with the consensus-decision-making tool Loomio that came out of the Occupy movement was again, for me, key. By the 2000s there was a sense that people had been siloed by neoliberalism, had become individual competitive agents.

Actually having to organise large groups of people to host the first projects challenged us to consider how we wanted people to work together. What were the organisational principles? Ironically, all this was in the 2010s, when much of the art talk was about 'relational aesthetics'. That ended up meaning that artists practised social change within the infrastructure of galleries that didn't change. Getting wider social outreach becomes the challenge for these spaces.

Sophie: I wanted us to lead the way in new methods of organising because it didn't feel like the existing ways of organising society, like capitalism and private ownership, were working. The first TEZA was, for me, probably the changing point. I realised that having a vision for new ways forward (like the sharing economy and collectivising) was one thing, but you needed to bring people with you rather than curate them.

That's where Urban Dream Brokerage came in; where we were distributing the permission rather than controlling it.

I've just come from a Vogelmorn Bowling Club reflection meeting and I was thinking about how I used to be, like, 'Open the floor to everyone and collectively we'll somehow know what we want!' I now realise that's too loose. Possibly some of the TEZAs were trying to distribute power in this same way, and became rather loose.

As a community-based practitioner you have to find the balance between being open to new ideas, but also disciplined enough to get to the 'minimal viable product', as it were, and to make something cohesive.

I think if we tried to design Letting Space now, it might be more permeable than it was in 2010, but less distributed than Urban Dream Brokerage. When we started we were very much running as curators; we were quite heavy-handed.

Mark: We were also very busy just trying to create the production environment. Because we were outside of an organisation of any sort, we had to do everything. Some of the artists we worked with were very equipped in that sense, but even so we were having to create an infrastructure every time.

Sophie: And there's always that tension, because then we became the institution, didn't we? What I liked about Letting Space is that we didn't have any ongoing overheads.

Mark: An unconscious low-carbon-footprint approach! Do you think, in retrospect, the temporary nature of what we were doing was irreconcilably flawed?

Sophie: I don't think it was flawed but I think we should have been more serious about structuring further possibilities; in that we could have gone, 'OK, this is

a trial, now make this permanent.' But we didn't always know how or have the capacity to make things long term. Temporary meant we were light on our feet, we didn't have big overheads, we could change our plans. We didn't have a huge number of sponsors or funders breathing down our necks watching what we were doing. But the disadvantage was that there was no real ability to scale things up because we were exhausted.

Mark: I think there are strengths to this model in terms of the empowerment it gives to other people — people are actively involved in creating — and its ways of looking at things differently. But it's a little ironic that we were busy at the same time developing other projects in Vogelmorn and Paekākāriki that exist to this day.

Sophie: In the early days I think both of us were probably driven to be elsewhere, somehow — wanting to take projects to as many new places as possible. And then we did quite an about-turn and went inwards to our own communities. Sometimes when I'm at Vogelmorn Bowling Club — in the Civic Room, in the building that we own, looking at the green that we've modified — I reflect that it's radical, as is the radio station. It's a kind of radical ownership. It's not unusual — we're not alone in having realised that local is radical. But these local projects are different to our outward art stuff that took a lot more sophistication from people to see what we were doing.

Mark: Art often gets the word 'radical' pasted over it. It's an opportunity for people to drop what they're doing and try something different, temporarily, rather than something that carries on.

Another observation of Pip's: 'After reading the book, I think about the increasing awareness and desire to confront the colonisation of New Zealand. I think what is really interesting about the timeframe of Letting Space is that it reflects a time where artists, activists and everyone became more aware of what colonisation actually meant and started thinking about how their work fitted in this landscape of trauma. I think the projects reflect this and I think this culminates in Lana Lopesi's essay.'

Sophie: That's generous of her. By the time we did the first TEZA, in 2013, we were working with Kāi Tahu, welcomed at Rāpaki and onto our site with Te Urutahi and Te Huirangi Waikerepuru from Taranaki/Parihaka. And we connected with Wiremu Grace on the Porirua TEZA in 2015. He worked hard to welcome us to Takapūwāhia with Ngāti Toa, and took us to Hongoeka for Conscious Roots.

Mark: There was dialogue, often difficult at a time when it didn't seem so common, it's true. But the dialogue was always with iwi who were already doing the work themselves, and well ahead of us. There was always the worry that you were actually creating more work for mana whenua than what you were providing.

It's not a case of 'how can we help you?' It's ultimately about making Pākehā feel more comfortable to develop understanding in this space, when iwi have more important work going on. So maybe the best work was taking that journey about how Pākehā operate in parallel with Māori, with Māori already there.

Sophie: For me, having Te Urutahi and Te Huirangi with us in Christchurch helped elevate everything to a higher level of awareness, though that didn't necessarily

mean a full understanding of the injustices. At Hongoeka, I was grateful to be able to work alongside Wiremu and offer support for his vision. And I learnt a heck of a lot about Ngāti Toa, which is still helping me in the job I'm doing now with Wellington City Council.

Mark: You become aware of how blinkered you are to the way other people see the land based on the history and the way that it's affected their people, their whānau. That takes time to see anew.

You said in correspondence with Chris Kraus, after reading her essay, that making Urban Dream Brokerage permanent was an attempt to make Letting Space's activities sort of less haphazard. In a way, we were hoisted by our own petard. Trying to keep a service running took quite a lot of the pleasure out of what we were doing.

Sophie: Yes. It wasn't so much about making Letting Space less haphazard but more about making it available to more people. My feeling was that the energy we had for big projects like TEZA was quickly eaten up by trying to keep Urban Dream Brokerage running while putting ourselves in the background, like wallpaper.

How do you perceive what happened to Letting Space?

Mark: We were thinly spread. And there was the confusion in Porirua with Urban Dream Brokerage (helping local groups obtain use of vacant spaces) and Letting Space (producing TEZA) — the two things ran together a little. I think there was some really great stuff that went on with Urban Dream Brokerage, in giving local groups space, but it also made things difficult.

It was similar with Common Ground, trying to do so much in such a short space of time. There was some magic there but the impact wasn't always as strong as it could be — it becomes top-coating rather than soaking deeper. But I see it everywhere. I see councils put all their arts budget into marketing arts trails or festivals, rather than focusing on a sustained investment to help develop a practice and an audience. And in a way it's at the expense of artists.

Sophie: Yes. A lot of smoke without heat. It's quite different from working with a community slowly and having an outcome that actually works for the people who live there.

Mark: Too much coming up with the ideas first, rather than working out what the ground needs.

Sophie: Exactly — the pretty planting on top rather than 'how do we feed the soil?'

Mark: The topsoil just washes away at the end of the season.

Sophie: Remember the striated model I showed you that I developed for my PhD? It shows these different levels of action. On the top is conversation — it's light and it's important but it's not necessarily going to change anything deeper than between the two people who have had the conversation. The next level is art and play; then there's planning and regulation. If you keep going down you have serious building works or war, things that are points of violence. At the very

bottom are earthquakes and geological planes. If you had a project that could work through multiple layers, then you'd really be changing things.

Over the years I would feel myself trying to have these conversations, or play, through some of the artworks and projects. I'd be trying to talk to regulators at various councils about change. But it wasn't done with any real substance or any tactics. Now, I would . . .

Mark: I'm reminded that with *Projected Fields* we had a genuine interest in working with Wellington City Council at a wider level, but were again spread thin. There was real excitement that we weren't just working with the arts team but also parks and recreation. Maybe we could do some good in changing the whole culture? We worked from further out, surveying and gaining buy-in.

Sophie: You know they came past afterwards and put fences around the park? They actually did take notice of what had gone on. Careful, nicely designed wooden surrounds to make it look a bit more cared for.

Mark: I think we wanted people to value their park more. Sometimes it's just about making people think a little more deeply about their relationship to these spaces and how important they are.

Sophie: The council did notice and came and attended to the park with more care than they had. So we had some weird effect on it.

And then, two or three years later, for Matariki, someone painted the stars on that same hillside.

The Rising Gale, Murray Hewitt,
Hutt Valley, February–March 2017.

Human First, Artist Second // Mark Amery and Sophie Jerram

Commonspace, Mouthfull Collective, Wellington, July–October 2021.

Shifting the Urgency: Situating Letting Space within the context of social arts practice // Zara Stanhope

> We propose . . . undisciplining, disturbing, challenging, and 'tickling' the dominant subjectivation of actors, places of existence, processes of becoming, modes of practice, and ways of relating within art practice.
> — Višnja Kisić and Goran Tomka[1]

In a reality where radical alternatives to the current neoliberal situation feel impossible, Letting Space's actions between 2010 and 2020 suggest a prioritising of the question 'what sort of futures do we want?'

Social art practice had a decades-long global context before the period of Letting Space's tenure. The artists working as and with Letting Space were aware of aspects of this practice and its recent histories. Sophie Jerram had spent time in Europe and Mark Amery followed local practice as a critic and advisor. They were well aware, for example, of New York organisation Creative Time's long and wide-reaching history.

Aotearoa New Zealand had just had an ambitious nationwide programme of temporary public art projects featuring homegrown and international artists, One Day Sculpture. Amery and Jerram also recall the impressions left by durational practices in Aotearoa, like the collectives Local Time and Public Share.[2] Also in the mix were artworks like Fiona Jack's *Palisade* (2008) — a work in collaboration with Ngarimu Blair and Ngāti Whātua Ōrākei to reinstall a 1943 mānuka palisade fence at Ōkahu Bay, Auckland — and Rachael Rakena's programme of public work in critical response to the 2011 Rugby World Cup.[3] Agnes Dean's planting of 2 acres of wheat on landfill in 1982 Manhattan had a local, earlier equivalent for Amery in Barry Thomas's *A Vacant Lot of Cabbages* (1978), an urban garden created in a long-vacant space in Wellington for collective action.

With some knowledge of the international antecedents for social art — and admiration for the artists they saw addressing political and social situations within Aotearoa — the Letting Space team set out, step by step, to determine where they could explore modes of social engagement as artists. In the spirit of Kisić and Tomka's words above, Letting Space was pursuing new modes of practice itself, and inviting in other artists, for the purpose of 'disturbing, challenging, and "tickling" the dominant subjectivation' of communities in public and private spaces.

There are a range of earlier social practices and interpretative theories which frame our understanding of Letting Space's actions. Yet its work also disturbs these models, as the Letting Space artists deliberately headed into new, untested modes of work. The global history of social practice until 2010 ranged from small-scale interactions in gallery spaces to extensive projects in public space, durational periodic events reminiscent of biennales, and shorter, activist interactions by artists engaged with community-building. A few well-known examples convey the multiplicity of types of practices.

In 1995, Californian artist Suzanne Lacy defined 'new genre public art' as a new form of aesthetics in her book *Mapping the Terrain: New genre public art*. The newness was characterised by experimental, process-based aesthetics and

1. Višnja Kisić and Goran Tomka, 'Tickling the Sensible: Art, politics, and worlding at the global margin', in Carin Kuoni, Jordi Baltà Portolés, Nora N. Khan and Serubiri Moses (eds), *Forces of Art: Perspectives from a changing world* (Amsterdam: Valiz, 2020), 49.
2. Mark Amery, email to author, 15 September 2022. Local Time was launched in 2007 by Danny Butt, Jon Bywater, Alex Monteith and Natalie Robertson. Public Share began in 2014 and comprises Monique Redmond, Harriet Stockman, Kelsey Stankovich, Deborah Rundle, Mark Schroder and Joe Prisk (see https://publicshare.co.nz).
3. For Fiona Jack's *Palisade*, see https://fionajack.net. Rakena's programme featured the work *Haka Peepshow* in Dunedin's Octagon, a video work in a sculpture resembling a giant Rexona deodorant roll-on container and video projections that critiqued the World Cup by focusing on women players.

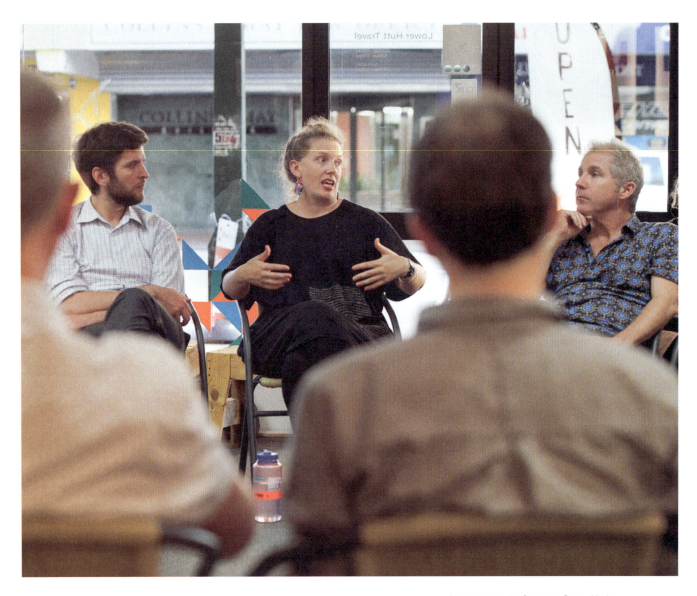

Discussion at the Common Ground hub,
Groundwater: Common Ground Arts Festival,
Hutt Valley, February–March 2017.

self-reflexive, interpersonal interactions in public contexts that were distinct from the usual sites of conventional public or community art.[4]

Lacy's work with marginalised communities around Los Angeles aimed to make visible black youth, older women, the homeless and others who felt socially marginalised by addressing their socio-political situations using installation, sculptural media and performative and process-based art. Lacy has publicly discussed navigating the questions of ethics in working with community participants and the challenges she has faced to her claim that her projects generate wider empathy and understanding.

Many writers have criticised claims that social art offers an instrument for transformative social change, arguing there needs to be more attention to the balance of power dynamics between artists and participants.[5] Some have questioned the role or form of social art, particularly whether artists should be charged with being 'service providers' of social good. Others have sought to determine where the meaning of social art lies — whether it can be found in its processes, aesthetics or outcomes.[6]

Familiar to artists at the time of Letting Space's activities was curator Nicolas Bourriaud's promotion of certain artworks as socially emancipatory, found predominantly in his book *Relational Aesthetics*. Bourriaud's examples of relational art from the 1990s include a diverse range of styles, such as Thai meals cooked in the gallery by Rirkrit Tiravanija; Gabriel Orozco's *Hamoc en la moma* (1993), a hammock slung in the gardens of the Museum of Modern Art, New York; and Felix Gonzalez-Torres' stacks of prints and piles of sweets placed in the gallery, free for the taking.[7] Social art for Bourriaud included artworks that encourage audiences to participate in their formation or evolution as well as static, non-participatory artworks that imply the different ways people join together socially.

Counter-arguments to Bourriaud brought other ways of working socially to light. By the mid-2000s Claire Bishop's advocacy for the political effectiveness of antagonist art was highlighting work such as Thomas Hirschhorn's *Bataille Monument* (2002) a monument to the French philosopher built with residents from housing projects near Kassel, Germany. Bishop promoted art that destabilised fixed community identity and privileges the viewer as a subject capable of independent thought through involvement with people from different backgrounds — a form of avant-garde provocation.[8]

Contrasting theories by Grant Kester argued that artists engaged in long-term and ethical dialogic relations could generate politically active communities.[9] For example, Southeast Asian artist Jay Koh has worked in the difficult conditions of Myanmar since 1997, and was consequently asked by local artists to help establish an independent art centre (NICA, 2002–07). Koh's support for independent artists' initiatives required a deep attention to place and the establishment of trust to operate effectively in a highly militarised state. Another example is American Fred Lonidier's process of establishing long-term relations with workers and unions to create art installations as part of larger initiatives to encourage labour solidarity across boundaries of national and class difference.[10] Such artists embed themselves in communities for a long period, in order that their practice becomes part of daily life.

Many other projects of which Letting Space artists were aware sit between

4. Lacy acknowledged her indebtedness to Joseph Beuys' concept of social sculpture and to the work of Guy Debord, Fluxus and Allan Kaprow, among others, in the integration of the artist's role into society and emphasis on the discursive and pedagogical nature of art, which she understood as offering an alternative history for public art through feminist, ethnic, Marxist, activist and collaborative methodologies. Suzanne Lacy (ed.), *Mapping the Terrain: New genre public art* (Seattle: Washington Bay Press, 1995), 25–30, 40, 190. On the precedents for new genre public art, see Malcolm Miles, *Art, Space and the City* (London: Routledge, 1997), 102.
5. Lacy, *Mapping the Terrain*, 29.
6. Miwon Kwon, 'One Place After Another: Notes on site-specificity', *October*, vol. 80 (Spring 1997): 85–110; Miwon Kwon, 'The Wrong Place', *Art Journal*, vol. 59, no. 1 (Spring 2000): 33–43; Miwon Kwon, *One Place After Another: Site-specific art and locational identity* (Cambridge, MA, and London: The MIT Press, 2004).
7. Nicolas Bourriaud, *Relational Aesthetics*, trans. Simon Pleasance and Fronza Woods with Mathieu Copeland

(Dijon: Les presses du réel, 2002). Other artists discussed in *Relational Aesthetics* include Vanessa Beecroft, Maurizio Cattelan, Liam Gillick, Pierre Huyghe and Philippe Parreno. Most artists discussed had participated in exhibitions curated by Bourriaud, such as *Traffic* (1996).
8. Claire Bishop, 'Antagonism and Relational Aesthetics', *October*, vol. 110 (August 2004): 51–79; Claire Bishop, 'The Social Turn, Collaboration and its Discontents', *Artforum* (February 2006): 178–84.
9. Grant Kester, *Conversation Pieces: Community and communication in modern art* (London: University of California, 2004).
10. Kester, *Conversation Pieces*, 176–80. Other projects include *N.A.F.T.A. (Not a Fair Trade for All)* (1997) on the conditions for Mexican maquiladora workers.
11. See Theaster Gates, 'Rebuild Foundation', www.theastergates.com/project-items/rebuild-foundation.
12. Engaging Publics/Public Engagement, organised by Auckland Art Gallery Toi o Tāmaki and AUT University, 2015.
13. Other recent publications include: *Let's Go Outside: Art in public — A MUMA reader* (Melbourne: Monash University Museum of Art,

these various theoretical models. Theaster Gates' work brought together activism and community involvement to create urban change,[11] drawing on the foundational Row Houses project originated by Rick Lowe in Houston in the 1990s, where artists worked to revitalise housing to serve the community. This is in contrast to one-off participatory performative projects such as *The Battle of Orgreave* (2001) by British artist Jeremy Deller, in which the artist worked with former Yorkshire miners to re-enact a violent clash between miners and police in the 1980s.

///

Other approaches to social practice by artists or curators evident by 2010 were concerned with the idea of 'undiscipline' mentioned by Kisić and Tomka. They wanted, like Letting Space, to challenge practitioners' existing ways of working. This was the case for artist Jeanne van Heeswijk, whose The Blue House (Het Blauwe Huis) project (2005–09) was set in IJburg: a new, centrally planned, suburban development on reclaimed land at the edge of Amsterdam intended to alleviate population pressures and assist in positioning Amsterdam as a global city.

Van Heeswijk invited artists, architects and academics to reside in a house in IJburg for periods of up to six months, leaving them on their own. The Blue House residents were expected to meet neighbours and determine how to create engagement while investigating the impact of urban design on life in the sterile surroundings of newly built public and private housing. The Blue House members aimed to document local history as well as be part of its production by fostering sociality and interrogating the nature of life in the emergent neighbourhood. The project resulted in over 50 events and activities at the house, including a social space for teenagers, children's library, community restaurant, edible garden, outdoor cinema, radio station, commercial ventures and debates and discussion events. The project was a catalyst for communication and awareness raising between locals and highlighted social tensions particular to the citizenship and cultural attitudes in the Netherlands.

Van Heeswijk spoke to her ideas of resetting oneself in a place of 'unknowing' in social practice in a symposium at Auckland Art Gallery Toi o Tāmaki attended by Letting Space and associated artists in 2015.[12] As well as supporting the development of artists' social practices, in her work van Heeswijk's publications encouraged the dissemination of new knowledge to inform art pedagogy.[13]

Similarly, the large-scale InSite project gave artists extensive time to work at the San Diego/Tijuana border between Mexico and the United States. It morphed from its initial exhibition model in the 1990s to deliberately challenge artists' thinking and process when working in a unique cultural and political contrast. *inSite2000–2001* and *inSite_05* sought to generate discussion on the nexus between public/private rights and the socio-cultural construction and use of space.

With its first iteration in 2000, after a decade of convincing local prefectures to participate, the Echigo-Tsumari Art Triennial (ETAT) in Japan set a particular example of social practice's ability to contribute to lasting rural social revival and micro-economic transformation. This project was a response

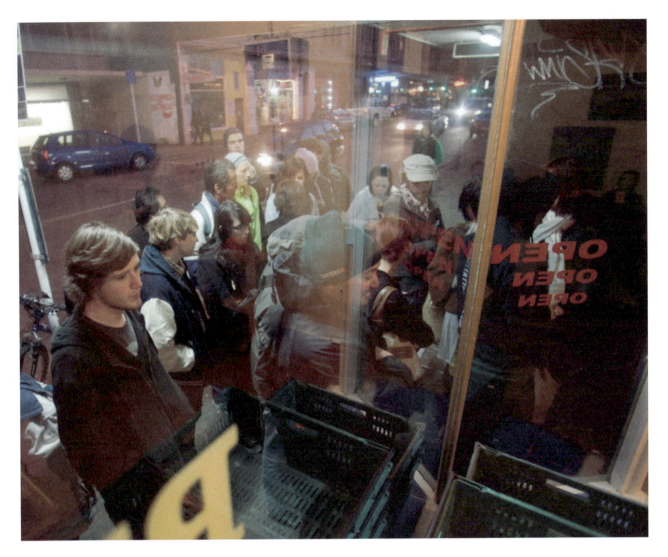

Free Store, Kim Paton, Wellington, 2010.

to Japan's economic stagnation and rural population loss. Artists were hosted in small towns and villages across the large, rural region of Niigata, often left to their own devices to work with local residents in a cross-cultural situation distinct from InSite and The Blue House. Some residents developed their own enterprises out of their participation as part of a diverse range of installations and activities that became attractions for summer audiences visiting the landscape of terraced rice fields as cultural tourists.

///

As these examples suggest, the concepts of cultural cities, creative capital and social enterprise that have been co-opted by governance and states are part of the complex intersections of social practice. Letting Space was clearly conscious of the risks of social art becoming co-opted or alternatively entangled in modes of social enterprise. Such issues have been navigated by other ongoing projects, such as the Conflict Kitchen restaurant founded in Pittsburgh, Pennsylvania, by artists engaging critically with the problematics of consumer capitalist society.[14] Operating over a similar time period to Letting Space, 2010–20, Conflict Kitchen served 'cuisine from countries with which the United States is in conflict'.

Despite the processes of social exchange in the arts being at the height of their critical analysis to date during the period of Letting Space's activities, much of the recent history of these practices remains unknown.[15] Not unique but important to Letting Space is that their approach of undertaking short-term activities as part of a longer-term project allowed for experimentation and self-reflection as creative practice. Actions responded to the ethical and pragmatic nature of sites and contexts. Letting Space's previous documentation, and now this book, offer a sense of the concerned artists' social engagement within micro-political situations and contribute to our understanding of the field of social art.

Looking back now, we can see the way Letting Space stepped outside the unrelenting pace of an increasingly uncaring neoliberal world to devote time and attention to the perceived social issues of the moment. Its invitations made time for engagement, conversation and argument. In the same way, this book is an opportunity for reflection that is outside of time. It is an invitation to ignore what we know — the limitations of the existing theorisation of social art — to unlearn and continue to reflect on practice as a proposition in itself. To reflect on how context influences practices, what types of aesthetic forms are favoured as effective, and how artists address power dynamics with participants.

Implicit are questions of how social art projects are remembered, and how they are archived. What is lost in documenting the imagining of alternative processes of living, relating and creating? What effect does remembering or retelling projects have in understanding the work, or in pinpointing its location on a spectrum from 'solely symbolic' to 'a force of change influencing communities or other outcomes'? These are important questions for readers of this book trying to retrospectively understand Letting Space projects' engagement with socio-political issues, whether they were working with or against existing structures in the creation of art as social meaning.

Monash Art Projects and Monash University Publishing, 2022); Jeanne van Heeswijk, Maria Hlavajova and Rachael Rakes, *Toward the Not-Yet: Art as public practice* (Utrecht: BAK, 2021); Martin Patrick, *Across the Art/Life Divide: Performance, subjectivity, and social practice in contemporary art* (Chicago: Intellect, 2018).

14. See www.conflictkitchen.org. This area is discussed in detail in Grace McQuilten and Antony White, *Art as Enterprise: Social and economic engagement in contemporary art* (London: IB Tauris, 2016).

15. Related critical writing from the time includes Chris Kraus, *Social Practices* (Los Angeles: Semiotext(e), 2018); Ted Purves and Shane Aslan Selzer, *What We Want Is Free: Critical exchanges in recent art* (Albany: State University of New York Press, 2014); Claire Bishop, *Artificial Hells: Participatory art and the politics of spectatorship* (London: Verso, 2012); Shannon Jackson, *Social Works: Performing art, supporting publics* (New York: Routledge, 2011); and the exhibitions and publication *Audience as Subject* (San Francisco: Yerba Buena Center for the Arts, 2011–12).

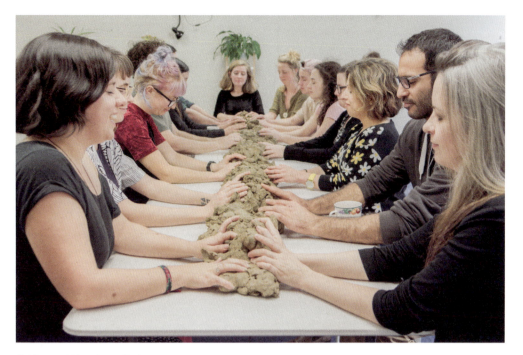

CoLiberate, Urban Dream Brokerage, Wellington, 2016.

Making time for people to engage with each other, listen, share and step away from existing assumptions and expectations, to unlearn and be open to one another, are all political acts that disturb the pace of neoliberal life. Such strategies enabled Letting Space to simultaneously engage and transcend the urgent particularities of their place and context.

It is artists who lead the field of art and culture. Where and how the people, institutions and theorists who contribute to the wider art world are able to make space for and catch up with artists' ways of thinking remains another question we take into the future.

Project Notes

Realty Pitch
6 May 2010
Adam Auditorium,
City Gallery Wellington
Pages 24–33

Production team:
Mark Amery, Sophie Jerram
Artists pitching:
Kim Paton, Erica van Zon, The PlayGround Collective, Bronwyn Holloway-Smith
Funder:
Wellington City Council
Property panellists:
Ian Cassels (The Wellington Company), Richard Burrell (Building Solutions), Rosemary Bradford (Colliers International)
Artist panellists:
Jeremy Diggle, Cathryn Munro, Rob Cherry
Other participants:
Ray Ahipene-Mercer (Wellington City councillor), David Cross (MC; Massey University)

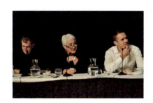

Realty Pitch
29 July 2011
Ilot Concert Chamber,
Wellington Town Hall
Pages 24–33

Production team:
Sophie Jerram, Mark Amery,
Matilda Fraser
Funder:
Wellington City Council
Pitching artists:
Tim Barlow, James R. Ford,
Shona Jaunas with Natalia Mann,
Bruce Mahalski with Bev Hong
Property panellists:
Chris Gollins (Colliers), Liz Mellish,
David McGuiness (Willis & Bond)
Artist panellists:
Heather Galbraith, Rob McLeod
Eve Armstrong
Other participants:
Ray Ahipene-Mercer
(Wellington City councillor),
Mark Westerby (MC),
Cook Strait Holdings

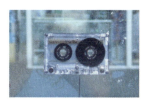

Popular Archaeology: Cassette, c.1967–94
Dugal McKinnon
18 April–9 May 2010
141 Willis Street, Wellington
Pages 34–41

Production team:
Sophie Jerram, Mark Amery
Funders:
Creative New Zealand
and Wellington City Council
Property partner:
The Wellington Company
Assistants:
Foster Clark, Jaime Cortez,
Jeremy Coubrough, India Davis,
Natalie Ellen-Eliza, Alexandra Hay,
Pieta Hextall, John Hobbs,
Jack Hooker, Zane Jarvis,
San Kang, Kirstin Martis, Sally
Ann McIntyre, Gabrielle McKone,
Melanie Moreau, Jeannie Mueller,
Briar Munro, Kannika Ou,
Patrick Philipona, Emi Pogoni,
Laura Preston, Richard
Robertshawe, Georgina Titheridge,
Roger Ward, Jason Wright, and
all who contributed cassette
players and tapes

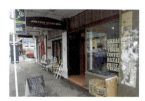

Free Store
Kim Paton
22 May–6 June 2010
38 Ghuznee Street, Wellington
Pages 42–51

Production team:
Mark Amery, Sophie Jerram
Funders:
Creative New Zealand and
Wellington City Council
Property partner:
Foodstuffs
Sponsors:
Progressive Enterprises'
supermarkets, Celcius Coffee,
Caffe Italiano, Cliff McNabb from
Barrels and Wedges (Stressing
Equipment and Lifting Anchors),
Vita Cochran, Tuatara Brewery
Assistants:
Natalie Ellen-Eliza, Jaime Cortez,
Kirstin Martis, Jack Hooker, Jason
Wright, India Davis, Pieta Hextall,
Jeannie Mueller, Johannah Morris,
Jack Nesbit, Sandra Anttila,
Caroline Redelinghuys, Melanie
Nieuwoudt, Philippa Clements,
Robin Murphy, Georgina Titheridge,
Omega Smith, Harriet Lethbridge,
Sai Dobui, Monique Davey, Leda
Farrow, Caleb Gordon, Jane Hyder,
Max Telfer, Hannah Zwartz, Helen
Keivom, Kylie Walker, Ish, Uri
Khein, Victoria Wevers, Gabrielle
McKone, Kirsty Lillico, Darryl
Walker, Mel Oliver, Monique
Davey, Sai Dobui, Andy Dickinson,
David Zwartz, Customs Brew
Bar, Bowen Galleries, Minimum
Graphics, Milk Crate, Hamish
McKay Gallery

Project Notes

 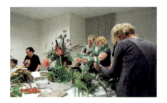

Beneficiary's Office
Tao Wells
15 October–1 November 2010
Level 3, 50 Manners Street, Wellington
Pages 52–67

Production team:
Sophie Jerram, Mark Amery, Laura Shepherd
The Wells Group:
Helen Keivom, Robyn Kenealy, Carla Schollum, Harry Silver, Dick Whyte
Inuit time: Artists, Employed vs Unemployed:
performed by Colin Hodson, Campbell Walker, Dick Whyte, Grace Russell, Bevin Linkhorn at the Frederick Street Sound and Light Exploration Society
Funder:
Creative New Zealand, Work and Income New Zealand
Property partner:
The Wellington Company
Sponsors:
Ambience Office Plants

Taking Stock
Eve Armstrong
20 November–2 December 2010
143 Featherston Street, Wellington
Pages 68–77

Production team:
Mark Amery, Sophie Jerram
Funder:
Creative New Zealand
Property partner:
CB Richard Ellis
Collection points:
The Dowse Art Museum, Mahara Gallery, City Gallery Wellington, Pātaka Art + Museum, Toi Pōneke, Enjoy Gallery
Plastic suppliers:
Grayley Plastics, The Glass Shoppe, Flight Plastics
Participants:
Philippa Clements, Gabrielle McKone, Harriet Lethbridge, Meryl Richards, Kirsty Lillico, Kylie Walker, Lauren Redican, John Grant, Lee Browne, Helen Keivom, Janet McGifford, Natalie Ellen-Eliza
Other help:
Ibis Featherston Street, Paul Wilson

Shopfront
Suburban Floral Association (Monique Redmond and Tanya Eccleston)
8–19 March 2011
Station Square, Newmarket, Auckland
Pages 80–87

Production team:
Sophie Jerram, Mark Amery, Sasha Savtchenko-Belskaia
Funder:
Creative New Zealand as part of Auckland Arts Festival 2011
Property partner:
Sunnyville Property Management
Participants:
Justin Andrews, Lisa Benson, Paige Bradley, Marie Brittain, Rachel Carley, Paul Cullen, Anne Downie, Norman Edgerton, Richard Fahey, Alicia Frankovich, Ceri Garland, Sandra Gorter, Colleen Hall, Glen Hayward, Sarah Hillary, Ian Jervis, Blair Kennedy, Wussy Lala, Ema Lyon, Sally Mannall, Holli McEntegart, Gabrielle McKone, Andrea McSweeney, Diet Meyburg, Louise and Benji Meyburg, Lisa Middelberg, Rebecca Mitchell, Ceili Murphy, Margy Pearl, Amber Pearson, Annemarie Pickering, Paul and Judy Redmond, Joshua Redmond, Adrienne Roberts, Trish Scott, Jo Somerville, Harriet Stockman, Linda T., Mandy Thomsett-Taylor, Layne Waerea, Felicity West, Carolyn Williams, Ian Jervis, Liz Bird, Cathy Carter, Lauren Crozier, Charlotte Drayton, Joyce Forsyth, Michael Kennedy, Vanessa Kong, Colin Nairn,

Alannah Pirrit, Franziska Poeschl (and Alex), Lydia Reusser, Chelsea Rothbart, Tanya Ruka, Deborah Rundle, Gemma Skipper
Supported by:
Carol Chen (Sunnyville Property Management), Ariane Craig-Smith (and all at Auckland Arts Festival), Paul Redmond (PR Renovations), Andy Thomson, Margaret Colligan, Janet Lilo, Marie Brittain, Robbie Fraser, Laresa Kosloff, Andrew Davidson (Loan Central, A&D), John Stevenson and Trevor Gordon (City Park Services — Kari Street Nursery), Paul and Tieneke at VISIGN, Graeme Bulling (Body Corporate, Station Square), Ashley Church (Newmarket Business Association), Wayne Cameron, Mac Redmond, Auckland University of Technology

The Market Testament
Colin Hodson
11–25 April 2011
139 The Terrace, Wellington
Pages 88–95

Production team:
Mark Amery, Sophie Jerram, Matilda Fraser
Funder:
Creative New Zealand
Property partner:
Prime Property Group
Supported by:
Chris Aspros (NZWireless), Richard Naylor (R2), Heath Edwards, Brett Mason (Museum of Wellington City and Sea)
Assistants:
Nic Cave-Lynch, Grant Joyce, Daniel Bar-Even, Kowhai Montgomery, Chris Brown, Douglas Bagnall, Grant Watson, Gert Verhoog, Brent Edwards, Grace Russell

Pioneer City
Bronwyn Holloway-Smith
17 June–10 July 2011
Ground Floor, Soho Apartments,
80 Taranaki Street, Wellington
www.pioneer-city.com
Pages 96–107

Production team:
Sophie Jerram, Mark Amery
Performer:
Heather O'Carroll
Architect:
Rachel Logie
Funders:
Creative New Zealand, Wellington City Council, The Emerging Artists Trust
Property partner:
Ananda Investments Ltd
Supported by:
Massey University, Te Papa, Niki at Ambience, Estilo Design, Michael Shaw (Alive Building Solutions), Marty Scott at Harcourts
Other participants:
Matthew Holloway, Lewis Urbahn, Matilda Fraser, John Grant and Philippa Clements, Kylie Walker, Doug Crane, Graeme Tuckett, Meryl Richards, Don Brooker, Dan Untitled, Murray Hewitt, James Gilberd, Thonet, Sarah Farrar, Hutch Wilco

Project Notes

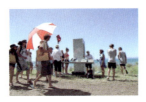

Free of Charge
Julian Priest
17–19 February 2012
Splore Festival, Tāpapakanga Regional Park, Auckland
Pages 110–15

Production team:
Mark Amery, Sophie Jerram
Funder:
Creative New Zealand and Splore Festival
Produced as part of Splore Festival 2012
Assistants:
Trudy Lane, Nicholas Twist, Aneurin Locke, AlphaLab Inc.

Productive Bodies
Mark Harvey
12–16 March 2012
City Gallery Wellington and Wellington CBD
Pages 116–27

Production team:
Sophie Jerram, Mark Amery
Funders:
Creative New Zealand, Wellington City Council
Produced as part of the New Zealand International Festival of the Arts and in association with City Gallery Wellington's sculpture exhibition *The Obstinate Object*
Participants:
Noel Meek, Amanda Priebe, Anna Halliday, Bev Hong, Douglas Lush, Gerald Dreaver, Leonie Smiley, Megan Buchanan, Michelle Osborne, Andy Palmer, Philip Braithwaite, Shona Jaunas, Jean Sergent, Gradon Diprose, Becky Turrell, Mica Hubertus Mick, Paula Bethwaite, Matilda Fraser, Murdoch Stephens, Louise, Emma Willis, Sarah Watson, Shiloh Dobie, Amanda Rodriguez, Sharon Rogers, Gail Higgs-West, Paora Allen, Tim Barlow, Renee Gerlich, Sophie Oxenbridge, Heather Johnston, Elyse Irvine, Tao Wells
Panellists:
Marilyn Waring, Susan Guthrie

The Public Fountain
Tim Barlow
16–19 May 2012
Horomātangi Street, Taupō; Marama Arcade, Taupō; Tūrangi town centre
Pages 128–43

Production team:
Mark Amery, Sophie Jerram, Laila O'Brien
Funder:
Creative New Zealand, Erupt Lake Taupō Arts Festival 2012
Produced as part of Erupt Lake Taupō Arts Festival 2012
Participants:
Dylan Tahau, Jenny Pattrick, Alison Harrington, Paul White, Gillian Cooke, Chris Mulcare, Pat Brown, Pattrick O'Brien, Bill Lomas, David Livingstone, John Ham, Anna McKnight

D.A.N.C.E. FM 106.7
D.A.N.C.E. Art Club (Chris Fitzgerald, Ahilapalapa Rands, Tuafale Tanoaʻi aka Linda T. and Vaimaila Urale)
16–19 May 2012
Wairakei Primary School; Rifle Range Pensioner Village, Taupō; Te Kura o Te Waitahanui; Tūrangi town centre; Bus Stop Cafe, Mangakino; Tokaanu Thermal Pools; Tongariro Domain, Taupō
Pages 128–43

Funders:
Creative New Zealand, Erupt Lake Taupō Arts Festival 2012
Produced as part of Erupt Lake Taupō Arts Festival 2012
Other supporters:
Timeless Taupo 106.4,
Mountain FM 89.6

Open Plan: An Art Party
Gap Filler, The Playground NZ and Letting Space
3 November 2012
Sustainability Trust, Forresters Lane, Wellington
Pages 144–47

Production team:
Sam Trubridge, Sophie Jerram, Mark Amery, Sustainability Trust
Contributors:
The Performance Arcade, Gap Filler, Linda T., James F. Ford, Beth Sometimes, Tim Barlow, Everybody Cool Lives Here, Seth Frightening, Siân Torrington, Mary Whalley, Karaoke Stories, Victoria Singh, All Seeing Hand, Bronwyn Holloway-Smith, Colin Hodson, Julian Priest, Samin Son, Claire Harris, Meg Rollandi, Thomas Press

Urban Dream Brokerage
2012–18
Pages 148–51

Wellington
Funders:
Wellington City Council,
Wellington Community Trust
Brokers:
Helen Kirlew Smith, Robbie Whyte, Laurie Foon
Advisory board:
Stathis Moutos, Alison Pharaoh, Liz Mellish, Walter Langelaar, Eve Armstrong, Mike Cole, Kim Paton, Anna Harley

Dunedin
Funders:
Dunedin City Council,
Otago Community Trust
Brokers:
Tamsin Cooper, Katrina Thomson
Advisory board members:
Nicky Aldridge-Masters, Ali Bramwell, Caroline McCaw, Vicki Lenihan, Chanel O'Brien, Josh Thomas, Cara Paterson, Kirsten Glengarry

Porirua
Funder:
Porirua Chamber of Commerce
Broker:
Mark Amery

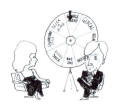 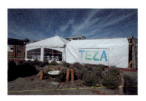

Masterton
(partnership with Toi Āria: Design for Public Good)

Funder:
Masterton District Council
Brokers:
Anneke Wolterbeek, Mark Amery, Helen Kirlew Smith, Sophie Jerram
Advisory board members:
Jade Waetford, Carolyn Corrin, Sandy Ryan, Andrea Jackson, Rongomaiaia Te Whaiti, Heidi Holbrook, Lydia Wevers, Andrew McCroskery, Tirau Te Tau, Andrew Winter, Gareth Winter, Kirsten Browne

Studio Channel Art Fair
7–11 August 2013
Auckland Art Fair
Pages 154–57

Production team:
Mark Amery, Sophie Jerram, Harry Silver (film), Cushla Donaldson (curator), Cathy Aronson, Charlie Baptist, Teresa Canal, Anthony Henderson
Funder:
Auckland Art Fair
Participants:
Scott Eady, Lonnie Hutchinson, Sue Gardiner, Marshall Seifert, Ron Brownson, Anna Pappas, Heather Galbraith, Lisa Fehily, Judy Darragh, Matt Nache, Reuben Paterson, Richard Moss, Jennifer Buckley, Paul McNamara, Jonathan Smart, Sait Akkirman, John Hurrell, Dick Quan, Anna Miles, Francis Till, Tracey Williams
Featured artists:
Erin Forsyth, Amber Wilson, Lonnie Hutchinson, Ryder Jones, Bob Van der Wal, Eddie Giesen, Ella Scott-Fleming, Cushla Donaldson, Reuben Paterson

Transitional Economic Zone of Aotearoa (TEZA) — New Brighton
24 November–1 December 2013
Creative Quarter, 101 New Brighton Mall, Christchurch
Pages 158–91

Production team:
Sophie Jerram, Mark Amery, Helen Kirlew Smith, Tim Barlow
Commissioned artists:
Tim Barlow, Phil Dadson, Kim Paton, Richard Bartlett, Te Urutahi Waikerepuru, Kura Puke, Mark Harvey, Stuart Foster, Kerry Ann Lee, Kiwi Henare, Kim Lowe, Simon Kaan, Ron Bull Jnr, Priscilla Cowie, Nathan Pohio, Tim J. Veling, David Cook
Associate artists:
Ash Holwell, Rebecca Ann Hobbs, Steve Carr, Lucien Rizos, Claire Harris, Layne Waere, Murray Hewitt, Heather Hayward, Tessa Peach, Trudy Lane, Audrey Baldwin, Margaret Lewis, Gabrielle McKone, Michelle Osborne, Te Huirangi Waikerepuru, Kalya Ward
Logo design:
Kerry Ann Lee
Supported by:
Creative New Zealand, Makeshift, Renew New Brighton, Positive Directions Trust, New Brighton Project, Chartwell Trust, Kāi Tahu, Pak'nSave, Massey University, WINTEC, University of Auckland, Ministry of Awesome, Ngāi Tūāhuriri, Life in Vacant Spaces, The Physics Room, Loomio, All Good Organics, The Wi-Fi Guys, Our Daily Waste, CIRCUIT Artist Moving Image Aotearoa New Zealand, New Brighton Historical Museum and many others

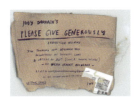
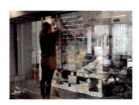
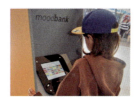

Please Give Generously
Judy Darragh
13 December 2013–2 May 2014
JWT offices, Imperial Lane, and Level 2, Imperial Building, 44 Queen Street, Auckland
Pages 194–201

Production team:
Mark Amery, Sophie Jerram, Harry Silver
Commissioned by:
JWT Advertising (Cleve Cameron and Kirsten Brown)

Te Ika-a-Akoranga
Bronwyn Holloway-Smith
May–October 2014
JWT offices, Imperial Lane, and Level 2, Imperial Building, 44 Queen Street, Auckland; Massey University, Wellington; and online
Pages 202–11

Production team:
Sophie Jerram, Mark Amery, Harry Silver, Kerry Males
Commissioned by:
JWT Advertising (Cleve Cameron and Kirsten Brown)

Moodbank Wynyard
Vanessa Crowe
18 March–6 May 2015
Wynyard Quarter kiosk, Auckland
Pages 214–19

Production team:
Mark Amery, Vanessa Crowe, with the assistance of Waterfront Auckland
Commissioned by:
JWT Advertising
Information kiosk assistants:
The Folk People, Selina Twomey
Development:
Sarah Elsie Baker

 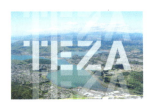

Projected Fields
Siv B. Fjærestad
From 19 April 2015
Macalister and Liardet Street parks, Berhampore, Wellington
Pages 220–31

Production team:
Mark Amery, Sophie Jerram, Helen Kirlew Smith, Kedron Parker
Funder:
Wellington City Council
Assistants:
Sorelle Cansino, Leonie May, Jared Connon, John Mills, Louise Thornley, Robbie Whyte, Ben Zwartz, John Grant, Irene McGlone, Samuel LaHood
Picnic events:
Tai Chi Associates, Community Music Junction, Berhampore Kindergarten, Kite Association, Berhampore Dogwalkers, Girl Guides, acroyoga (James Mason and Kelly Wells), Zumba (Beth Beard), face painting (Helen Williamson), hula hooping (Lucy Cooper), kī-o-rahi (Push Play, led by Daphne Pilaar and Marina Kirikiri), history booth (Kerryn Pollock), poet Jodie Dalgleish, DJ Kedron Parker

Transitional Economic Zone of Aotearoa (TEZA) — Porirua
21–29 November 2015
Cobham Court, Porirua City Centre, Porirua
Pages 232–67

Production team:
Sophie Jerram, Mark Amery, Helen Kirlew Smith, Marieke Groenhart, Linda Lee, Cassidy Browne, Helen Keivom, Sam Buchanan
Commissioned artists:
Kāwika Aipa, Barbarian Productions, Tim Barlow, Herbee Bartley, David Cook, Vanessa Crowe, Wiremu Grace, Simon Gray, Mark Harvey, Ash Holwell, Amanda Joe, Kava Club, Kerry Ann Lee, Linda Lee, Lana Lopesi, Paula MacEwan, Moana Mitchell, Jason Muir, Jennifer Whitty, Leala Faleseuga
Associate artists:
Alicia Rich, Moses Viliamu, Faith Wilson, Richard Bartlett, Awhina Mitchell, Pip Adam, Kris Faafoi, Tracey Wellington, Annie Bretherton, Dave Brett, Amelia Espinosa, Lotte Kellaway, Kaia Hawkins, Sarah Maxey, Kemi and Niko, Shay Green, Eli Apinera, Te Kupu, Kristen Paterson, Barry Thomas, Kedron Parker, Thomas LaHood, Andrea Sellwood, Miriama Grace-Smith, Trish Given, John Lake, Pikihuia Little, Marcus McShane, Margaret Tolland, Zac Mateo

Funder:
Creative New Zealand
Property partner:
Kiwi Property
Graphic design:
Kerry Ann Lee
TEZA hub designer:
Debbie Fish
Supported by:
Porirua City Council, Mana Community Grants Foundation, Chartwell Trust, New Zealand Chambers of Commerce: Porirua, Peoples Coffee, Urban Dream Brokerage, Tautai Pacific Arts Trust, Whittaker's, All Good Organics, Ludlum Corporation, Te Rito Gardens, Pātaka Art + Museum, Whānau Kotahi, Hongoeka Marae, Rūnanga Ngāti Toa o Rangatira, New Zealand Green Bike Trust, Te Korowai Aroha, Strong Pacific Families, Access Radio, Wesley Community Action, Porirua Community Arts Council, Porirua School Garden Club, Aspiring Walls, Kiwi Community Assistance, Porirua Hospital Museum, Wellington Riding for the Disabled

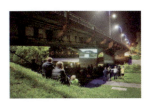

Groundwater: Common Ground Arts Festival
25 February–4 March 2017
Hutt Valley, Wellington
Pages 272–97

Production team:
Mark Amery, Pippa Sanderson (Hutt City Council), Helen Kirlew Smith, Debbie Fish, Linda Lee, Robert Laking
Commissioned artists:
Julian Priest, Gabby O'Connor, Stu Farrant, Bruce McNaught, Kedron Parker, Paula Warren, Murray Hewitt, Johanna Mechen, Angela Kilford, Aliyah Winter
Associate artist projects:
Josephine Garcia Jowett, Andrea Sellwood, Liana Stupples, Dionne Ward, Birgit Bachler, Stringbean Puppets
Funders:
Creative New Zealand, Hutt City Council and Chartwell Trust
Supported by Waiwhetū Marae, About Space, Hutt City Council, Dowse Art Museum, GNS Science, Greater Wellington Regional Council, Wellington Water, 1st Assembly
Collaborators:
Gem Wilder, Damien Wilkins, Helen Heath, Brydee Rood, Ross Jackson, Alistair Allan, Connor Baird, Access Radio, Jason Wright, Christine Fagan, Hutt Valley Community Choir, Sendam Rawkustra, Mixmusicmania, Bruce Mahalski
Participants:
Teri Puketapu, Simon Bowden, Mike Joy, Huhana Smith, Morrie Love

Unsettled
Rana Haddad and Pascal Hachem
3–12 May 2017
2 Tory Street and other city streets, Wellington
Pages 298–303

Production team:
Helen Kirlew Smith, Sophie Jerram
Supported by:
Urban Dream Brokerage, Victoria University of Wellington

Our Future Masterton — Ahutahi ki mua
May–December 2017
Pages 304–09

Production team:
Anna Brown, Helen Kirlew Smith, Mark Amery, Sophie Jerram, Anneke Wolterbee, Sophie Munro, Nina Boyd, Jhana Millers
Funder:
Masterton City Council
Supported by:
Massey University, Toi Āria: Design for Public Good, Aratoi, Te Pātukituki O Wairarapa, Jade Waetford
Advisory panel:
Andrew Donald, Lydia Wevers, Tirau Te Tau, Kirsten Browne, Geoff Copps, Andrea Jackson, Carolyn Corrin, David Hedley, Gareth Winter, Laura Bradley Rongomaiaia Te Whaiti

Project Notes

Acknowledgements

Thank you to all the makers and creators featured here for your trust with your work. It continues to inspire us.

This book has only been possible due to much collaboration with remarkably talented people.

Pip Adam, a concept driver and early editor, has played a vital role guiding us into the 'bookness' of this project.

Out of all we three co-editors, Amber Clausner kept everything together and constantly provided a gentle critical eye and suggestions to make things clear.

Thank you to Massey University Press and in particular to Nicola Legat, for her steadfast belief. Meticulous editorial work has been provided by the Annas: Anna Hodge, Anna Bowbyes and Anna Jackson-Scott. Meanwhile — talking of steadfast — designer Anna Brown has been a vital creative power and engine for good community change for us since this journey began.

The involvement of co-director Helen Kirlew Smith was vital to Letting Space and the evolution of Urban Dream Brokerage. Thanks to you, our systems, planning and the confidence provided to artists was hugely boosted.

Since 2009 Letting Space has been supported steadfastly by our dear friends and inspirations who have been fellow trustees in the Wellington Independent Arts Trust, our umbrella organisation: since 2009, Gaylene Preston and Jan Bieringa, and more recently and/or formerly, Julian Priest, Anna Brown, Nik Shewring and Jo Randerson.

Fundamental to everything recorded in this book has been the support and belief in us shown by funders Creative New Zealand and the Wellington and Dunedin city councils. Here's to living in a country that is prepared to trial out-of-the-box solutions!

We also acknowledge the passing of kaumatua Teri Puketapu of Waiwhetū in May 2023, a key collaborator in Groundwater: Common Ground Arts Festival. After the festival, Puketapu achieved his mission to see a reopening of community access to the Waiwhetū aquifer.

Mark: Huge thank-yous and all my love to Hannah Zwartz and Alison, Solomon and Pearl Amery-Zwartz, who made it possible and constantly inspired the work.

Amber: I'd like to offer a particular thank-you to Mark and Sophie for their guidance and trust throughout this process, as well as appreciation to the many others who offered their help and support during the making of this book.

Sophie: A big shout-out to my mother, Mary Jerram (1930–2013), who in her last days enjoyed watching our TEZA roll-out in Christchurch. She modelled change as a journey from the inside out.

Mark Amery, Amber Clausner and Sophie Jerram

Note on the Text

Letting Space commissioned essays and responses for the majority of its projects between 2010 and 2017, as well as keeping other notes, diaries and records. The essays, diaries and responses were published on the Letting Space website (www.lettingspace.org.nz) around the time of each project's realisation. The original essays have been edited and abridged for inclusion in this book by Mark Amery, Amber Clausner and Sophie Jerram.

'Open Call' by Chris Kraus, 'The Time Travellers' by Pip Adam and 'Shifting the Urgency' by Zara Stanhope were newly commissioned for this volume. The yearly event frontispieces were written by editorial consultant Pip Adam, who also offered other framing advice. The 'Before' and 'After' texts were written by Mark Amery, and the project introductions were written by Mark Amery, Amber Clausner (page 111) and Sophie Jerram (page 299).

David Cross's essay 'Corporation Wells' was originally published in *EyeContact*, 22 October 2010. 'Love Your Labour — Don't Labour to Live' by Tao Wells and The Wells Group was originally published in the *Dominion Post*, 28 October 2010. The quotation by David Cross on page 51 is from his essay 'Wellington's Free Store', *EyeContact*, 7 June 2010. The quotation by Megan Dunn on page 77 is from her essay 'Prospect Goes Cerebral', *EyeContact*, 16 December 2011. Tim Barlow's essay 'Shock and Salve: Bathing in the healing waters' is an extract adapted from his PhD thesis: 'Caring Deception: Community art in the suburbs of Aotearoa (New Zealand)', Massey University, 2016. The piece by Vanessa Crowe and Sarah Elsie Baker, 'How Do You Feel and What Is It Worth?', is from texts originally published in Vanessa Crowe and Sarah Elsie Baker, *Moodbank: How do you feel and what is it worth?* (PDF). Thomasin Sleigh's essay, 'Murray Hewitt's The Rising Gale' was originally commissioned by CIRCUIT Artist Moving Image Aotearoa New Zealand and published on the CIRCUIT website, 11 April 2017.

Image Credits

'Open Call': Grant Sheehan, Dionne Ward and Gabrielle McKone

'The Time Travellers': Kelvin Hu, https://commons.wikimedia.org/wiki/File:John_Key_and_family.jpg

'Before': Artspace projects — Letting Space

The Urban Dream Brokerage Realty Pitch Forums: Lance Cash (2011 event photographer), content provided by Tim Barlow, Bruce Mahalski, Murdoch Stephens and Kim Paton

Popular Archaeology: Mark Amery, Boofa and Mary-Jane Duffy

Free Store: Murray Lloyd

Beneficiary's Office: Tao Wells, Murray Lloyd, Gabrielle McKone, Mark Amery, New Zealand Listener, Are Media Ltd., Stuff Ltd.

Taking Stock: Murray Lloyd, Gabrielle McKone, Mark Amery, Prospect Image — Eve Armstrong, *Taking Stock*, 2010–11, mixed media, in *Prospect: New Zealand Art Now*, City Gallery Wellington Te Whare Toi, 2011–12. Photo: Kate Whitley

Shopfront: Suburban Floral Association, Margaret Colligan, Laresa Kosloff and Hannah Zwartz

The Market Testament: Mark Amery, Murray Lloyd and Gabrielle McKone

Pioneer City: Mark Amery and Murray Lloyd

Free of Charge: Letting Space, Emma Underhill, Julian Priest

Productive Bodies: Gabrielle McKone

The Public Fountain and D.A.N.C.E. FM 106.7: Letting Space

Open Plan: An Art Party: Fraser Crichton and Gabrielle McKone

Urban Dream Brokerage 2012–18: Justin Spiers, Louise Clifton, Gabrielle McKone, Imaginarium and Modelab

Studio Channel Art Fair: Harry Silver

Transitional Economic Zone of Aotearoa (TEZA) 2013: Mark Amery, Richard Arlidge, David Cook, Bayley Corfield, Anake Goodall, Sophie Jerram, Gabrielle McKone, Kim Paton, Tim J. Veling, Kalya Ward and Hannah Watkinson

Please Give Generously: Judy Darragh and Harry Silver

Te Ika-a-Akoranga: Sophie Jerram, Bronwyn Holloway-Smith, Shaun Waugh, Claire Robinson and Leanne Radojkovich; photograph of ComPac mural, 1975, taken by K. V. Lunn. Collection of Archives NZ

Moodbank Wynyard: Vanessa Crowe, Russel Kylen (studio shots) and Gabrielle McKone

Projected Fields: Gabrielle McKone, Mike Orchard and Grant Sheehan

Transitional Economic Zone of Aotearoa (TEZA) 2015: Mark Amery, Cassidy Browne, Georgina Conroy, David Cook, Wiremu Grace, Sophie Jerram, Amanda Joe, Jung Shim Kreft, Linda Lee, Andrew Matautia, Gabrielle McKone, Frankie Padallec, Alicia Rich, Ann Shelton and George Staniland

Groundwater: Common Ground Arts Festival: Dionne Ward and Mick Finn

Unsettled: Sophie Jerram and Gabrielle McKone

Our Future Masterton — Ahutahi ki mua: Janelle Preston and Our Future Masterton crew

'After': Milan Maric, Anne Noble and Lily Dowd

'Human First, Artist Second': Letting Space and Mick Finn

'Shifting the Urgency': Milan Maric, Dionne Ward and Murray Lloyd

About the Contributors

Pip Adam is the author of four novels: *Audition* (2023); *Nothing to See* (2020); *The New Animals* (2017), which won the Acorn Foundation Prize for Fiction; and *I'm Working on a Building* (2013); as well as the short story collection *Everything We Hoped For* (2010), which won the NZSA Hubert Church Best First Book Award for Fiction in 2011. She makes the *Better Off Read* podcast.

Mark Amery is a writer, producer, curator and facilitator who works across the public arts and media with a focus on new forms of participation. Co-founder of Letting Space, Paekākāriki.nz and Paekākāriki FM 88.2, Amery currently works at RNZ and as a contributing arts editor for *The Post*. He is a member of the Wellington City Council Public Art Panel and in 2022 completed a public art project, *The People's Voice*, with Wellington social housing residents.

Cathy Aronson is a multi-media journalist and the past editor of creative community website The Big Idea and newspaper *Local Matters*.

Sarah Elsie Baker is head of research and a senior lecturer in design at Media Design School in Auckland. Her practice-based research explores queer feminist approaches to data visualisation.

Sally Blundell is a freelance journalist and writer in Ōtautahi Christchurch. She holds a PhD from the University of Canterbury and has been books and culture editor for the *New Zealand Listener* and a judge for the fiction category in the 2018 Ockham New Zealand Book Awards. Her book *Ravenscar House: A biography* was published in 2022 by Canterbury University Press.

Ali Bramwell is a practising artist who is based in Ōtepoti Dunedin.

Anna Brown is a book designer, educator and researcher who works with visual artists, curators, art historians and musicians. She has taught editorial design, typography and courses about the future of the book. She is the director of Toi Āria, a research unit harnessing design for positive social change. Prior to joining Massey University, she ran her own design business with a specialisation in book design.

Amber Clausner works across various arts organisations in Aotearoa, producing, managing and creating community-focused projects.

Andrew Clifford is a writer and curator, and the director of the Sarjeant Gallery Te Whare o Rehua Whanganui. From 2013 to 2023 he was the director of Te Uru in Tāmaki Makaurau. He has produced music programmes for 95bFM and RNZ. He is a trustee of the Len Lye Foundation and the Edith Collier Trust.

David Cross is a Naarm Melbourne-based artist, writer and curator. He is co-director of Public Art Commission and a professor of visual art at Deakin University.

Chloe Cull is a curator, teacher and writer based in Ōtautahi Christchurch. She works as Pouarataki Curator Māori at Christchurch Art Gallery Te Puna o Waiwhetū.

Gradon Diprose is a human geographer who works as an environmental social scientist at Manaaki Whenua Landcare Research. He is currently involved in research on urban wellbeing, climate change adaptation and circular economy practices.

Megan Dunn is a New Zealand writer and editor with a BFA and MA in creative writing from the University of East Anglia. She previously ran the artist-run space Fiat Lux in Auckland. Her art reviews and criticism, essays and stories have been widely published.

Reuben Friend (Ngāti Maniapoto, Pākehā) is an artist, writer, curator and former museum director. He has a bachelor's in Māori visual arts from Te Wānanga o Aotearoa and a master's in Māori visual arts from Massey University.

Heather Galbraith is a Pākehā curator, writer and educator based in Te Whanganui-a-Tara Wellington. Currently professor of fine arts and director postgraduate at Toi Rauwhārangi Massey College of Creative Arts, she has a strong interest in art in public space and expanded fields of curatorial practice.

Sophie Jerram works with artists and communities in university, government and community roles. Her research focuses on how shared space and time are important actors in community landscapes.

Rangimarie Sophie Jolley is a writer of Waikato-Tainui descent, and is based in Porirua.

Chris Kraus is a writer and critic who lives in Los Angeles via New York and Aotearoa New Zealand. Her work has been translated into more than a dozen languages, and her most recent book is *Social Practices* (2018).

Lana Lopesi is a Samoan and Pākehā author whose books are *Bloody Woman* (2021) and *False Divides* (2018). She is assistant professor in Pacific Island studies at the University of Oregon.

Bruce Mahalski is a Ōtepoti Dunedin artist known for his illustration, street murals, and sculpture incorporating animal bones. He is founder and director of the Dunedin Museum of Natural Mystery, a private museum of natural history and ethnographic objects and curios.

Lucy Matthews is an artist and activist and is part of the Ōtautahi-based collective The Social. She is a graduate of Ilam School of Fine Arts, a mum, a psychotherapist and someone who is generally intrigued by the human experience.

Melanie Oliver is a curator at Christchurch Art Gallery Te Puna o Waiwhetū.

Michelle Osborne is a writer who lives and works in Auckland. At the time of the TEZA project she was involved in creative development and worked as an arts practitioner. She has a bachelor of arts with honours in anthropology, a master's in art and design and a diploma of museum studies.

Martin Patrick is a writer and historian and an associate professor at Whiti o Rehua School of Art at Massey University. He is the author of the books *Across the Art/Life Divide: Performance, subjectivity, and social practice in contemporary art* (2018) and *The Performing Observer: Essays on contemporary art, performance, and photography* (2022).

Bruce E. Phillips is an independent curator and writer from Aotearoa based in Edinburgh. As a curator he has worked with more than 200 artists and his writing has been published in *ArtAsiaPacific*, *Artlink Magazine*, *Art News New Zealand* and in a number of exhibition publications such as for Auckland Art Gallery Toi o Tāmaki, the Govett-Brewster Art Gallery and Te Tuhi.

Kerryn Pollock is an historian and heritage advisor who lives in Te Whanganui-a-Tara Wellington.

Max Rashbrooke is a Wellington-based writer and public intellectual, with twin interests in economic inequality and democratic renewal. His latest book is *Too Much Money: How wealth disparities are unbalancing Aotearoa New Zealand* (2021), based on research he carried out as the 2020 J. D. Stout Fellow at Victoria University of Wellington.

Tiffany Singh is an Aotearoa-born artist of Indian and Pacific descent. Her practice explores the intersection between arts, education and wellbeing. Since graduating from Elam School of Fine Arts in 2008, Singh has worked on sustainable community outreach, exploring engagement in the arts through social practice to engender policy and advocacy of social justice.

Thomasin Sleigh is a writer and editor with a focus on visual art.

Zara Stanhope is the ringatohu director of the Govett-Brewster Art Gallery | Len Lye Centre in New Plymouth.

Murdoch Stephens is a writer and publisher with the Lawrence & Gibson collective. He hails from Waitepeka. His two most recent novels are *Down from Upland* (2022) and *Rat King Landlord* (2020). He previously wrote under the nom de plume Richard Meros.

Giovanni Tiso is an Italian writer and translator based in Te Whanganui-a-Tara Wellington, and the online editor of the literary journal *Overland*.

Moira Wairama is a storyteller and award-winning writer from Te Awakairangi who also works part-time at a kura kaupapa Māori.

Darryl Walker works on community and small business boards integrating social business perspectives with underlying principles of generosity, reciprocity and responsible management.

Gem Wilder grew up in Te Awakairangi. They currently write, read, parent and live in Berhampore.

Emma Willis teaches theatre at the University of Auckland and works as a dramaturge in theatre and dance. Her interests span all forms of performance that relate to themes of loss, connection, empathy and understanding.

Andrew Paul Wood is a Christchurch-based arts and cultural commentator whose writings appear in *Art News New Zealand*, the *New Zealand Listener*, The Big Idea and other publications in Aotearoa, Australia and further afield. He is art editor for *takahē* magazine and is the author of the book *Shadow Worlds: A history of the occult and esoteric in New Zealand* (2023).

Hannah Zwartz is a gardener and garden consultant, designer, writer and educator. She is currently working on garden and play-scaping projects at schools on the Kāpiti coast.

About the Commissioned Artists

Kawika Aipa is an events producer, heritage artist and kanaka lomi (Native Hawaiian healer). He is the Creative New Zealand inaugural manager, Pacific arts, and provides expertise on Pacific arts in New Zealand and internationally.

Eve Armstrong is an artist based in Te Whanganui-a-Tara Wellington who works across sculpture, installation, collage and participative art projects. Her practice examines the sculptural and creative potential of the everyday with a focus on the products and by-products of consumption, and the activities of trade and exchange.

Barbarian Productions is a theatre and live performance production company based in Te Whanganui-a-Tara Wellington.

Tim Barlow is an artist with a history of creating public artworks and conversations about community, resource issues and ethical values. He has a PhD in fine arts from Massey University.

Richard Bartlett is a conservative anarchist, applied sociologist and participant-agitator at Enspiral, Loomio, Microsolidarity and The Hum. He makes groups that feel good.

Herbert Bartley is of Tokelauan and Samoan descent with ancestral ties to Tuvalu and the Cook Islands. Herbert is part of the LGBTQIA, MVPFAFF community. He is the co-founder of Kava Club, a Wellington-based Māori and Pacific Collective which ended in 2017. Now creative director Pacific at Toi Rauwhārangi Massey College of Creative Arts, he also leads the Pacific portfolio and is the first Pacific executive in the college leadership team.

David Cook is a Wellington-based photographer specialising in socially engaged art projects. His collaborations have included mining communities, social housing tenants and schools. Since 2016 he has been one of the key organisers of Wellington's biennial Photobook NZ Festival. David is a senior lecturer at Whiti o Rehua School of Art, Massey University.

Vanessa Crowe is a practising artist and creative and engagement specialist. Her art practice explores methods to celebrate and make visible unseen aspects of everyday life — from mood to messy laundry. She worked in creative academia for 16 years and she now leads Wai Tuwhera o te Taiao, a nationwide community science project empowering communities, iwi, hapū and whānau to protect and restore local waterways.

Philip Dadson ONZM is a New Zealand musician, artist and sculptor. He graduated from Elam School of Fine Arts, where he lectured from 1977 to 2001 before taking up a full-time art practice. He was a member of the foundation group for Scratch Orchestra and, later, founder of Scratch Orchestra and From Scratch.

D.A.N.C.E. Art Club was established in 2008 and comprises Tuafale Tanoa'i, Vaimaila Urale, Chris Fitzgerald and Ahilapalapa Rands. They form a collaborative art collective that creates projects in public spaces to encourage audience engagement. Manaakitanga, hospitality, music, food and sharing space are key elements.

Judy Darragh ONZM is an artist renowned for her brightly coloured sculptural assemblages, collage, video and photography. She played a significant role in the development of ARTSPACE Aotearoa and artist-run spaces Teststrip and Cuckoo. She was a co-editor of *Femisphere*, a publication supporting women's art practices in Aotearoa.

Leala Faleseuga is a multidisciplinary artist of Samoan (Salelologa) and Dutch (Limburg and Friesland) heritage whose practice is rooted in photography, alternative processing and painting. They work and exhibit solo as well as being part of the 7558 Collective.

Siv B. Fjærestad is an artist, writer and collaborator. She is co-editor of *Collaborative Art in the Twenty-First Century*, and a member of the Tramping Gently Club Art Collective. Her work explores the influence of social constructs upon access to information, participation and our relationship with the landscape and environment.

Stuart Foster is a spatial designer and senior lecturer at Toi Rauwhārangi Massey College of Creative Arts in Wellington. His research applies digital technologies to the creation of spatiotemporal narrative environments, and he employs interdisciplinary aesthetics and ritual performance in public or site-specific works to communicate cultural and social connectedness between people, place and space.

Wiremu Grace is a carver, performing artist, children's book writer, community development worker and kura kaupapa Māori teacher. He is also a writer and director for radio, TV, film and stage.

Simon Gray is an artist and zine maker, and the art coordinator at The White Room Creative Space in Ōtautahi Christchurch.

Pascal Hachem is a Lebanese artist and product designer interested in the link between the city, the transitory and the uncertain. Co-founder of 200Grs, he has won several awards including Bang & Olufsen and the Boghossian prize, Brussels. He has work in the Nadour Collection, Germany, the Galila Barzilai-Hollander Collection, Belgium, and, with 200Grs, the Victoria and Albert Museum in London.

Rana Haddad is an artist, activist, AA graduate and co-founder of 200Grs who is based in Beirut. Her practice aims to question the ability of objects and places to become means of political expression. She has lectured and given workshops in many art and architecture international institutions and is an assistant professor at the American University of Beirut, where she founded BePublic lab. She is completing an artist residency at la cité internationale des arts de Paris, France.

Mark Harvey (Ngāti Toa, Ngāti Raukawa, Pākehā) is an Aotearoa New Zealand-based artist, researcher and curator who works in arts advocacy, contemporary art and performance, ecology and the environment, mātauranga Māori, social justice and related social and political perspectives. He has exhibited widely both locally and internationally.

Murray Hewitt is a video and performance artist whose works contemplate consumer behaviour, historic events and recent politics. He has presented work throughout Aotearoa and internationally. He works as an exhibitions preparator for the Govett-Brewster Art Gallery | Len Lye Centre.

Colin Hodson is an Aotearoa-born artist and filmmaker who lives in Naarm Melbourne via New York and Amsterdam. His previous works include the improvised feature films *Shifter* and *.ON*. He also creates drawing works on paper and experimental music using repurposed machines. He is shooting a new verité-styled feature film with a digital camera with a pinhole lens.

Bronwyn Holloway-Smith is an artist, author and co-director of Public Art Heritage Aotearoa New Zealand. Her fine arts doctorate examined the Southern Cross Cable and New Zealand national identity, and the resulting artworks were exhibited at City Gallery Wellington in 2018. Her book, *Wanted: The search for the modernist murals of E. Mervyn Taylor* (2018), was a finalist in the 2018 Ockham New Zealand Book Awards.

Ash Holwell is a design activist and founder of spacelamp focused on building the physical and social infrastructure needed to create a just and sustainable world. Practising in Te Whanganui-a-Tara and Whangārei, their recent work includes co-founding a space for work and play (two/fiftyseven), an arts incubator (oneonesix) and artistic hub (oneonethree); pioneering mental health peer support trainings with CoLiberate; and a co-housing project.

Simon Kaan is of Chinese, Kāi Tahu and Pākehā ancestry. He graduated with a diploma of fine art in printmaking from Otago Polytechnic in 1993 and has exhibited widely in New Zealand in both public and dealer galleries. With Ron Bull Jnr, Priscilla Cowie and Nathan Pohio, Kaan worked on the Kaihaukai project as part of TEZA 2015.

Kava Club is a non-profit of Pasifika Māori creatives established to collaborate, connect, support and network in their community.

Angela Kilford (Te Whānau a Kai, Ngāti Porou, Ngāti Kahungunu ki Wairoa) is an artist, designer, educator and researcher, and lecturer and major coordinator for textile design at Massey University, Wellington. Her research practice focuses on how mātauranga Māori and Māori participation can inform textile design practice and research to produce ways to benefit Māori communities and to sustain Papatūānuku.

Kerry Ann Lee is an artist, designer, scholar and educator from Te Whanganui-a-Tara Wellington whose work explores culture clash, settlement, transformation and exchange in the Asia-Pacific region and beyond. Lee regularly exhibits nationally and internationally and is well-known for her work in independent publishing and fanzines over the past two decades.

Linda Lee (Ngāti Raukawa, Ngāti Huia, Ngāti Kurī, Te Rarawa, Te Aupōuri) is a mixed-race (Māori, Chinese, Pākehā) artist and kaiwhatu. She holds an MFA from Ilam School of Fine Arts and is creative director of Shared Lines Collaborative, co-producer of Urban Dream Brokerage and producer of Ōtari Raranga. Her practice explores identity, family and indigenous histories through exhibition, installation, photography and book form.

Kim Lowe is an artist, printmaker and educator who lives on the east side of Ōtautahi Christchurch.

Paula MacEwan is an artist and community activist behind The Koha Table in Cannons Creek, Wellington, and TEZA's *Active Citizen's Funeral* project.

Dugal McKinnon is a composer and sound artist whose creative interests encompass electronic, acoustic, visual and textual practices. He is the deputy director of Te Kōkī New Zealand School of Music and co-director of the Lilburn Studios for Electronic Music.

Gabrielle McKone is best known for a daily photo blog that she maintained continuously for 11 years until 2018 and re-started in March 2020. Gabrielle has self-published two books, *Catch My Eye* and *Bondage*, and has exhibited at Photospace Gallery. Her exhibition *Three Stories Up* was featured in Wellington City Council's Courtenay Place lightboxes.

Bruce McNaught is an artist and musician who lives in Te Whanganui-a-Tara Wellington.

Johanna Mechen is an artist, curator, writer and teacher. Her work explores performativity and participation in photographic practice, exploring community and site engagement to tell ecological, social and personal stories. She has completed residencies at Toi Pōneke (2018) and Enjoy Gallery (2016) and is a PhD candidate at Whiti o Rehua School of Art at Massey University.

Moana Mitchell is a writer and advocate who is passionate about working with whānau and communities living with inequity.

Jason Muir is a career hairdresser and public artist with a passion for bringing participatory activations to life. His main body of work has been under the Political Cutz banner, offering free haircuts in exchange for political conversations. He is currently director of Urban Dream Brokerage.

Gabby O'Connor is a New Zealand-based installation artist. Her research and sculpture practice is climate focused and participatory, centring on the connection between art, science and climate.

Kedron Parker is a multi-media artist in Wellington. She co-created innovative eco and social practice works such as the city's first sound-based public artwork *Kumutoto Stream*, as well as *Inanga Love Park*, *Hello Pigeons*, *ubdTV* and the photo series *Rock 'n Roll Marae* and *Socially Distanced Portraits in the Time of Covid*.

Kim Paton is the director of Objectspace, a public gallery dedicated to the fields of craft, design and architecture. She works with artists, makers and designers on a broad range of exhibitions and publications, and has curated and written extensively on object-based artforms.

Julian Priest is an interdisciplinary artist currently based in Copenhagen. He works with participatory and technological forms. He has lectured at Victoria University of Wellington, Auckland University of Technology and Massey University, and is a researcher in satellite technology at IT University of Copenhagen.

Kura Puke (Te Āti Awa, Taranaki) is an artist and researcher specialising in Māori visual arts, with a focus on sculptural, light and sound artworks as cultural, aesthetic and spatial experiences. Since 2011, Kura has been a founding member of Te Matahiapo Indigenous Research Organisation, creating both iwi-based and international works. Kura is associate dean Māori at Toi Rauwhārangi Massey College of Creative Arts.

Suburban Floral Association comprises Tanya Eccleston and Monique Redmond. They collaborated on various projects in Tāmaki Makaurau Auckland from 2009–15. Significant projects include *The Floral Show at Fresh Gallery Otara* (2014), *Park for Day for Make Believe* (2014), *Shopfront* with Letting Space for Auckland Arts Festival (2011), and *An Event of Sorts: Treespotting* for Threaded ED8 (2009).

Tim J. Veling's practice is primarily focused on issues and people close to home and heart. His work straddles the genres of fine art and documentary photography, and he has exhibited nationally and internationally. He is a senior lecturer in photography at Ilam School of Fine Arts.

Te Urutahi Waikerepuru is managing director of Te Matahiapo Indigenous Research Organisation. She is experienced in developing indigenous, cross-cultural and inter-disciplinary networks, particularly mātauranga Māori, working in partnership with Western sciences, the arts, technology and spirituality, providing women-only retreats (wāhine purotu), and international public speaking and workshop facilitation.

Paula Warren is an artist and place maker who lives in Te Whanganui-a-Tara Wellington. She was trained as an ecologist and helps run many community restoration projects. Her primary focus as an artist is public space art and using art to connect people to nature.

Tao Wells is a Democratic Socialist Public Welfare artist, father, community conceptualist and founder of 'Democracy at home' relationship economics. He is a founder of Wellington's Enjoy Public Art Gallery, a member of the artist-run Gambia Castle Gallery. He was bestowed Peter McLeavey's 500th show.

Jennifer Whitty is a sustainable design educator, researcher, designer, facilitator, writer and activist. Originally from Ireland, she is an associate professor of design at Te Herenga Waka Victoria University of Wellington.

Aliyah Winter is an artist who works across photography, video and performance. Her research-based practice often draws on historical material, with a particular focus on language, voice and the body. She has exhibited widely nationally and internationally.

First published in 2023 by
Massey University Press
Private Bag 102904, North Shore Mail Centre
Auckland 0745, New Zealand
www.masseypress.ac.nz

Text copyright © individual contributors, 2023
Images copyright © as credited on page 346, 2023

Design by Anna Brown
Cover photograph by Gabrielle McKone

The moral rights of the authors have been asserted

All rights reserved. Except as provided by the Copyright Act 1994, no part of this book may be reproduced, stored in or introduced into a retrieval system or transmitted in any form or by any means (electronic, mechanical, photocopying, recording or otherwise) without the prior written permission of both the copyright owner(s) and the publisher.

A catalogue record for this book is available from the National Library of New Zealand

Printed and bound in China by Everbest Investment Ltd

ISBN: 978-1-99-101646-1

The publisher gratefully acknowledges the assistance of Creative New Zealand